Man, Myth and Museum

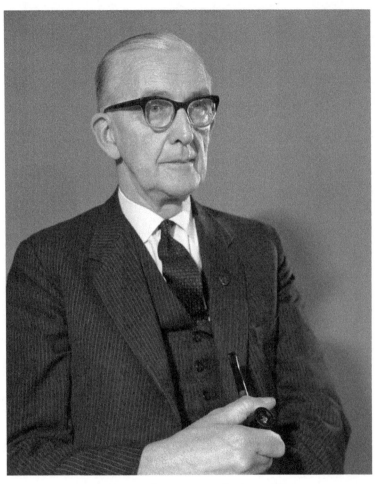

Figure 1: *Iorwerth Peate, pictured as he would have wished, on his retirement day in 1971.*

Man, Myth and Museum

Iorwerth C. Peate and the Making of the Welsh Folk Museum

Eurwyn Wiliam

UNIVERSITY OF WALES PRESS

2023

© Eurwyn Wiliam, 2023

All rights reserved. No part of this book may be reproduced in any material form (including photocopying or storing it in any medium by electronic means and whether or not transiently or incidentally to some other use of this publication) without the written permission of the copyright owner except in accordance with the provisions of the Copyright, Designs and Patents Act 1988. Applications for the copyright owner's written permission to reproduce any part of this publication should be addressed to the University of Wales Press, University Registry, King Edward VII Avenue, Cardiff CF10 3NS.

www.uwp.co.uk

British Library Cataloguing-in-Publication Data
A catalogue record for this book is available from the British Library.

ISBN 978-1-83772-039-2
eISBN 978-1-83772-040-8

The right of Eurwyn Wiliam to be identified as author of this work have been asserted in accordance with sections 77 and 79 of the Copyright, Designs and Patents Act 1988.

The University of Wales Press gratefully acknowledges the funding support of the Books Council of Wales in publication of this book.

Typeset by Marie Doherty
Printed by CPI Antony Rowe, Melksham, United Kingdom

Yn y fro ddedwydd hon mae hen freuddwydion
A fu'n esmwytho ofn oesau meithion;
Byw yno byth mae hen obeithion,
Yno mae cynnydd uchel amcanion.

(In this region of content remain dreams of old
That once soothed the fears of mighty aeons;
Ancient hopes dwell there forever,
And high aspirations come to fruition.)

T. Gwynn Jones, 'Ymadawiad Arthur'
['The Departure of Arthur'] (1902),
in *Caniadau* ['Songs'] (Caerdydd: Hughes a'i Fab, 1934)

Contents

List of Illustrations ix
Preface xi

1 Introduction 1
2 The land of lost content: the developing academic and the rural dream 19
3 The National Museum of Wales 43
4 Trouble and strife 73
5 The vanishing country craftsman 95
6 The search for the Welsh house 115
7 'A fair field full of folk': Iorwerth Peate and folk life 141
8 To dream the impossible dream ... a folk museum for Wales? 167
9 Opening St Fagans and the early years 193
10 Developing the folk park 217
11 Frustration and fulfilment 243
12 Retrospects 267

Select Bibliography 303
Index 309

List of Illustrations

Figure 1 Iorwerth Peate, pictured as he would have wished, on his retirement day in 1971.

Figure 2 The original Welsh Kitchen in the National Museum of Wales, as laid out by Cyril Fox.

Figure 3 The young Iorwerth Peate at his desk in the National Museum.

Figure 4 The official opening of the East Wing Galleries in 1932: Fox and Peate with Prince George. Peate must have appreciated the fact that his nemesis, the Museum Secretary Archie Lee, is partly obscured in the photograph.

Figure 5 The East Wing Folk Gallery, 1932.

Figure 6 Peate's Welsh Kitchen, 1932.

Figure 7 The Welsh Parlour, 1932.

Figure 8 The reconstructed Smithy in the East Wing basement, 1934.

Figure 9 Peate's most evocative Epynt photograph, with a family to be evicted from their home within a few days.

Figure 10 St Fagans Castle, c.1910.

Figure 11 The furnished Hall in St Fagans Castle, c.1950.

Figure 12 The New Galleries at the Welsh Folk Museum, 1957: the Saddler's Shop case.

Figure 13 The Folklore case.

Figure 14 The completed museum block, 1976.

Figure 15 Iorwerth Peate's bookplate, as designed by himself.

Preface

In many ways it has been an odd time to attempt to write a work of history, or at least history as I understand it, namely a quest for truth about the past. Of course the authors of every biography have to contend with their own prejudices, perceptions and (often) agendas; but I wrote this book when the very concept was being questioned, not just by the creation of the term 'alternative facts' by Kellyanne Conway in her effort to justify the numbers claimed as attending President Trump's inauguration in 2017, but also by the 'my truth' and the cancel and no-platforming culture that seem so beloved of the younger generation.[1] It may thus now appear incredibly old-fashioned to write a book that seeks to separate myth from truth. However, I had from the start of this project appreciated that to possibly identify a perceived truth as at least partly a myth would require the publication of supporting evidence, and in an effort to be as fair as possible to my subject – whatever the outcome – I have paraphrased and quoted extensively, whilst providing copious references so that readers can form their own conclusions if they wish, irrespective of my interpretation. Naturally, any author of a biography can be accused of not publishing material that might prove inconvenient, but all I can say to that is that I did not set out to write with any agenda other than an honest and open enquiry, and I have proceeded in that vein throughout. It is in that spirit that I offer my views on one of the twentieth century's most controversial Welsh figures, whilst always conscious of H. T. Buckle's famous put-down, 'Great minds discuss ideas; average minds discuss events; small minds discuss people.'[2]

Although I only met him twice, Iorwerth Peate has fascinated me for many years. He is a person whose views, and his selective recollection, I have sometimes found less than admirable; but it was the existence of the Folk Museum, and his book *The Welsh House*, that together led me to my own career in museums and to become one of his successors at

St Fagans. Peate's work has generated a considerable volume of criticism and also attention in museological (a term he would have detested) writings (which I elaborate on later). So is there need for yet another study? I believe there is, for only his work as poet, essayist and commentator has been examined in any critical depth. His work as curator and academic – the work which made him his professional name and which effectively funded his other activities, and of course is part and parcel of the story of St Fagans – has been addressed inadequately. Even when it has, Peate's own version of events has been accepted as the definitive record, when the truth often turns out to be far more nuanced or downright different. Much of what he wrote was in Welsh, and so commentators without knowledge of the language have been able to access only some of his thinking. Very many of his Welsh-speaking mentors and contemporaries have attracted full biographies over the years, but Peate remains almost alone in not having done so.[3] Almost without exception, those biographies have been in Welsh, because their subjects wrote predominantly in Welsh and they are known largely to Welsh speakers. Iorwerth Peate, however, was the only one of that circle who not only contributed to literature and scholarship through the Welsh language, but also attracted a much wider and non-Welsh-speaking audience, something that distinguishes him from his group of contemporaries. Alone amongst them, he was influential outside Wales, and that fact itself makes him worthy of a biography. One of my aims in this book has accordingly been to introduce him and his work to an audience wider than that which knows him largely as founder of the Folk Museum and as poet and man of letters; the other is to examine the narrative which he crafted assiduously over the years, namely that it was he, alone and heroically, who created the Welsh Folk Museum. The 'man' and 'museum' in my title are obvious, whilst the 'myth' is that which he developed and fostered about himself; I discuss the concept briefly later. This book is therefore only a part-biography, but there are (I hope) good reasons for that – quite a lot has already been written about his poetry and prose to which I am incapable of adding, whereas no single work has addressed his influence on the study of ethnology and on museums in Britain.

I joined the Folk Museum in 1971 as the first curatorial appointment of Iorwerth Peate's successor Trefor Owen, to be the Museum's first curator of buildings (a role that Peate had undertaken himself). I came to know the staff whom Peate had appointed. Most of them either

Preface

respected him or expressed no view, and while clearly he had his quirks, all felt that he would have defended them in time of need. I do not recall any non-curatorial staff speaking of him, apart from some of the more senior re-erected buildings team and demonstrating craftsmen: he had taken a great interest in both of these areas. My wife, one of his former staff reappointed by Owen, also regarded him with the greatest respect, and after marrying we lived for some time in what had been his deputy Ffransis Payne's flat in St Fagans Castle, next to Geraint Jenkins (later to be Peate's successor-but-one), who lived in Peate's old flat. During my fieldwork days from the early 1970s on, when I introduced myself and said what institution I represented, the very frequent response was recognition marked by, 'Oh, Dr Iorwerth Peate': institution and man were clearly one. By the 1980s I was able to travel quite extensively in Europe and north America, and visited many open-air museums; and it struck me that St Fagans, like so many others, did not address the concept of change in history in any meaningful way through the medium of its main exhibits, the re-erected buildings. That realisation led to my decisions to recreate an Iron Age settlement and re-erect the Rhyd-y-car terrace from Merthyr Tydfil and the Gwalia Stores from Ogmore Vale, in an attempt to demonstrate the change in Welsh society that Peate had stood so resolutely against. By this time I was Curator (Director) and thus one of Peate's successors, the only one of the five to hold the post not to be an Aberystwyth geographer.[4] I did not really question the founding myth until the National Eisteddfod visited Peate's home county in 2003 and I was asked to lecture on his book *The Welsh House*, which forced me to look at the volume in forensic detail and realise that very little of it was actually original work, and indeed that I agreed with what his critics at the time had to say about it. Delivering versions of that lecture to varying audiences and then comparing the three giants of Welsh vernacular architecture studies, Peate, Sir Cyril Fox and Peter Smith,[5] led me to examine the influence of Fox on the development of the Folk Museum.[6] At the same time I was writing a study of Trefor Owen for a conference in his memory, and it was these two things together that made me realise fully that actually no one had ever examined properly how the Folk Museum had come into being; and hence this book.

Iorwerth Peate left a huge amount of source material for anyone wishing to research his life and work, though little of that reflects the private core of the man; what exists is what he chose to make public, and

he made it clear that there were areas he had no wish to expose. He did not keep a diary (or at least one that has survived), other than that he kept during his visit to Sweden in 1946, but preserved carefully a great number of papers, either generated by himself or about his work. His published output is in four parts, namely poetry (four volumes and one anthology of his favourites); essays and literary criticism (very many, including three volumes of collected essays); autobiographies (two volumes and some smaller works); and academic monographs and papers and more popular expositions of folk life and museology (half a dozen books and very many papers and articles). This book is almost entirely concerned with the latter two categories but draws on some of his more relevant essays. And, as Catrin Stevens recognised in the opening words of her volume on Peate, rather like the inscription on Christopher Wren's tomb in the crypt of St Paul's Cathedral ('Reader, if you seek his monument, look around you'), one of the principal documents that explains his life is also built in timber and stone, in the form of the open-air folk museum at St Fagans.

Stevens's brief but beautifully written study of 1986 for the University of Wales's 'Writers of Wales' series remains the sole analysis of Peate's entire life and work. However, the book, with its sensitive and informed review of his poetry, is based only on his published work; his papers were not then all available to the public and she did not use the archives of the National Museum of Wales, with the consequence that the work is informed only by Peate's view of people and events. Her study is supplemented usefully by R. Alun Evans's *Bro a Bywyd Iorwerth C. Peate*, a work of pictorial homage by another native of Llanbryn-Mair, the home village that Peate so mythologised. His poetic and literary output has also been addressed by Manon Wyn Roberts, Robin Chapman and Bobi Jones: I summarise their conclusions in the Introduction. Assessments of Iorwerth Peate as an academic have up to now been largely limited to the observations of Trefor M. Owen, who wrote perceptively about him, helped by his close personal knowledge and his perspective as one of Peate's appointees and immediate successor (but who accepted as true some of Peate's assertions, when that can now be proven not to be the case). His observations, however, were all made in the form of introductions to revisions or republications of some of Peate's major works or memorial lectures and obituaries, and he did not choose to put his thoughts into book form, or examine the archival background of and detailed evidence for Peate's decisions or ones taken which affected him.[7] Sadly, no full

Preface

history of the National Museum of Wales has been published, but its former Director, Douglas Bassett, not only wrote four lengthy articles on the subject but, like me, was fascinated by Iorwerth Peate, lecturing often about him and producing comprehensive handouts to accompany his lectures. Other specialists have referred to Peate's work and writings as part of wider studies, and I will mention them at appropriate points.

Nobody, however, has attempted to introduce Peate's writings on folk life, museums and allied matters, in both languages, to the non-specialist reader, as I have tried to do here. I have made extensive use of quotation and translation from his published writings and unpublished archival material in order to give a fuller flavour of the man and his immediate working environment. To the extent that it is possible, I have also deliberately eschewed introducing theoretical concepts and language. Iorwerth Peate prided himself on the clarity of his thought and expression; and in similar manner, at least as regards the latter attribute, I too have tried to express my feelings in language understandable to all. I have chosen to deal with the subject in a thematic manner because to adopt a strictly chronological approach would have been very confusing, although the content of each chapter is largely arranged chronologically. I should also note that whilst I have usually referred to my subject as 'Peate' for brevity's sake, it was a form he regarded as English, and detested: after all, he informed someone who had transgressed by referring to him by his surname alone, in a radio programme, that if he was to be referred to then it should be as 'Iorwerth C. Peate' or 'Dr Peate';[8] and I consider myself rebuked. I also refer frequently to the site which became the National Museum of Wales's open-air folk museum as 'St Fagans', simply because it has been known by four different titles in English since its opening; I also use 'Welsh Folk Museum' and 'Folk Museum', the two titles that Peate would have been happy with. As another form of shorthand and to make the distinction between site and corporate institution, I sometimes refer to the main building of the National Museum (currently known as National Museum Cardiff) as 'Cathays Park', which is its location in Cardiff; staff at St Fagans four miles (6.5 km) away on the outskirts of the city have always known the headquarters as Amgueddfa'r Dre and '[the] Town Museum'. In order to introduce more clarity I have also sometimes (as in the previous sentence) used square brackets to insert my comments into a paraphrased piece; anything within normal brackets will have been so treated by the author himself. All translations are mine, and

in an attempt to make the subject more accessible to non-Welsh speakers I have also translated book and article titles on first mention, or in the Select Bibliography, in the case of my subject's writings. In the footnotes, all references to title without author are to works by him. That bibliography is selective: Geraint Jenkins included a reasonably full list of Peate's publications up to 1967 in the Festschrift for Peate that he edited, *Studies in Folk Life*, and a fuller list was compiled by Emrys Bennett Owen in 1980, 'Llyfryddiaeth (1919–1980): Iorwerth C. Peate', which is available in the National Library of Wales.

Iorwerth Peate's personal papers were deposited by the family in the National Library of Wales, and I am particularly grateful to them for their ready consent to quote from those papers. Numerous letters from him have been preserved in the papers of recipients also deposited in the National Library. Much that refers to the National Museum can of course be found in the Museum's archives, but where they are duplicated I have normally referred to the National Library copies, which have individual archival numbers, unlike most of the Museum documents: the references I give to Museum documents are mostly to how they were stored when I accessed them. 'Annual Report' in the footnotes refers throughout to the Annual Reports presented by the National Museum's Council to its Court, and 'Council Minutes' similarly means the minutes of the meetings of the National Museum's Council. Peate's books were left to the Museum after his death and are housed at St Fagans, where I have also been able to use to my great benefit its library and archival and photographic collections: 'SFNMH' in a reference means 'St Fagans National Museum of History', and 'NLW' the National Library of Wales. I am most grateful to Dr David Anderson, Director General of the National Museum, for his support for this project, and for the National Museum's permission to quote from official papers and for supplying at no cost all the photographs in this volume and for which it holds copyright, and to the staffs of the Museum (particularly Kristine Chapman, Jennifer Evans, Sally Carter and Dafydd Wiliam) and the National Library for their practical help throughout this project. Professor Prys Morgan and Celia Hunt most kindly read the entire text and made helpful comments. Dr Robin Gwyndaf lent me his files on Peate and on the Folk Museum, and I am grateful too to other former colleagues and to friends for their help and interest: individuals are named in the footnotes. I should also like to thank the staff of the University of Wales Press for all the care taken in bringing this work to publication.

Preface

Notes

1. Though interestingly Iorwerth Peate's friend, the great oral historian of East Anglian life, George Ewart Evans, had noted in 1976 that 'there is not one truth ... but many truths': *From Mouths of Men* (London, 1976), p. 176.
2. This saying is sometimes attributed to Eleanor Roosevelt, but it was Buckle in 1901: https://quoteinvestigator.com/2014/11/18/great-minds/, with full references (accessed 16 August 2020).
3. Such as T. Robin Chapman, *Dawn Dweud W. J. Gruffydd* (Caerdydd, 1993) and *Un Bywyd o Blith Nifer. Cofiant Saunders Lewis* (Llandysul, 2006); R. Gerallt Jones, *Dawn Dweud T. H. Parry-Williams* (Caerdydd, 1999); Bedwyr Lewis Jones, *Dawn Dweud R. Williams Parry* (Caerdydd, 1997); Derec Llwyd Morgan, *Y Brenhinbren. Bywyd a Gwaith Thomas Parry 1904–1985* (Llandysul, 2013); Emyr Hywel, *Y Cawr o Rydcymerau. Cofiant D. J. Williams* (Talybont, 2009); Alan Llwyd, *Byd Gwynn. Cofiant T. Gwynn Jones 1871–1949* (Llandysul, 2019), *Kate. Cofiant Kate Roberts 1891–1985* (Talybont, 2001) and *Bob. Cofiant R. Williams Parry 1884–1956* (Llandysul, 2013).
4. Matrix management was introduced to St Fagans after 2009, with no director based at the site thereafter.
5. Eurwyn Wiliam, 'Three giants: Iorwerth Peate, Cyril Fox and Peter Smith, and the study of vernacular architecture in Wales', *Trans. Ancient Monuments Soc.*, 61 (2017), 8–33.
6. Whilst Peate (somewhat grudgingly) thanked Fox for his support (as he saw it) for Peate's endeavours in establishing St Fagans, he largely did so in his Welsh-language publications; his entry for Fox in the *Dictionary of Welsh Biography* makes no mention of any involvement with the Folk Museum. And very ironically, when this book was being completed (August 2022) an internet search for I. C. Peate produced the abbreviated Wikipedia text with a portrait of Fox rather than Peate.
7. I remember J. T. Smith, the great scholar of vernacular architecture, who admired Peate and was admired by him in return, saying to Owen and myself at a conference, 'Excellent obituary of Peate in *The Times*. Did you see it?' to which Owen could only reply, 'Well ... I wrote it, actually.'
8. R. Alun Evans, *Bro a Bywyd Iorwerth C. Peate* (Llandybie, 2003), p. 4; but he followed convention readily enough in his early days at the National Museum, as when he introduced himself by his surname to a Welsh-speaking attendant, who naturally enough responded by saying that he was called 'Jack': *Y Llwybrau Gynt* (Llandysul, 1971), pp. 26–7. He was called 'Ior' by his friends, including the only member of staff so classed, Ffransis Payne, although that did not stop less respectful colleagues also calling him 'Ior' behind his back.

I
Introduction

Iorwerth Peate is known in Wales and particularly to Welsh speakers as a poet, man of letters and above all as the founder and first Curator (head, before the term became generic, and Director in today's parlance) of the Welsh Folk Museum. That institution is now called in English St Fagans: National Museum of History, though it retains the Welsh-language title bestowed on it at its opening, one that Peate himself must have created – Amgueddfa Werin Cymru (of which 'Welsh Folk Museum' is a literal translation). And just as there is an inherent tension between the differing concepts encapsulated in those two titles, Peate himself was a complex character, well summarised by his successor as Curator, Trefor M. Owen, as

> a cluster of paradoxes – a conservative poet but a political and religious radical; a militant pacifist; a good companion but also a man who made his own opinions very clear; a geographer who did not believe in using maps ... unwaveringly argumentative, and a harsh and unrelenting critic, who would write to console others who had been so treated; a defender of logic ... but of whom you could not be sure that his own response would be logical.

And more, in a similar vein.[1] But his life and work is also relevant to many outside Wales. He was the leading pioneer of the study of folk life and of the development of open-air museums in Britain. He was elected President of Section H (Anthropology) of the British Association in 1958, was first President of the Society for Folk Life Studies, and received many other honours; but he was angered to be offered an honour by the Queen.[2]

The 'authorised version' of his life story – not authorised by him, but he would not have been entirely unhappy with it – is his entry in the *Oxford Dictionary of National Biography*, penned by the critic, anthologist and obituarist Meic Stephens. It provides a good summary of Peate's life and work, albeit with a couple of fundamental errors, such as 'In 1932 he joined the sub-department of folk culture and industries' (Peate joined the National Museum in 1927 as a member of its Archaeology department, of which a sub-department with him in charge was created in 1932), and 'the museum [St Fagans] itself (later renamed the Museum of Welsh Life and made part of the National Museums and Galleries of Wales)', here missing the essence of Peate's great and much-trumpeted struggle to achieve a degree of independence from the National Museum, which had opened St Fagans as a branch in 1947–8.

Iorwerth Peate published two works of autobiography. The first part of the title of *Rhwng Dau Fyd. Darn o Hunangofiant* ('Between Two Worlds. A Part Autobiography') was borrowed, aptly, from his friend J. Middleton Murry's autobiography of 1935;[3] in Peate's case it referred not only to the differences between his early, monolingual Welsh life in the country and his later life in anglicised Cardiff, but also the cultural dissonance between the Edwardian world that he looked back on with longing, and modern times. The volume included a chronological overview of his life and career, with the remaining chapters dedicated to his views on religion, his literary and political activities, and brief biographies of six friends. This work was followed posthumously by *Personau* ('Persons'), with much of it devoted to people whom he had known, such as ministers of religion and musicians and friends whom he had not already written about, and a description of journeys, including his early travels in Europe and later professional visits. The autobiographies were selective; in today's terminology they would be described, not inappropriately, as having been carefully curated. He revealed nothing of his private life, and his courtship and married life merited only a single sentence; but he declared his love for Nansi in several of his poems, and the death of their son and only child Dafydd in adulthood was also marked by a poem noting that his and Nansi's love for each other would enable them to survive. He wrote as he spoke, in correct literary Welsh, with almost no trace of a regional accent or marked use of dialect words. Much of what we know of him comes from his essays, such as the collection he brought together as *Syniadau* ('Ideas'), and a radio talk.[4] Revealingly, however, in his preface to *Rhwng*

Introduction

Dau Fyd he seized upon the Orkney-born poet and novelist Edwin Muir's distinction between myth and story and how his 'story' was influenced subconsciously by the 'myth' of his genetic inheritance, such that a poem would sometimes come to him as if from a deep past.[5] There is a vast and complicated (and often conflicting) literature regarding myth and its role in society,[6] with most definitions stressing its relevance to religious values and norms, differing from legends and folk tales, which are generally accepted not to be sacred narratives. In its colloquial sense it refers to a false story, although even then (and appropriately) a larger-than-life character is often involved; and even if he did not consider himself worthy of mythical status in the non-colloquial sense, Peate clearly felt that he was different. He summarised these feelings in the introduction to *Rhwng Dau Fyd*:

> Throughout my life, I tried to bear witness to the truth as I saw it. As a consequence I acquired 'enemies', men who castigated me since they saw matters differently from me, or who felt bitter towards me because of my views, or even sometimes because it was I who opposed their views ... Any misjudgements or harsh and spiteful blows penetrate me to the quick. But – thank heavens – I am incapable of retaining anger; indeed, some who formerly castigated me mercilessly afterwards became my close friends.[7]

Others had a different view. D. J. Williams, the author and one of the three nationalists who took direct action against the RAF bombing school at Penyberth in Llŷn in 1936, noted of Peate in 1945, 'He is a man, I fear, who has let his hatred of people colour all his opinions and prejudices'.[8] The academic and poet Bobi Jones (Professor R. M. Jones) recalled being appalled at such a divisive figure as Peate being appointed first chair of Yr Academi Gymreig (The Welsh Academy), in 1959, but admiring of his proposer's reasoning when that individual explained to him that 'If you have a difficult person sitting on a committee, you put him in the chair'.[9] But whatever the feelings of others, Peate felt he could not take credit for this character trait: 'dyma etifeddiaeth fy hil arbennig i' – it was the birthright of his particular race, and in such matters he felt very close to that liminal zone between the 'story' (*stori*) which he would tell and the 'myth' (*chwedl*) that it was not possible for him or anybody else to pen.

A huge amount has been published on memory and how people tell their life story selectively, with one of the most influential writers on the subject, the Nobel Prize-winning psychologist and economist Daniel Kahneman, warning of the 'cognitive trap' of confusing experience and memory. His view is that we have two selves, the 'experiencing self' and the 'remembering self'. Experiences are real and happen, but memory is formed or constructed by what we choose to remember to make sense of the experience; in essence, the experience is transient and what remains is the story that we have formed and chosen to keep. The remembering self is a storyteller who chooses the experiences we have been through and fits them into a coherent narrative, and it is not just individuals but nations who do this.[10] Likewise, the act of remembering is always assumed to be a good thing, and forgetting or choosing not to remember bad, but that might not necessarily be the case. Memory is a notoriously fallible medium but it can be reinvented to fill a gap in recall or knowledge, often a necessary and liberating act for an individual and reinforcing their self-worth. We should not judge Peate too harshly, therefore, for burnishing his remembered tale.[11] He was, of course, far from alone in clinging to his youth as the one true past, particularly at a time of great change. Thomas Hardy was exactly the same, in his case refusing to use modern conveniences such as a bath, and writing his best poems in memory of his first wife after her death, having ignored her for many years before that.[12] Similarly, much of Laurie Lee's career was founded on his recollections, sometimes true and sometimes manufactured, of his life in Slad,[13] while Patrick Leigh Fermor rewrote in improbable detail of his early journeys years after his diaries were lost.[14] Bob Dylan is known for reinventing his history as frequently as he reinvented himself as a singer; whilst in Wales, the entire and sociologically important oeuvres of writers such as D. J. Williams and Kate Roberts are predicated on their recollections of life in their square mile. It is probably the case that most, if not all, of us unconsciously edit out our failures and amplify our triumphs, and as a consequence we are the heroes of our autobiographies.

Much, too, has been written about the contribution of history and heritage as a way of establishing legitimacy by using the past, none more so than through using museums to afford authority to such claims.[15] For cultural nationalists such as Peate, the National Museum served as such an institution from his first awareness of its existence, and later in his life and career it provided a home in which he could realise his

Introduction

aspiration of presenting (and indeed recreating) the day-to-day life of the Welsh-speaking and freethinking inhabitants of the uplands from which he sprang. But *y werin* itself, the Welsh peasantry who became identified from late Victorian times as carriers of the true spirit of the Welsh nation, is in one sense another myth, or at least a concept that became mythologised. The historian Prys Morgan has shown how the term was developed as an intellectual construct and used as a form of propaganda from the 1890s onwards, reproduced as the image of the nation and itself reproducing that image.[16] As a general reaction to industrialisation, rural Wales became presented as the 'real and authentic' essence of the nation, and this idealisation extended to its inhabitants, the 'folk'.[17] Leading Welsh-language writers and poets elaborated on Romantic notions first put forward by Wordsworth, Coleridge, Ruskin and Morris to present an idealised picture of an unblemished and indeed perfect rural past, which in Wales was inextricably linked to the survival and transmission of the Welsh language.[18] The art historian Peter Lord has criticised the National Museum for seizing on the material remains of past rural life in Wales and adopting a folk-culture methodology to deal with Welsh history to the exclusion of native artisan art,[19] but in reality that approach was more to do with pragmatism than a carefully considered strategy at the time. Unquestionably, however, Iorwerth Peate was the leading exponent in the twentieth century of the assertion that the prime role in defining the national culture should be accorded to the *gwerin*. And not any old *gwerin*: although he repeatedly noted that his vision of 'folk' encompassed all classes of society, at heart the 'folk' to him meant the cultured, Welsh-speaking country-dwellers whose high rate of literacy was based on the Sunday school, who held nonconformist religious beliefs and who were liberal and anti-establishment in their politics; and while there were elements of truth in this picture, Peate stretched the definition to its extremes.

Whilst he believed that professional matters should be discussed through an international language, such as English, so that scholars from other countries could appreciate what was being done and all contribute to greater understanding,[20] Peate's literary output was entirely through the medium of Welsh, and he and his Welsh-speaking contemporaries believed that poetry and prose were the highest expressions of a language that was older than and superior to English. Commentators are agreed that the major theme that runs through all his poetry is decay, whether it be of the flesh, past glories, or the collapse of the rural life that he saw

as so central to the continued existence of the Welsh language; other themes which preoccupied him were his love for Nansi and his birthplace of Llanbryn-Mair in the old county of Montgomeryshire, and, in the 1930s and 1940s, war and its effects on Wales. Peate was one of a second wave of Welsh neo-Romantics, following on from scholar-poets such as T. Gwynn Jones and W. J. Gruffydd (both of whom he idolised), and even though most of his output was later, his spiritual home lay in the first quarter of the twentieth century, which he saw as a Golden Age. Industry was transient and so was irrelevant to what a poet should be concerned with.[21] Some of his early poetry was inspired by the objects he saw in the Museum's collections, inspiring him to think of their former owners or makers, such as addressing a Bronze Age Beaker and querying whether it had held mead or wine to drown the sorrows of those mourning the dead, who would no longer savour its contents.[22] A mail coach prompted him to visualise the long-dead travellers on their way to market, whilst a dead lamb in the Zoology collections inspired him to conjecture what its life might have been.[23] His classic poem in this genre was 'Yng Nghegin yr Amgueddfa Genedlaethol' ('In the Kitchen at the National Museum'), where he noted its silence but where the clock still ticked, which conveyed the passing of time and enabled him to query if the old inhabitants would once again re-enter from cowshed and field to populate the scene. In 'I Fen Ychen' ('To an Ox-drawn Wagon'), he contrasted the life of the oxen who drew a wagon in the Vale of Glamorgan with 'the hell that lurks today', where the fertile acres across which they had plodded were now turned into military airfields.[24] In general, Peate's poetry was formulaic, based on rhythmic patterning and clichéd terminology. His friend, the academic Sir Thomas Parry, in an obituary piece of 1982, felt that no recent poet had been so fiercely criticised and accused of revelling in insipid memories of bygone bliss, without offering any message to contemporary Wales, and identified as an unadventurous conservative; but his critics had not appreciated that Peate's poems were the product of a journeyman-poet, one of those craftsmen who had a most honoured place in civilised society. Peate, too, was a craftsman, a master of his own medium, the words, measures and rhymes of the Welsh language. The craftsman imitated his master and did not strive for originality, and Peate's poetry should be viewed in this light; accordingly, noted Parry, he never became a poet of his own age, protesting against the ills of society like some of his contemporaries.[25]

His volumes of essays often consisted of extended reviews or responses to perceived attacks on himself; other essays were travelogues. Whereas his poetry expressed his private thoughts, in the essays he addressed the public and put forward his own invariably strong views rather than offering balanced arguments. The essays are also littered with the opinions of those he respected, which Robin Chapman has interpreted as an attempt to curry favour. One unifying feature of the essays was Peate's attempt to define culture and the nature of civilisation, but in none of them did he seek to define tradition or how he knew that rural life had been unchanging. Chapman concluded that Peate had fixed too early in life on a world-view from which he could not (or chose not to) deviate afterwards. His inability to experiment and reassess led to a personality that was ultimately too narrow to make a true critic, even though he saw himself as a cultural leader and prophet whose duty it was to stand guard against the evils of modernity that threatened his Wales.[26] The journalist and writer John Eilian expressed much the same view contemporaneously:

> I don't think much of Peate. He has a second-rate and confused mind, but believes that there is no one in the world like Iorwerth Peate, and he cannot forget himself for more than half a minute. A great pity, since he strangles in this way whatever ability he might possess.[27]

Bobi Jones deplored Peate's unwillingness to engage constructively and personally with the matter in hand, seeing him as guilty of conservative and unadventurous thinking. He repeated his thoughts so often that Jones entitled the chapter in which he voiced these views, punningly, 'Re Peate'. But it was not through his poetry or his essays that Peate made a significant contribution to Welsh literature, Jones felt; rather, it was through his works on material culture, particularly *Y Crefftwr yng Nghymru* ('The Craftsman in Wales') of 1933 and *Diwylliant Gwerin Cymru* ('Welsh Folk Culture') of 1942. Through these works, Peate had made a unique and lasting contribution and showed himself a true innovator, for these volumes changed the way the Welsh nation thought of itself; and the creation of the Welsh Folk Museum was the work of a visionary national benefactor.[28] As Catrin Stevens remarked, Iorwerth Peate was also author of a biography of Wales, written in timber and stone for all to see at St Fagans,

and in a very real sense this was in many ways also an autobiography; but, as I will endeavour to show, it was as selective as his ones on paper were.

From distant Cardiff (distant in time as well as space), Iorwerth Peate looked back at his boyhood home as *Y Deyrnas Goll*, 'The Lost Kingdom'.[29] He was so beholden to, and influenced by, his place of birth that it is almost impossible to disentangle the man from his home area, in Welsh *y fro* or *y filltir sgwâr* ('the square mile'). The latter is a term invented by Peate's contemporary and literary rival Saunders Lewis, but *y fro* (the mutated form of *bro*) features from the thirteenth century onwards.[30] Geographically, the term can equate to 'locality', 'area' or 'vale', as in *Bro Morgannwg*, the Vale of Glamorgan, or the French *pays*, but it has a deeper and more resonant cultural meaning to Welsh speakers.[31] Even though he only lived there for his first seventeen years, Peate always regarded Llanbryn-Mair and its surrounding countryside (*Bro Ddyfi* – the catchment of the river Dyfi) as his home, and he remained deeply attached to his idea of the area as representing all that was good and inalienable about Wales. Like his hero, W. J. Gruffydd, who 'dwelt' (*trigo*) in the Cardiff suburb of Rhiwbina but still 'lived' (*byw*) in his home village of Bethel in north-west Wales, Peate believed that the country folk he knew were possessed of a mystic power that enabled genius to flourish; and that genius could not be acquired anywhere else.[32] 'Wales is above all a country of local cultures' was his summation of 1931.[33] This formed the basis of his belief of an unchanging people in an unchanging world, something that had to be defended at all costs as, unaccountably, the world around it changed for the worse. He made it clear that his Wales was an exclusively Welsh-speaking Wales, with the urbanised industrial areas an aberration fervently to be wished away; and the core of that Wales was its mountainous heartland – though he never talked of Snowdonia or the Brecon Beacons, for his Wales was very firmly an extrapolation from his own square mile.[34]

In appearance, Peate was tall and well dressed, and when young was slim and almost gaunt in appearance: like George Orwell amongst groups of International Brigaders, his bespectacled form towers over everyone else in photographs, and throughout his life, the sound of his heavy, leather, size fourteen shoes gave warning of his approach. His later deputy Ffransis Payne was taken aback on first meeting him in the late 1920s:

> he was wearing a vivid brown suit, with fawn-coloured spats over his shoes. He was wearing a paisley-pattern tie, and I thought,

Introduction

'Good Lord, I didn't expect him to look like this!' He was impatiently pacing the street . . . 'You're late', declared Peate irritably.[35]

He differed in character too, not fitting readily into any category of his intellectual circle, and his views were often at variance with those held by his literary circle as well as by professional peers. He was raised as a freethinking Independent (Congregationalist) and remained a deeply committed Christian all his life, albeit one who seldom attended a place of worship after his arrival in Cardiff and whose own brand of religion could well not be regarded as Christian by mainstream believers.[36] He saw faith as a virtue, but so was a questioning mind; and since he abhorred any form of dogma, Methodism to him was mindless Catholicism reinvented.[37] Partly under the influence of his subject mentor, H. J. Fleure at Aberystwyth, he came to view the creation as one entity, with no barrier which had to be breached between Heaven and Earth. To Peate, Christ was not *the* Son of God, for all humankind were God's children, and people were not inherently corrupt and in need of saving – the difference between Christ and ourselves was one of degree rather than of kind, though he conceded that creation could be viewed as a pyramid with Christ at its apex.[38] He was opposed to ecumenism, but his commitment to the Christian principles of love and freedom was to be demonstrated in 1940, when he famously declared that he regarded Hitler as a brother, albeit a rather wayward one. His belief that all men were brothers inevitably led to him holding strong pacifist views, which as we shall see were to cause him much grief; but he did not deviate from his principles. Peate's role as one of the small group of Welsh-language intellectuals who effectively created a distinctively Welsh form of pacifism has been identified by Linden Peach.[39] These individuals, who included conscientious objectors such as Thomas Parry, T. H. Parry-Williams, Gwenallt Jones and Waldo Williams, as well as Peate himself, were driven by an agenda by which their concern for the future of the Welsh language and for Wales itself distinguished them from their English counterparts. Peate's principles led him to treat all alike: positive discrimination would have been an alien concept to him, and apart from two or three idols, he pulled no punches in reviewing works by his friends.[40] He has also latterly been assumed to have been teetotal, and to have been opposed to having a pub amongst the re-erected buildings at St Fagans; but neither assumption is true, and Geraint Jenkins has told how much he enjoyed

the company of friends at conferences, contributing rather suspect stories to the proceedings.[41]

Iorwerth Peate is often stated to have been a nationalist. He most certainly was, but as with his religious beliefs, he was on his own terms: his nationalism was fundamentally cultural rather than political. True nationalism in Wales disappeared for centuries after the failure of Owain Glyndŵr's revolt against English rule in the early fifteenth century, and the natural leaders of society, the gentry, became increasingly wedded to English values. Religious revivals in the eighteenth and nineteenth centuries fuelled religious nonconformity and widened literacy, at the same time replacing the oral tradition with the written word, whilst in political terms the Liberal party became ascendant. The huge growth of industry in south-east Wales saw a great influx of English speakers from the mid-nineteenth century onwards as well as the depopulation of the countryside, and Victorian Wales was essentially happy to be part of the Imperial dream. It was not until the late nineteenth century that nationalistic feelings began to emerge again. Support for Welsh independence did not feature in any election manifesto until 1886, and then only in that of an individual, T. E. Ellis, who went on to found the loose consortium of interests Cymru Fydd ('Future Wales' or 'The Wales that Shall Be'). This attracted support from fellow MPs such as David Lloyd George, but the Liberals as a party were far more concerned about the Irish Home Rule issue; and although the first Wales-specific piece of legislation, a Sunday Closing act, was passed in 1881 and the University of Wales accorded its Charter in 1892, the movement lasted only a decade.[42] Plaid Cymru, then known as the Welsh National Party, was not formed until 1925, with Iorwerth Peate amongst the first to join, becoming briefly a committee member and one of the editors of its organ *Y Ddraig Goch* ('The Red Dragon'). On arrival in Cardiff he joined the Cardiff branch (Nansi became its Secretary) and became a member of the regional committee, but he felt its move towards becoming a bilingual organisation committed to linguistic inclusivity was a major mistake: 'The Party should concentrate all its energies and all its resources on emphasising the fundamental importance of the Welsh language and campaign to win all the county and local councils to ensure that viewpoint. I believed then and I believe now', he wrote in 1976, 'that our duty as Welsh people was to establish Welshness *within Wales*, in our own country', rather than go cap in hand seeking favours from Westminster. Additionally, and perhaps

more surprisingly, he felt that seeking dominion status like Australia and Canada was a mistake, for Wales was bound so closely with the rest of the British Isles that true independence was a chimera that should not be pursued.[43] He resigned from the party in the 1930s and because of his pacifist views refused to support a defining moment in Plaid Cymru's mythology, the setting on fire by Saunders Lewis and two others of workmen's huts at the RAF bombing school at Penyberth. To the end of his days he believed that the party should concentrate on grass-roots activities supporting local regeneration (implicitly in rural Welsh-speaking Wales): only in this way would the fundamental core of all that was Welsh, the language, be fostered, and to seek any form of political independence before that was secured was madness. In one of his last public pronouncements he noted that 'the present belief of large sections of Welsh society in bilingualism as the panacea for all its ills only sows the seed of that society's destruction. Wales will survive only if it is Welsh [that is, Welsh speaking]'.[44] And whilst it was Saunders Lewis who had urged his contemporaries to stand in the gap and prevent the swine from trampling the vineyard, it is quite clear that Peate saw himself as one of the warriors who, independently, had heeded the call.[45]

It should be no surprise that a man of such external contradictions should present himself as complex to his staff. At St Fagans, Peate saw himself as father-figure of a family. However, according to his appointee and successor-but-one Geraint Jenkins, he was not well known to most of the staff, despite enjoying his morning walk around the site with his black Labrador, Simon, sometimes in Nansi's company or otherwise accompanied by Trefor Owen.[46] Nevertheless, whilst he projected the external appearance of a stern patriarch he was not humourless, and his love of a dirty joke was proverbial amongst the male staff. He fostered a family feeling through staff club activities such as choirs, recitation and skits. He was normally hugely supportive, so long as his staff followed his rules. A then-junior member recalls telling Peate that he intended using three weeks of leave to visit folklore institutions in Sweden, and being given unasked an additional fortnight's paid leave to add to his time there. However, the same individual later failed to tell Peate that he had been awarded a three-week scholarship to visit the Welsh colony in Patagonia, in addition to which the government had offered to pay the full costs of a two-month folklore-collecting expedition. His departmental head thought this a wonderful opportunity, but the golden rule of seeking

the Curator's permission had been broken, and Peate flatly refused to let him accept the offer.[47] Having suffered for his own views, he was most supportive of the concerns of individual staff, but had no time for union activity: he was incandescent when the Folk Museum warding staff went on strike in support of Tower of London colleagues, and told them to collect their cards if they felt so strongly about the matter.[48] Peate was the first to insist on the use of the Welsh language within the National Museum, and made much of this;[49] but he guarded jealously his status as the only such champion. When the Department of Oral Traditions and Dialects petitioned for the Folk Museum's accession cards to be bilingual rather than in English only, Peate's response was a harsh reminder to his staff that 'English is the official language of Wales'.[50] In private as well as in public, he craved attention and reassurance. He would invite individual members of staff with a literary leaning to his office to listen to his latest poems, when he would sometimes be so affected that he would recite or read with tears in his eyes,[51] but equally he would run down the reputations of colleagues when he felt his primacy was threatened. Despite expressing his appreciation of Ffransis Payne's academic work and noting in *Diwylliant Gwerin Cymru* that 'It is difficult to name a subject in the volume that I have not sometime discussed with my friend and colleague',[52] Payne's increasing reputation as a master of Welsh prose meant that he was a rival;[53] and when a review (invariably hugely complimentary) of one of Payne's volumes appeared Peate would journey from office to office bad-mouthing the review and the reviewer as a means of undermining him.[54] Perhaps Payne was deemed to have been over-familiar when he responded to Peate's comment about his footwear, 'I can't stand suede shoes', with 'Well, don't wear them then.'[55] Perceptively, another former member of staff has noted that Peate was always supportive of him, 'but then, as a junior member of staff I was no threat to him, was I?'[56] He ruled with a rod of iron: no one was allowed a long weekend,[57] for example, and his dealings with any member of the public who dared to complain were less than ideal. His secretaries sometimes had to type the most appallingly rude responses,[58] but he was insistent that every donor to the collections received a letter of thanks, for without them there would be no Folk Museum.[59] He was also susceptible to a pretty face: 'He had a soft spot for the ladies' was how a female member of staff put it, recalling going in fear and trembling in her early twenties to the great man's office to confess to having run the Museum's Land Rover into a hedge whilst

on a collecting trip, but the only reprimand she received was 'That's all right, my dear – don't do it again.'[60]

But even people who had reason to be less than magnanimous in their view of Peate felt that his destiny was clear, a tribute both to his abilities and to his self-promotion; this latter may have been unconscious, but if not, then justifiable, as to promote himself was to promote his dream. Saunders Lewis, more than once poorly reviewed by Peate, in himself reviewing *The Welsh House* chose to welcome Peate back into the fold of academia.[61] A harsh critic of Peate's literary writings, he now noted that when Peate left aside prophesying and passed through the doors of the National Museum, he became a scholar and an important innovator. Wales had a proper national museum where one could see and trace the life of the Welsh folk in their homes and rooms and costumes and crafts: this museum had no equivalent in the British Isles, and the picture it presented was all Peate's work: 'My prayer is that we will soon see Mr Peate as head of this great institution which he more than anyone has fashioned into a true National Museum of Wales'.[62] This was not to be, but he was to head a part of the National Museum that was for decades far better known amongst the people he saw as his own than the parent institution which paid his salary; and he did it largely his way, a way dictated by his character. We shall attempt to unravel how well he undertook that task in the pages that follow, and see how much of the myth that grew around him is true.

Notes

1. Trefor M. Owen, 'Iorwerth Peate a Diwylliant Gwerin' ['Iorwerth Peate and Folk Culture'], *Trans. Hon. Soc. Cymmrodorion*, 1998 (1999), 62; my translation. Peate was not alone in being difficult: many of his literary contemporaries such as Saunders Lewis, Kate Roberts and D. J. Williams were equally plain-speaking, but Peate was the supreme exponent of the art.
2. *Personau*, p. 22. But in absolute balance, he likewise never agreed to be nominated to the Gorsedd of Bards, the community of literary figures associated with the National Eisteddfod invented by Iolo Morganwg in 1792 and to which practically all Welsh speakers of his distinction belonged.
3. J. Middleton Murry (1889–1957) was an author and successively Marxist and a radical Christian and pacifist. Peate identified with Murry's radical Christianity (he was a believer who did not worship in company) and translated one of his pamphlets into Welsh. Murry's first wife was Katherine Mansfield and her early death turned him towards mysticism, whilst the couple's friendship with D. H. Lawrence was equally influential. During the

Second World War he edited *Peace News*. Peate became friendly with him, corresponding on occasion and having him to stay. Murry's choice of title for his autobiography was in turn probably influenced by William Morris's 'Let us admit that we are living in the time of barbarism betwixt two periods of order, the order of the past and the order of the future', with its hopes of a more enlightened future: May Morris (ed.), *The Collected Works of William Morris* (London, 1914), xxii, p. 317. Peate himself used this quote as an epilogue to *The Welsh House*.

4. In Alun Oldfield-Davies (ed.), *Y Llwybrau Gynt* ['Past Paths'], 1 (Llandysul, 1971), pp. 7–30.
5. Edwin Muir, *An Autobiography* (London, 1954); *Rhwng Dau Fyd*, pp. 10–13.
6. See, for example, Lauri Honko, 'The Problems of Defining Myth', in Alan Dundes (ed.), *Sacred Narrative. Readings in the Theory of Myth* (Berkeley, LA and London, 1984), pp. 41–52.
7. *Rhwng Dau Fyd*, p. 14; my translation. Emyr Hywel, *Y Cawr o Rydcymerau. Cofiant D. J. Williams* ['The Giant from Rhydcymerau. A Biography of D. J. Williams'] (Llandysul, 2009), p. 214.
8. Hywel, *Y Cawr o Rydcymerau*, p. 14; my translation.
9. R. M. Jones, 'Ysgrifau Dros Fy Ysgwydd', published online only in 2016, *rmjones-bobijones.net/llyfrau/YSGRIFAU.pdf*, p. 250 (accessed 29 January 2022). The wise man in question was the poet, broadcaster and critic Aneirin Talfan Davies (1909–80). The Academy is now known as Llenyddiaeth Cymru – Literature Wales.
10. Daniel Kahneman, *Thinking, Fast and Slow* (London and New York, 2012).
11. Veronica O'Keane, *The Rag and Bone Shop. How We Make Memories and Memories Make Us* (London, 2021).
12. Claire Tomalin, *Thomas Hardy. The Time-Torn Man* (London, 2006).
13. Valerie Grove, *Laurie Lee. The Well-Loved Stranger* (London, 1999).
14. Artemis Cooper, *Patrick Leigh Fermor. An Adventure* (London, 2012), p. 65: 'he was . . . re-creating a new memory, shaped and coloured in his imagination, so perfect in every detail that he could say "When I was riding across the Alföld [the Great Hungarian Plain]" meaning most of it, without a trace of self-consciousness'.
15. For Wales, see Bella Dicks, *Heritage, Place and Community* (Cardiff, 2000).
16. Prys Morgan, 'The Gwerin of Wales: Myth and Reality', in I. Hume, W. T. R. Pryce and E. Jones (eds), *The Welsh and their Country: Selected Readings in the Social Sciences* (Llandysul, 1986), pp. 134–52; and see also D. Adamson, 'The Intellectual and the National Movement in Wales', in R. Fevre and A. Thompson (eds), *Nation, Identity and Social Theory: Perspectives from Wales* (Cardiff, 1999), pp. 48–68.
17. Pyrs Gruffudd, 'Prospects of Wales: Contested Geographical Imaginations', in Fevre and Thompson (eds), *Nation, Identity and Social Theory*, p. 150.
18. For example, Alun Llywelyn Williams, *Y Nos, Y Niwl a'r Ynys: Agweddau ar y Profiad Rhamantaidd yng Nghymru 1890–1914* ['The Night, The Fog and The

Introduction

Island: Aspects of the Romantic Experience in Wales 1890–1914'] (Caerdydd, 1960), pp. 141–8.
19. For example, Peter Lord, *The Aesthetics of Relevance* (Llandysul, 1992), p. 37.
20. *Rhwng Dau Fyd*, pp. 175–6.
21. Manon Wyn Roberts, *Barddoniaeth Iorwerth C. Peate* ['The Poetry of Iorwerth C. Peate'] (Llandybïe, 1986).
22. 'I Ddiodlestr o Oes y Pres yn Sir Gaerfyrddin'['To a Bronze Age Drinking Vessel from Carmarthenshire'], *Plu'r Gweunydd. Cerddi a Sonedau* (Lerpwl, 1933), p. 40.
23. 'I Glychau'r Goets Fawr'['To the Bells of a Stagecoach'], *Plu'r Gweunydd. Cerddi a Sonedau*, p. 39 and 'Yr Oen'['The Lamb'], *Plu'r Gweunydd. Cerddi a Sonedau*, p. 38.
24. 'I Fen Ychen o'r ddeunawfed ganrif yn Amgueddfa Genedlaethol Cymru'['To an eighteenth-century Ox-drawn Wagon in the National Museum of Wales'], *Y Deyrnas Goll a Cherddi Eraill* ['The Lost Kingdom and Other Poems'] (Caerdydd, 1947), p. 25; he wrote of this very wagon from Ewenny in *Diwylliant Gwerin Cymru*, pp. 57–8. Translations of some of his poems, including 'Yng Nghegin yr Amgueddfa Genedlaethol', but with its title changed to 'Museum piece', were published by Joseph P. Clancy in his *Twentieth Century Welsh Poems* (Llandysul, 1982).
25. Sir Thomas Parry, 'Cofio cyfaill' ['Recalling a friend'], *Barn*, 238 (1982), 339–40.
26. Robin Chapman, *Llên y Llenor. Iorwerth Peate* ['A Writer's Writings. Iorwerth Peate'] (Caernarfon, 1987).
27. John Elwyn Hughes, *Trysorau Coll Caradog Prichard* ['The Lost Treasures of Caradog Prichard'] (Talybont, 2020), p. 195; my translation. I am grateful to Dr Dafydd Roberts for drawing my attention to this passage.
28. R. M. Jones, *Llenyddiaeth Gymraeg 1902–1936* ['Welsh Literature 1902–1936'] (Llandybïe, 1987), pp. 270–6.
29. *Y Deyrnas Goll a Cherddi Eraill*, p. 1.
30. *Geiriadur Prifysgol Cymru* ['University of Wales Dictionary'], s.v.; but despite their many differences, Lewis and Peate were united in their belief that the Welsh language was by far the most vital component of Welsh culture.
31. On this, see Hywel Teifi Edwards, *O'r Pentre Gwyn i Gwmderi. Delwedd y pentref yn llenyddiaeth y Cymry* ['From the White Village to Cwmderi. The image of the village in Welsh literature'] (Llandysul, 2004). The concept was not merely geographical – it encompassed the intangible family and acquaintanceship links which bound the community together and differentiated it from neighbouring ones.
32. Iorwerth C. Peate, *Dyfodol ein Llenyddiaeth. Llenyddiaeth Gymraeg mewn 'Cymdeithas Ddwyieithog'* ['The Future of our Literature. Welsh-language Literature in a "Bilingual Society"'] (Llandybïe, 1962), p. 6.
33. *Cymru a'i Phobl* (Caerdydd, 1931), p. 63; my translation.
34. It would have been fascinating to know of his response to the geographer Frank Emery's separation (on linguistic and population-number grounds) of the 'Upland Wales' so dear to Peate from the 'Welsh Heartland' on its

western fringes, in a volume to which they both contributed: R. Brinley Jones (ed.), *Anatomy of Wales* (Cowbridge, 1972), p. 4. R. S. Thomas held similar views about the centrality of the uplands to the Welsh nation: 'The Depopulation of the Welsh Hill Country', *Wales*, 7/7 (1945), 75–80.

35. Marged Haycock, 'The Scholarship and Creativity of Ffransis Payne', *Trans. Radnorshire Soc.*, 75 (2005), 31.
36. He was a member at Minny Street Independent chapel.
37. *Tradition and Folk Life*, pp. 83–4.
38. *Rhwng Dau Fyd*, pp. 168–70.
39. Linden Peach, *Pacifism, Peace and Modern Welsh Writing* (Cardiff, 2019). Somewhat strangely, whilst discussing Peate's prose writings, Peach does not discuss his poetry treating of the effects of war on Wales at all.
40. He was not alone in doing this. The philosopher-archaeologist R. G. Collingwood prefaced his autobiography with the words, 'I have written candidly, at times disapprovingly, about men whom I admire and love': *R. G. Collingwood. An Autobiography* (Oxford, 1939), preface.
41. He listed a pub amongst his desiderata for the site in *Rhwng Dau Fyd*, p. 151; J. Geraint Jenkins, *Morwr Tir Sych. Hunangofiant* ['Dry-land Sailor. An Autobiography'] (Aberystwyth, 2007), p. 95.
42. For a summary, see the relevant sections of John Davies, *A History of Wales* (London and New York, 1993).
43. 'Dyddiadur Cymro' ['A Welshman's Diary'], *Heddiw*, 5 (1939), 194-4 ; 'Dyfodol Cymru' ['The future of Wales'], *Heddiw*, 5 (1940), 476–9; and *Rhwng Dau Fyd*, p. 181; my translation.
44. 'Society in Wales', in R. Brinley Jones (ed.), *Anatomy of Wales* (Cowbridge, 1972), p. 53.
45. Saunders Lewis, *Buchedd Garmon* ['The Life of Garmon'] (Cardiff, 1937), p. 48.
46. See, e.g., J. Geraint Jenkins, *Morwr Tir Sych. Hunangofiant*, nn.38, 90.
47. Pers. comm., Robin Gwyndaf, 22 December 2020.
48. Howell Mudd, *Rhai Ysgubau Allan o Ysgubor y Cof* ['Some Gleanings from the Storehouse of Memory'] (privately published, 2021), reviewed in *Y Faner Newydd*, 97 (2021), 29.
49. I will mention his confronting Cyril Fox about not having learnt Welsh later. But while he castigated both Fox and his predecessor Mortimer Wheeler for not speaking Welsh, he only *noted* that their successors Dilwyn John and G. O. Jones did not do so (*Rhwng Dau Fyd*, pp. 101–2): so, strangely, he did not seem to expect the same linguistic commitment from these two Welsh but non-Welsh-speaking Directors as he did from their English predecessors. Perhaps he felt that John and Jones had some awareness of what it meant to be Welsh (they did).
50. Pers. comm., Robin Gwyndaf, 22 December 2020.
51. The sonnet that brought tears to his eyes, appropriately, was 'Goleuni' – 'Light' – about his ophthalmic operation; *Cerddi Diweddar* ['Later Poems'] (Dinbych, 1982), 12.

Introduction

52. *Diwylliant Gwerin Cymru*, p. xii.
53. The two volumes of *Crwydro Sir Faesyfed* ['Wandering through Radnorshire'] (1966 and 1968), were universally acknowledged as masterpieces, as were the essays collected together after his retirement. Professor Marged Haycock has rated Payne's sensitive prose more highly than Peate's: Marged Haycock, 'The scholarship and creativity of Ffransis G. Payne', *Trans. Radnorshire Soc.*, 75 (2005), 25–42.
54. Pers. comm., Eryl B. Roberts.
55. Pers. comm., T. Alun Davies.
56. Pers. comm., D. Roy Saer, 7 May 2020; my translation.
57. Pers. comm., Eryl B. Roberts.
58. Pers. comm., Mary Brown; and I saw some of them.
59. Pers. comm., Mrs Eirlys Peate, 19 March 2021.
60. Pers. comm., Mary Wiliam (then Middleton): 'Popeth yn iawn, fy merch i; ond peidiwch a'i wneud o eto'; my translation.
61. J. Saunders Lewis (1893–1985) was Wales's principal literary figure of the twentieth century. One of the founders of the National Party in 1925, who soon afterwards converted to Catholicism, he had served as an infantry officer in the First World War, and was thus at odds with Peate in his fundamental beliefs; but like him he had been sacked from his job as a lecturer, in his case for being one of the three involved in the direct action against the RAF bombing school at Penyberth, and did not find employment again until 1952. The two clashed often, and the contrast in beliefs between them shows the wide range of thought that Welsh nationalism could attract – but they were as one in their belief in the importance of the Welsh language.
62. Saunders Lewis, 'Gwaith Newydd Mr. Iorwerth Peate' ['Mr. Iorwerth Peate's New Work'], *Y Faner*, 23 October 1940; my translation.

2

The land of lost content: the developing academic and the rural dream

The making

If Iorwerth Peate was to fashion a myth around his achievements, his origin story is well documented and uncontestable. He was born on 27 February 1901 at Glan-llyn in the hamlet of Pandy Rhiwsaeson, Llanbryn-Mair in the old commotte of Cyfeiliog (hence his middle name) in Montgomeryshire, mid Wales, then an almost-monoglot Welsh-speaking area. He was the second son of George and Elisabeth Peate. His father had followed the grandfather as a country carpenter before becoming a schools attendance officer, while his mother had crossed the linguistic divide from the English-speaking east of the county to rapidly master her new language. He had a happy childhood, being close to his elder brother (Dafydd, named after their paternal grandfather) and recalling the pleasures of tickling trout in the little stream that ran at the bottom of the garden; and if wet, both boys spent hours in their father's workshop working the foot-operated lathe. Although he could not recall a time when he was not interested in reading and in composing poetry, he was regarded as more unruly than his brother.[1] The household was literate and religious, playing host to many well-known Independent ministers, and politically was radical and Liberal-supporting. Llanbryn-Mair came to represent to Peate everything that was fundamental to being Welsh, with the beliefs of its most famous son, Samuel Roberts, a particular influence. Samuel Roberts (1800–85, known as 'S.R.') was an Independent minister, author and radical who opposed fervently the 'Betrayal of the Blue Books' (the government report on education in Wales of 1847 which concluded that the Welsh language was an

impediment to progress), capital punishment, slavery, imperialism and the Crimean War, and many similar causes. Peate was to sanctify the beliefs and practices of Roberts and his two brothers, a mixture of non-party political radicalism and religious independence and tolerance, as a quasi-mystic 'Llanbryn-Mair tradition' of which he was its prime (and apart from his great hero, W. J. Gruffydd, only) exponent.[2] He edited a selection of S.R.'s writings, including the mock-autobiography 'Farmer Careful of Cilhaul-uchaf', of 1881, which chronicled the misfortunes of a man doing his best to farm in an age of landlords and agents of very different persuasions and priorities to himself, an important document for understanding the social history of the mid-nineteenth century.[3] The principled and undeviating stance taken by Roberts and others greatly influenced his views. Peate also completed the task his father had started of editing a volume of essays celebrating the bicentennial of their chapel. But there was also a physical dimension to Peate's feelings for his home parish and to the wider area, and he saw the eastern limit of the parish, the Talerddig Gap, the watershed between the westwards-flowing Dyfi and the Severn, which flowed east, as 'the boundary between things Welsh and things English, the great barrier to invasion from the Saxon east'.[4] For Iorwerth Peate, not only was Llanbryn-Mair a core area of Welsh culture, it also fulfilled the historical role of the March, its physical barriers forming a bastion against the lands to the east where cultures intermingled. Fundamentals of geography and culture came together in this one place that were to guide his entire life and work.[5]

He attended the local primary school and then Machynlleth Grammar School ('twelve miles from Paradise'), where he was influenced by the headmaster, H. H. Meyler. He did well at school and in 1918 moved on to the University of Wales College at Aberystwyth. Later he was to say that he felt guilty about his choice of not following the family tradition, but that cannot have been other than sentiment. His family could not afford the fees for the course (the grant that he had been awarded by the education authority was insufficient), so he registered as one who intended to proceed to teacher training, and received free board and some additional grant. His years at Aberystwyth, as with his birthplace, were to be entirely formative and influence deeply his life, personally and professionally: indeed, his world-view was formed here, and he later described finding his 'haven in my spiritual pilgrimage' by the time he left the town at the age of twenty-six, and never changed his (somewhat iconoclastic) views

on the matter.[6] Many of his fellow students were returned soldiers, and since the war was not over he had to join the Officer Training Corps and briefly wear its uniform.[7] His original wish had been to take Honours in History, and if possible in Welsh; but another of his teachers at Machynlleth, himself a recent graduate, had persuaded him that he should study geography, and so he chose that subject as a subsidiary. In later years he regretted giving up the chance of getting a First in Welsh and instead getting a Second in Geography, but he did get a First in Colonial History.[8] He then took an Honours course in Geography and Anthropology in a department newly established under Professor H. J. Fleure.

Herbert John Fleure (1877–1969) was a Guernseyman who had graduated in Zoology at Aberystwyth in 1901, where he was later appointed a lecturer in Zoology, Geology and Botany, then Professor of Zoology. In 1917 he became Aberystwyth's first and only Gregynog Professor of Geography and Anthropology, leaving for Manchester in 1930. It was Fleure who insisted on having 'Anthropology' in the chair's title, as he had been influenced by the evolutionary theories of Darwin and Huxley and sought to apply them to human society.[9] He was particularly interested in the interplay between man and his environment (as was the terminology of the time), and began an anthropometric study of the Welsh people in 1905, visiting all parts of the country to measure heads and record physical features, reporting his conclusions in some thirty learned articles. He was author of several textbooks, such as *Human Geography in Western Europe* and *Races of England and Wales*, and his teaching of human geography inspired many of his students, not least Iorwerth Peate.

But whilst Fleure was unquestionably the greatest influence on Peate's professional outlook, and particularly so on him as a young academic, it was another of his lecturers who shaped his world-view; as Peate put it,

> He, unquestionably, was the greatest influence on the course of my life. He lit an unquenchable flame in the hearts of many of us for Wales and the Welsh language. His lectures were a sheer joy and his passion an inspiration. His influence on dozens of students was immeasurable ... It was T. Gwynn Jones alone who moved and inspired me to know my own people and gave me the simple conviction that I could do no other than dedicate my life to their service.[10]

Thomas Gwynn Jones (1871–1949) was a poet, writer and translator who also had a deep and abiding interest in folklore and allied matters. He was appointed a lecturer in Welsh at Aberystwyth in 1913, and in 1919 became the first and only holder of another Gregynog chair, in his case in Welsh Literature, which he held until his retirement in 1937. He was part of the Celtic literary renaissance and his major poetic works took that early period as his inspiration; another great influence on Peate, W. J. Gruffydd, described T. Gwynn Jones as the greatest-ever Welsh poet. A radical nationalist and virulent anti-Imperialist, Jones described himself as a '*pacifist* with the emphasis on the *fist*'. Of direct interest to us are his two works, *The Culture and Traditions of Wales* (1927) and *Welsh Folklore and Folk Custom* (1930), and his election as President of the Folklore Society was well earned. The vast majority of students at Aberystwyth at this time came from Wales and many were Welsh speakers, as were many of the staff, several of them well known in their own fields. Peate thus found a congenial atmosphere where he felt at home and partook fully of student life, enjoying concerts and socialising as well as attending chapel regularly; and he met his future wife Nansi (they married in 1929) and made several lifelong friends. He attended the Celtic Society and (not surprisingly, given his later tendencies) the Debating Society, and as an avid competitor won chairs for poetry both within the College and in inter-college eisteddfodau – though the urge left him at the age of twenty-three and he never competed thereafter. He edited the student newspaper *The Dragon* in his last year at Aberystwyth, when he was undergoing the teacher training that he had committed himself to doing as the price of his education, and also working on his MA.

Under Fleure, Peate and three others chose to specialise in Celtic Archaeology, and as part of their course they prepared a Welsh-language textbook on the subject, which was published in 1923 as *Gyda'r Wawr: Braslun o Hanes Cymru'r Oesoedd Cyntefig* ('With the Dawn: A Sketch of the History of Wales in Primitive Times'). Fleure's preface (in English) noted that 'This little book is the result of years of work by a group of students who have wished to express their loyalty to their country and have herein tried to dissipate the opinion that Wales before the Romans was the home of mere uninteresting savagery.'[11] The text was written by Peate, the others taking subsidiary roles.[12] *Gyda'r Wawr* was a slim volume, a résumé of knowledge about pre-Roman Wales with more context than detail, laid out in flowery language. The book today is only of

interest as a synopsis of what was then believed, but is significant as the earliest attempt to provide a scientific presentation of the known evidence about Wales's deep past in the Welsh language, and thus an early signifier of Peate's route of intellectual travel. It traced the coming of several waves of people from the European mainland and their struggle to tame the wilderness that Wales then was. Much research was needed before a complete story could be told, but at last Wales could rejoice in a National Museum, and it was important that people who had collections should send them there to be preserved for posterity. Traces of these different cultures might survive in various dialects, of which clear boundaries could be identified. Peate concluded with a discussion on the physical characteristics which distinguished one race from another; Wales was a refuge where a mixture of traits survived, such as a very old type in the Pumlumon area and in northern Carmarthenshire. Character traits were associated with these physical types: the Beaker people were organisers who showed independence of mind and opinion, as exemplified by the 'independent people' of Montgomeryshire (!). But Wales and the world had need of all these people and their various skills, so that life might be constantly improved.

His MA thesis had a lengthily prescriptive title, 'The Dyfi, its people, antiquities, dialects, folklore and place-names, studied in correlation to one another, with a special aim of ascertaining what degree of correlation there may be between physical anthropology, archaeology and dialect distribution'. By chance, a young Norwegian scholar who taught Celtic Studies at Oslo University, Dr Alf Sommerfelt, wished to study a mid-Wales dialect as a follow-up to his previous studies of Breton and Irish. Through family connections, the Peates were asked to find accommodation for him over several summers, and Peate helped him with his Welsh in exchange for learning about the principles of dialect studies. Sommerfelt's *Studies in Cyfeiliog Welsh* was published in 1925 and Peate maintained a close friendship with him until Sommerfelt's death in 1965.[13] Rather dashingly travelling on his motorcycle, Peate carried out his anthropological fieldwork between 1922 and submission in 1924, when the thesis was examined and deemed satisfactory by Sir John Myres, Wykeham Professor of Ancient History at Oxford, and the doyen of Welsh History, Professor Sir John Edward Lloyd of Bangor. Peate published its conclusions in the Journal of the Royal Anthropological Institute, where Fleure published his papers.[14] Science and romanticism came together in this

paper, and using the former to support the latter was to be a marked feature of his academic output henceforth. Very much of its time, the paper is also transparently and proudly the work of a native observer who in the midst of pages of detailed statistical analysis also noted just as definitively that the people were quiet and reserved, great thinkers and philosophers of their kind, 'leaven in the life of Wales from time immemorial'.[15] His own parish, 'the truly Cymric' Llan bryn Mair (*sic*), was 'just safe on the Welsh side of the language boundary', but fearful of the Severn and what that represented. As a whole, too, Cyfeiliog was both a region set apart from its neighbours and 'a fortress and a haven against the hordes of the East'.[16] Peate's anthropometric survey followed Fleure's methodology; he recorded the details of 180 men and 66 women whose ancestors had been native to the district for many generations. His objective (possibly retrospectively) was not to see if people of a certain district who were predominantly of a particular racial type spoke a particular dialect, but rather to establish if there was a correlation. Its starting point was Fleure's assertion that in antiquity the moorlands – the natural human units, as he put it[17] – exported people and ideas to the river valleys, and this test supported Fleure's assertion in every way. Peate concluded that there had been penetration into the basin from both north and south, reflected in types and dialects, which then fused because of later penetration 'by the tyrants of the east' in time to face further Norman penetration, and it was this realisation of ever-present danger that had so moulded the character of the region.

In 1923 he was invited by the Director of the College's Department of Extramural Studies to become one of its tutors, which he did for the next four years. He enjoyed greatly this time exploring rural Cardiganshire (though its roads, or lack of, soon did for his trusty motorcycle) and south Merioneth, teaching and discussing with class members keen for enlightenment on all sorts of subjects (though the scientific version of the descent of man was not always well received!) He looked back at this time with great affection and made many friends.[18] During this period, too, his cultural awareness was greatly increased by being one of a small group invited to accompany on holiday a Montgomeryshire landowner, J. B. Willans, who took a keen interest in students from the county (E. Estyn Evans, founder of the Ulster Folk Museum, was similarly honoured). He was thus fortunate to be able to travel quite extensively in France, Italy and Spain, and benefited greatly from the experience.[19]

The archaeologist

Iorwerth Peate would have been appalled to know that his entry on the website of the National Archives reads 'Peate, Iorwerth Cyfeiliog (1901–1982) Curator of Welsh Folk Museum, Archaeologist'; but whilst (as we shall see) he spent much of his later career railing against the inadequacies of archaeologists and their unsuitability to have anything to do with folk studies, he was speaking with the zeal of the convert, for his early academic work was all archaeological. During the 1920s he published notes of discoveries in the journal of the Cambrian Archaeological Association, *Archaeologia Cambrensis*, of finds in mid Wales such as flint arrowheads, holed stones, stone axes and cinerary urns. He published a longer paper just before joining the National Museum, however, on Early Bronze Age finds from the Dyfi Basin, the type of paper known in archaeological circles as 'with a note on the type', where reporting a single find is expanded into a lengthy discussion often incorporating a catalogue of all known examples. Finds recovered in 1911 from a tumulus at Darowen (near Llanbryn-Mair) included two bronze daggers and fragments of pottery which, when reconstructed by another Aberystwyth graduate (and later one of Fleure's successors as Professor, E. G. Bowen), turned out to be a beaker. Dagger finds were rare in Wales, as R. E. Mortimer Wheeler had shown in his *Prehistoric and Roman Wales* (1925), but Cyril Fox had directed his attention to several examples. It had been asserted that certain dagger forms were associated with certain types of beakers, but 'I do not think this statement will hold generally'.[20] Nineteen beakers had so far been found in Wales, but their distribution, as mapped by Fox, gave rise to questions. How had the use of beakers reached the 'northern slopes of inhospitable Plynlymon'? Movement from the West Midlands had been suggested, but that area was covered by dense forest (then commonly thought to be the case) which Fox had argued was the major reason for the 'backwardness' of Welsh culture at the time – and Peate agreed, for 'Dr. Fox's suggestion . . . seems to be irrefutable'.[21] The twenty-five-year-old Peate was displaying the certainty of youth and was clearly not afraid of taking on the big guns; and clearly he could not conceive of a time when he would have reacted violently to any suggestion by Cyril Fox that Wales at any time in its history was 'backward': that was to come.

He followed this with a paper on 'The Kelts in Britain', a bold

reappraisal of the interface between linguistics and archaeology. In elaborating a theory advanced by Edward Lhuyd in the seventeenth century the eminent philologist Sir John Rhŷs (1840–1915) had postulated that Britain had been invaded by two waves of Kelts, firstly the Goidels and then the Brythons. Since the consonant Q which occurred in Ancient Irish was replaced by P in the corresponding forms of Ancient British, Rhŷs projected this linguistic classification into the archaeological field and used the term 'Goidel' for the Q-Kelts and 'Brython' for the P-Kelts.[22] This linguistic classification was commonly accepted by archaeologists but should be discontinued, for there was no evidence for it: 'Of the invasions there can be no doubt; but the modern archaeologist is open to just criticism when he equates archaeological periods with philological events for the dating of events for which there is no evidence.'[23] In an assertive conclusion he called on archaeologists to re-examine 'the whole problem of the Kelts in Britain' in the light of his conclusions. Peate wrote this piece at a time when associating language and race was being done on a wider and much more damaging canvas, since speakers of the Indo-European languages were being branded and promoted racially as Aryans; Fleure too was warning of this danger.[24] Peate persisted in using the spelling 'Keltic' long after it was abandoned by everybody else (he did not invent it, as has been asserted or assumed) because it conveyed more accurately its pronunciation than starting the word with a 'C' – a 'celt' with the 'c' pronounced softly anyhow was a type of stone axe. But the assumed link between language and material culture remained, such that in another way Peate was much ahead of his time. He was asked to revisit the topic for the International Congress of Prehistoric and Protohistoric Sciences in London in 1932.[25] By 1934, however, he was starting to distance himself from archaeology. In an address to the British Archaeological Association, he noted:

> As one whose work has taken him during the last seven years outside the field of prehistoric archaeology to the more entrancing one – at least to a reasonably imaginative Welshman of peasant stock – of Welsh folk-culture, I feel somewhat hesitant in appearing before a society which concerns itself entirely with archaeological research. I am emboldened to do so by the conviction that the study of folk-culture is always a corollary and sometimes a corrective to archaeological research.[26]

Wales, he noted, presented a 'singularly appropriate and compact topographical unit' for the study of folk culture. It possessed not only an important body of folklore and a well-defined cultural life but also a wide range of furniture, utensils, implements and tools (the usual stuff of archaeology), and it was the study of this wealth of material that called out for attention. Sir Cyril Fox had formulated an important truth when he noted of cultures that 'in the lowland you get *replacement*, in the highland *fusion*',[27] and even in the lowlands conquered by the Normans, true Welsh culture was not replaced until the effects of the Industrial Revolution were felt: 'We have in Wales therefore a complete cultural unit wherein have been preserved from time immemorial old customs and old traditions, an old language and even old types – all of value, if properly studied, to the archaeologist and anthropologist.'[28] He later noted that his personal view was that the difference between archaeology and folk-life research was not a temporal one – there was no date where one ended and the other began – but rather a 'difference of *method*';[29] but his view that archaeologists were not capable of studying anything that could be defined as folk life was never modulated after this time.

His Christian beliefs combined with his anthropological interests such that by 1940 he was writing persuasively of the unity of mankind. By then, leading anthropologists were coming to realise that by not standing up for scientific facts they had in fact colluded in the growth of fascism and Nazism, partly by choosing to study exotic cultures at the expense of not recognising problems nearer home.[30] Peate rehearsed the arguments: eighteenth-century scholars had used language as the definer of national identity, such that the myth of a 'Celtic race' had been accepted. The reasoning lacked logic – race could not be determined by studying what people did as a culture.[31] At the same time, biologists sought to identify physical characteristics and fit them into this scheme, with the result that modern archaeologists spoke of Celtic and Teutonic races, concepts too readily accepted by politicians and which went unchallenged by scientists. As a consequence, Hitler and others found acceptance for such false ideas as an original European 'master race', subsequently corrupted by external admixture. But more locally, there were no physical differences between the Welsh and the English – the only difference of note lay in language. That, however, was fundamental, and if the Welsh language disappeared then there was no logical reason to have Welsh national institutions – they would be merely regional ones.[32] By now, clearly, Peate must have felt that

there was no longer a place for studies such as he had carried out some twenty years before; and in time, of course, they would be overtaken entirely by another form of racial mapping, using genetic analysis, but the old arguments about the interrelationships of race, culture and language would remain.[33]

Peate was still lecturing on archaeological topics, even as head of the National Museum of Wales's Sub-Department of Folk Culture and Industries (1933–6), for a ten-page typed lecture on 'Wales in Prehistoric Times' is preserved amongst his papers. He traced the time frame from the Upper Palaeolithic and Paviland Cave, the long cairns of the Neolithic and the axe-factory at Penmaenmawr, through the encrusted urns of the Bronze Age, and to the cauldrons of Llynfawr and the hoards of the Early Iron Age.[34] One of his last archaeological contributions (in 1942) was to write on fire-dogs. In a well-reasoned paper he argued that Cyril Fox's recent assumption that the magnificent blacksmith-wrought Iron Age Capel Garmon fire-dog would have been used as one of a pair flanking an open fire in the centre of a roundhouse was incorrect. Fox had based his assumption on the fact that two fire-dogs had been found at Welwyn and other sites, but they were also found singly or even in threes. Peate argued his case from two positions. A central fire required a fire-back stone; this was termed in the Welsh Laws, codified into Latin around 1180, as a *pentanfaen*, and regarded as of such fundamental importance that it was never moved and was taken as a perpetual sign that here was an occupied homestead, even if the house itself had been destroyed. Such features remained in the Keltiberian stone huts of western Spain, as Sir Cyril had told him. The Laws also talked of a *pentan haearn*, a term wrongly translated as 'iron hob', for the hob was a much later invention, and the Latin translation for this object was the singular *retentaculum*, 'something which holds in [the fire]'. The work of Welsh poets of the fifteenth and sixteenth centuries proved that *pentan* (singular, again) was the normal Welsh word for fire-dog. With only one fire-dog to a central fire and with a fire-back stone behind it, the fire-dog could therefore have only be placed in front of the fire, and in the case of the elaborate Capel Garmon example its decoration would have been shown to full advantage as well as supporting the spits it was designed to hold. Finding two or even three fire-dogs rather than just one was an indication of the social standing of the deceased, just as more than one sword was sometimes found.[35]

The land of Wales

As well as writing primarily on archaeological matters, Peate was still active as an interpretative geographer. In 1931 he published *Cymru a'i Phobl* ('Wales and its People'), a study of the influence of geography on the people of Wales.[36] The book was one in a series by the University of Wales Press called *Y Brifysgol a'r Werin* (literally 'The University and the Folk'), designed as a major exercise in introducing concepts and topics of the day to non-academic Welsh speakers; twenty-three titles were published between 1928 and 1949. The title suggested to Peate was *Daearyddiaeth Cymru* ('The Geography of Wales') but he felt that he wished to write the kind of 'new' human geography developed by Fleure. Fleure, as we have seen, sought to illuminate human life and the way it was influenced by inheritances and environments, but also by the way people had sought to master their surroundings. For Peate, likewise, Welsh history was the history of interaction between society and its environment. Such things as economic facts, considered by many to be what geography was about, were rather, he felt, 'but spume on the crest of the wave; the spirit of the living being is underneath and beyond it, and it is the search for that which is the real geography'.[37] Clearly, the maxim quoted at Aberystwyth that 'Geography is about maps, anthropology is about chaps' was out of date even then.[38] The book was an elegiac introduction to the fragments of an idyllic past that still remained in Wales, a consequence of its location on the far reaches of Europe and as such the last refuge of broken civilisations. Describing the country through references gleaned from his mentor T. Gwynn Jones's great ode of 1902, 'Ymadawiad Arthur' ('Arthur's Departure'), there were, he said

> recollections ... of old things, old ways and old visions which have been lost in the outside world – folk tunes, 'superstitions', craft techniques, the natural courtesy of 'poor' folk, and dozens of other things which are like fragments of old dreams lost by the thrust of the 'juggernaut' called Industry.[39]

Tongues of lowland penetrated the mountain massif from the east, along which had penetrated successive waves of new customs, to an extent that now threatened the old. The combination of largely poor land and wet weather meant that the nation had been essentially pastoral, with

crop-growing confined to the coastal and riverine lowlands. Peate's chapter on early times was an updated synopsis of *Gyda'r Wawr*. Iron was not commonly used until the Roman period, during which the Roman army occupied the lowland but were content for the natives to erect and occupy hillforts.[40] To us this is an amazing statement, but it was received doctrine, as laid down by Mortimer Wheeler in his *Prehistoric and Roman Wales* of 1925, though his comment about native settlements such as Tre'r Ceiri and Din Lligwy was that they were 'occupied and sometimes built' during the Roman period, and perhaps it suited Peate to assert that a strong native culture flourished through the Roman occupation, about which he had very little to say.

Peate then broke into his chronological narrative to discuss what he termed one of the founding principles of geography, namely the belief that the inhabitants of any area would develop a particular and unique way of viewing life. This was certainly true of Wales, and from its uniqueness had developed the Welsh character.[41] Externally introduced changes could be beneficial if they were absorbed by societal choice, but they could be harmful if imposed, as had happened in the industrialised areas. He then picked up his chronological thread by going back to the hillforts, which were now believed to have been constructed by people from the continent fleeing the growth of Rome and who had brought the Welsh language with them, a statement somewhat at odds with the date he ascribed to such structures in his previous chapter. The early Welsh Church was cut off from its parent by the arrival of Anglo-Saxon barbarians, whilst Vikings and Normans too contributed to a mixture of cultural traits. Native society remained strong in most of the country, being tribal and dispersed, resulting in Wales being a land of many cultures. Many elements of these arrangements persisted, and it was the task of the geographer to discern them, as E. G. Bowen had recently done.[42] People in Moorland societies depended mostly on pastoralism and their dwellings were inevitably scattered, their society characterised by traits of co-dependency, such as lending and borrowing implements and labour; they often intermarried, were notably open-handed and generous, and highly cultured. The much rarer Vale villages with church, tavern and village green were found only in the areas of English penetration, where crops were the main sustenance. But Bowen had identified a third settlement type, Circle villages, usually found on the low hills above the coastal plains. These clustered around the church and the often-circular graveyard (which perpetuated in its form

an underlying megalithic circle and thus a continuity of worship of millennia on the spot). Later villages took on some of the characteristics of towns, but never achieved growth, St Clears in Carmarthenshire being a classic example. Other villages developed with the coming of the railways.

Language was an inherent part of the concept of *bro*. The precursor of Welsh was almost certainly brought to Britain between 500 and 200 BC, and evolved into Welsh very shortly before the arrival of the Romans. The creation of a linguistic atlas (as had been done in France and Brittany) was desperately needed to aid historical and geographical studies, for the philologist ignored the contribution of the archaeologist and the anthropologist, and they in turn did not seek the philologist's expertise. Whilst the Bible was translated into Welsh, much that the Tudors brought about posed a threat to the Welsh language, and the Industrial Revolution brought an influx of non-Welsh speakers who created towns and cities that were bereft of any connection to their locality. In border areas such as Radnorshire, too, a bastard culture that was no culture at all had developed, with people speaking Welsh through the medium of English.[43] Religion was similarly influenced by geography. Peate felt that Catholicism had once had a particular grip on upland Wales, populated as it was by conformists who believed naturally in predestination and never thought deeply of spiritual matters, traits such as were also seen amongst the peasantry of Spain, France and Italy.[44] Puritanism likewise never had a deep impact on the uplands but flourished along the Marches, a border region where tensions were always present and where it was no surprise that the Independents and Baptists took root. Unitarianism was strong in south Cardiganshire amongst people of a distinct racial background.[45] In their belief in inherent sin and human unworthiness Peate saw a strong similarity between Calvinistic Methodism and Catholicism, and it was no surprise to him that these beliefs once again flourished in the uplands, in contrast to the anglicised Wesleyanism which was more at home in the centres of semi-industrialism, such as Cwm Ystwyth in Cardiganshire and Brynmawr in Breconshire.

The European continent in the nineteenth century had seen a growth of national feeling and an emphasis on native languages, with one reason being the growth of printing and the press through which ideas were spread; and no doubt the same would have happened in Wales were it not for the Industrial Revolution. The industry of the countryside was firmly anchored around the peasant-artisan with no unemployment, but

local businesses could no longer compete and workers, exploited by their landlords, sought opportunities elsewhere.[46] The growth of industry had sucked in huge numbers from adjoining areas of England, but despondency was not an answer: those who could look beyond a narrow time frame would see that what had happened to the Romans and the Normans would happen again and the invader would be subsumed by the native culture, though it required work to ensure that; and the nation's salvation lay in the hills.[47]

His chapter on houses was one of the best and certainly the most original, if only because of a lack of published material on which to base his text. The importance he accorded geography shone through:

> Despite the builder's preferences and the fashion of the age in which he lives, building construction is influenced to a far greater extent by the requirements of his home area, and none would think to build a house Eskimo-fashion in the tropics or the grand structures of Rome on the top of Snowdon. The influence of geography can be more obviously seen in the nature and use of our buildings than in almost any other sphere.

But this chapter was only an introduction to the subject:

> The work of describing the houses of Wales awaits the hand of an expert in architecture who will also be sympathetic to the geographer's way of looking at the development of society ... All that is attempted here is to draw attention to some types and the effects of geography on them.[48]

Here Peate started to identify regional differences on the basis of building materials and constructional styles, but ended with a diatribe about the poor-quality housing of the industrial areas and the 'bungaloid growth' that was happening in the countryside. But rest assured, for as D. H. Lawrence had put it, 'And so it will be again, men will smash the machines'.[49]

He started his discussion on races with the health warning that the term was often misused, when 'nation' or some such word was meant; it was not possible for there to be a Welsh or an English race, for the word referred only to physical characteristics and it was the national experience

and culture which distinguished similar people from another. This chapter effectively repeated what he had to say on the matter in *Gyda'r Wawr*, but he stressed again that it was in the uplands that the characteristics which best defined the Welsh people survived: 'The uplands can be seen as a treasure-house of old things, as the keeper of the old traditions and as the least changeable element in the life of the country . . . the mountains are the fortress of our history.'[50] The 'little dark people' who formed the most distinct element in the population exhibited quite different character traits from the Nordic strain. They were passive and as a result were frequently poor and suffered from the diseases associated with poverty, such as tuberculosis. His final conclusion was that the Welsh were a nation of mixed roots, unified through adversity, which had allowed local diversity to flourish. Peate may have been a geographer but he was certainly no historian; in particular he ignored the published evidence for the great poverty that had always existed in the countryside, and was clearly entirely blinkered by his vision of a rustic nirvana.[51] He denied that Welsh rural society suffered from poverty yet noted it to be a character trait of the most common physical grouping. Sadly, he not only peppered his text with homilies but based a lot of it on wishful thinking which surely must have appeared as baloney to many who read it. He was clear that race and nation and language were quite distinct, but he also believed that physical traits and character were linked, and exhibited geographical determinism in his analysis of the location of religious sects. Whilst the chapter on archaeology could have been updated substantially and the one on houses informed definitively (at the time) by *The Welsh House*, both author and publisher were clearly happy for the book to be reprinted without amendment in 1948, and indeed as a whole there is still nothing comparable in Welsh, even today.

Many of Peate's works were to be entirely innovative in their subject matter and remained so for some time, but a direct comparator to *Cymru a'i Phobl* exists, published only a decade later and by Peate's contemporary at Aberystwyth, E. G. Bowen. Emrys Bowen (1900–83) was appointed an assistant lecturer in Fleure's department in 1929 and its head in 1946, and is recognised as foremost amongst British geographers in stressing the significance of culture in the shaping of the landscape.[52] *Wales. A Study in Geography and History* was published by the University of Wales Press in 1941, in the same format as Peate's book but somewhat longer, and because the Press had agreed to the author's request (and

known that it would have a much greater readership in English, and so more sales to recoup the cost) was copiously illustrated. It had a foreword by Fleure, who made the point that poverty had in many ways been the saviour of Welsh culture, though the reverse of the coin was a narrowness of attitude and parochialism; and even the crowded masses of the industrial valleys had not wholly lost touch with their rural background and heritage. Although the subject was exactly the same, Bowen's book is wider in its scope – it brought the story up to date and devoted a considerable number of pages to industry – and was as factual as any book could be in its approach.[53] Based on a radio series and aimed particularly at school pupils and students, the text progressed logically, describing in turn physical landscape, then historical geography, and finally economic geography, in which he discussed the industries and occupations of the day. He used what he called 'period-pictures' to recreate in considerable detail the landscape and history of selected parts of the country, such as the borderland in Tudor times, the rise of nonconformist Wales (where he repeated Peate's points about the geographical spread of the different denominations, but much more effectively), and was particularly strong on the geography of the Welsh language. Bowen's language throughout was restrained, with none of Peate's poetic flourishes, and the content was entirely devoid of sentiment, judgement or unlikely hopes for the future. Whilst his bibliography revealed that most of his sources had also been available to Peate a decade before, the result is incomparably superior in every way, apart perhaps from literary merit: Bowen's is factual prose, conveying balanced information effectively and succinctly, but less likely to touch the soul than Peate's.

Peate's view of the importance of rural life for the future was welcomed by (mainly Welsh-speaking) academics, and also a far wider circle of people than those interested in the material culture of Wales. He took a very different view from Saunders Lewis and his followers, who, in his view, sought to link Wales with continental urban high-art culture which, on examination, turned out to be Catholic southern Europe. Wales was part of a wider Europe,[54] though he noted that the country was fortunate (from his perspective) in lying on the outer fringe of western Europe, and in being home to a conservative nation.[55] Interestingly, he cited as evidence for his arguments the distribution maps published by Fox in *The Personality of Britain* which showed that most continental influence on Wales, at least in prehistory, reached Wales via England (a view now

entirely discredited, at least for the Neolithic), and that it was foolish to try to explain Wales's traditions as if England did not exist.[56] Neither Roman nor Norman had any influence on the vast moorland (*y gweundir maith*) that made up the Welsh heartland, but the roots of our material culture stretched as far as north-east Europe and had very little to do with Italy and the Mediterranean lands. Critics claimed there was no Welsh architecture but they had been blinded by the Classical, Latinate tradition: 'Wales has inherited the traditions of all Europe. Our Welshness requires nothing other than a love of truth, and freedom from the shackles of religious and political systems which have outlived their day'.[57] Via Fleure, Peate was deeply influenced by the French geographer Vidal de la Blache's view that geography was fundamentally the study of man's interaction with the environment.[58] Historians felt that it was man's control of nature that was the only thing of importance in the study of communities, whereas geographers felt that interaction and the essential unity between man and nature was fundamental; but at least historians accepted that there were two, if not more, different forms of native community in Wales, that of the moorland and that of the lowland village.[59] In 1928 he had argued that the village had always been a self-sufficient and cooperative community which encouraged courtesy, artistry and kindness and

> where work and leisure, individual enterprise and co-operation were combined to produce a rural polity which seems to be far nearer perfection than the unhealthy striving of those communities where poverty is extreme and wealth out of all proportion to the needs of those who enjoy it.[60]

However, he should have realised that villages were a Victorian feature in Wales, with very few of earlier date outside the areas of Norman settlement in Pembrokeshire and the south-east.

Issues to do with the land had long been important in Wales, with land ownership an increasing source of conflict during the second half of the nineteenth century. A staggeringly high percentage of land in Wales was in the hands of great landowners, and the increasing shift of the tenantry towards the Liberal party, whom they saw as a hope towards addressing their grievances about rent, tithes and many other issues, led to major fractures. Political disillusion with the Liberals' failure to address these problems became a plank for nationalistic views in the

early twentieth century, with leaders such as Saunders Lewis advocating de-industrialisation and a return to the land.[61] Peate had crystallised his views of the impact of heavy industry in Wales by 1929, as he noted in his *Guide to the Collection of Welsh Bygones*:

> The present day mining industry in Wales, carried out on a scale destructive to the beauty of the countryside, is a product of the mechanical developments of the nineteenth century; up to that time the valleys of South Wales were as fair and as pleasant as those of rural Wales at the present day.[62]

Country-dwelling Welsh speakers, or those from such a background, viewed their heritage very differently from others. To them rural Wales represented civilisation, whereas to most educated English people civilisation was equated with urbanisation.[63] The views of two Aberystwyth men were particularly influential in how the countryside was perceived in Wales during the inter-war years. Both Fleure and the agricultural scientist R. George Stapleton (1882–1960) were convinced of the role of the inhabitants of rural areas as keepers of perpetual values and argued passionately for a rebuilding of British society on the basis of such strengths. To both, the decline of the countryside and its inhabitants could only lead to the break-up of civilisation by rampant materialism. Peate too felt strongly about the matter and readily espoused these views. They were also pragmatic. Peate deplored the conclusions, and indeed the assumptions, of the Report of the Committee on Land Utilisation in Rural Areas (popularly known as the Scott Report, 1942) which drew a distinction between rural and urban problems and regarded the countryside essentially as an amenity to be enjoyed by city-dwellers.[64] This artificial dichotomy had to be opposed, whilst the idea of trying to preserve the countryside as merely a place of respite and relaxation for the urban masses was entirely immoral; here, of course, he was in direct conflict with the strong movement from which had sprung organisations such as the National Trust, the Ramblers Association and the English-dominated Council for the Preservation of Rural Wales (CPRW). Peate may have been introduced to the latter by one of its founders, his Rhiwbina neighbour, the architect T. Alwyn Lloyd, whose booklet *Brighter Welsh Villages* of 1931 Peate translated into Welsh. While most members of the CPRW saw what was happening in the countryside as merely an intrusion of bad

taste, common to all the British countryside, to Peate as to others it was far more fundamental – an erosion of Welshness. It followed that his views on the importance of preserving unspoilt by progress the Welsh-speaking upland core of the nation led to him opposing any talk of a highway that would link north and south – and those two distinctions were themselves an artificial construct of the same media that proposed a solution to a problem that only they perceived.[65]

The Scott Report concluded that the countryside had to be preserved as it was, and the cheapest way of doing that was by farming; but to Peate the answer was a mix of farming and industry. Rural population had declined and farms were still increasing in size, with a further population decline inevitable, and the coalfields had shown the problem of over-reliance on one source of employment. Reviving rural crafts was not the answer, for crafts needed a market, and rural Wales was depopulated. There was nothing new to mixing agriculture and industry as an answer to the problems of rural Wales, he noted again: 'In the most prosperous age for rural society, it had this dual foundation – quarry and smallholding, coal-mining and farming, the woollen factory and the farm, that was the rule once.'[66] Perhaps more surprisingly, he did not oppose what later became a hugely emotive issue for Welsh nationalists, namely the drowning of valleys for the generation of electricity for English cities. He recognised that if the Elan Valley were to be drowned when he was writing (the dam was completed in 1904) the process would face strong opposition, but 'I am certain that the Elan Valley as it is today is more attractive than before it was drowned. We have to acknowledge these facts rather than live with woolly sentiment and settle for the continuing stagnation of the country. True beauty has dynamic roots.'[67] Hydroelectric schemes could be developed, but the only real answer lay in light industry which did not depend on a bulky raw material: plastics were ideal, with one raw material, casein, a by-product of milk. Making cosmetics was another option, as was reusing slate waste. But awaiting some heaven-sent answer was foolishness, for 'I am certain that "saving" rural Wales from the new civilisation and preserving it in aspic will be its death.'[68] Here again he was at variance with the preservationists, who saw the demand for water-power as a great evil.[69] Nevertheless, in 1955 he wrote to the press and signed and sought further signatures for a CPRW petition opposing the possible location of a nuclear power station at Edern on the northern coast of Llŷn, despite considerable local support for the project in an area of low

employment.[70] Overall, however, Peate, channelling the thoughts of Fleure and Stapleton and promoting his brand of techno-arcadianism (as Pyrs Gruffudd has expressed it) through the pages of the National Party's organ *Y Ddraig Goch* ('The Red Dragon'), had an influence on the wider political discourses of the time. Gruffudd sees the 'back to the land' movement of the inter-war years as not a regressive step, but rather an alternative approach to the industrial and urban hegemony of contemporary thinking. Peate's views on the primacy of the rural should not necessarily be seen as merely of their time and approached solely from his seemingly narrow perspective: they are reflected in today's alternative and ecologically based approaches to living. As such, Peate's views on the importance of the historical rural basis of Welsh life are still very relevant.[71]

Notes
1. *Personau*, p. 35.
2. 'Traddodiad Llan-bryn-Mair' ['The Llan-bryn-Mair Tradition'], *Trans. Hon. Soc. Cymmrodorion* (1954), 10–18. His assertion, in 'Ordinary Folk', *Béaloideas*, 39/41 (1971–3), 280, that respect for the individual personality of all human beings 'was a Christian philosophy peculiarly associated in Wales with my own native parish of Llanbryn-Mair' was typical of his frankly ridiculous assertions on this topic. Others felt the same about their own 'square mile': the author D. J. Williams claimed for his own home area of Rhydcymerau in Carmarthenshire many of the virtues that Peate saw as specific to Llanbryn-Mair – a completely classless society, bound together by home, chapel and school: Emyr Hywel, *D. J. Williams. Y Cawr o Rydcymerau* (Talybont, 2009), p. 36.
3. *Cilhaul ac Ysgrifau Eraill Samuel Roberts, Llan-Bryn-Mair* ['Cilhaul and Other Writings by Samuel Roberts, Llan-Bryn-Mair'] (Cardiff, 1951).
4. 'The Dyfi Basin: A Study in Physical Anthropology and Dialect Distribution', *Journal of the Royal Anthropological Institute*, 55 (1925), 59.
5. Peate was not alone in having such beliefs about his place of birth. Raymond Williams, twenty years younger, noted that 'a real structure of values' could develop around such a place, and observed that the only landscape he ever saw in his dreams in Cambridge was that of Pandy in the Black Mountains: Raymond Williams, *The Country and the City* (London, 1973), p. 84.
6. *Rhwng Dau Fyd*, p. 168.
7. *Rhwng Dau Fyd*, p. 46.
8. *Rhwng Dau Fyd*, p. 50.
9. Pyrs Gruffudd, 'Back to the land: historiography, rurality and the nation in interwar Wales', *Trans. Royal Inst. British Geographers*, 19/1 (1994), 62.
10. 'Atgofion am Thomas Gwynn Jones', *Y Llenor* (1949), 109; my translation. On Jones, see now Alan Llwyd, *Byd Gwynn: Cofiant T. Gwynn Jones, 1871–1949*

['Gwynn's World: A Biography of T. Gwynn Jones, 1871–1949'] (Llandysul, 2019).
11. *Gyda'r Wawr*, 'Rhagair' ['Foreword'].
12. *Rhwng Dau Fyd*, pp. 55–6. Although the book's bibliography references an article by the archaeologist O. G. S. Crawford, it does not mention's Crawford's *Man and his Past* (Oxford, 1921), an introduction to the practice of archaeology and an up-to-date summary of knowledge about British prehistory that Peate could have used to advantage.
13. *Personau*, pp. 51–4.
14. 'The Dyfi Basin', 58–72.
15. 'The Dyfi Basin', 60.
16. 'The Dyfi Basin', 59.
17. H. J. Fleure, 'Ancient Wales – Anthropological Evidences', *Trans. Hon. Soc. Cymmrodorion* (1915–16), 141–2.
18. *Rhwng Dau Fyd*, pp. 71–81.
19. One of his best-known essays is 'Tua Granada' ['Towards Granada'], reproduced in *Sylfeini. Ysgrifau Beirniadol* (Wrecsam, 1938), pp. 123–38. These travels gave him a context against which to measure British and Welsh culture: *Personau* (1982), pp. 66–75.
20. 'Early Bronze Age Finds in the Dyfi Basin', *Arch. Cambrensis*, 81, 7th ser., 6 (1926), 357.
21. 'Early Bronze Age Finds in the Dyfi Basin', 360–1.
22. The distinction between 'Q-Celts' and 'P-Celts', although simplistic, remains a useful tool for separating the two branches of the Celtic languages – Scottish and Irish Gaelic and Manx on the one hand, who use 'ken' meaning 'head', as in 'headland', and Welsh, Cornish and Breton on the other, who use 'pen'.
23. 'The Kelts in Britain', *Antiquity* (1932), 158.
24. H. J. Fleure, 'The Nordic myth: a critique of current racial theories', *Eugenics Review*, 22 (1930–1), 117–21.
25. Which he published as 'The Kelts: A Linguistic Contribution', *Arch. Cambrensis* (1932), 260–4, effectively a word-for-word repetition of his 1931 paper.
26. 'Archaeology and Folk-Culture', *Arch. Journal*, 91 (1934), 211.
27. Cyril Fox, *The Personality of Britain. Its Influence on Inhabitant and Invader in Prehistoric and Early Historic Times* (Cardiff, 1932), p. 31.
28. 'Archaeology and Folk-Culture', 214.
29. 'The Study of "Folkliv"', *Man*, 45 (1945), 120.
30. G. M. Morant, 'Racial Theories and International Relations', *Journal of the Royal Anthropological Institute* (1939), 151–62.
31. 'Anthropoleg a Phroblemau Cyfoes' (1941), repr. *Ym Mhob Pen*, p. 20.
32. 'Anthropoleg a Phroblemau Cyfoes', p. 24.
33. There is a huge literature on this topic. Race, too, is now accepted as a social reality but as more of a cultural construct than defined by physical features.
34. NLW ICP Papers, A2/9(i).

35. 'The Double-ended Firedog', *Antiquity*, xvi (1942), 64–70. Peate's thesis was supported by Stuart Piggott, using European and ethnological evidence: 'Fire-dogs again', *Antiquity*, xxii (1948), 21–8.
36. The title was first used in English by Fleure in his pamphlet *Wales and her People* (Wrecsam, 1926).
37. *Cymru a'i Phobl*, p. v; my translation.
38. But the maxim was not that old: the phrase was clearly adapted from the clerihew, 'The Art of Biography / Is different from Geography. Geography is about Maps, / But Biography is about Chaps': E. C. Bentley, *Biography for Beginners* (1905), Introduction. Bentley invented the clerihew and the form was so called after his middle name.
39. *Cymru a'i Phobl*, pp. 1–2; my translation.
40. *Cymru a'i Phobl*, pp. 32–3.
41. *Cymru a'i Phobl*, pp. 40–1.
42. 'A study of rural settlements in South-West Wales', *The Geographical Teacher*, 13 (1925–6), 317–26; such study was clearly the preserve of the historical geographer rather than the historian, and Bowen was succeeded in this by other Aberystwyth geographers, particularly G. R. J. Jones and Colin Thomas.
43. The term 'Wenglish' was coined by John Edwards in the 1980s: *'Talk Tidy'. The art of speaking Wenglish* (Cowbridge, 1985).
44. *Cymru a'i Phobl*, p. 88.
45. *Cymru a'i Phobl*, p. 93.
46. *Cymru a'i Phobl*, p. 100.
47. *Cymru a'i Phobl*, p. 110.
48. *Cymru a'i Phobl*, pp. 111 and 113; my translation. Much to Peate's discomfort at times, this paragon was indeed to come, in the form of Peter Smith.
49. *Cymru a'i Phobl*, p. 120.
50. *Cymru a'i Phobl*, p. 124; my translation.
51. *Cymru a'i Phobl* appeared in 1931, the same year as the collected researches on the hardship of early nineteenth-century life in upland north Wales published in parts in *Y Beirniad* between 1923 and 1926 by Hugh Evans, *Cwm Eithin* ['The Gorse Glen'], trans. E. Morgan Humphreys (1948). W. J. Gruffydd was in the process of publishing parts of his own autobiography in his magazine *Y Llenor* (1930–6), to be brought together as a volume in that latter year, *Hen Atgofion. Blynyddoedd y Locust* ['Recollections. The Years of the Locust'], a wonderful description of the life of the quarryman-cottager and his community based on his own recollections of Bethel in Gwynedd. Peate really had no excuse for ignoring rural poverty – if only because he would have known of the large workhouses at Machynlleth, Llanidloes and Rhaeadr, if nothing else.
52. For Bowen, see Colin Thomas, 'Emrys George Bowen 1900–1983', *Geographers: Biographical Studies*, 10 (1986), 17–23.
53. Peate's denial of the Industrial Revolution and its effect was not an issue that afflicted other Welsh-speaking academics: it was particular to himself. The University of Wales Press published a Welsh-language volume in the same

year as Bowen's book – *Braslun o Hanes Economaidd Cymru* ('An Overview of Welsh Economic History') by Ben Bowen Thomas, a comprehensive study of Wales's economic history, which devoted over half of its 230 pages to the triumph of industry. Yet another Welsh-speaking economist, Brinley Thomas, was to show how the influence of industry affected wages and prices in the countryside and how huge internal migration to the coalfields was in Wales.

54. 'Traddodiad Ewrop' ['The European Tradition'], *Y Llenor*, xv/i (1936), 8–15, repr. *Sylfeini*, pp. 165–76.
55. 'A Folk Museum for Wales', *Museums Journal* (1934), 230.
56. 'A Folk Museum for Wales', 168.
57. 'A Folk Museum for Wales', 175–6; my translation.
58. Paul Vidal de la Blache (1845–1918) conceived the idea of *genre de vie*, the belief that the lifestyle of a region reflects the economic, sociological, ideological and psychological identities imprinted on the landscape.
59. 'Daearyddiaeth a'r Haneswyr' ['Geography and the Historians'], *Y Llenor* (1931), 161–8, repr. *Sylfeini*, pp. 109–19. I am partly paraphrasing Peate, who in the terminology of the time used 'man' to mean all people.
60. 'The social organisation of Welsh rural industries', *Welsh Housing and Development Yearbook* (1928), 104.
61. Wil Griffith, 'Saving the Soul of the Nation: Essentialist Nationalism and Interwar Rural Wales', *Rural History*, 21 (2010), 177–94.
62. *Guide to the Collection of Welsh Bygones* (1929), p. 49; and implicitly, Cyril Fox must have agreed with this view, since he did not edit out the sentence.
63. Dafydd Jenkins, *D. J. Williams* (Cardiff, 1973), pp. 9–10; John Davies, *Hanes Cymru* (London, 1990), p. 347.
64. 'Yr Ardaloedd Gwledig a'u Dyfodol' (1943), repr. *Ym Mhob Pen*, pp. 120–1.
65. 'Ffordd i "Uno Cymru"' ['A Way to "Unite Wales"'], *Heddiw*, 3 (1937), 126–30.
66. 'Ffordd i "Uno Cymru"', 123.
67. 'Ffordd i "Uno Cymru"', 124; my translation. He would no doubt have expressed a different view had he known of the larger-scale displacement of Welsh-speaking communities that was soon to come (Chapter 6).
68. 'Ffordd i "Uno Cymru"', 128.
69. Edmund Vale, 'Wales: Its Character and its Dangers', in Clough Williams-Ellis (ed.), *Britain and the Beast* (London, 1938), pp. 256–65. Clough and Amabel's *Headlong Down The Years* of 1951 was very much a satire on plans to dam Welsh valleys for this purpose: Jonah Jones, *Clough Williams-Ellis. The Architect of Portmeirion* (Bridgend, 1996), p. 88.
70. Mary Allan, *The Women of Plas yn Rhiw* (Llanrwst, 2005), p. 107. I am grateful to Celia Hunt for this reference.
71. Pyrs Gruffudd, 'Tradition, Modernity and the Countryside: the Imaginary geography of Rural Wales', *Contemporary Wales. An annual review of economic & social research*, 6 (1993), 33–47.

3
The National Museum of Wales

The National Museum

Like the National Library of Wales, the National Museum (today known as Amgueddfa Cymru) was founded in 1907, both fruits of a national cultural revival which had already seen the creation of the University of Wales. As such, and even though government-funded, the historian Prys Morgan has claimed they could initially be characterised as anti-British institutions founded on the back of protest at the British state's neglect of Wales.[1] The Museum's Objects, as stated in its Royal Charter, were 'mainly and primarily the complete illustration of the geology, mineralogy, zoology, botany, ethnography, archaeology, art history and special industries of Wales and the collection, preservation and maintenance of objects and things of usefulness or interest connected therewith.'

Its first mission statement, coined by its President, Lord Pontypridd, in 1912, was 'to teach the world about Wales and ... the Welsh people about their own fatherland'.[2] The history of its early days has been written in some detail by a former Director, Douglas Bassett, and aspects in greater depth by others.[3] Bassett identified the earliest calls for such an institution to 1858, when the politician G. H. Whalley of Ruabon proposed at that year's National Eisteddfod that a museum and record office for Welsh manuscripts and books should be established.[4] The movement for such institutions, however, really dates to the early 1880s and was part and parcel of the general reawakening of cultural consciousness in the country and from which flowed the foundation of three University Colleges, at Aberystwyth (1872), Cardiff (1883) and Bangor (1884) (Swansea followed in 1920), and their amalgamation into a University of Wales in 1893. From

then on, the concept of national cultural institutions was discussed in the House of Commons, by the London-based Cymmrodorion Society at National Eisteddfodau, and in various town halls, which saw opportunities to house such structures. A decisive step was a presentation to the Chancellor of the Exchequer in 1903, led by Sir Alfred Thomas and Sir Isambard Owen, where the case was made (for the museum) that the range of subjects later noted in the foundation charter (including ethnography) should be included within the purview of such an institution.[5] A special committee of the Privy Council was appointed to determine where the two institutions (museum and library) should be located, adjudicating between submissions from Swansea and Caernarfon as well as the eventual winners, Cardiff and Aberystwyth.

Cardiff, then still a town and not a city (it was granted city status in 1905), had started to express an interest in becoming home to a national museum in 1893 and began lobbying seriously thereafter, describing the town as 'the largest coal-exporting port in the world' and 'the premier port of the British Empire'.[6] The town's municipal museum, established in 1868, was consciously and ambitiously rebranded in 1901 as the 'Welsh National Museum of Natural History, Arts and Antiquities'. Having an existing good collection on offer as the nucleus of the new National Museum proved a major advantage for Cardiff, and in June 1905 the Privy Council decreed that the National Library should be located in Aberystwyth and the National Museum in Cardiff. Royal Charters for both bodies were issued on 19 March 1907; that of the Museum prescribed a supreme governing body, the Court, to represent all interests in Wales; an executive body, the Council; and a Director as Chief Administrative Officer. There would be three 'officers' – a President (the first being Sir Alfred Thomas, later Lord Pontypridd, appropriately, given that he had led the deputation of 1903), a Vice-President and a Treasurer. Dr W. E. Hoyle (1855–1926, later to style himself as W. Evans Hoyle, learn Welsh, and be admitted to the Gorsedd of Bards as *Amgueddfab*, 'Son of the Museum') was appointed the first Director: Iorwerth Peate regarded him as the National Museum's greatest benefactor. Curator of the University Museum, Manchester, when appointed, he was a distinguished zoologist who had been elected President of the Museums Association in 1906 as a recognised authority on the planning, construction and operating principles of museums. He had a very clear view of what the Cardiff institution's mission should be, asking rhetorically,

What is a museum? A place to keep and preserve things. What effect will the National Museum have on the national life of Wales? Will it make Wales more of a nation than ever it was before? Will it foster our love for our nation and make the lives of the Welsh people better and nobler than ever before? The efforts of the National Museum's staff should be inspired and governed by one ideal – to awaken all that is best in the national spirit.[7]

A competition for the new museum building, to be located in Cathays Park on land given by the Marquess of Bute, was launched, and in 1910 the design of Messrs A. Dunbar Smith and C. C. Brewer was declared victorious. The plan called for a long rectangle of buildings around two central courtyards, with stores all around the outside of the building and galleries on the inside.[8] A. H. Lee was appointed Secretary to the Director in 1912 (his post was retitled Secretary to the Museum soon afterwards), while the staff of the Cardiff Museum transferred across in the same year, with its Curator John Ward (1856–1922) becoming the National Museum's first Keeper of Archaeology. By 1919 four other Keepers had been appointed, of Art, Botany, Zoology and Geology. Ward retired in 1920 and was succeeded by R. E. Mortimer Wheeler, who also became Lecturer in Archaeology at the University College next door.[9] Whilst a Keeper of Industries (the sixth department seen as necessary by the Museum in 1908) still had not been appointed, a purchasing policy for Art and Ceramics compiled by Sir William Goscombe John RA included reference to the need to 'Collect as rapidly as possible the smaller objects of the arts and handicrafts, especially those connected with the Peasant arts and crafts'.[10]

One of the last things that the Committee of the old Cardiff Museum did before transferring the collections to the National Museum in 1912 was 'to form a collection to illustrate old-fashioned Welsh life – the obsolete and obsolescent objects, conveniently called "by-gones"'.[11] The individuals most credited with compiling this material were T. H. Thomas (*Arlunydd Penygarn*), William Clarke, Miss Gwenllian Thomas and T. W. Proger.[12] Some of the collection so gathered (and a few other items) was displayed in the Museum's temporary accommodation at City Hall, Cardiff in 1913 in an exhibition arranged by John Ward, who also penned the accompanying catalogue. 'The aim of the Exhibition', he noted, 'is to illustrate old-fashioned life, and especially that of Wales – the life which is slowly

and silently passing away ... the collection as a whole is made up of old-fashioned things'.[13]

It was divided into three sections – 'The old home', 'The old farm' and 'Some old industries'. Between its opening on 20 June and 30 September, when it had another month to run, the exhibition was visited by over 15,000 people.[14] Two cases of beautiful and rare objects lent and arranged by Robert Drane 'illustrating old manners and customs' were particularly admired.[15] The organisers had difficulty in deciding whether to call the objects 'antiquities' 'as they might imply a greater age than they possess', 'bygones', which was not an acknowledged term yet, or 'old fashioned things';[16] nevertheless, the *Annual Report* titled it an 'exhibition of Welsh Antiquities'.[17] Additions to the collection were made over the years, with the more photogenic items, such as wickerwork donkey panniers and a triple harp, being illustrated by plates in the *Annual Reports*. A temporary exhibition of dolls was put on in 1914 and of toys in 1915, and for the visit of the Royal Welsh Agricultural Show to Cardiff in 1917 an exhibition of agricultural implements and appliances was arranged, with a circular sent to agricultural societies asking for donations or loans of appropriate material.[18] In the same year 'The collection of Welsh carved wooden spoons, numbering about fifty [was] classified and divided into two sections, and damaged specimens ... repaired'.[19] In the following year an early Welsh dresser, a panelled bacon cupboard with a seat, a *cwpwrdd tridarn* ('three-piece cupboard'), and 'an arm-chair formerly the property of Twm o'r Nant' were received.[20] Amongst items received in 1926–7 were an early nineteenth-century family coach and four rails and four stone blocks from the Penydarren–Abercynon railway over which Richard Trevithick's locomotive had run in 1805, whilst efforts were being made to acquire the equipment of a woollen yarn factory from Llanrhystyd, which it was planned to exhibit once space became available.[21]

On Hoyle's retirement in 1924 the thrusting young Keeper of Archaeology, Mortimer Wheeler, became Director, but stayed at Cardiff for only eighteen months. He was succeeded in both posts by his protégé Cyril Fox, who was appointed Director without interview. The only other name considered by the appointing panel was that of Peate's mentor, Professor H. J. Fleure, but he was not invited to interview.[22] I do not know if Fleure was ever aware of this; Peate clearly was not, otherwise he would have reflected many times on what might have been. Cyril Fred Fox (1882–1967), an Englishman who came late to formal education

and who did not turn to archaeology until the age of thirty-six, was a polymath who published groundbreaking studies of many aspects of archaeology, from Bronze Age barrows to Iron Age art, Offa's Dyke and vernacular architecture. Fox's *The Personality of Britain. Its Influence on Inhabitant and Invader in Prehistoric and Early Historic Times*, of 1932, introduced contemporary geological and geographical concepts to the archaeological world and gave him an international reputation. The use of the word 'personality' was common in contemporary geographical circles, being used by Vidal de la Blache (1845–1918) in France and Sir Harford Mackinder (1861–1947) in Britain, but there is no evidence that Fox had any direct knowledge of the work of either; rather, he seems to have absorbed both term and concept from their general use in geography.[23] Elwyn Davies, who as a postgraduate followed H. J. Fleure from Aberystwyth to Manchester (and years later became Chairman of the Welsh Folk Museum Committee), remarked that Fleure had taught for years many of the principles put forward by Fox.[24] However, his proposed division of Britain into Highland and Lowland Zones was to prove hugely influential for archaeologists and students of traditional buildings.[25] Cyril Fox was knighted in 1935 for his contribution to archaeology and to the development of the National Museum.

After the early exhibitions the 'bygones' collection had to be put in store until in 1925, 'the Council, appreciating the importance and interest of the Collection, erected . . . a temporary gallery adjoining the Entrance Hall, in which a representative selection could be displayed'.[26] This Bygones Gallery was opened in 1926 early in Fox's tenure as Director: he described it in 1930 as 'the first attempt made by any national museum in this country to illustrate the traditional culture of the people'.[27] The new gallery included some furniture, a carved wooden screen of the sixteenth century and a weaving loom, and several rows of cased material, with larger items such as bicycles and spades hung on the walls.[28] Other exhibits were displayed in the Entrance Hall and on the balconies around it, inevitably crowded and without much logic to their order of display. The Museum's *Short Guide* noted that the objects shown were 'of the highest interest to the student as illustrating the native arts and crafts of Wales prior to the advantage of modern methods of mass production', with cases illustrating the development of the miner's lamp; trapping and fishing implements; locks and keys; spectacles; dairying, knitting and lacemaking appliances; and cockfighting.[29] In addition, some of the

collections were displayed in two room settings, namely a 'Welsh Kitchen' and a 'Welsh Bedroom', both furnished as they might have been in the nineteenth century. The kitchen display – with bare walls, floor and ceiling – was packed with furniture, including a dresser, a settle, a lipwork (woven straw and rush) armchair, a long-case clock, a spinning-wheel and a bread-crate hanging from the ceiling, and a fireplace appropriately dressed but also with a dog-wheel by its side, a feature of gentry rather than farmhouse kitchens but an object which it was clearly thought too good not to display.[30] The gallery, and especially the two room-settings, apparently 'excited general interest' within and without the profession.[31] This 'Welsh Kitchen' appears to have been only the second created in Wales – the first was that of 1919–20, created by Lt Col. W. E. Ll. Morgan at the Royal Institution, Swansea (Wales's oldest museum). Isaac Williams, the National Museum's Keeper of Art, created another one at the Rapallo House Museum and Art Gallery in Llandudno in 1927.[32]

The curator

In 1926 a vacancy for an Assistant (also termed 'Qualified Assistant') arose in the Museum's Archaeology Department. Iorwerth Peate was persuaded by one of his influential acquaintances, Edgar Jones, a member of the Museum's Council, to apply for the post, and he did so having understood that it was his for the taking, although, as he later told it, he was not particularly interested. But Edgar Jones had forgotten that Peate had complained in a Welsh-language newspaper about how anglicised the Scout movement in Wales was, and that another member of the Council, George Eyre Evans, the antiquary and founder of Carmarthen Museum, was also Deputy Scout Commissioner for Wales.[33] Eyre Evans put it about that Peate was a rabid nationalist, and Fox told him at the end of the interviews that he had not been appointed because of his political views; whereupon Peate told him that he would never *apply* for a post in the National Museum again, and left, he claimed, relieved. A freshly graduated young man named Grimes was appointed, later becoming well known as Professor W. F. 'Peter' Grimes, Wheeler's successor as Keeper of the London Museum and Director of London University's Institute of Archaeology; he and Peate were to share a room amicably until Grimes's departure in 1938. By now Fleure had been appointed to the Museum Council, and D. Lleufer Thomas was also a member, so Peate had more

friends in high places. Nevertheless, he was much surprised to receive in December 1926 a letter from Fox *inviting* him to become the third and most junior member of the department, and he started on his duties in April 1927.[34] His honour was presumably satisfied by not having had to apply for the position, and clearly he had been found appointable at the earlier interview. In addition to the academic background to which Fleure could testify, Peate brought with him a maturity, a self-confidence and a world-view helped by his period in the cut-and-thrust of extramural teaching, as well as an intimate knowledge of the people whom he was to see as those he ultimately served. Amongst his more general archaeological duties was the specific task of curating the 'bygones' collections, which encompassed developing, exhibiting and interpreting it through research, publication and lecturing.

Wales at the time of these events in the Museum was in dire straits. Peate's move south was replicated many thousands of times over as people fled the countryside, leaving an ageing and ailing population often living in substandard houses where tuberculosis was rife and local authorities little concerned. The year 1926 had represented a nadir for the industrial areas too, with the great lockout of men from the pits merely a memorable marker in the downward spiral of unemployment and mass migration, and where the closure of 241 mines between 1921 and 1936 halved the number of working miners. The numbers able to speak Welsh plummeted, with Cardiff now an overwhelmingly English-speaking city, a fact which struck Peate forcefully. Conversely, improved transport and facilities such as cinemas enabled more leisure activities, and 100,000 trippers visited Barry Island on August Bank Holiday Monday 1927.[35]

After the flurry of activity associated with its foundation and the beginning of building work, the Museum had been inevitably affected by the Great War and then the Depression of the 1920s and 1930s, which greatly slowed all developments. The western section of the Entrance Hall and the galleries leading from it were opened to the public in 1922 and expanded to include the whole of the Hall by 1925: 193,960 visits were recorded in 1926–7. Work did not begin on the East Wing until 1930 and it was only an extraordinarily generous gift by Sir William Reardon Smith that made its completion possible in 1932. The institution that Peate joined was thus very much in its infancy, with only a dozen qualified curatorial staff and fewer support and front-of-house staff. The fact that the curatorial staff were all English, or at least not Welsh-speaking, unquestionably

influenced the new institution in a way that was at variance with the aspirations of its founders to create a uniquely Welsh national institution. He started during the hive of activity in preparation for the formal opening of the building by King George V in April 1927, with nobody with time to spare for him. He was taken aback to realise how un-Welsh and in many ways anti-Welsh language the institution was. The senior attendants were ex-military and the Secretary Archie Lee (now Captain Archibald Lee, MC, after a good war) set the tone. Efficient and capable, he proved indispensable to four successive Directors; but he had a sharp tongue and a habit of basing his advice on information gleaned from junior members of staff.[36] Fox himself made no attempt to pronounce Welsh place names properly. The only Welsh speaker on the staff was the Librarian, Miss Breese. Peate started pressing for the appointment of attendants who could answer Welsh-speaking visitors 'to my galleries' in Welsh. By the 1940s, he was able to note that, due to the efforts he made during his three or four first years, the majority of the uniformed attendants were Welsh speakers. However, the only bilingual typist in the whole institution remained Miss Price in Folk Culture, and the only Assistant Keeper Ffransis Payne. He was the only Welsh-speaking department head.[37]

Until his interview of the previous year, Peate had never seen the National Museum or its collections. However, T. Gwynn Jones had emphasised to him just before he left Aberystwyth the need for someone to write the history of Welsh folk culture, and in his opinion the person to carry out the necessary years of research was Peate. Jones had clearly seen in Peate one who could bring about the wish he had expressed in 1892 that 'we are awaiting that history of the character of the Welsh nation – the history of its spirit and heart'.[38] That conversation reinforced what Peate's Norwegian friend Alf Sommerfelt had been telling him about the national folk museum at Bygdoy and the other Scandinavian museums, and the influence they had on contemporary life in those countries. When he then saw at Cardiff the displays of rural material (presented in the cases acquired second-hand from the Victoria and Albert Museum and with their woodwork still painted black in mourning for Prince Albert), he recalled thinking that these were not old-fashioned relics but rather the material culture of Wales and indeed the core of a Welsh folk museum – for the wooden candle-holders displayed here were not just of the eighteenth and nineteenth centuries, as described by the labels, for did not his mother still make and use rush candles? Not for him any longer the life of

an archaeologist, although his duties still encompassed such activity for some years, and he helped with the continuing excavations at Caerleon and collected Bronze Age urns in west Wales.[39]

He was able to make an early corporate contribution as well as starting the institution on the long road to bilingualism by offering to translate the Museum's *Short Guide* into Welsh.[40] Professor W. J. Gruffydd believed the work was more important than many substantial works which appeared in Welsh, for it broke new ground at a time when the Welsh language needed to expand into technical literature. Gruffydd ended his brief review by quoting some of Peate's new translations, such as *adfachog* ('barbed'), *amryfaen* ('conglomerate'), *deiliant* ('foliage') and *porslen* ('porcelain').[41] Peate also offered Welsh forms for accepted English terms such as archaeology, anthropology, botany, fauna and zoology. He took as his guiding principle that he would attempt to start in all cases from classical roots.[42] He also wished to expand the Museum's field of study – a bold and strategic leap by a very junior member of staff – for in addition to his earlier anthropomorphic studies, Peate as we saw had also studied his regional dialect and its distribution. That experience was to translate into Peate's realisation that the National Museum should be involved in recording dialects. His first suggestion of this is in an undated draft memorandum for the Director's attention, prompted by a comment made by Fleure:

> Ever since I began to work out dialect distributions in 1922 I have felt that linguistic data can be of the highest value to the student of early history and for that reason I have held on to the secretaryship of the Dialects Section of the Guild of Graduates [of the University of Wales] in the hope that at some future time something can be done ... Sommerfelt suggested to me some years ago that the work of collecting the linguistic material should be, for the sake of uniformity of treatment alone, the work of one man if possible ... But, unfortunately, as you state, it can't be done in our present financial circumstances. And, unfortunately, much of the linguistic material (more so than the objects themselves) will disappear in the next few years.[43]

Here Peate the visionary, though still approaching the subject from an archaeological viewpoint, is tempered by Peate the realist; but he was putting down a marker for an approach that was to bear much fruit later.

The Museum that Peate joined had been titled formally 'Amgueddfa Genedlaethol Cymru: National Museum of Wales' at the very first meeting of the Council in March 1908, and both words were featured on the institution's Common Seal, on the imposing front doors, and prominently on the walls of the Court Room. That did not stop Peate never being very happy with '*amgueddfa*' as the Welsh term for 'museum'. It had first been proposed by William Owen Pughe in 1793 and never superseded, but Peate chose to gloss its meaning rather than suggest a new term. Most European languages used a word (such as 'museum' itself) derived from the Greek *mouseion*, namely the seat or home of the Muses. A name of this derivation enabled a wide role for an institution, whereas *amgueddfa* was derived from *amgudd*, which meant 'treasure' – so *amgueddfa* meant 'treasure-house', a restrictive term which did not reveal the whole range of functions that a museum should carry out. Naturally it would collect objects, natural and manufactured, and make them meaningful to an audience; but it should also be a research institution, staffed by experts who published their findings. They should use the objects as other scholars used manuscripts to build new syntheses of historical or scientific knowledge, and that knowledge should be conveyed to visitors and the wider public by all means and media. That meant a museum was fundamentally an educational institution, duty-bound through the sponsorship of music, drama and film events at the museum but also outreach work (he had, after all, been an extramural lecturer himself) to inform and interpret, and play a leading role in supporting local institutions. Indeed, the task of museums in Wales was not only to preserve relics of the old, but to build a new Wales.[44]

'Welsh Bygones'

By 1929, when he had progressed to Qualified Assistant Keeper, Peate's task of cataloguing the Bygones collection had reached the stage where it was ready for publication. The resulting *Guide to the Collection of Welsh Bygones. A Descriptive Account of Old-fashioned Life in Wales* followed the formula that the National Museum had already used and continued to do so for years afterwards, namely an overview of the subject prefacing a catalogue. Peate later professed himself unhappy with the title that Fox had chosen and called the *Guide* 'that book mistitled *Welsh Bygones*'.[45] One of the reasons why Peate was unhappy with the term was that it

emphasised the subsidiary role that archaeologists accorded to the material so classified. Fox regarded some of the items in the collection as 'trivial and without intrinsic value'; 'bygones' were tolerated only because they offered clues to what excavated objects might have been used for, and indeed a visit to the Bygones Gallery was quoted by the Cambridge prehistorian Grahame Clark as being helpful, along with the 'all too rare folk-museums, like those at York and Cambridge'.[46] In many ways, archaeology in the 1920s was still in its infancy as a science, with now long-standard tools such as stratigraphy and aerial photography little understood, and archaeologists depended disproportionately on more recent ethnographic material and observations to make sense of their discoveries, particularly in prehistory. The *Guide*'s overview referenced material stored in the basement until appropriate galleries were provided in the planned east wing, as well as the 1,294 objects on display and catalogued. Fox felt that the most important objects were those which bore a date, for 'they provide a valuable foundation on which to build up a systematic chronology for Welsh Bygones'.[47] Some of the material in the first part was taken from Ward's 'excellent' handbook, but most was the work of Peate, and he is credited as the only author. Fox wrote an Introduction as well as the Preface, in which he noted that the purpose of the collection of Welsh Bygones was 'to illustrate the life and work of the people of Wales before the centralized industrial developments of the nineteenth century', though it also encompassed rural industry. The collection had two uses – to excite the interest of visitors through exposure to items with which they were relatively familiar and so lead them to appreciate better objects illustrating the early history and prehistory of Wales,[48] and secondly 'to encourage the maintenance, and where necessary the revival, of native and country crafts . . . and to teach that beauty springs . . . from fitness of purpose, soundness in construction and simplicity and adequacy of form'.[49] Now was a turning point in history, the end of the age when societies were based on the soil and on local production, which in Wales gave rise to the 'peasant artisan' who was able to fall back to working the land when demand for his product was low.[50] Fortunately, some vestiges of the old order still survived in places, and it was to be hoped that growing appreciation of native crafts might yet help to maintain them.[51]

Peate's contextualising text, 'Old Fashioned Life in Wales' was a long (seventy-nine pages) and comprehensive overview of the field. After T. Gwynn Jones's pamphlet *The Culture and Traditions of Wales* it was

only the second study of any aspect of Welsh folk life (to use the term that Peate subsequently adopted), and the first to do so based largely on the surviving material evidence.[52] Appropriately, Peate started by looking at the rural community which he believed to be the basis of Welsh life, but in a foretaste of both his fundamental belief and his over-riding academic interest, he laid heavy emphasis on the role that the craftsman had played in Wales ever since the Welsh Laws and the court poets of the Middle Ages. Consequently,

> one is led to believe that it is something more than an accident of history or of local conditions that rural wisdom should have manifested itself in the village smithy or the carpenter's shop and at the shoemaker's bench. Anyone who knows the real Wales well can estimate the importance of these craftsmen in the life of their communities, and with the decline in the demand for their services comes the disintegration of small societies of folk which are of real value in a civilized state ... It is, therefore, natural to find that Welsh social life had the village as the centre of a self-sufficient community where work and leisure, individual enterprise and mutual co-operation were combined to produce a rural polity where poverty was never extreme nor wealth out of all proportion to the needs of those who enjoyed it.[53]

This highly romanticised and amazingly inaccurate view ignored completely the historical and geographical fact that villages did not exist in Wales, other than in Pembrokeshire and Glamorgan, until the mid-nineteenth century, and it was only the coming of the railways and the chapel-building craze that resulted in a scattered population becoming more concentrated; and another author with whose work he was well acquainted, Hugh Evans, had been publishing in *Y Brython* ('The Briton') ever since 1923 parts of what would be his masterpiece about the poverty and hardship of rural life in nineteenth-century Wales, *Cwm Eithin* ('The Gorse Glen'). But to Peate social interdependence and economic cooperation manifested themselves in all ways, 'a natural result of the organization of life upon a basis which presumes the brotherhood of man and the family as the unit of life'.[54] Nevertheless, he had to concede that 'the old order is changing, and it is only in the realms of literature and song that one finds the native life adequately represented today'.[55]

The overview then proceeded in a mostly logical sequence, from the home, the kitchen and the bedroom (these two reflecting the room displays), the buttery, laundry appliances, lighting, the farm, trapping and fishing, industries, social and commercial life, folklore and customs, transport and corporate life. There were two classes of old houses, those of the gentry which were English in style and the humbler native dwellings, which

> free from architectural devices or detail . . . achieve a memorable effect by a fine simplicity, becoming part and parcel of the lovely landscape in which they are set . . . we may be permitted to plead that every effort be made by those owning or occupying characteristic examples of the Welsh builders' art to preserve them unimpaired for future generations.[56]

Peate's text then interwove descriptions and analyses of material objects with the historical and documentary background against which they were used, showing a familiarity with the whole field. His comments about furniture reveal his acceptance of social diffusion:

> In the eighteenth and nineteenth centuries there were added to the equipment [that is, furniture] the dresser and the settle. The familiar dresser, the pride of the housewife who displayed on its shelf her 'garnish' of pewter or delft, was to be found in all the farmhouses. It came to stay, and is still seen, translated into grained deal, in the kitchen of the modern villa and in the workman's cottage . . . So highly decorated are these pieces, as a rule, that we may infer their transfer to the farmhouses when discarded by the local squires as hopelessly at variance with the new fashions which came in under Anne and the Georges.[57]

The buttery occupied an important position in the home, for 'even the *tyddynnwr* (that excellent type of small farmer that was partially wiped out as a result of the Enclosure Acts) had one cow'.[58] Generally, however, agriculture had always been of less vital importance in Wales than in England, for its uplands were better suited to pasturage than tillage, whilst the remoteness of some areas meant the survival of old methods and implements.[59] The importance of sheep-rearing was reflected in rural

industries such as spinning and weaving, well represented in the equipment from the Llanrhystyd factory in the reserve collections,[60] whilst another important collection reflected the wood-turning industry.[61] 'No guide to bygone Wales would be complete without an account of some, at least, of the customs of the people, and of some important aspects of Welsh social life', such as the Eisteddfod, which unlike the Gorsedd, had a long history.[62] The *Mari Lwyd* or *Ladi Wen* was one of the most popular mediaeval survivals in south Wales: it appeared to be a relic of the Festival of the Ass which commemorated the Flight from Egypt, with such festivals being adaptations of primitive ceremonial.[63]

Whilst Peate later chose to remember that 'I received the strong support of Cyril Fox in the task of cataloguing the collection', it would be more accurate to note that he was appointed to undertake this task and instructed to do so; but he admitted it was the best kind of discipline:

> Every item passed through my hands, to be measured, to be described in detail, dated, ensuring its location and the name of the donor. In all this, one had to be ordered, consistent in the describing, logical, and consult any correspondence that related to the item in question so that the final record and the information on the label was accurate.[64]

In other words, he did exactly what every other curator in any museum anywhere did. But whilst museum cataloguing principles had been already established, Peate, following Ward, had to apply them to material previously not regarded as worthy of such attention. But he did one thing that was unique – he wrote all his exhibition labels in Welsh as well as in English, surely the first time that any professional curator in Britain had done such a task bilingually,[65] though he was not the first to use bilingual labels in Wales: R. Alun Roberts of the Department of Agricultural Botany at Bangor had created a 'Museum of Agricultural By-gones' in the School of Agriculture there in 1926 with such labels.[66] The *Guide* drew special attention to dated objects; the dates proposed for the remaining material depended on a combination of form, technique, condition and ornament, with varying degrees of probable accuracy. Some groups of objects, such as love-spoons, rush-light holders and candle-holders, lent themselves to typological analysis: 'the probable evolution of such is now being worked out in the Museum and will be the subject of separate studies'.[67] It proved

to be seminal and not just for Wales. It was a landmark for the study of such material, the first time that proper museological principles had been devoted to the everyday material of recent (and in some cases, even contemporary) life. Although based on objects, the volume drew attention to intangible aspects such as oral traditions, customs and folklore: not only, as Gaynor Kavanagh has put it, was he effectively 'drafting an agenda for folk life studies in Wales',[68] he was doing so for a whole new subject area.

In 1931 room became available for the temporary Bygones Gallery to be relocated, and as Peate recalled 'The first truly national exhibition of Welsh folk life was set up in the galleries on the first floor of the east wing . . . by Mr. Carter [see below] and myself'; he clearly did not wish to accord primacy to Fox's efforts of 1925-6, even though they were illustrated in the *Guide*, or even to Fox's involvement with these galleries.[69] The reconstructed period rooms were relocated and upgraded, to be recalled with much affection with visitors for years after their demise and to become an inspiration for one of Peate's most-quoted poems.[70] The new rooms were designed by the Museum's architects, Smith and Dunbar, and it was Fox who discussed the minutest details with them. Two reserve storerooms were available, both measuring some 40 ft by 20 ft (12 m by 6 m), linked by a doorway. A kitchen and buttery were created in one room and a bedroom and parlour in the other, designed to represent a Welsh farmhouse of the eighteenth and nineteenth centuries and based on recorded examples. Original fittings and fixtures were sourced through the good offices of committee members. Stone floor slabs, floorboards and ceiling beams were obtained from Danyrallt farm, to be demolished in advance of the construction of the Taf Fechan reservoirs that fed Cardiff, with more boards coming from the old Cefn Mabli house, then in use as a hospital.[71] The walls of the rooms were finished to give the appearance of rough stone walling, involving much use of crumpled packing paper and glue by the museum taxidermist, and visitors viewed them over low sill walls. Peate's involvement seems to have been limited to research and furnishing. The new 'Welsh Kitchen' was an improvement on its predecessor, if only because it was larger, showing a circular staircase next to the fireplace; but it still contained an unlikely assortment of contents, with a table flanked by jointed chairs of the seventeenth or early eighteenth century, an early nineteenth-century dresser, and a Victorian corner cupboard and Staffordshire ornaments. Peate pointed out that 'period' rooms – by which he meant rooms containing items of a single historical

period – had never actually existed in the homes of country folk, so that any room at any one time might have included items that were several hundred years old.[72] He must have been happy that the fireplace was created by the Llanbryn-Mair blacksmith and that a pair of milk-pans from the village were shown in the buttery. An illusion of reality was achieved by placing a pair of spectacles on an open Bible, dried herbs hung from a beam, and a drip of wax on a candle.[73] The workload of preparing the remainder of the gallery was enormous. Items had to be chosen and labels written, and all put in place by just Peate and a young lad, F. R. (Bob) Carter, who had joined the Museum as an apprentice technician straight from school in 1928 aged fifteen. They frequently had to work until the early hours.[74] The Museum's East Wing (including these rooms) and the Reardon Smith Lecture Theatre were opened formally by Prince George on 25 October 1932, when Sir William Reardon Smith's Presidency came to an end. With Fox, Peate showed items from the folk collections to the Prince. An exhibition of ship models was held in the Circular Gallery above the lecture theatre in 1933, and after it Sir William arranged for himself and some of his fellow shipowners to donate a considerable number of ship models to the Museum, for which Peate was to be responsible.[75] By 1934 two further period rooms – a parlour and a dairy – were added, as well as a turner's workshop and blacksmith's shop.

An impression of the impact the new galleries presumably had on the BBC producer and author T. Rowland Hughes was reflected in his novel *William Jones*, when the eponymous hero, a north Wales quarryman who ventured to the south Wales valleys in search of work during the Depression, visited the National Museum:

> They turned to see the rooms of the Welsh farmhouse – a kitchen, a dairy, a parlour, and a bedroom. 'Who would think it, eh, Crad?' 'Think what?' 'That it would be possible to create a picture like this of a farmhouse kitchen. Who placed these things together here, do you think?' 'I don't know, boy. But he's quite a boy, whoever he is.' 'You get a strange feeling when you stand here, don't you', William Jones remarked . . . 'It's hard to explain it. You are standing outside a kitchen looking at the tables and the dresser and the corner cupboard and the spinning-wheel and the old clock, and yet you feel as if you are inside and part of the kitchen somehow. As if you are outside but inside at the same time.'[76]

Peate must surely have been rather gratified when he read this. He had found his mission quite early, and carved out a niche in which he believed he could make a contribution to a unique and important area. But he found the routine work in the still lightly staffed Department of Archaeology irksome and a diversion from what he wanted to do. Following a conversation about matters with the Keeper and Director, he wrote to the latter in February 1933 seeking clarification on aspects of his duties. The opening of the Folk Gallery in 1932 and that of the Folk Industries Gallery in the near future would take up all his time, quite apart from the imminent need for guidebooks to both. Additionally, it was necessary to overhaul all the folk material in the reserve collections and store it in an orderly sequence, whilst compiling at the same time a comprehensive card catalogue, since the existing catalogue only included material accessioned after 1910. He proposed to do all this himself (he really had no choice: there was nobody else) and 'it will occupy all my time for many months to come', leaving no time for collecting trips. But finally, he came to the nub of the matter: it was he who was responsible for dealing with the accessions register for the whole department, not just his own collection area, and how could he possibly still be responsible for registering prehistoric, Roman and mediaeval objects too? Surely folk material should have a separate register (for which he would be responsible), for the Department of Geology had registered fossils separately from rocks and minerals since 1914.[77] Letters of thanks were sent out from 1932 onwards, no doubt at Peate's instigation, with the accession cards for specimens acquired from individuals who should be thanked in Welsh being catalogued bilingually.[78] But he must have been gratified when a Welsh-speaking secretary, Miss Eileen Price, was added to the complement in 1934.

The creation of a department

Because the collection had expanded so substantially and with a higher profile, Fox put a proposal to create a sub-department of Folk Culture and Industries within the Department of Archaeology to the Art and Archaeology Committee in January 1933. The sub-department would be under an Assistant Keeper (Peate), who would have charge of the Welsh National Folk Collections and who would also be in charge of the material illustrating Welsh folk industries, which he was expected to develop in

conjunction with the Folk Collections. The Assistant Keeper would see no change in salary or seniority and the Department of Archaeology would not be allowed to use this change in arrangements as an excuse to claim more staff or increased grant.[79] In this position, Peate was sometimes copied into matters which were otherwise confidential to Keepers, such as the conclusions of Fox's review of the 'Inner Working of Departments' in 1934, which sought to suggest uniform administrative methods and ways in which efficiency might be improved as well as draw attention to good practice. The Keepers were already widely known in Wales, but more junior staff should have the opportunity of raising their profile and improving their expertise also; they too should 'have opportunity to gain reputation – if they have it in them.'[80] Here Fox was trying both to improve efficiency amongst his small staff and develop their capabilities – an early example? In 1935 he asked Peate to represent the Museum at the opening of the German National Museum of Folk Culture in the Tiergarten in Berlin and to give a paper at an associated meeting: no other British museum had been invited, as it turned out. The museum was housed in a baroque-style schloss built in 1785 and had no external displays, but Peate praised what he saw highly.[81] In later years he was to recall little other than peasant costumes and several dozen variations of the swastika that were displayed in every room, and chose to regard the whole visit a total waste of time.[82]

Peate was constantly thinking of improvements that could be made. In 1936 he suggested that overcrowding of exhibits in the Folk Gallery might be alleviated by moving the ship models then displayed there to the more logical Industries Gallery, whilst hoping that the collection could one day be augmented by models of the coastal vessels which had played so crucial a role in the economy of Wales's western seaboard. He had to admit defeat when he tried to acquire examples of shipwrights' tools from north Wales in 1929, but was to be delighted in 1943 when he learnt of the existence of a model of the barque *Mary Evans*, the largest ship built on the Dyfi.[83] His plan of the Industries Gallery shows that more than half of it was devoted to the woollen industry, but it also contained recreations of a smithy and a turner's workshop, and exhibits illustrating cider-making and sawing. But this reorganisation was not to be: 'Various circumstances combine to postpone consideration of this', wrote Fox on the note some months later.[84] Donations of industrial material continued to be received, including in 1935 an object so large and iconic that it was

installed outside the Museum. This was the nineteenth-century water-balance pit-head winding gear from Brynpwllog Pit, Rhymney, presented by the Marquess of Bute – the first large item of plant connected with the coal industry to be conserved in Wales.[85] Room was also sometimes found for temporary exhibitions, such as a display of Welsh Bibles from Monmouthshire churches 'set up not for its bibliographic interest, but as illustrating a fact of historical importance, namely the extent to which the Welsh language was formerly in use in Monmouthshire': such a text on an introductory label implies that much more was expected of the museum visitor of the 1930s than would be the case later, but also illustrates well Peate's commitment to ensuring that the visitor learnt of things that he considered important, as well as being an early example of using objects to tell a story rather than exhibiting them for their own sake as curiosities.[86] In addition, the sub-department and the new full department contributed to the special weekly exhibition presented in the main hall, with the text and an illustration of the chosen object published every Monday morning in the *Western Mail*. Peate was also able to influence the choice of speakers to the series of lectures that the Museum was now holding on its work in the Reardon Smith Lecture Theatre, like the Director of Den Gamle By folk museum in Aarhus, Denmark; Principal Leslie Evans to talk on 'the personality of Wales'; T. Gwynn Jones; Professor Thomas Jones to discuss folk tales; and several others, including Séamus Ó Duilearga from Dublin.[87]

One who supported Peate throughout his own involvement with the National Museum was Sir Leonard Twiston Davies (1894–1953), who was appointed High Sheriff for Monmouthshire in 1933, the same year as he published *Men of Monmouthshire*; two years later and jointly with Averil Edwards he followed with *Women of Wales*. He chaired the Council for Social Service for Wales and was Treasurer of the National Library and then its Vice-President. He represented the Library and Museum on the Standing Commission for Museums and Galleries. He was knighted in 1939, the same year that he published *Welsh Life in the Eighteenth Century*; together with Herbert Lloyd-Johnes he also wrote *Welsh Furniture: An Introduction* (1950). Peate regarded him as

> the chief mover in urging the creation of the Department of Folk Culture and Industries. His gift of £500, which formed the Twiston Davies Folk Culture Fund, made possible the formation of the

Sub-Department ... His gifts to the Folk Collections, over a long period of years, have been very numerous.[88]

Within less than two years after the formation of the Sub-Department Peate proposed that it should become a full, sixth, Department of the National Museum. Bypassing his Departmental Keeper, Nash-Williams (who had no interest in this aspect of his department's work), he wrote to the Director in October 1934:

> I have been 'thinking aloud' over the problem raised by Capt. Twiston Davies's gift and the possible formation of a Department of Folk Culture and Industries ... While the work of the present five departments ... is concerned largely with material ... much if not most of which is in no danger of rapid disappearance ... the evidence of Welsh Folk Culture is disappearing rapidly and its preservation for Museum purposes must be accomplished at once. Every year's delay makes the task more difficult ... I feel convinced that the National Museum of Wales's final claim to pre-eminence as a great Museum will rest ultimately upon the completeness of its experience of Welsh Folk Culture and Industries. Art etc can be done equal [sic] or better elsewhere, Welsh Folk Culture and Industries only the National Museum of Wales [can do]. The Museum's duty is clear: it must give a lead – as it has given in the past in several directions – to the whole of Britain in this matter.

This was ambitious thinking, for he had no time for any extramural work as things stood, and on his present salary could not afford a car. The fieldwork that should be done included the systematic collection of all local types of material, in line with the specification of the Charter ('the complete illustration of ...') and field study. Council was happy to accept his prescription, and agreed to use Twiston Davies's gift for the systematic collection of local types of domestic objects, early agricultural implements and objects illustrating Welsh crafts and industries; for studying early house-types, village and farm layouts, rural crafts and early industrial methods; a survey of material illustrating the life of the landed gentry in Wales in the seventeenth and eighteenth centuries; and 'propaganda: the education of the Welsh public for the preservation of

the material evidence of Welsh culture, crafts and early industries'. It also agreed that the sub-department should be raised to full departmental status 'as soon as the financial situation permits'.[89] This became possible in 1936, with the Treasury responding to representations and increasing the annual grant-in-aid from £17,000 to £18,500; the Council was accordingly able to advance the sub-department to a full Department of Folk Life and Industries. The brief of the new department was spelled out in the *Annual Report*:

> The field to be covered by the new Department is the national ethnography and cultural history of Wales from the Act of Union (1536) [when Wales was joined legally to England] to the present day, with the proviso that modern industrial civilization will not be included save to a limited degree (e.g., the collection of ship models). The Department will concern itself with the trades and crafts, the ways of living and working, the domestic and industrial environment, the clothes and the customs, of our forbears of all social grades – in so far as life and work can be illustrated within the four walls of a Museum. The aim is to provide the people of Wales with a source hitherto untapped of national self-knowledge. 'Hitherto untapped' is, of course, hardly correct; the new Department has a ten-years tradition behind it, and a collection already large and important, well-known throughout Wales. But the change of status permits and encourages development in all directions far beyond the scope hitherto possible.[90]

Peate also finally got the support he so badly needed, with an Assistant Keeper added to the establishment. Ffransis George Payne (1900–92) had put forward an exemplary application, emphasising how his varied experience qualified him for the post. Born just across the border in Knighton, he was now thirty-five years old (a year older than Peate), and had worked on upland sheep farms and lowland arable ones alike. He had worked at the Ebbw Vale ironworks, been a wireless operator in the RAF, and later spent five years working for an industrial wagon-repairer; and he had been an itinerant bookseller, an Assistant at Carmarthen Museum and finally a cataloguer and Welsh-language specialist at the Library of University College Swansea. He was also currently engaged in preparing a thesis on the Welsh-language poets of the area

between the Wye and Severn. The application was supported by glowing references from Professors W. J. Gruffydd of Cardiff and Henry Lewis of Swansea.[91] According to Peate, he and Fox met to draw up a shortlist from a very strong field. Fox cast aside Payne's application as he had no university degree, but Peate pointed out that Fox himself would not have been appointed at the same age as he too then had no degree – and the application was put back in the pile.[92]

In 1936 an arrangement was made whereby for fees paid to the Museum, Peate acted as Lecturer in Folk Culture at Aberystwyth and Swansea, with a similar appointment made at Bangor in 1937–8.[93] He had been no slouch when it came to his lecturing and representational responsibilities before, either, particularly to the local Cardiff Naturalists Society (as reported in their *Transactions*). He talked several times to their Junior Section, on 'Races and dialects in central Wales' in 1928, on 'Potters and weavers' in 1931, and on 'Home Life in the Welsh Moorlands' in 1933 – as exotic a topic to his young audience as no doubt talking about the inhabitants of Amazonia would have been. In January 1939 he lectured to the Society's Archaeological Section on 'Archaeology and Folk Culture', and he and Payne performed a double act in April of the same year, with a show-and-tell session involving samplers and embroideries, turned-wood chairs, decorated wall plaster from Cardiganshire (later illustrated in *The Welsh House*) and – no doubt a great favourite – 'Part of a Gibbet with Skull' (which he also published). More strategically, Peate had a view on how to publish material germane to the folk collections. He had in 1935 compiled a follow-up to the *Guide to Welsh Bygones* in the form of a *Guide to the Collection Illustrating Welsh Folk Crafts and Industries*, but a proposed complementary volume, a Guide to the Folk Culture Collections which would have described and explained the objects exhibited in the new gallery, did not materialise. In 1940, following the selling-out of *Welsh Bygones*, he sent a detailed note to Fox. He proposed a comprehensive series of publications, including four which were already in print, namely (1) *Guide to Welsh Crafts and Industries* (2) *Samplers and Embroideries*[94] (3) *Welsh Society and Eisteddfod Relics* (4) *A Small Town House of the Georgian Period in Wales*. In addition, he envisaged titles on (5) house fittings, furniture and utensils; (6) costume and dress; (7) folklore; (8) musical instruments; (9) banking; and (10) agricultural implements and practice, probably at least two publications. He recognised that the scheme would have to be spread over several years. Fox responded that

he was prepared to consider sympathetically any proposal for publication, provided that 'it covers a rational and reasonable unit of the collection', and that it would include a complete catalogue of items within that category – but very sensibly avoided answering the thrust of Peate's request that the Museum sign up to a comprehensive scheme of publication for his department's collections but not those of the other departments.[95]

In addition to its Department of Folk Life and Industries, another of the aspects that made the National Museum unique amongst the national museums of Britain was its links with local museums and societies. In his application for the Directorship in 1924, Mortimer Wheeler had noted that 'It is essential that even in the remotest parts of the Principality the existence of the National Museum should be known and its influence felt', and he himself as Keeper and then Director spent much time traversing the country and raising awareness.[96] Arising out of demand from archaeological societies to find adequate repositories for their finds, he proposed a scheme of affiliation for 'the mutual benefit of local museums and the National Museum' in 1922. Thirteen local museums joined immediately, and in return for agreeing to care properly for their collections and lend agreed specimens for temporary exhibition in Cardiff, the National Museum would provide identification and conservation services and lend material for exhibition in return.[97] Often, however, local expectations were too great to be fulfilled: according to Fox, Wrexham's curator expected the National Museum to fill his galleries for him, and on seeing the state of Powysland Museum in Welshpool reflected that it was unfair for local museums to be managed without a permanent curator.[98] Peate played a similar part in preaching the gospel of his subject and the role that all museums, local as well as national, should play. He addressed the Carmarthenshire Antiquarian Association in 1941, and was pleased that his talk became the first to be published in Welsh since the Society's foundation in 1905. After quoting Evans Hoyle's aspirations for the National Museum, and praising the Society's past work, he noted that there was still much for it and other such societies to do. Inter alia, he noted how much he hated the term 'bygones'. Bronze Age vessels were bygones, as were pre-Norman stone crosses and other items; but none were termed 'bygones'. The term was reserved for the everyday objects of rural life, which were very often not only still in use, but essential. He proposed a number of ways for members to contribute, such as following Lleufer Thomas's lead in recording old farmhouses, but also cottages

and farmstead layouts; and they should not worry about typology – what was required was a record. The county clearly had distinct styles of furniture which deserved collection and preservation, and he offered his own services to mentor anyone with an interest in helping with this kind of activity, since that was part of the role of a national institution.[99] The title of his talk, 'Pregeth ar Hen Destun' ('A sermon on an old topic'), suggests that he was treading on what to him was familiar ground. Incidentally, it was not Peate alone who killed off the term 'bygones'. The inter-war years saw a change in vocabulary in British anthropology and archaeology, from using the word 'technology' to favouring 'material culture'. The change facilitated the emerging modern British social anthropology, where studying objects was giving way to studying people and societies. This resulted in separating – or sidelining – ethnographic collections in museums and universities and viewing them as a legacy of earlier times, and at the same time validating the collections to curators as more than simply assemblages of objects.[100]

In 1944, again, when as he noted it was difficult for the understaffed National Museum to fulfil all its obligations, he expanded on the theme to the Powysland Club, the historical society of his home county. He started by defining the role of museums, concluding that

> A great museum ... must have at least a fourfold function: (a) to display material so that it is intelligible, instructive and inspiring; (b) to carry out research in every subject with which it deals so as to enrich scholarship in all those directions; (c) to encourage aesthetic appreciation and understanding and (d) to educate the greatest number possible of the public which it serves.[101]

He proposed to address this last point in particular. The National Museum was a museum *for* Wales, for the education of Welsh people, and it would have to do more in the extramural field after the war; but it was also a museum *of* Wales, with a duty to teach the world about Wales. The principal direction in which the Museum could be the final world authority ('if I may use a high-falutin phrase') was that of Welsh culture, and one of the ways that the Museum had identified as necessary for undertaking that task was through the creation of an open-air museum, where buildings such as the derelict Abernodwydd farmhouse might be re-erected and exhibited to the public. The Powysland Museum was a

county museum, and one of the National Museum's recommendations to the Welsh Reconstruction Advisory Council was that there needed to be provision for two peripatetic curators who would help such small museums. This did not happen, but the National Museum co-produced touring exhibitions with the Council for Museums in Wales within the lifetime of that body (1965–2007), with the Folk Museum contributing heavily to the programme. Peate then presented a primer for what local museums should do in his field of interest – in effect, he diagnosed the illness and then offered a prescription. 'County museums', he noted, 'should represent the life of the county itself. Museum collections, like charity, should begin at home. Local loyalty – a sin said to beset every Welshman – is a virtue in the museum world.'[102] It was not enough to collect haphazardly, for a local collection should reflect local life scientifically. Items of furniture, for example, should be representative of what was made or used locally, and 'pedigree pieces', ones with a known history or even maker, should be actively sought. With only restricted space available, a collecting policy was essential. Photographs would do if there was no room to exhibit large items and in this way a series of exhibitions on themes such as agriculture, house-types and crafts and industries could be built up, and readily reproduced to tour schools and youth centres; and yes, youth should be taught about the Romans and the Normans, the Puritans and the Quakers, but let them also learn about the life of their local communities. The museum could also create a photographic record of such vanishing features. With a museum but no curator, the members of the Club could undertake many of these functions – and there was a desperate need for such work, particularly in the Welsh-speaking west of the county. Peate concluded by calling for the Powysland Club to engage in outreach work within the county boundary, just as the National Museum was doing nationally, for museums were just as necessary for true education as schools and libraries.

Notes
1. Prys Morgan, 'The creation of the National Library and the National Museum of Wales', in John Osmond (ed.), *Myths, Memories and Futures. The National Library and the National Museum in the Story of Wales* (Cardiff, 2007), p. 20.
2. Rebecca Brumbill, Jo Collins, Mari Gordon, Kay Kays and Phill Smith (eds), *Amgueddfa Cymru National Museum Wales. Celebrating the First 100 Years* (Cardiff, 2007), p. 4.

3. Douglas A. Bassett, 'The making of a national museum', *Trans. Hon. Soc. Cymmrodorion*, 1982, pp. 3-35; Part II, 1983, pp. 3-36; Part III, 1984, pp. 1-100; Part IV, 1992, pp. 193-260. The following paragraphs draw heavily on Bassett's work, though most of his material is collated from the Museum's published *Annual Reports*.
4. Bassett, 'The making of a national museum' (1982), p. 5.
5. Bassett, 'The making of a national museum' (1982), pp. 10-11.
6. Bassett, 'The making of a national museum' (1982), pp. 12-13.
7. Partly quoted in 'Folk Studies in Wales', *The Welsh Review*, iii (1944), 53, and in translation in 'Pregeth ar Hen Destun', *The Carmarthen Antiquary*, 1 (1941), 43-4.
8. For a detailed discussion of the building in its context, see John B. Hilling, *The History and Architecture of Cardiff City Centre: Black Gold, White City* (Cardiff, 2016).
9. For Wheeler, see Sir Mortimer Wheeler, *Still Digging. Interleaves from an Antiquary's Notebook* (London, 1955). Jacquetta Hawkes, *Mortimer Wheeler. Adventurer in Archaeology* (London, 1982), based her chapter on his time in Wales entirely on Wheeler's memoir.
10. *Annual Report 1913-14*, p. 17. Cardiff-born John (1860-1952) was a very well-known sculptor whose work included many commissions in Cardiff; he designed a set of ceremonial tools for the Museum's opening.
11. *Annual Report 1912-13*, p. 14.
12. *Guide to the Collection of Welsh Bygones. A Descriptive Account of Old-fashioned Life in Wales* (1929), p. ix.
13. *Guide to the Collection of Welsh Bygones*, p. viii.
14. *Annual Report 1912-13*, p. 16.
15. *Annual Report 1912-13*, p. 16.
16. Bassett, 'The making of a national museum' (1982), p. 33.
17. Bassett, 'The making of a national museum' (1982), p. 33.
18. *Annual Report 1915-16*, p. 15.
19. *Annual Report 1916-17*, p. 17.
20. *Annual Report 1917-18*, p. 11; Twm o'r Nant was a well-known writer of eighteenth-century folk dramas or 'interludes'.
21. *Annual Report 1926-7*, p. 23.
22. The selection committee's report is reproduced in Charles Scott-Fox, *Cyril Fox. Archaeologist Extraordinary* (Oxford, 2002), pp. 215-16.
23. Scott-Fox, *Cyril Fox*, pp. 124-5. For Fox, see E. M. Jope, 'Sir Cyril Fred Fox 1882-1967', *Dictionary of National Biography, 1961-70* (Oxford, 1981), pp. 383-5; Colin Thomas, 'Sir Cyril Fox 1882-1967', *Geographers: Biographical Studies*, 20 (2002), n.p.
24. Elwyn Davies, 'Herbert John Fleure, 1877-1969', *Y Gwyddonydd*, xiii, 3-4 (1975), 94-6; but to be fair to Fox, his book was designed for an archaeological audience. Alexandra Ward devotes a chapter to Fox and another to the interplay between Fox and Peate in her PhD thesis, 'Archaeology, Heritage

The National Museum of Wales

and Identity: the creation and development of a National Museum in Wales', Cardiff, 2008, orca.cardiff.ac.uk/id/eprint/54744/1/U585133.pdf (accessed 30 January 2021).

25. Peate was bitterly opposed to this concept, for example in his review of M. W. Barley, *The English Farmhouse and Cottage* (London, 1961), in *Antiquity*, xxxv (1961), 251.
26. Cyril Fox, Preface to *Guide to the Collection of Welsh Bygones*.
27. Cyril Fox, 'The National Museum of Wales', *Museums Journal*, 30 (1930–1), 131, a paper read at the Museums Association Conference of 1930.
28. *Guide to the Collection of Welsh Bygones*, pl. III.
29. National Museum of Wales, *The Museum and its Contents. A Short Guide*, 6th edn (Cardiff, 1931), pp. 67–9.
30. *Guide to the Collection of Welsh Bygones*, frontispiece.
31. Anonymous, but presumably Peate, 'Welsh Interiors in the National Museum of Wales', *Museums Journal*, 31 (1931–2), 532.
32. Douglas A. Bassett, *Folk-life studies in Wales: 1890s–1940s. A selective chronology of events . . . notes prepared to accompany a lecture on Iorwerth C. Peate and the Welsh Folk Museum* (Cardiff, 1966), p. 11.
33. For Eyre Evans, see the obituary in *The Carmarthen Antiquary*, 1 (1941), 5–10. Perhaps unknown to Peate, he was also an assiduous collector of bygones on behalf of the Carmarthen Museum.
34. *Rhwng Dau Fyd*, pp. 82–3; the emphasis is his.
35. For comprehensive treatments of this period, see John Davies, *A History of Wales* (London, 1993), and Kenneth O. Morgan, *Rebirth of a Nation: Wales 1880–1980* (Oxford and Cardiff, 1981).
36. Scott-Fox, *Cyril Fox*, pp. 96, 152.
37. NLW ICP Papers A 3/3, Staff, 'Welsh-speaking members of the National Museum of Wales staff', undated note.
38. Alan Llwyd, *Byd Gwynn. Cofiant T. Gwynn Jones 1871–1949* (Llandysul, 2019), p. 74.
39. *Rhwng Dau Fyd*, pp. 106–7.
40. *Yr Amgueddfa a'i Chynnwys: Hyfforddwr Byr* ['The Museum and its Contents: Brief Guide'] (Caerdydd, 1928).
41. *Y Llenor*, 7 (January 1928), 184–5.
42. *Rhwng Dau Fyd*, p. 174.
43. NLW ICP papers A 3/5(ii), n.d.
44. 'Gwerth Amgueddfa', *Lleufer*, 2/1 (April 1946), 14–16.
45. *Personau*, p. 56.
46. Grahame Clark, *Prehistoric England* (London, 1940), p. 41.
47. *Guide to the Collection of Welsh Bygones*, p. ix.
48. J. Gwyn Griffiths (1911–2004, another nationalist and pacifist poet, and later Professor of Classics and Egyptology at Swansea) noted that 'It is the connexion with the life around them that gives to museums and departments of "Folkliv" their freshness and their power of stimulating interest. Indeed, the subject has contributed much to the modern conception of a museum

as being not merely a collection of curiosities': 'The Study of "Folkliv": Its Name, Scope, and Method', *Man*, 45 (1945), 66.
49. *Guide to the Collection of Welsh Bygones*, p. xiv.
50. *Guide to the Collection of Welsh Bygones*, p. xiv, a point Peate had recently made in the Festschrift for Fleure which he had edited.
51. *Guide to the Collection of Welsh Bygones*, p. xvi.
52. T. Gwynn Jones, *The Culture and Tradition of Wales* (Wrexham, 1927).
53. *Guide to the Collection of Welsh Bygones*, pp. 1–2.
54. *Guide to the Collection of Welsh Bygones*, p. 2.
55. *Guide to the Collection of Welsh Bygones*, p. 4.
56. *Guide to the Collection of Welsh Bygones*, p. 5.
57. *Guide to the Collection of Welsh Bygones*, p. 20.
58. *Guide to the Collection of Welsh Bygones*, p. 27.
59. *Guide to the Collection of Welsh Bygones*, p. 36.
60. See Chapter 5, 'The vanishing country craftsman'.
61. 'Some Welsh Wood-turners and their Trade', in *Studies in Regional Consciousness and Environment. Essays presented to H. J. Fleure, D.Sc., F.S.A.* (Oxford, 1930), pp. 175–88.
62. *Guide to the Collection of Welsh Bygones*, p. 54.
63. *Guide to the Collection of Welsh Bygones*, p. 63.
64. *Rhwng Dau Fyd*, p. 107; my translation.
65. *Rhwng Dau Fyd*, pp. 107–8.
66. Melfyn R. Williams, *Doctor Alun. Bywyd a Gwaith Yr Athro R. Alun Roberts* ['Doctor Alun. The Life and Work of Professor R. Alun Roberts'] (Talybont, 1977), p. 45.
67. *Guide to the Collection of Welsh Bygones*, p. 81.
68. Gaynor Kavanagh, *History Curatorship* (Leicester and London, 1990), p. 23.
69. NLW ICP Papers A 2/9 (i), 'The Welsh Folk Museum' (1970), 18pp MS; and this myth spread so successfully that his successor Trefor Owen, who regarded him highly, believed that Peate had created the first period rooms at the National Museum: [Trefor M. Owen], *Iorwerth Cyfeiliog Peate M.A., D.Sc., D.Litt., D.Litt.Celt., F.S.A. Cyn-Guradur Amgueddfa Werin Cymru / Former Curator of the Welsh Folk Museum*, funeral address (1982).
70. 'Y Gegin Gynt yn yr Amgueddfa Genedlaethol' ['The Old Kitchen in the National Museum'], in *Y Cawg Aur a Cherddi Eraill* (1933), repr. in *Canu Chwarter Canrif* (Dinbych, 1957), p. 62.
71. SFNHM/Miscellaneous/ Pro Numbers etc./New Bygones Gallery, correspondence of 1930–1.
72. *Guide to the Collection of Welsh Bygones*, p. 7.
73. Anonymous, but presumably Peate, 'Welsh Interiors in the National Museum of Wales', 531–6. The report was commissioned by Bather as the journal's editor: 'This official account has been supplied at our special request'.
74. *Rhwng Dau Fyd*, p. 108.
75. David Jenkins, *From Ship's Cook to Baronet. Sir William Reardon Smith's Life in Shipping 1856–1935* (Cardiff, 2011), pp. 130–1.

76. T. Rowland Hughes, *William Jones* (Llandysul, 1944), pp. 154–6; my translation. Peate's 'Welsh Kitchen' was recreated in the National Museum's Main Hall in 1982 to mark the fiftieth anniversary of the creation of the Sub-Department of Folk Life: *Y Cymro*, 12 October 1982.
77. NLW ICP papers, 'Memorandum: Problems of Routine', 2 February 1933.
78. SFNHM/ Miscellaneous/Pro Numbers/Official Instructions/ICP to VE Nash-Williams, quoting the Secretary's instructions, this being more than a departmental issue.
79. NLW ICP Papers A 3/5 (i), Report from Director to Art and Archaeology Committee meeting of 18 January 1933.
80. SFNHM/Miscellaneous/Pro Numbers etc., 'Memorandum on the Inner Working of Departments', December 1934.
81. 'The German National Museum of Folk Culture, Berlin', *Museums Journal*, 35 (1935), 329–32.
82. *Personau*, p. 76.
83. NLW ICP Papers A 4/13 Amryw, small bundle of letters, August 1929; David Jenkins, 'Shipbuilding and Shipowning in Montgomeryshire: the Evans family of Morben Isaf, Derwenlas', *Montgomeryshire Collections*, 88 (2000), 63–86.
84. SFNHM/Miscellaneous/Pro Numbers etc./Gallery re-organisation, 22 February 1936 and 29 March 1936.
85. *Annual Report 1935–6*. The winding-gear is now displayed at Big Pit National Mining Museum.
86. SFNHM/Untitled/Monmouthshire Bibles.
87. *Rhwng Dau Fyd*, p. 131.
88. NLW ICP papers A 3/5 (ii), n.d. but on Twiston Davies's death.
89. NLW ICP papers A 3/5 (ii), memo of 23 October 1934; *Annual Report 1934–5*, p. 17.
90. *Annual Report 1935–6*, p. 13.
91. NLW ICP Papers A 3/3, Staff, 'Folk Culture and Industries. Appointment of Assistant. Application of FFRANSIS GEORGE PAYNE'.
92. *Rhwng Dau Fyd*, p. 111.
93. *Annual Report 1936–7*, pp. 10–11. Nash-Williams, like Wheeler and Fox before him, was jointly Keeper of Archaeology and lecturer in the same subject at Cardiff.
94. A catalogue to accompany a temporary exhibition arranged by Ffransis Payne in 1938–9.
95. SFNHM/Untitled/Policy for Departmental Publications, ICP to CFF 27 September 1940 and response 29 October 1940.
96. Quoted in Jacquetta Hawkes, *Mortimer Wheeler. Adventurer in Archaeology* (London, 1982), p. 92.
97. Douglas A. Bassett, 'The making of a national museum. Part II', *Trans. Hon. Soc. Cymmrodorion*, 1983, pp. 19–23.
98. D. Hill and S. Matthews, *Cyril Fox on Tour 1927–1932: Two of Sir Cyril Fox's Notebooks Describing Minor Earthworks of the Welsh Borderland and Visits to Four Welsh Museums . . . (British Archaeological Reports 364)* (Oxford, 2004),

p. 85. Fox talked about 'the rehabilitation of unprogressive museums' in 'Affiliation: From the Point of View of a Parent Institution', *Museums Journal*, 30 (1930–1), 343–53.
99. 'Pregeth ar Hen Destun', *The Carmarthenshire Antiquary* 1 (1941), 43–8.
100. For a good discussion of this, see Dan Hicks, 'The Material Cultural Term: event and effect', in Dan Hicks and Mary Beaudry (eds), *Oxford Handbook of Material Culture* (Oxford, 2010), 37–8
101. 'Museums and the Community', *Montgomeryshire Collections*, xlviii (1944), 125.
102. 'Museums and the Community', 127.

4
Trouble and strife

Tensions

'Dr Peate believes that the scholar should not hide himself in an ivory tower but rather express a considered view on every subject that impacts directly on his life' is the wording of the publisher's blurb on the dust jacket to *Ym Mhob Pen* ... (1948);[1] it may well have been written by Peate himself. One of the great guiding principles that shaped Iorwerth Peate's life was that a Christian had a duty to attack injustice wherever he detected it, and seek to eradicate it by all means possible, short of physical violence. This hugely commendable approach to life had negative aspects, however, such that he saw compromise as a weakness: and the consequence was that, like a lightning rod, he attracted trouble and strife all his life. A 'militant pacifist', as Trefor Owen so accurately characterised him, he relished a scrap, sought out opportunities to be difficult, and treasured grudges. But neither did he discriminate: if friends were worthy of censure, then so be it, with no holds barred, and he had no concept of favours due and owed. There were one or two exceptions to what was otherwise a rule: his old mentors T. Gwynn Jones and H. J. Fleure were exempt, and everything that W. J. Gruffydd did was sacrosanct. Equally, others could normally do no right, and Cyril Fox was one of that number. Whilst Fox was his immediate superior only between 1936 and 1948, Peate actually interacted closely with him almost from his appointment, since his department head Nash-Williams (as we have seen) took very little interest in him and his work.

According to Peate, battle lines between him and Fox were drawn almost on first meeting. The only other Welsh speaker on the staff in

1927 was Miss Breese, the librarian. After the end of one working day a few weeks after his appointment he went to chat with her but found Fox, whose office was only two doors away from the library, already in conversation with her; Fox explained that they were discussing matters to do with Wales. Jokingly, Peate said that he hoped that they were doing so in Welsh, and the conversation continued for a quarter of an hour. When he left, Fox asked Peate to accompany him, and outside the library door turned on him and asked how dare he, a new member of staff, so insult his superior? He demanded an immediate apology, whereupon Peate said that in his naivety he had assumed that the head of a Welsh national institution, paid by the Welsh taxpayer, would as a matter of courtesy have learnt the language, and that he could whistle for an apology, whilst being prepared for instant dismissal; but Fox merely smiled, said 'Forget the matter', and walked away.[2]

Peate seems never to have regarded his Director as much of a scholar, noting in his autobiography that Fox was regarded in the archaeological field as 'quite an authority' but actually one who depended to a large extent on contributions from Keepers such as North of Geology, Hyde of Botany and Matheson of Zoology to inform his studies. It is doubtful if anyone is elected President of the Society of Antiquaries and a Fellow of the British Academy by being merely 'quite an authority'; and archaeology is a field where specialist contributions have always been essential, and Fox would have been a very foolish man indeed not to tap into the potential at his disposal: in truth he was a polymath. Nevertheless, in his autobiography Peate recounted with considerable glee how Fox mistook an electric fan made in 1930 and delivered to the Museum for the building works as a traditional hay-drier, taking Peate to task in front of senior colleagues for not collecting it from the corridor where it had been left and lecturing them on the cultural significance of this English-made implement being used in upland Breconshire before Peate corrected him – an illuminating little episode throwing light on the character of both men.[3] But Peate's recollections were not always as accurately remembered (or retold) as they might be. Peate recounted Fox coming into his room one morning and seeing a number of photographs of sleds, photographs taken by Peate's father and which he was himself examining prior to publishing on the subject. Without a word, Fox took the photographs and Peate next saw them reproduced in a paper entitled 'Sleds, Carts and Waggons' in *Antiquity*.[4] Reading Fox's article, however, forces one to question the

veracity of Peate's telling. The article is a deeply researched and well-illustrated paper that arose from Fox observing whilst on fieldwork in Radnorshire 'a remarkable vehicle the like of which he [Fox] had never imagined', namely a wheeled sled or wheel-car; a second, which was being constructed in a nearby workshop, was acquired for the Museum collection. He quoted farmers whom he had quizzed on the matter, the archaeologist W. J. Hemp (who is also credited for three photographs which Fox reproduced), and included a lengthy quote from Peate, which Fox must have had in written form; and he credited Peate's father for three photographs.[5] It took another four years for Peate to write on the subject.[6] This is a rather different tale from Peate's telling: Peate would never have missed the opportunity of saying that it was he who acquired the wheel-car for the collection had he been in any way involved, and one is forced to conclude that he felt it highly unlikely that any reader of his autobiography would read Fox's paper – and he never published his tale in English.

Relations between the two men fluctuated. They were clearly on very good terms in 1934, when Fox wrote from holiday in Cambridge to thank Peate for drawing attention to the role of sheepfolds in a pastoral economy at a time when the Foxes were investigating settlements on Margam mountain, and commending the recording and study of these features to Peate – 'My dear Peate' was the salutation to Fox's handwritten missive, which ended with 'P.S. My kind regards to your Father & Mother': Peate's parents must have visited their son at the Museum and been introduced to the Director.[7] Fox does appear to have had problems with delegation and perhaps with communication. The Keepers of the science departments and Art were spared too much interference, but as the former Keeper of Archaeology (and Acting Keeper and sole curatorial member of the department when Nash-Williams and the Assistant Keeper, Hubert Savory, were both on war service), Fox had knowledge of and interest in both Nash-Williams's and Peate's areas of activity. Nash-Williams himself dealt with the Roman and Early Christian periods and had no discernible interest in prehistory (and indeed that area was most capably covered by the Assistant Keeper Grimes), so Fox sometimes interfered or intervened; but as he was the National Museum's senior and best-known prehistorian he would sometimes be approached directly, as he was when some contemporary tools discovered at Stonehenge were offered for the collections. The donor, R. S. Newall, who appears to have

rescued the items abandoned in a shed on the site after earlier excavations, wrote to Fox in October 1931 noting, 'At last I can make you an offer of Stonehenge objects', but Fox was not around. The letter was forwarded to Nash-Williams, with a query as to how to answer it, by the Secretary, to whom Nash-Williams replied, 'I know nothing of the attached. No mention has been made to me', before suggesting which items should be accepted. On his return Fox noted to Nash-Williams, 'The connexion of Stonehenge with Pembrokeshire makes this collection important, and I think we ought to be very glad to have it', but accepted the compromise in the number of objects that the Keeper had proposed. He was at fault for not having drawn Nash-Williams's attention previously to the possibility, a trait that Peate too was to discover for himself.[8] Charles Scott-Fox in his biography of his father noted that he never had the same friendly relationship with Peate that he enjoyed with the other Keepers, which Scott-Fox put down to Fox selecting Grimes before Peate for appointment in 1926 and to Peate's determination to press 'his nationalistic and pacifist views, on his English and conservative Director, and vice versa.'[9] Aileen Fox was later to say that she got on well with all her husband's colleagues apart from 'Iorwerth Peate, the arrogant Welsh-speaking Welshman in charge of Folk Life', who defeated her utterly.[10]

Fox was not a well man for most of his life. His son noted that he was nervous and highly strung, with a tendency to hypochondria. His hard work not unsurprisingly sometimes caught up with him, such that the pressures of his commitments to learned societies, the Museums Association, the Royal Commission on Ancient Monuments in Wales, excavating and publishing and the opening of the East Wing, and not least the death of his first wife in a swimming accident led to him having to take seven months off work effectively with a nervous breakdown: he was unable to attend the investiture of his knighthood in 1935.[11] But he may not have helped himself. Fox's clear desire to be all-controlling is apparent in the case of a letter sent out to a lender to an exhibition of furniture in 1936. This was a major temporary exhibition held in the National Museum's Circular Gallery from April to September. Under the influence of Ralph Edwards, the V&A's Keeper of Furniture, the exhibition concentrated on exceptional pieces displayed individually rather than in any social context, showing the contrast between simple native pieces and very highly developed examples, mostly imported into Wales. Fox seems to have largely arranged it himself, relegating Peate to a secondary

position so far as the arrangements went, although the subject matter was entirely within the remit of Peate's department. The exhibition was a huge success, attracting 64,000 visitors and attention from the London illustrated press; Peate published an article in the art magazine *Apollo* as a consequence.[12] Arrangements for acquiring loan items for the exhibition were made by Fox writing to the great and the good amongst his acquaintances and through recommendation, with Peate writing to those he knew and following up with collection and return arrangements; most owners responded favourably to the request. One lender was G. E. Blundell of Nottage Court, Porthcawl: he and his wife were on dining terms with Fox and Lady Aileen, and Fox took a personal interest in the letter that noted that two chairs lent by Blundell could not be accommodated in the exhibition as finally arranged. Fox amended a draft letter that would have been sent out in his name, changing 'I have no doubt that you would be glad to have the [chairs] sent back to your house as soon as possible; if this is the case, will you let me know, and I will make arrangement for their delivery in the course of a week' to 'Unless you specially wish these to be returned at once, they will be retained until the close of the exhibition & sent back with your other loans' – a good and sensible change. But then Fox went away to north Wales and asked Peate to send the letter in his stead; strangely, he managed to edit Peate's typed letter, on his department's headed paper, before it was sent out, and amended Peate's concluding words from 'If it is convenient to you these chairs will be returned to you in a short time and I shall arrange that notification will be sent to you as soon as our arrangements are made' to 'These chairs will shortly be returned to you; I will let you know as soon as our transport arrangements are made, when they will arrive.'[13] The substance of Peate's text – at variance with Fox's amendment to his own draft – was not changed; the chairs would again be returned at once, not held back until they could be returned with the exhibited items, and the changes Fox made to Peate's text were only to correct his grammar and phrasing. It almost seems as if Fox could not resist any chance to improve on someone else's drafting, forgetting the logic of his change to his own letter.

The relationship between the two men was punctuated by similar and fraught little episodes, often caused by Fox's lack of thinking or Peate's intolerance. Sometimes the fault is reasonably clear. In March 1937 the Director sent out a note to landowners, estate agents and auctioneers drawing attention to the Museum's interest in antiquities, folk

culture including 'early house-types' and historical material relating to Welsh families, and seeking information about these areas, the result of a suggestion made by Peate and intended to support his researches in this field. The letter was sent to all members of the Central (later Country) Landowners' Association in Wales, the Chartered Surveyors' Institution, and the Incorporated Society of Auctioneers, with the societies themselves circulating their members. What happened next – or rather what did not happen – is revealed in an angry file note by Peate. Responses were received, but 'this mass of information about houses' only reached him on 14 April 1942 (two years after the publication of *The Welsh House!*) when one of the typists in the General Office was 'spring-cleaning' the Director's room during his absence, came across the file, and thought that the place for it was the Department of Folk Culture. Peate commented 'Not only was important information concerning Welsh houses withheld from the one person who had been working on the subject but the scheme for securing the co-operation of landowners etc. . . . was – as far as I can judge – wrecked by the Director's inaction.'[14] Peate, however, clearly knew his position then was somewhat precarious (below) and had the sense not to rock the boat any further, and restricted his fury to this note (of which he made several copies) without taking the matter further.

In 1937 the National Eisteddfod was held at Machynlleth. Peate was asked to adjudicate, but he and seven others resigned when they learnt that the local committee had invited prominent Englishmen, such as the Marquess of Londonderry (who owned the land on which the Eisteddfod was to be held) and Winston Churchill, to be day presidents. The action gained considerable notice in the press and contributed to a meeting chaired by D. Lloyd George (Prime Minister, 1916–22), with the outcome of a Welsh-only rule for the Eisteddfod that was designed to avoid such ill-feeling in future, and that served to consolidate the Eisteddfod's position as a bastion of the Welsh language.[15] Peate explained his position to Fox, who remarked that it was a personal matter and nothing to do with the Museum. However, the Council met shortly afterwards, and immediately after the meeting Peate received a letter from the Director noting that the matter had been discussed in Council and that the Council did not want the Museum's reputation tarnished in this way. Peate, according to his telling, rushed downstairs and collared two members of Council on their way out: both confirmed that not only had the Council not ruled on the

matter, but that the matter had not been raised at all; and it became clear to Peate that the letter had been typed and signed before the meeting.[16] That night Peate responded forcefully, asking Fox that he read this letter to the next meeting of Council:

> During my nine years as a member of your staff, I have given – almost literally – every minute of my time to further the cause of the institution which I serve. During that period I pride myself that I personally have brought the National Museum nearer to the heart of the nation (which it is meant to serve) than it had ever been before.[17]

According to Peate, Fox begged him to take back the letter, admitting with tears in his eyes that there was no Council decision; Peate accepted the apology (although he wondered afterwards how right he was to do so), and had it later confirmed by the Secretary that the matter was not raised at the Council meeting: one member only had mentioned the matter to the Director in private conversation. This is not the only time that Fox exaggerated matters in this way, as we shall see later.

Peate found Fox's micro-management irritating, and the trait led to clashes. Ever since 1937 Peate's department had noticed that more and more metal objects (such as old ploughs and the like) were being acquired by scrap merchants, to the potential detriment of the Museum's collections. A list of scrap merchants in south Wales was obtained through the good offices of Allan E. Renwick of the Principality Wagon Company, and Peate wrote to them asking for their assistance. Most of those who replied were helpful, at least in principle. With the coming of war, the government instituted a scheme of collecting scrap iron for reuse: the iron railings that surrounded the Museum building were surrendered to this cause. Peate felt that much of historical value could be lost in this way, but that equally the scheme could represent an opportunity if council officials, charged with implementing the scheme at local level, could similarly be made aware of the Museum's needs, and so Fox and Peate wrote a joint letter to the press in April 1940 drawing attention to the Museum's needs. The Art and Archaeology Committee of September 1940 agreed that it would be opportune to intervene further, and Peate drafted a letter to councils which was approved by Fox, with one minor change. Two hundred cyclostyled copies were prepared for distribution, but held back at the

last minute for the Director to read again, whereupon he made further changes. Peate protested, to receive by response,

> I take exception ... to your memorandum ... It is in my opinion acid and faintly contemptuous – a tone unsuited to an official communication addressed to the Director by a Keeper. The last paragraph with its veiled recommendation that I should economize is wholly improper.[18]

Two thin-skinned men were here unknowingly laying the groundwork for a much bigger conflict, one that would play a crucial part in Iorwerth Peate's mythology. The years 1940 and 1941 were to be memorable ones for Peate, for very mixed reasons. *The Welsh House* was published to mostly favourable reviews (see Chapter 6). But there were wider repercussions for Peate. His introduction to the volume, after complaining about the general lack of interest in vernacular buildings and their unthinking destruction, noted further

> Unfortunately, in areas such as Llanychaer, in the Vale of Glamorgan, in Llŷn, in Monmouthshire, and in Cardiganshire, the destructive 'march of time' has been hastened by the actions of the British Defence Ministries which have occupied so many areas of rural Wales. The wanton and unintelligent destruction by the Air Ministry of Penyberth in Llŷn, a house with fifteenth-century features, and with strong historical associations, is well-known. The timbering was hacked down and sold for firewood ... The Ministries have now come to an arrangement with the Museum whereby the Museum authorities examine the sites before they are 'developed', with a view to the preservation of antiquities. This is however little solace to a nation whose rural amenities and traditional culture are ruthlessly assailed by such 'developments'.[19]

An anonymous letter published in the south Wales newspaper the *Western Mail* attacked Peate for condemning the Air Ministry in this way. As a consequence, some members of the National Museum committee that oversaw his department's activities wanted to reprimand him officially, but a senior member, Lord Raglan, and others felt that actually it was the Air Ministry that needed reprimanding. Peate himself stressed that the

fieldwork for the book and its writing alike had been undertaken in his own time, and that it had not been published by the Museum. Rather than being rebuked, he was formally congratulated for writing the book – contrary to Fox's wishes, according to Peate; Fox had also sought not to mention the commendation in the minutes of the meeting, but reinstated the item on being challenged by Peate.[20]

The Second World War and its aftermath

We now move to a point where it would be helpful to say a few words again about the National Museum's governance. Under the Royal Charter, its supreme governance lay in the hands of the Museum's Court of Governors, headed by the President, who held office for four years, normally to be succeeded by the Vice-President. During the early war years the President was Lord Harlech until he was called to serve as a High Commissioner, whereupon his predecessor, the Earl of Plymouth, was asked to take over the reins until his untimely death in 1943. The Museum's influential Treasurer was D. E. Roberts. Court was an unwieldy body which met only once a year to receive the institution's annual report. Its membership comprised past presidents, representatives appointed by the Privy Council, the University Colleges and the County Councils, representatives of special interest groups, a number of members co-opted by the Court itself, and all the MPs representing Welsh constituencies, totalling some one hundred individuals. The executive body which reported to the Court was called the Council, and it normally met every two months. The President acted as its chairman, with a membership drawn from the Court; at this time it normally numbered some twenty members. These two bodies were supported by standing committees such as Finance, with each curatorial speciality having its own advisory committee which included experts in a relevant field – but these were not executive bodies and they could only make recommendations to Council. Over the war period a special Emergency Committee was also formed in the eventuality that urgent decisions had to be made. This consisted of three individuals, namely the President, the Treasurer, and long-standing Council member Edgar Jones.

With war declared, the Ministry of Labour and National Service had classed National Museum staff as civil servants and therefore exempt from compulsory military service, but changed their minds some six

months later, resulting in the staff no longer being regarded as working in a reserved occupation.[21] Council's policy was 'to release for service in the Armed Forces of the Crown members of its staff, without exception, as and when they volunteered or were called up for such service', and the Keeper of Archaeology, V. E. Nash-Williams, was the first to go, with Fox taking over the Department at the beginning of 1940.[22] It was known that three of the five remaining Keepers – Baxandall of Art,[23] Hyde of Botany, and Peate – held pacifist views, as did several more junior members of staff, but the Museum chose to regard this as a personal matter for the individuals concerned. Hyde, younger than Peate, was of an age group that was shortly to be called up; would Peate accompany him to see the Director to obtain clarification on whether Museum staff were considered as reserved or not? Fox did not know the answer, and Peate asked if he would write to the Ministry of Labour and National Service to find out. Fox did not want to do this, as he felt it a matter for the Museums Association; he would have a word with its Secretary. Peate responded by saying that the booklet sent to all staff on national service stated that anyone with a query should write to the Ministry, to which the Director replied, 'Well, you write to them; it is not my business', so Peate said he would. A fellow old boy of Machynlleth Grammar School, albeit considerably older than Peate and whom he had never met, was Sir Thomas Phillips, now Permanent Secretary of the Ministry of Labour, so Peate wrote to him from his private address and received confirmation that National Museum staff were indeed considered as being in a reserved occupation and that the Museum would inform him officially of this shortly.[24] Peate sought out Fox to report this, but Fox was away (as he frequently was during the war because of ill health and carrying out archaeological investigations for the Ministry of Works in advance of construction), so Peate showed the letter to Hyde, who then compounded the matter by visiting an official of the Ministry of Labour with the intention of postponing the medical examination of a departmental attendant who had, with Museum approval, volunteered for service with the RAF.

Both Keepers were then summoned to attend a meeting of the Museum's Emergency Committee where they were suspended until the next meeting of the Council. Twiston Davies felt that Peate had acted irregularly by writing to Phillips without asking Fox's permission, but thought the offence a trivial one '& you are far too valuable to the Museum to be penalised for it.'[25] Sir Thomas Phillips himself thought the Museum's

response astonishing, unnecessary and improper. Council reprimanded both Keepers without hearing their defence of the charges against them, which in Peate's case were that he

> had made use of his personal friendship with a high official in the Ministry of Labour and National Service to place privately ... a case for the inclusion of members of staff of this National Museum in the List of Reserved Occupations. On receiving ... private intimation by letter that the staff of the museum was included ... he made known this information to a number of members of staff without the permission of the Council or the Director and before any official communication was received by the Council from the Ministry.[26]

Fox was aware that the situation could divide Council and Court, and proposed a compromise whereby the two Keepers would be censured but reinstated, subject to guarantees of future loyalty. Robert Richards MP (*ex officio* a member of the Court) wrote to Fox congratulating him on achieving this compromise through his 'very generous and statesmanlike' action, noting that Sir Ifor Williams (the pre-eminent Celticist of the time, and a friend of both Fox and Peate) had said that they would still be discussing the matter were it not for Fox's courageous intervention.[27] Peate blamed not so much Fox for the matter – he regarded him as weak and willing to be led from what might be his own views – but rather the Secretary, who as an ex-First World War officer and holder of the MC had no time at all for pacificism, and was devious in his dealings, getting Fox to fire the bullets that he had prepared. Peate clearly hated him, and no doubt the feeling was reciprocated;[28] but Peate seems to have been unaware that Fox had had to achieve a compromise to prevent an escalation of this situation.

In 1941 Peate was awarded the DSc that he had put in for by the University of Wales. The higher doctorate was awarded for the sixteen pieces of work that he clearly rated most highly of his output so far and included three free-standing studies – *The Welsh House*, *Cymru a'i Phobl* and *Y Crefftwr yng Nghymru* – and three Museum guidebooks, namely those to Welsh bygones, to Welsh folk crafts and industries, and to Welsh society and Eisteddfod medals and relics. The rest were papers of varying size. Four were on aspects of material culture, on furniture, on chairs, and

on agricultural transport and eel-traps. Another four were on the folklore of Glamorganshire, on the wassail bowl and the Mari Lwyd, on the wren, and on corn customs. The remaining two papers he submitted were his early paper on the Dyfi basin, and his analysis of the mediaeval hunting manuscript 'Y Naw Helwriaeth'. He will have chosen these to show the range of his interests as well as the quality of his analysis. The degree was awarded in absentia, because the graduation ceremonies scheduled for July were not held, which caused Fox, in congratulating him on 'The highest distinction among the doctorates, in my opinion' (Fox's was a PhD, an ordinary doctorate), to also ask 'Are we to wait till you are "capped" before using the title officially?' Thomas Parry felt it odd that a man of letters should be awarded a DSc (a doctorate of science), but noting the rush of DLitts (doctorates of literature) awarded recently, felt it equally worthy. But telegrams of congratulation, dictated over the telephone, caused some difficulty for Post Office clerks: one came from LLANBBOINMAWR, and another was addressed to IOWETH PEAKE![29]

Sadly for Peate, however, his new doctorate and the events of 1940 proved to be but a prelude to the most traumatic episode of his career and indeed life. In July 1941 he appeared before the South Wales Tribunal to defend his refusal to serve in the armed services; he was then forty years old. He chose to follow this course rather than the easier option of taking up for the duration of the war one of the reserved positions in the Ministries which were available to people in his situation. He took his stand on moral and religious grounds, and was supported, inter alia, by Sir Leonard Twiston Davies and Professor W. J. Gruffydd (a member of the Museum Court), both disagreeing with his views but supporting his right to hold them. Peate was granted a reasonably courteous hearing, at which he responded to being questioned as to his feelings towards Hitler by saying that in spite of his appalling behaviour he had to regard him as a brother, for the family of God did include wayward members. He noted that he felt it his duty to serve his country in the best possible way by carrying out the duties of the post he had been appointed to, and was placed without reservation on the list of conscientious objectors. The brief report in the *South Wales Echo* was headlined inevitably as 'Regards Hitler as brother'. That was that, as far as the law was concerned: Peate could carry on with his career as normal.

But not so fast, said the Museum. The Emergency Committee reconvened and prepared a report for the Council meeting of 11 August, with

Edgar Jones dissenting. Peate was accused of making every effort to avoid war service and thus to obtain a reversal of Council's position that every effort be made to support the war effort, and of misleading the Council in 1940 by saying that he was ready to serve his country. The Museum was thus misreading (or choosing to) his meaning that he intended to do so in his current post as a willingness to join the armed forces, and also alleging that he had taken advantage of his friendship with Sir Thomas Phillips (whom he had never met, as we have seen). The majority recommendation (two of the three) of the members of the Emergency Committee was that having a conscientious objector on the staff would have a detrimental effect on the Museum's interests and that therefore Peate, despite his 'excellent peacetime record', should be barred without pay from Museum service for the duration of the war. Fox asked Peate (who was on leave in Llanbryn-Mair) to attend the Museum on the day of the Council meeting, but he was not called; rather, he recalled that a tearful Sir Leonard came to his office to tell him that not only had he been dismissed for the duration of the war but permanently.[30] He was given three months' pay in lieu of notice and another three months's *ex gratia* payment in recognition of his excellent service to the Museum. The action was reported in one laconic sentence in the *Annual Report*: 'The appointment of Dr. I. C. Peate, M.A., F.S.A., as Keeper of Folk Culture and Industries, was terminated on August 11th, 1941.'[31] But Peate's stand had been a moral and religious one, and the Royal Charter specified that no Museum body had the right to punish any member of staff for their religious belief. The following Monday came the first letters of sympathy and support, from Lloyd George ('Punishing you for taking advantage of the provisions of a parliamentary law would be an appalling injustice')[32] and W. J. Gruffydd. Lord Davies of Llandinam (Liberal politician and prominent pacifist, brother of the sisters Gwendoline and Margaret, and President of the National Library) wrote to Lord Plymouth in October to apologise that he had been unable to attend the subsequent meeting of the Museum Court. Whilst he deplored Peate's views 'at this critical moment in the history of our country', nevertheless it was clear that Peate was not dismissed for dereliction of duty but rather because of his pacifist views. In law, only a tribunal could judge on such matters, and Council by its arbitrary action had over-ridden the ruling of the tribunal.[33] Several MPs (as we have seen, all members of the Museum Court) demanded publicly to know the cause behind Peate's dismissal: what was his crime, if he was not dismissed for being a conscientious objector?[34]

Gruffydd took up Peate's cause in both languages in the press. In a hard-hitting article he noted that the Museum Council had set itself above Parliament and the law, which had decreed that Peate's actions were legal, for the tribunal had accepted that Peate, in continuing to work for the Museum, was indeed doing his duty to the country. 'Gruffydd worked tirelessly to research every aspect of the Museum's administration ... [he] discovered all this of himself' was how Peate put it disingenuously in his memoirs.[35] This was certainly rewriting history, for his own papers make it clear that he supplied Gruffydd with every scrap of material from his personal files that might be of use – and who can blame him? – such as the tale of the sacking of Miss Mavis Cooke the Archaeology typist, the third member of the Museum staff (along with Hyde and himself) of the Peace Pledge Union, who had been dismissed for insubordination and incompetence in March 1940 by means of a letter that also praised her 'energy, capacity and intelligence'! (Peate had tried to support her at the time and drew attention to the fact that she had in her leisure time completed the typescript 'of a volume of mine on a literary nature written in Welsh.')[36] Peate could not see that whilst he could blame Archie Lee for fashioning bullets for Fox to fire, he did exactly the same for Gruffydd to carry out the same service for him. We cannot blame him in seizing upon the availability of a willing supporter, but with the benefit of time he might have noticed that there was not all that much difference between Lee's actions and his.

In the meantime James Griffiths MP (later to be first Secretary of State for Wales) had written to Fox to condemn unreservedly the Museum's actions. He was followed by the South Wales Miners' Federation and the National Council for Civil Liberties, and dozens of other public bodies. By the end of July over 200 bodies had so protested as well as very many individuals, and Peate's file of correspondence with his supporters is huge; he must have been as busy responding and seeking support as when he was engaged on Museum business. Not surprisingly, his immediate colleagues were appalled at his treatment. Bob Carter (Pte F. R. Carter 13045602 of the Auxiliary Military Pioneer Corps) wrote several times from various RAF stations in Scotland, firstly to note,

> I have only just heard of the treatment meted out to you by the Museum authorities, & am deeply distressed. I hardly know how to express my feelings about the matter, but to me it presents itself

as a clear case of victimisation ... What a rotten lot they are at the N.M.W.[37]

Ffransis Payne (now graduated, and promoted to Assistant Keeper) was equally flabbergasted:

> This is the first time I have wanted to write a letter and found myself without anything to say. Rather without words to express myself. To say that Helly and myself send our commiserations sounds daft. We are angry and dispirited, unable to comprehend somehow ... The Director summoned me this morning. He has arranged to take over your Department himself for the time being [Payne was acting as Keeper of Art as well as retaining his role in Folk Culture]. He is the Keeper (bow down before him!) and, in his absence, the Secretary will be our Keeper.[38]

The Departmental Secretary, Eileen Price (later Mrs Fellowes), noted that she felt like leaving straight away, but realised she could be more of a nuisance to 'them' by staying, at least for a while: 'It is exactly like "amateur dramatics" here at the moment.'[39]

His friends also rallied round. He must have been particularly affected to hear from Alf Sommerfelt, an exile from his native Norway who had had to leave his family behind, and who like Peate felt he had to express matters exactly as he saw them. Sommerfelt naturally saluted him in Welsh as *Fy annwyl gyfaill* ('My dear friend') but went on in blunt terms that Peate would have respected:

> I am sorry for you personally but also for Wales because I know what splendid work you have been doing. Let it be clear, however, that I disagree most emphatically with your pacifist views [but] I know that you will not be convinced unless Wales were to come under the German heel ... I just want to send you a word of sympathy in your difficulties which, I hope, will not last too long, but I cannot do that without stating my own position.[40]

H. J. Fleure raised a constitutional issue, believing that the Council was within its rights to dismiss his old student if it wished, but if the Museum Court overruled that decision then the only option for Council members

was to resign if they were unwilling to accept the Court's decision.[41] Walter Davies from the Brynmawr Settlement had written about the matter for *Reynolds's News* ('Wanted – a Welsh Zola') but was not confident that it would be published – understandably, perhaps, for he saw things along very stark class lines: 'Our enemies, the aristocratic few on the Museum Council and their clique of hanging-on-the-coat-tails lick-spittles, *are persistent* and will not lightly yield'. The Council was not democratic 'and is under the thumb of that arch-reactionary the Earl of Plymouth and he is displaying on the Council precisely that contempt for democracy and its elected leaders that he shewed on the infamous non-intervention . . . during the Franco rebellion in Spain.'[42] Council's offer of reinstatement for a probationary six months was insulting: 'We need, perhaps, a Zola to rouse Wales as France was roused against her anti-Semite gangsters. It [as chairman of an independent inquiry] is a job for, shall we say? – Professor Gruffydd. Will he take it on?'[43]

It is to Peate's credit that he also kept the miniscule number of contrary views he received. Those few tended to be expressed just as clearly as Walter Davies's, such as this anonymous letter from London:

> I cannot address you as Sir, So I will address you as MISERABLE FELLOW . . . How can you be such a fool. You surely cannot call a man your brother who has broken all the laws of man and God . . . If you have parents they should be ashamed you were ever born and that your career has been tainted and ruined by your cowardice,

and so on, with much use of capital letters.[44] Others whom he had expected to support his cause were in a cleft stick, such as Professor Ifor Williams, who was torn because he also considered Fox a friend, and did not respond.[45] Peate had praised Williams's stance in not bringing up at the University of Wales Court the case of his old enemy within the nationalist ranks, Saunders Lewis, who had been dismissed by University College Swansea for being one of the 'Penyberth three' who had committed an act of political arson on the building site of the RAF airfield, the construction of which Peate had noted in *The Welsh House*. He complained to Thomas Parry that Williams had not bothered to attend the special meeting of the Museum Court when his case was being discussed.[46] Peate was hoist with his own petard, but could see no conflict between what he

expected in his own case and what he had wanted meted out to others. In his darkest months, too, he contemplated applying for the vacant Chair of Welsh History at Aberystwyth, though only if he were allowed to introduce a strong element of folk life into the curriculum; however, he was reinstated shortly after these thoughts, and the Aberystwyth Chair remained vacant until the end of the war.[47]

The Museum's supreme body, the Court, met on 24 October 1941, with the meeting held not in the Museum's Court Room but in the Reardon Smith Lecture Theatre, since so many members had indicated they would attend (the public also had a right to attend, but were turned away unless they insisted, which one or two knowledgeable individuals did). The meeting lasted three hours and Thomas Parry (who represented Bangor University College on Court) remembered the meeting as the most acrimonious he had ever attended, with over a dozen MPs in turn savagely attacking the platform group who attempted to defend their decision.[48] Aneurin Bevan was especially critical. W. J. Gruffydd proposed that the Court deplore Council's action in sacking Peate and that Council make arrangements to restore him to his post. Thomas Jones, CH (former Deputy Secretary to the Cabinet) tried for a compromise but was not supported, and Gruffydd's resolution was passed with an overwhelming majority. Council waited until the following January before inviting Peate back, not as Keeper but as 'senior Assistant Keeper' with an intent that he become Keeper again shortly (a move which Peate interpreted, surely correctly, as a face-saving move). James Griffiths counselled Peate not to accept this option but was persuaded by Lord Plymouth not to take the matter back to the Court, and Peate accepted the offer. Twiston Davies counselled him to 'be patient & exercise with your colleagues all the famous *tact* which you display with the general public when they press unwanted gifts on the museum & I know all will be well!'[49] He was back at work in March 1942, 'after eight quite nightmarish months' and restored as Keeper by the summer.[50]

Understandably after this, Peate supported the underdog and provided an ear for discontented staff, but he seems to have always done that. The departmental typist, Miss Price, appointed in 1935, had had her automatic progression delayed, resulting in loss of salary; and after his return to work, a graduate botanical illustrator, Eveline Jenkins, in seeking Peate's help noted that 'Fortunately, there are more enlightened people than Sir Cyril Fox in the world', whilst remarking 'You have already

suffered enough. Best of luck in your own affair'. It does seem that Fox could be a dissembler.[51] When staff leave was cut in 1942 and representations were made by the Senior Keeper, F. J. North, and the 'chairman of the staff meeting', Ffransis Payne, Fox merely reported to Council that staff had agreed to a reduction in their holiday allowance.[52] Only a week after Peate recorded the staff leave matter, he penned another file note (keeping multiple handwritten and typed copies – perhaps his earlier experience had made him extra cautious about recording any potentially difficult situation) remarking that now he had to sign in, like all staff apart from the Keepers, Secretary and Director, who used a board to mark themselves 'IN' or 'OUT'. What really galled, however, was when he and others discovered that the Finance Clerk was regularly abusing the system and getting away with it. Peate's note about the matter includes details such as 'She was seen by the wives of two members of the staff leaving a bus [at a time when she was at work, according to the book]' – and how was it that this person could get away with abusing her position when Assistant Keepers with twenty years service observed the regulations?[53]

Quite trivial issues could quickly escalate because of recent history and the personalities involved. Peate submitted a sensible report on how woodworm was treated in his area to the Art and Archaeology Committee in June 1942, stressing that polished surfaces were not touched; but this prompted a member of the committee, Ralph Edwards, Keeper of Furniture at the Victoria & Albert Museum and author of the much-respected *Dictionary of English Furniture* (three vols, 1924–7) to write directly about the matter to Fox:

> My dear Cyril, I know that the Assistant Keeper, or whatever he is [Peate was, of course, a Keeper], of your old 'bye-gones' ... doses your woodwork with Cuprinol, & as I have no desire to communicate with him myself, I make bold to suggest that in your Directorial Capacity you had better tell him to stop.[54]

Peate stood his ground, prompting Edwards to complain to Fox (whilst enquiring when next he and Aileen might come to stay) that, 'I really feel strongly on the way my opinion has been challenged'.[55] It would not be the last time!

But it was not only Fox and the Museum that Peate found irritating. He had a love–hate relationship with the BBC throughout the 1930s and

1940s. The BBC studios in Cardiff were in Park Place, directly opposite the National Museum. When the BBC started producing children's programmes in Welsh in 1933, Peate was one of the first to be invited to contribute scripts, and did so on history and geography as well as a number of items on folk life and customs.[56] The National Party of Wales felt then that the Corporation needed to improve its service for Wales. Peate drafted a memorandum calling for reform, which was adopted and promoted by the Court of the University of Wales. He then became involved in a highly acrimonious correspondence with the regional director of the BBC, Robert Appleton, with the result that he was blacklisted until Appleton left in 1936[57] – a clear conflict of interest resulting in an effect on his ability to carry out one of his professional duties, but which seems not to have come to the attention of his superiors. He was again asked in 1938 to create a series for schools. He contacted craftsmen whom he knew, such as the wood-turner William Rees, and ones he had not yet met, such as the coracle-maker F. C. Llewelyn.[58] They were willing to try but naturally wanted the BBC to recompense them for their time – Llewelyn would lose two days' fishing – and often proved reluctant speakers, with Peate effectively having to script their contributions for them.[59] All scripts had to be agreed beforehand in those days, and the correction of Peate's Welsh by a brave BBC underling led to a major confrontation; during the war all conscientious objectors or those who were known to have pacifist leanings were anyhow banned from the airwaves.[60]

Peate had a knack of misrepresenting history when it suited him, even in small matters; he may have done it unconsciously. An example is when he noted 'When my colleague Mr Trefor Owen came to St Fagans to work with us, the natural step was to send him to Uppsala University to learn there from Professor Campbell'[61] – but in truth Trefor Owen had already obtained a scholarship to study in Sweden before he was appointed to the Folk Museum and was merely given permission to accept that scholarship. Peate could also take offence at, and feel the need to correct, the slightest misrepresentation. In many of his writings he had hailed Skansen as the model open-air museum and had not been disappointed when he visited it; but nobody else was allowed to say the same thing. In a review of a Welsh-language tour guide to Sweden, he had to note,

> By the way, it is entirely untrue that Skansen was the model for the Welsh Folk Museum. The truth about Skansen is that it was

the first museum of its kind, and that the intention of its founder was to make it a national centre in every sense, for old buildings, animals, and even including more than a suggestion of what can be seen at the Tivoli [Gardens amusement park] in Copenhagen. In Wales, we can profit from some of the mistakes of the innovators, but nevertheless Skansen is a tribute to its designers

– a statement he would have castigated for its non sequiturs if anyone else had written it.[62] *Gwerin*, the journal Peate had founded, nominally had an international editorial panel, but it was never consulted, as Peate wanted to run the operation himself. Whilst of high quality, sales were always low and the journal came to an end in 1960. Geraint Jenkins (who had contributed articles to *Gwerin*) realised on joining the Folk Museum staff that the only way a journal could survive was if it had a society behind it, and he himself called a meeting on the back of the British Association meeting of that year in Cardiff. Peate had not shown much interest until he realised that he was being fingered as President of the new society; and so the Society for Folk Life Studies came into being formally in 1961, with Peate its first President; the first volume of the journal *Folk Life* appeared in 1963.[63]

Notes
1. From the alliterative saying, 'Ym mhob pen y mae piniwn', literally 'in every head there is an opinion'. My translation of the publisher's blurb.
2. *Rhwng Dau Fyd*, p. 103.
3. *Rhwng Dau Fyd*, p. 105.
4. *Rhwng Dau Fyd*, p. 105.
5. Cyril Fox, 'Sleds, Carts and Waggons', *Antiquity* (1931), 185–99.
6. 'Some Aspects of Agricultural Transport in Wales', *Arch. Cambrensis*, xc (1935), 219–38.
7. SFNMH/Correspondence re above/Last Inn Barmouth etc./letter CFF to ICP 4 September 1934.
8. NMW Acc. Corr. 33.561. I am grateful to Dr Elizabeth Walker for bringing this story to my attention.
9. Charles Scott-Fox, *Cyril Fox. Archaeologist Extraordinary* (Oxford, 2002), pp. 143–4.
10. *Aileen: A Pioneering Archaeologist. The Autobiography of Aileen Fox* (Leominster, 2000), p. 78.
11. Scott-Fox, *Cyril Fox. Archaeologist Extraordinary*, pp. 140–4.
12. 'Welsh Furniture from Tudor to Georgian Times', *Apollo*, xxiv (1936), 217–24: the article was based on the catalogue of the same title.

Trouble and strife

13. Fox's notes on visits to houses and museums in search of items are preserved as SFNMH MS 714.
14. NLW ICP papers A/3/5 (ii), 'Note re. a circular sent to landowners, estate agents, auctioneers, etc.', 14 April 1942; the Museum's official file in SFNMH/ Untitled/Auctioneers & Estate Agents does not include Peate's personal note.
15. *Y Llenor* ['The Writer'] (1937), pp. 65–9.
16. *Rhwng Dau Fyd*, pp. 113–14.
17. NLW ICP papers, 1937 National Eisteddfod file.
18. NLW ICP papers A 3/5 (ii), 'scrap iron' bundle, memo of 15 November 1940; non-private papers referring to the scheme are in SFNMH/Miscellaneous/ Scrap Iron.
19. *The Welsh House*, 3rd edn (1946), pp. 6–7.
20. Peate's story is told in *Rhwng Dau Fyd*, pp. 115–16.
21. SFNMH/Miscellaneous/Pro Numbers, Official Instructions, 18 July 1940 and 17 February 1941.
22. Scott-Fox, *Cyril Fox. Archaeologist Extraordinary*, p. 161; the Assistant Keeper, Savory, also signed up, and there was no Assistant in post.
23. A Quaker, he later signed up for the RAF, and noted that there was more respect in the armed services for differing opinions than in civvy street: NLW ICP Papers A1/25 (i), Letters A–F, letter to Peate January 1942. He later became Director of the National Gallery of Scotland.
24. *Rhwng Dau Fyd*, p. 117.
25. NLW ICP Papers A1/25, Letters A–F, 23 July 1940.
26. Scott-Fox, *Cyril Fox. Archaeologist Extraordinary*, p. 161.
27. Scott-Fox, *Cyril Fox. Archaeologist Extraordinary*, p. 162.
28. *Rhwng Dau Fyd*, p. 119.
29. NLW ICP Papers A1/26, Gradd DSc.
30. *Rhwng Dau Fyd*, p. 122.
31. *Annual Report 1940–41*, p. 26.
32. NLW ICP Papers A1/25 (ii), Letters G–J, letter dated 14 August 1941; my translation.
33. NLW ICP Papers A1/25 (i), Letters A–F, letter from Davies to Plymouth, 21 October 1941.
34. Particularly in the pages of the *Western Mail*: SFNMH Press Cuttings file, Toriadau Papur Newydd 1946 ymlaen – Amgueddfa Werin Cymru.
35. *Rhwng Dau Fyd*, pp. 124–5; my translation.
36. NLW ICP Papers A3/3, Staff, memo of 27 March 1940.
37. NLW ICP Papers A1/25 (i), Letters A–F, undated.
38. NLW ICP Papers A1/25 (iii), Letters N–W, 12 August 1941; my translation.
39. NLW ICP Papers A1/25 (iii), Letters N–W, 14 August 1941; my translation.
40. NLW ICP PapersA1/25 (iii), Letters N–W, 6 September 1941.
41. NLW ICP Papers A1/25 (i), Letters A–F, 30/10 and 19/12/41.
42. Plymouth as Under-Secretary of State for the Colonies was the British representative and Co-Chairman of the International Committee for Non-Intervention in the Spanish Civil War. Britain's official

non-interventionist position was seen by activists as an upper-class conspiracy favouring fascism.
43. NLW ICP Papers A1/25 (i), Letters A–F, 12 August 1941.
44. NLW ICP Papers A1/25 (iii), Letters N–W, 2 September 1941.
45. *Personau*, p. 51; Williams provided expert advice on early Welsh inscriptions to the RCAHMW, to which he was appointed in 1943, and both were Fellows of the British Academy.
46. Derec Llwyd Morgan, *Y Brenhinbren. Bywyd a Gwaith Thomas Parry 1904–1985* ['The Founder Oak. The Life and Work of Thomas Parry 1904–1985'] (Llandysul, 2013), p. 118.
47. Trefor M. Owen, 'Iorwerth Peate a Diwylliant Gwerin' ['Iorwerth Peate and Folk Culture'], *Trans. Hon. Soc. Cymmrodorion*, 1998 (1999), p. 72, quoting NLW W. J. Gruffydd papers.
48. NLW, Yr Academi Gymreig. Cynllun Ymchwil Llenorion Cymraeg Diweddar ['Welsh Academy Recent Writers Research Project'] / ffeil 19/tâp 14, Atgofion Syr Thomas Parry am Iorwerth Peate, 1984. Parry mentioned the event more briefly in his 'Cofio Cyfaill' ['Recalling a Friend'] piece in *Barn*, 238 (1982), 339.
49. NLW ICP Papers A1/25 (i), Letters A–F, 25 February 1942.
50. *Rhwng Dau Fyd*, p. 128.
51. NLW ICP Papers A3/3, Staff, notes of 29 May 1942 and 18 July 1942.
52. NLW ICP Papers A 3/3, Staff, ICP note 'Staff Vacation 1942', 22 May 1942.
53. NLW ICP Papers A 3/3, Staff, 'Time-keeping in the Museum', 29 May 1942.
54. NLW ICP papers, A 3/5 (i), ICP report of 25 June 1942, RE letter to CFF 10 July 1942.
55. NLW ICP papers, A 3/5 (i), ICP report of 25 June 1942, RE to CFF 13 July 1942.
56. R. Alun Evans, *Bro a Bywyd Iorwerth C. Peate* (Llandysul, 2003), pp. 84–5.
57. John Davies, *Broadcasting and the BBC in Wales* (Cardiff, 1994), pp. 55, 73.
58. Who, on receiving instructions to meet Peate at Cardiff station, responded that he would recognise Peate, as he had seen him pictured often in the newspapers, but that he himself was short, only a little taller than Zaccheus – a reference that would be appreciated by far fewer today: NLW ICP Papers A4/6, Coracles, undated letter.
59. NLW ICP Papers A4/12, Turnio.
60. Davies, *Broadcasting and the BBC in Wales*, pp. 112, 133.
61. NLW ICP Papers A 2/9 (i), 'Dau Gyfaill', and also *Rhwng Dau Fyd*, p. 133; my translation.
62. Review of Dafydd Jenkins, *Ar Wib yn Sweden* ['Travels in Sweden'] (1959), in *Lleufer*, 16/3 (Autumn 1960), 154; my translation.
63. J. Geraint Jenkins, *Morwr Tir Sych. Hunangofiant* (Aberystwyth, 2007), pp. 92–3.

5
The vanishing country craftsman

Early writings on craft

Iorwerth Peate was always proud of his descent from country craftsmen, in his case from carpenters, wheelwrights and textile manufacturers. His grandfather Dafydd (1831–96), after whom he and Nansi named their son, was a carpenter and wheelwright successively assisted by his sons John and George, Peate's father. Dafydd Peate's account books had survived from 1858 to his death and not only gave Peate material for several papers but also provided him with irrefutable credentials for assuming expertise in this area.[1] It is no surprise, therefore, that he showed an early interest in traditional crafts and their central role in rural society, and throughout his working life ensured that the subject was researched by himself and others and that craft buildings were adequately represented at St Fagans. However, he was far from alone in showing an interest in traditional crafts at this time. The period between the two world wars saw the resurgence of a desire to identify national cultural characteristics – in which traditional crafts clearly had a role – but also to use craft and other simpler and more sustainable ways of manufacture as a way of providing employment. The economic crisis of the 1920s ushered in nearly two decades of deep depression and cataclysmic unemployment, particularly in the areas that depended on the traditional heavy industries of coal, steel and shipbuilding, but life in the rural areas was just as hard. Radical solutions proposed by both the Welsh National Party and the Chancellor Neville Chamberlain included effectively transplanting the population of areas such as the Rhondda so that they be de-industrialised. Attempts were made at addressing the crisis by reformers including the Quakers, which

resulted in the establishment of educational settlements such as had been pioneered in England by Joseph Rowntree and others, and in Wales by the Cardiff University Settlement of 1901. In 1927 a Quaker-led settlement was established in the Rhondda which included tuition in crafts such as weaving, embroidery, pottery and woodwork as part of its curriculum, whilst another at Merthyr also taught woodworking. The Brynmawr & Clydach Valley Industries, also Quaker-led, operated a successful furniture factory from 1929 to 1940, and items were bought for the National Museum collection and by Peate himself.[2] The Rural Industries Bureau launched a particularly successful scheme in 1928 whereby young women were trained to make handmade quilts, reviving a traditional activity; the products were sold in London outlets and Peate secured an example.[3] In the same year the National Council for Social Service set up an advisory service and a sales outlet in London for the products of rural industries. This revival of interest resulted in practising craftsmen such as the west Wales wood-turners (see below) being able to sell their products to a wider and sometimes metropolitan clientele. In Wales, for example, Winifred Coombe Tennant (wealthy suffragist, Liberal activist and collector) patronised young artists but also sought out the last vestiges of dying crafts, particularly handloom weavers, and the well-known art patrons the Davies sisters likewise sourced handcrafted items for their home at Gregynog in mid Wales.[4]

Peate's first detailed study of Welsh craft was his description of the machinery already purchased by the Museum and removed from a woollen-yarn factory at Llanrhystyd in Cardiganshire, and the role played by such factories in their community.[5] He described the individual machines – the willy, the scribbling machine, the carding machines and the jack, and their roles in the process. Only the yarn-spinner/owner and his wife worked full-time at the factory, with the weavers and (off-site) fuller combining their tasks with smallholding; the mill owner on receipt of wool from a farmer and an order for the articles wanted took responsibility for the entire process, the fulling and dyeing. Peate could only conclude that this was utopian in many ways, with the factory the pivot of an ideal community 'where mutual aid was the ruling principle of life'. Sometimes, too, 'A villager desires to obtain blankets. *He gives the order to a farmer*, who supplies the wool to the spinning factory; the spinner sends it to the weaver, the weaver to the fuller, and the buyer pays the farmer!'[6] Only one of eleven such factories in the area still survived – this one had closed in 1926.

The nearby *pandy* (fulling mill) with its water-powered wooden hammers remained, worked part-time by a farmer. Peate must have been delighted to discover that the scribbling machine at the factory was the work of John Davies (*Peirianydd Gwynedd*, 1783–1855) of Llan bryn mair (*sic*) and even more to discover that Davies's account books for 1836–93 still survived, albeit with no reference to this particular machine. The accounts testified to the phenomenal growth and then sharp decline of the business over an area much wider than mid Wales. With its own smithy, John Davies's works could make complete spinning jacks and carding machines on site, with all the big accounts settled through small instalments over long periods.[7] In conclusion, Peate felt it satisfying that the National Museum was taking steps before it was too late to secure 'as comprehensive a range as possible of evidence relating to such industries'; and

> I am permitted by the Director to state that ultimately, when extensions to the Museum permit, the [Llanrhystyd] plant will be reconstructed as nearly as possible in its original lay-out and that the policy of securing material related to other local industries of Wales will be actively pursued, so that future generations may learn of factors, now vanished, which have contributed to the development of Welsh culture.[8]

After his years as an extramural lecturer Peate knew Cardiganshire better than any other area apart from his home county, and a wider range of traditional crafts seems to have been still practised here than perhaps anywhere else in Wales. It was therefore no surprise that it was here that he started his researches on crafts, work he summarised in an address to the Cardiganshire Antiquarian Society in 1929.[9] Welsh country folk were peasants (*gwerinwyr*) whilst their English equivalents were farmers, 'and there are in England practically no rural crafts such as we have in Wales' (a patent untruth, as George Sturt's *The Wheelwright's Shop* of 1923 had shown, and as other works, such as Walter Rose's *The Village Carpenter* of 1937, would reinforce even before Geraint Jenkins's researches of the 1960s onwards).[10] In that respect, Welsh civilisation was part and parcel of the civilisation of western Europe, closely related to the life of the Continent. A feature of folk culture (*diwylliant gwerin*) in whatever country it survived was the importance accorded to arts and crafts, both oral and material; but by now, sadly, changes had come about with the arrival of

industry. The charabanc had pushed its way into the remotest of places, jazz music was now heard on the radio, old boundaries were breached, and the uniqueness of far-away places was destroyed. Cardiganshire, however, was well placed to resist, and the way students came straight from field and workshop to attend the extramural classes he had taught here for four years, making no distinction between physical and mental work, had made a great impression on him. But the problem facing his audience now was how to apply modern work methods to their traditional crafts whilst retaining the spiritual essence that lay behind rural culture, for without such an injection it would be impossible to keep alive the essence of the nation. And who were the prime customers of such a man as William Rees, the wood-turner of Henllan? Not the Welsh, but the people of London, Cambridge, Oxford, Windermere, Dumfries and such places.[11]

Peate's detailed study of the work of William Rees and other wood-turners formed his own contribution to the Festschrift he edited to celebrate H. J. Fleure's twenty-five years on the staff of University College Aberystwyth, with contributors amongst whom were several names that would later become familiar, particularly E. Estyn Evans, R. U. Sayce and E. G. Bowen. Peate's paper, 'Some Welsh Wood-Turners and their Trade', met fully the requirements of a first-class academic contribution – descriptive, analytical and definitive, like others of his early papers.[12] Between 1925 and 1928 the National Museum had acquired (initially presumably through Fox's actions) examples of the lathes and tools used by turners from west Wales as well as numerous examples of their work, and he described these items, the typology of the turned vessels and the extent and methods of the turners' trade. The industry centred around the wooded lower valleys of the Cych and Teifi, where families of turners operated pole-lathes to produce a great variety of utensils for domestic and dairy use, such as spoons, ladles, bowls, plates, trenchers, skimmers and the like, and implements for outdoor use such as hay-rakes and scythe handles. The items were sold at fairs (where up to a dozen turners had once displayed their wares), markets and in local shops, but 'the introduction of German-made spoons into Pembrokeshire, and of Woolworth spoons into the larger towns' was slowly destroying the trade, which would be extinct in a couple of generations.[13] The objects made were beautiful and artistic, but also fit for purpose: Cyril Fox had pointed out to him how long-lasting were the forms, found as they were in the prehistoric lake-dwellings of Europe and at Glastonbury.

Another piece of work resulted in articles in both languages.[14] His colleague, the National Museum's Keeper of Zoology, Colin Matheson, had drawn Peate's attention to a manuscript source that he had mentioned in his *Changes in the Fauna of Wales within Historic Times* (1932). This was an old Welsh-language text known as 'Y Naw Helwriaeth' ('The Nine Huntings'), of which two versions existed in print and another three in manuscript form; all differed in detail from each other. The earliest version appeared to date to c.1560. With the help of Griffith John Williams of the department of Welsh at University College Cardiff, he was able to discuss in detail the various manuscripts and confirm that whilst much of their content was old and the various categories of hunt (the common hunt, the hunt with baying and the hunt with cries) and their subdivisions were based on the ancient Welsh triads, the section on bear-hunting was anachronistic, as such beasts had been extinct in Britain since before the Norman conquest. Through a detailed examination of the zoological, botanical and literary evidence he was able to propose that the mysterious *ceiliog coed* ('cock of the wood') must have been not the pheasant but the capercaillie. Later, however, William Linnard was able to find that Peate had missed one version of the text, that the *ceiliog coed* was most likely to have been the black grouse or blackcock, and that the work was a confection most likely compiled by Gruffudd Hiraethog (d.1564).[15]

He had introduced some of the themes running through these studies when he addressed the Folk-lore Society in December 1932 on the subject of 'Welsh Folk Industries'.[16] To that society he began by quoting the views of 'my friend, Mr. Middleton Murry' on William Morris: 'Hard practical experience had taught him that a living art could only arise out of a surrounding body of living crafts, and the crafts could not be made to live again while the system remained what it was.'[17] Peate then made a truly astonishing statement, painting a picture of his people and the role of craft in the lives of all of them that would have been more appropriate to 1833 than to a century later:

> The Welsh are a peasant people whose main industry even now is agriculture. They are a nation of pastoral farmers living on the moorland and in the valleys, in small rural communities with their literary societies, their eisteddfodau, their evening choral classes and their chapel meetings. In such a nation, in such communities, the craftsman is always a prominent individual. This is so in the

life of any nation which has maintained a close contact with the soil: it is a truth which must be fully realised to understand the bases of Welsh culture.[18]

But then, '[In] the course of time came the catastrophe. Large parts of Wales became affected by the Industrial Revolution'. The craftsmen, too, became infected and 'sent their sons into the educational machine to make teachers and preachers of them. The result was disastrous.' In his own valley sixty years previously there were a dozen flannel factories, forty shoemakers and a score of carpenters, '[but now] my own father is the only really first-class carpenter left there. Honour left the house of the craftsman to be placed upon the industrialist who had two letters to his name, or who could boast of a diploma or a certificate.'[19] What was needed was not a return to primitive methods but a control of the system of production such that the spirit of the old could be reborn and the machine became man's servant and not his master. Strangely, he did not end on this note; rather, this was just the conclusion of his introduction. The bulk of his lecture was a recitation of the roles of the various craftspeople, but he did also note the cultural deterioration that could result from such a social change. Radnorshire in the eighteenth century played a full part in Welsh life, but its language had now changed; not that it had become English, it had merely ceased to be Welsh –

> the country folk cannot speak Welsh but neither can they speak English. They speak Welsh in English words ... These people have lost the key to the past of their own nation through losing the language and at the same time they have not been grafted onto a living English tradition.[20]

Before ending by reciting D. H. Lawrence's poem about the point of work, he concluded that the true folklorist 'must of necessity be also the true anthropologist'.[21]

An elegy for craft

Peate elaborated on these themes in Welsh the following year (1933) when he was given the opportunity of publishing a small volume entitled *Y Crefftwr yng Nghymru* ('The Craftsman in Wales'). He prefaced it

with one of his own poems, 'Carol y Crefftwr' ('the Craftsman's Carol'), inspired by the list of craftsmen in Ecclesiasticus 38 which he included as an epilogue; the poem was to become much loved.[22] Printed on good quality paper with nine photographic plates,[23] albeit with no footnotes or bibliography, the volume looks and feels definitive, but was written at his publisher's request for 'the boys and girls of Wales as an attempt to raise a little the curtain on part of their heritage', to which end he hoped that many of them would make a follow-up visit to the National Museum. Peate explained the book's skimpiness because 'The leisure hours of any officer in a rapidly expanding national institution are few and it was in the leisure hours of such a man that this volume was written'. It was impossible to do justice to the subject in such a book, and he hoped later on to publish 'a more detailed and complete study of this aspect of Welsh culture'.[24]

The bulk of the work is a chapter-by-chapter recital of the role of the blacksmith, the wood-turner, the spinner and weaver, the carpenter, the coracle fisherman, the quilt-maker and the potter. The chapter on the smith is entirely historical, with no description of working methods, but includes mention of the admired work of the gate-makers Robert and John Davies of Wrexham. The Welsh wood-turner now made items for the kitchen and the dairy and farm implements such as rakes, with the products of the west Wales makers still sold in country fairs and beyond. The work of the spinner, the weaver and the fuller was a craft not an industry, all meeting a local need rather than working for profit (surely he cannot have thought the two things incompatible?). Different areas of the country specialised in different products. In the nineteenth century the Teifi and Tywi Valleys became truly significant in the history of cloth manufacture 'but since the craft by then had become an industry we need not pursue it here'.[25] He began his chapter on the carpenter by noting that fashion developed in large towns and cities and only slowly permeated the countryside so that there might be a considerable time-lag in the adoption of metropolitan styles:

> It follows then that when one attempts to 'date' an item of furniture he ascertains if he can where it was made. An item dating from 1600 in London could be as late as 1700 in Cardiganshire. And if you see some of those all-knowing types who ... speak of an item as made in, say, 1625, then you can be quite certain that they are speaking about a subject of which they know little.[26]

He charted the course of fashion in furniture through the static Gothic period and the revolutionary Renaissance, leading to the golden age of oak furniture in Britain. After discussing the technique of turning a log through pit-sawing and quartering into a usable piece of timber he turned to wagon-making, noting the two-wheeled cart that derived from southern Europe and the heavy 'Teutonic' cart that was seen in its glory in the Vale of Glamorgan. He mentioned woodcarvers and coopers almost in passing.

Caesar and Gerald (Giraldus Cambrensis, writing in the 1190s) alike had described the coracle, and whilst they were still built and used on the Teifi and Tywi, the Dee and the Wye, they were under threat from the imposition of fishing licences. Lobster-pots and lip baskets were made using similar techniques, the latter being an inland phenomenon using rushes and briars. Quilted bedclothes presupposed the bed as an item of furniture, but quilted items of dress were also much in vogue in the seventeenth century. The making of bed quilts had seen a revival in southeast Wales after the Great War, their patterns based on those unique to the country. Samplers, however, were largely made by girls as part of their education. Finally, the potter's craft was one of the oldest anywhere. Suitable clay was found in Wales only in Flintshire and around the margins of the south Wales coalfield. Peate outlined the process, from grinding to throwing on a wheel, dipping in slip, and firing in the kiln. The Ewenny potteries had produced many items in the National Museum collection, including fine wassail bowls. He then discussed in some detail the different kinds of product – earthenware, stoneware and porcelain, and elaborated on the subtypes within each group. In Wales, porcelain had only been made briefly at Swansea and Nantgarw and that by outsiders, and notwithstanding how fashionable its collecting now was, the products would not strike any ordinary Welshman as things of beauty, for despite their quality they represented a break from the native tradition and had no roots in the life of the people. He was less judgemental about the japanned wares produced at Pontypool and Usk, for they made useful things such as trays, teapots, candlesticks and the like, but once the fashion moved on they were replaced – which was what happened to any exotic craft. He ended the chapter with a purple flourish that formed the conclusion to the work: the only crafts of perpetual value were those that developed with a nation, that suffered and succeeded with it. History had shown what happened to every attempt to unseat the Welsh craftsman, and

The vanishing country craftsman

When it comes to the crunch and a battle between society at large and the life of the craftsman, there is no doubt that it is the system that shatters into pieces because in every age it is the craftsman who keeps alive the spirit of the nation.[27]

Here indeed was further wishful thinking. Apart from this last page and a few remarks here and there, the main text was essentially a recitation of Peate's state of knowledge about the various crafts and their practitioners, six or so years into his tenure at the Museum. We need to go back to his opening words to understand the message behind the work, and perhaps to him the justification for the publication. The gist of some chapters had already been published in *Y Ddraig Goch* ('The Red Dragon', the organ of the National Party of Wales, as Plaid Cymru was known) or broadcast, which may explain why the chapters are all of equal length, even though the author clearly had far more to say about some crafts than others. The book's introductory chapter on 'The spirit of craft' began as addressed to (surely quite precocious) children but then moved rapidly to an analysis designed for a literate and politically aware adult readership.[28] Professor T. Gwynn Jones thought that much of what was pleasant and valuable (*dymunol a gwerthfawr*) had been lost, and this volume accordingly attempted to throw some light on the lives and work of these craftsmen to see how much of what had been lost was indeed pleasant and valuable, and to what degree it might be possible to reclaim that. Much of the past culture of Wales, like that of western Europe in general, was based to a large extent on a love of craftsmanship. Wales was a nation of peasants rather than farmers, dependent on their local community: but whilst their horizons were limited their life was not poor, and if narrow, was also deep and full of riches, now scarce. The courts of the Welsh princes had seats reserved in honoured places for three craftsmen – the priest, keeper of the written word; the poet, the keeper of the spoken word; and the blacksmith, representing the material culture of his nation.[29] This historical background was important, for as Middleton Murry had noted in paraphrasing William Morris, a living art could only arise out of a surviving body of living crafts. The craftsman came into being through creating useful things and meeting a need; his craft lay in creating something wholly useful but at the same time beautiful. Sadly, today ornament for its own sake was added. There had been two linked changes of significance. The first was the Industrial Revolution

which brought factories into being and killed the country craftsman; but on the whole the changes it brought were beneficial, for much of the old way of life was harsh and brutal. However, we and our forefathers alike had failed to keep the machine in check, with disastrous consequences. Factory workers had nothing to fall back on if there was over-production or a diminished call for the goods they produced, whilst country craftsmen were all smallholders with another string to their bow. Along with this change in production methods came a change in mindset, from belief in the strength of the community to the Darwinian self-help philosophy of Samuel Smiles. In Wales such necessary individual success was equated with being English, and so 'in all seriousness' the Welsh created an educational system that was as English as it could possibly be.[30] Elegiacally, he described the consequence of all this:

> You will not today see a smith who can make a complete plough or a shoemaker a shoe. Rather, we see men who spend their lives making bolts and cobblers who fashion soles. And whilst the system remains thus, we live in an age of superficiality . . . our system has turned our industry into an enemy of our culture.[31]

The nation was at a crossroads. Its future lay in the countryside. Craftsmanship was the body that housed the nation's soul and it would be our fault if that spirit were not refreshed. It was no use crying over spilt milk, but new factories could be built that, against the sound of *harnessed* machinery, would respect the spirit of the rich inheritance bequeathed to us by the craftsmen of old, for without craftsmen there could be no nation.[32] The book, then, was effectively two works rather crudely forced together. The main body was largely in line with what he had been asked to do, and suitable for a teenage readership; but the introduction was a polemic based on Peate's social and political views, and aimed at a very different audience. He railed against the age of the machine, his words showing how deeply he was influenced by the thoughts of William Morris, and certainly those thoughts as mediated by Gwyn Jones and Middleton Murry. His views were both extravagant and uncritical, for here was no reference to the poverty and struggle that must surely have often characterised the existence of many craftsmen, and the possibility that some must have produced shoddy work was clearly not worth contemplation; and he seems to have believed much like Morris and Murry

that craftsmen worked merely to meet a local need and not for profit. His definition of craft, too, largely excluded those practised by women, such as the marram-grass weavers of Anglesey, the stocking-knitters of Merioneth, and all the home crafts practised by housewives and which contributed so significantly to family incomes; if pressed, he would no doubt have retorted that what was in his mind was work which provided a living for the head of the household – another signifier of his fixed view of the nature of rural society. Nevertheless, *Y Crefftwr* was to remain the only book-length historical overview of its subject in Wales to be published in either language until Geraint Jenkins's *Crefftwyr Gwlad* ('Country Craftsmen') of 1971, which was effectively a revised edition but without the polemical parts.[33] Jenkins had already included much Welsh material in his *Traditional Country Craftsmen* of 1965, but nothing comparable to Peate's book was published for England until Dorothy Hartley's *Made in England* in 1939, followed by several detailed studies of individual crafts from the 1940s onwards.

In 1935 the Museum published Peate's catalogue to the folk craft and industries material acquired since 1927. His introductory essay on 'The spirit of craftsmanship' was in large measure a translation of *Y Crefftwr yng Nghymru*.[34] The descriptive account of the collections (sensibly) reused previously published material as much as possible, and also followed the order of *Y Crefftwr*, which of course itself was based on the arrangement of the catalogue. The volume should really have been titled 'Welsh Folk Crafts and *Folk* Industries', because the only industrial items included were Trevithick engine-related items and the balance pit-head gear that the Museum had acquired: the bulk of the 'industrial' items represented those country crafts that Peate by now specialised in collecting and studying. In 1935 he also published a substantial paper on agricultural transport in Wales. He claimed in his autobiography that he had been working on the subject in 1931 but that Fox had effectively stolen his material (see Chapter 4); whatever the circumstances, it was four years later before he committed anything to print himself. The subject was one that merited careful attention but unfortunately had long been neglected, 'and much valuable evidence has disappeared.'[35] He traced the typological development of vehicles, from the hand barrow, the slide-car and the 'Irish car' with one set of wheels, examples of all which were in the collections. The types existed side by side both spatially and temporally, depending on how useful they were to topographical circumstances.

The 'traditional' wagon 'invaded' Wales along the invasion routes and was not native. The Glamorgan variant belonged to a type well known in southern England and showed the intrusive influence of the English plain, as indeed did both the thatching techniques and the village layouts of the Vale of Glamorgan. The wagons made by his own grandfather differed considerably, and were in the style of the English Midlands. Peate had also developed an interest in furniture, arising from the exhibition of 1936. For this he researched the history of the chair, lecturing on 'Some Light on the Evolution of the Chair' to Section H of the 1938 British Association meeting. Professor Ifor Williams had drawn his attention to a type of chair known as the *lleithig* in the *Gododdin*,[36] and Peate became convinced that this was the chair shown in the Peniarth 28 manuscript (the earliest surviving copy of the Laws of Hywel Dda, also of the thirteenth century) and that therefore there was in Wales a moveable chair with separate legs at 'a period considerably earlier than the evidence for the English lowlands leads us to believe.'[37] Richard Bebb, in his definitive study of Welsh furniture, has accepted Peate's view but without exploring the issue any further.[38]

Peate felt that the work of innovators was critical in areas outside the main geographical locus of the Industrial Revolution. In 1929 the Museum had acquired the type-specimens of three of the inventions of John Williams (*Ioan Madog*, 1812–78), who was engaged throughout his working life in inventing labour-saving mechanical devices. The known examples of his work, created in his smithy on the quay at Porthmadog, included a *pedfuanydd* or velocipede bicycle, a revolving windlass, an expanding jumper or rock drill, a bench machine for making rope-thimbles, and a self-acting sandbox for use on the Ffestiniog railway.[39] By the 1940s he had developed an interest in clockmaking and clockmakers, something he retained for the rest of his life. Peate's first published work on clockmaking was in 1943 with a note on the account-books of two Montgomeryshire craftsmen, to which he drew attention not just because of their intrinsic importance but also in the hope that any reader in possession of similar material might deposit it in the National Library.[40] The first craftsman was a Samuel Roberts of Llanfair Caereinion, a clockmaker, whose account-book of 1755–74 included detailed descriptions of clocks made for 'our Club'; his work was not represented in any public collection.[41] Peate was compiling a catalogue of Welsh clockmakers, and any information was welcome; and was it 'too much to hope that

some public-spirited benefactor will in the near future secure examples of Samuel Roberts's craftsmanship for both the National and Powysland Museums?' The other craftsman was Peate's carpenter grandfather, Dafydd, who was much interested also in literary matters and the incipient nationalism of the age. His early accounts are written nominally in English but with the technical terms as he knew them, such as 'for make a *clwyd* [gate]'; and 'repair the *sgubor* [barn]'. He made a wide range of furniture as well as working on houses and sheds, and his saws were now shown in the Folk Industries Gallery at the National Museum. Peate followed this paper with one on another clockmaker. One deposit of papers such as he wished for was made to the National Library in 1943, when a collection relating to John Tibbot was given by a Llanbrynmair (*sic*) family, including a draft of a letter sent by Tibbot to the Rev. Abraham Rees, another native of Llanbryn-Mair and compiler of the well-known *Cyclopaedia* (thirty-nine volumes published between 1802 and 1820), the letter being a complaint against the Royal Society of Arts for its failure to recognise his contribution in inventing a clock 'on an entirely new principle' in 1816; frustratingly, the Royal Society's papers were inaccessible. Two Tibbot clocks still existed in Llanbryn-Mair and others were known of elsewhere.[42] Such national connections of craftsmen from his own locality must have reinforced Peate's belief in the importance of their role in society.

By 1945 Peate knew enough about the history of clockmaking for the National Museum to publish his list of Welsh clock- and watchmakers.[43] This differed from his previous Museum publications in that the catalogue section was small, for the Museum then had only fifty six items in the collection. In the preface Fox thanked numerous individuals who had helped with information over the years, including 'a small band of school-teachers' who had enlisted their pupils in getting details of clocks in their locality. The author laid no claim to be an expert horologist, but provided a twenty-four-page summary of the history of clocks and watches and how they worked, and the history of the craft in Wales. Poetic evidence from the Middle Ages showed that Wales was not on the fringes of Europe in this matter, and by the eighteenth century Welsh craftsmen were active in London; but it was the spread of clocks into ordinary households in that century which saw the great growth of manufacture this side of the border, the craft often running in families. Some, such as Samuel Roberts, were self-taught, whilst John Tibbot was not

only a maker but a student of horology. During the nineteenth century, however, the Welsh maker gradually became a retailer only, with longcase and other clocks imported with the dealer's name already inscribed on the dial; at the same time there was an influx of foreign makers, mostly German, into almost every part of the country. The introductory essay was followed by a fifty-page list of known makers and a catalogue of the timepieces in the National Museum's collection. Peate published revised editions in 1960 and 1975, by which last date the number of items in the Museum's collections had grown to 179; even though by then out of date, the work was only superseded in 2003 by William Linnard's *Wales. Clocks & Clockmakers*.

Wider platforms

In addition to researching into craft traditions and techniques and lecturing and publishing on the subject, by the 1940s Peate was given the opportunity of another public platform for his wider aspirations. The National Museum had contributed exhibitions to both the Royal Welsh Agricultural Show and the National Eisteddfod since 1919.[44] Isaac Williams, the Museum's first Keeper of Art, had been a leading voice on the National Eisteddfod's Arts and Crafts Committee, where he emphasised the contribution that Welsh artists had made to the English high-art tradition. His death in 1939 left a vacancy which Peate was able to fill with advantage for nearly a decade, serving as Chairman of the Committee in 1945 and 1950 and also organising several exhibitions.[45] One such was at Cardigan in 1942, where he showed items relating to the rural crafts and industries of the county, on which of course he was the unquestioned authority. He had already lectured at the National Eisteddfod before then, as when he addressed the Honourable Society of Cymmrodorion at the Machynlleth Eisteddfod of 1937. He had urged the members to remember the lip-basket maker, the millers of all kinds, the potters, the carpenter and the mason, the thatcher, the turner, the shoemaker, the smith, the clockmaker, the miner and the quarryman –

> This is where you will find the art of the folk. The essence of that art is that it is natural, not something learnt from a book, but the unblemished product of feeling showing itself in a natural way – *unlearned artistry*, as they say in English.[46]

As an example, he referred to the quilt made by the tailor James Williams which he had shown at the Wrexham Eisteddfod four years previously, a colourful composition of thousands of pieces of cloth and which showed a mixture of motifs – some from the Bible, a fragment of the willow-pattern design, and some of the inventions and constructions that were new when the quilt was made – the Menai Bridge and the Pontcysyllte aqueduct with [bizarrely] a train running over it, all in the quilting tradition. Peate was desperately unhappy with the chair that was offered as the principal poetry prize at Machynlleth, which he described as 'repugnant', for it followed the recent tendency to have chairs donated by expatriate Welshmen in exotic styles. He proposed instead that the Eisteddfod should 'ask the Brynmawr designers or the craft departments of our colleges and technical universities to design a chair that would bring distinction to the Eisteddfod rather than leaving it open to competition amongst amateurs or the old fashioned taste of a far flung territory'.[47] The Eisteddfod listened, and the chair for the 1938 Cardiff Eisteddfod was indeed made by the Brynmawr company. By 1946 Peate was flexing his muscles even more. In his opening address to the National Eisteddfod art and craft exhibition at Mountain Ash he noted, 'Not only are the poet and the musician important in the Welsh tradition, but also the craftsman, who has always been a man of importance in Welsh life'.[48] He was also bullish about his intent for the new national open-air museum (for which a site had at last been offered earlier that year), where

> We shall preserve and develop every significant traditional craft in Wales. We shall have craftsmen's workshops where Welsh craftsmen will work and there you will see all the year round what you see at this eisteddfod for one week ... Who can measure the influence of this new development on the whole future of Welsh craftsmanship?[49]

The Eisteddfod's organising committee had already donated £250 towards the open-air museum project. Peate's influence also lay behind a long article by the noted bibliophile Bob Owen on the crafts and industries of Merioneth in the 1949 catalogue, and by now the Rural Industries Bureau was supporting the exhibition, which featured practising craftsmen. Other institutions were also becoming involved in the arts scene in Wales. The recently formed Arts Council of Great Britain had established an office in

Wales in 1946 and appointed the artist and critic David Bell (1915–59) as its officer. His emphasis was very much on developing a professional and contemporary art scene in Wales.[50] His approach may have been partly dictated by his belief that Wales had no visual culture, or as he put it in 1951,

> What painting there has been in Wales has been done by English artists visiting the houses of the landed country gentry and working under their patronage without knowledge of or interest in any native tradition of culture, which, when manifested in literature or religion, we call Welsh.[51]

In this statement Bell ignored Richard Wilson and was seemingly unaware of Thomas Jones, whose genius was effectively first recognised by Ffransis Payne when he was the National Museum's Acting Keeper of Art during the war; but from different starting points he was also in agreement with Iorwerth Peate, who did not believe in the concept of a national art and certainly viewed all the fine art produced in or of Wales as extraneous and irrelevant.[52]

The 1950 National Eisteddfod was held in Caerphilly. As chairman of the organising committee Peate spoke at the opening and wrote the introduction to the accompanying handbook. The committee had tried to reform the proceedings and experiment, one of the most interesting things (he felt) being that it had been decided not to hold a competition in fine art, since that had been criticised by highbrow critics as unlikely to lead to a raising of standards. It was true that the Eisteddfod had not yet made a lasting contribution to art in Wales, and in his mind one of the reasons for that was that 'we' were still too dependent on judges and views from outside the native tradition; and if the Eisteddfod was to make a true contribution in this field, then it had to be bold and brave, and choose adjudicators who knew about Welsh life and education and about the problems facing the artist in Wales.[53] That, no doubt, would lead to a temporary lowering of the standards deemed acceptable to the art world. But if the old saying that living art grew out of living crafts was true, it was also true that an entirely Welsh contribution to the arts would be made by Welsh people whose work was adjudicated by people who knew about Wales. That contribution might be of the standard of 'craft' at first, but it would soon reach the standard of living art.[54] For the exhibition, the National Museum had lent examples of Nantgarw porcelain, and the

National Library some of the poet Islwyn's manuscripts; and Peate lauded as another innovation an Industrial Design competition – 'It won't pay us to restrict the Eisteddfod's interests to the wooden spoon and the "homespun" in an age where science and industry are of such great importance' was how he put it – although he forgot to mention that the Eisteddfod had previously held competitions of timbering in the coal-mining areas and slate-dressing in the equivalent regions: but the experiment was not repeated the following year.[55] In a separate note in the handbook, David Bell explained the rationale behind the ending of the fine-art competition and that an exhibition of work by contemporary Welsh artists was being shown instead, accompanied by the creation of an Eisteddfod collection, to be developed by annual purchases. But Peate was more prescriptive about what needed to be done in his remarks at the opening:

> Welsh artists should not be too complacent about the establishment of a Welsh school of painting just because they have enjoyed a successful exhibition at Caerphilly. If we in Wales are to see a school of Welsh artists, the artist himself must familiarise himself with the whole background of Welsh material life. It is not enough to rear our children to take an interest in art and then export them to England or France. Education abroad is an excellent thing but we will never get truly Welsh artists by depending entirely on others for their training. The Eisteddfod alone cannot produce such a Welsh school of painting but it can help greatly by setting standards and choosing adjudicators who know something of the background of Welsh life and education.[56]

Despite Peate's views, Peter Lord has seen the Caerphilly exhibition as a triumph for the espousers of 'high art' and that David Bell there laid the foundation for the development of art in Wales for the next decade.[57] The importance put on industrial imagery in exhibitions henceforth also enhanced the link between the urban English-speaking proletariat at the expense of Peate's view of an art springing from the native craft and cultural tradition.[58] Peate's work on crafts was innovative, in that no one else had addressed the topic or even seen it as a topic worth addressing. He was the first to see value in this sphere of activity, and in his case it enabled him to not only pay homage to his forefathers but also identify one strand of employment that would help to sustain the Wales of the

future, and a clear contribution that his longed-for Folk Museum could make in training young people to go back and strengthen their communities; sadly, it proved impossible to do this in more than a couple of cases, but providing job opportunities at St Fagans certainly contributed to the survival of several crafts.

Notes

1. 'Pennod o fywyd hen ffatriwr' ['A chapter in the life of an old factory owner'], in *Ym Mhob Pen*, pp. 32–8; 'Two Montgomeryshire craftsmen', *Montgomeryshire Collections*, xlviii (1943), 3–10.
2. Lucinda Matthews-Jones, 'How women from all classes came together in the Splott Settlement', *Western Mail*, 24 January 2017, 20–1; J. Elfed Davies, 'Educational Settlements in South Wales with Special Reference to the Merthyr Tudful Settlement', *Trans. Hon. Soc. Cymmrodorion*, 1970, 177–98; Mary, Eurwyn and Dafydd Wiliam, *The Brynmawr Furniture Makers. A Quaker Initiative, 1929–40* (Llanrwst, 2012).
3. Elen Phillips, 'A picture of the past and a mirror of the present: Iorwerth Peate and the origins of the Welsh Folk Museum', in Owain Rhys and Zelda Baveystock (eds), *Collecting the Contemporary. A Handbook for Social History Curators* (Edinburgh and Boston, 2014), pp. 46–8.
4. Peter Lord, *The Tradition. A New History of Welsh Art 1400–1900* (Cardiff, 2016), p. 301; Oliver Fairclough (ed.), *Things of Beauty: What Two Sisters Did For Wales* (Cardiff, 2007), pp. 81–95.
5. 'A North Cardiganshire Woollen Yarn Factory. Its History, Machinery, Trade and Rural Associations, with a note on a Family of Montgomeryshire Millwrights', *Y Cymmrodor*, 39 (1928), 68–87 (and separately by the Museum, also 1928). As a total aside, my first publication for the Folk Museum was a guidebook to the Melin Bompren corn mill, when like Peate I had to immerse myself quickly in processes and terminology entirely new to me.
6. 'A North Cardiganshire Woollen Yarn Factory', 76, Peate's emphasis.
7. 'A North Cardiganshire Woollen Yarn Factory', 82.
8. 'A North Cardiganshire Woollen Yarn Factory', 84.
9. 'Rhai o Grefftau Ceredigion', *Trans. Cardiganshire Ant. Soc.*, vii (1930), 50–5.
10. 'Rhai o Grefftau Ceredigion', 50.
11. 'Rhai o Grefftau Ceredigion', 53: Peate listed some of William Rees's customers in his paper in Fleure's Festschrift (*Studies in Regional Consciousness and Environment* (1930), p. 183) and they included the Peasant Arts Society and the Rural Industries Bureau in London, The Artificers' Guild in Cambridge, and the Arts and Crafts furniture-maker Stanley Reynolds in Windermere, who later moved to Brynmawr as Paul Matt's deputy and successor.
12. *Studies in Regional Consciousness and Environment* (1930), pp. 175–88.
13. *Studies in Regional Consciousness and Environment*, p. 183.
14. 'Y Naw Helwriaeth', *Bull. Board of Celtic Studies*, vi (1933), 301–12; 'The Nine Huntings', *Antiquity*, 8 (1934), 73–80.

15. William Linnard, 'The Nine Huntings: A Re-examination of *Y Naw Helwriaeth*', *Bull. Board of Celtic Studies*, xxxi (1984), 119–32. We shall meet Professor Griffith John Williams later (Chapter 11).
16. 'Welsh Folk Industries', *Folk-lore*, xliv (1933), 176–88.
17. Middleton Murry, in H. J. Massingham and Hugh Massingham (eds), *The Great Victorians* (London, 1932), p. 176.
18. 'Welsh Folk Industries', 176.
19. 'Welsh Folk Industries', 179.
20. 'Welsh Folk Industries', 185.
21. 'Welsh Folk Industries', 187.
22. A translation by Joseph P. Clancy is included in Clancy, *Twentieth Century Welsh Poems* (Llandysul, 1962).
23. By 1937 Peate realised, with Ffransis Payne's help, that some of the tools illustrated in the sixteenth-century manuscript which he had used as a frontispiece to the book were actually millwrights' tools, and he revisited the document and published a transcript of it, though without commentary. The document lists the 'dos and don'ts' for a miller, like not allowing the wheel to sit so low as to scrape the bottom of the pit or letting the mill sit idle with grain available: 'Traethawd ar Felinyddiaeth' ['A Treatise on Molinology'], *Bull. Board of Celtic Studies*, viii (1937), 295–301.
24. *Y Crefftwr yng Nghymru*; my translations.
25. *Y Crefftwr yng Nghymru*, p. 40.
26. *Y Crefftwr yng Nghymru*, p. 51; my translation. He was later to modify his views about the time lag in fashion as dependent on the distance from London. His chief concern remained the importance of tradition, as with furniture that showed the persistence of early styles into a later period: *Tradition and Folk Life. A Welsh View* (London, 1972), 48.
27. *Y Crefftwr yng Nghymru*, p. 86; my translation.
28. 'Have you ever read "Cwm Eithin" by Mr Hugh Evans or the essay on the "Spirit of Craft" by Professor T. Gwynn Jones in *Y Tyddynnwr* (February 1923)? If you have, then you will already know quite a lot about the past life that is spoken of in this book': *Y Crefftwr yng Nghymru*, 1; my translation.
29. *Y Crefftwr yng Nghymru*, p. 3.
30. *Y Crefftwr yng Nghymru*, p. 10.
31. *Y Crefftwr yng Nghymru*, pp. 10–11; my translation.
32. *Y Crefftwr yng Nghymru*, p. 12.
33. *Crefftwyr Gwlad* ['Country Craftsmen'] (Llandysul, 1971). The *Wales* volume by Anna M. Jones for Oxford University in 1927 was a survey of contemporary craft which did not include a historical perspective.
34. *Guide to the Collection Illustrating Welsh Folk Crafts and Industries* (Cardiff, 1935).
35. 'Some Aspects of Agricultural Transport in Wales', *Arch. Cambrensis*, xc (1935), 219–38.
36. The early oral epic put to parchment in the thirteenth century; but Jarman in his later edition translates *lleithig* as 'bench' or 'couch': A. O. H. Jarman,

Aneirin: *Y Gododdin. Britain's Oldest Heroic Poem* (Llandysul, 1990), pp. 27 and 51.
37. NLW ICP Papers A4/2, The Chair, typed lecture text and letter of 9 February 1938 from Ifor Williams; also Iorwerth C. Peate, 'Some Welsh Light on the Development of the Chair', *Apollo* (December 1938), 299–300.
38. R. Bebb, *Welsh Furniture 1250–1950. A Cultural History of Craftsmanship and Design. Vol. I 1250–1700* (Cardiff, 2007), p. 106.
39. 'A Caernarvonshire Inventor: A Note on the Work of John Williams (*Ioan Madog*)', *Y Cymmrodor*, xlii (1931), 148–54.
40. 'Two Montgomeryshire Craftsmen', *Montgomeryshire Collections*, xlviii (1943), 3–10.
41. On Samuel Roberts see W. T. R. Pryce and T. Alun Davies, *Samuel Roberts Clock Maker. An eighteenth-century craftsman in a Welsh rural community* (Cardiff, 1985).
42. 'John Tibbot, Clock and Watch Maker', *Montgomeryshire Collections*, xlviii (1944), 175–85.
43. *Clock and Watch Makers in Wales.*
44. *Twelfth Annual Report, 1918–19* (1919), p. 10.
45. Peter Lord, *Y Chwaer-Dduwies. Celf, Crefft a'r Eisteddfod* ['The Sister-Goddess. Art, Craft and the Eisteddfod'] (Llandysul, 1992), pp. 107–8.
46. 'Diwylliant Gwerin', *Trans. Hon. Soc. Cymmrodorion*, 1937, 241–50; my translation.
47. Mary, Eurwyn and Dafydd Wiliam, *The Brynmawr Furniture Makers*, p. 110; my translation.
48. *Western Mail*, 6 August 1946, 3; my translation.
49. *Western Mail*, 6 August 1946, 3; my translation.
50. For a detailed analysis of Bell's activities, see Peter Lord, *Y Chwaer-Dduwies. Celf, Crefft a'r Eisteddfod*. Bell was quite supportive of Peate's efforts to preserve craftsmanship at St Fagans: David Bell, *The Artist in Wales* (London, 1957), pp. 104–6.
51. David Bell, in *Welsh Anvil* (Cardiff, 1951), p. 26.
52. 'I abhor all this recent noise about "Welsh National Art". There is no such thing as national art. There are artists who are Welsh and that alone': 'Cymru a Chelfyddyd' ['Wales and Art'], *Heddiw*, 4 (1938), 40; my translation.
53. Iorwerth C. Peate, 'Rhagair' ['Introduction'], *Llawlyfr Arddangosfa Celfyddyd a Chrefft Eisteddfod Genedlaethol Frenhinol Cymru* ['Handbook to the Arts and Crafts Exhibition of the National Eisteddfod of Wales'] (Cardiff, 1950), pp. 5–6.
54. Peate, 'Rhagair', *Llawlyfr Arddangosfa Celfyddyd a Chrefft Eisteddfod Genedlaethol Frenhinol Cymru*, p. 6.
55. *Western Mail*, 8 August 1950.
56. *Western Mail*, 8 August 1950.
57. Peter Lord, *The Visual Culture of Wales: Imaging the Nation* (Cardiff, 2000), p. 399.
58. Peter Lord, *The Visual Culture of Wales: Industrial Wales* (Cardiff, 1998), pp. 232–3.

6

The search for the Welsh house

A topic worth studying

Although he actually wrote relatively little on the subject, the publication of *The Welsh House* in 1940, together with the heavy emphasis on traditional buildings as the most obvious part of the visitor experience at St Fagans, has meant that Iorwerth Peate is often identified as one of the leading exponents of the study of traditional buildings in Wales (he detested the term 'vernacular architecture' – the adjective related only to language, in his view). He was one of the very first to pay proper attention to the subject in Britain, and certainly within a museum context. On arrival in Cardiff he was invited to visit a man to whom he had been introduced in Aberystwyth and of whose work he knew, Daniel (later Sir Daniel) Lleufer Thomas (1863-1940). As Secretary to the Royal Commission on Land in Wales in the 1890s, Thomas had compiled the massive volume of historical appendices that accompanied the Commission's report, and as part of that had studied a group of old farmhouses in his home area of north Carmarthenshire. As a result of this visit Peate resolved to include the study of traditional homes within his research remit; he was encouraged similarly by the great master of Welsh history, Sir John Edward Lloyd (1861-1947).[1] Very little had been published in Wales on the subject before Peate started his researches – Lleufer Thomas's work, an excellent article on the round-chimneyed houses of the St David's area and another record of a derelict house near Strata Florida, and a charming and important little book on the old cottages of Snowdonia, but hardly anything else.[2]

Between 1934 and 1938 he devoted some of his summer holidays to visiting traditional buildings across Wales, and in being allowed some official time for this became the first person paid to study the subject in Britain.[3] His original scheme had been to carry out a series of regional studies, but ultimately that was prevented by other duties and the looming shadow of war.[4] In 1934 he examined parts of Cardiganshire and Carmarthenshire, reporting that 'An interesting type examined and planned is that of the long farmhouse, with the living-room and cowhouse adjoining and separated only by the *penllawr* or *bing* (feeding-walk)'.[5] He extended his visits to Pembrokeshire and Montgomeryshire in 1935, when he noted the alarmingly rapid disappearance of mud-walled cottages and the fact that most of the round-chimneyed houses recorded some forty years previously in the St David's area had disappeared; to Radnorshire and the borders in 1936; to Denbighshire and a return visit to Cardiganshire in 1937; and to Anglesey, Caernarfonshire and Denbighshire again in 1938, when he noted that the complete rebuilding of farmhouses on many large estates in the last fifty years had increased the difficulties of his survey. In that year too he noted 'It is hoped to publish the 1940 volume of *Y Cymmrodor* as Part 1 of this survey, when the problems mentioned in this note will be discussed more fully'.[6] He summarised his interim findings in an eleven-page article entitled 'Some Welsh Houses' in *Antiquity* in 1936, where for the first time he proposed the term 'long-house', a direct translation from the Welsh-language term he had heard in the field, 'tŷ hir'. Here also he outlined his ambition –

> by studying all old houses which are still in existence in Wales, by segregating and distinguishing the types and their distribution and by relating them to those described in Welsh literature it may be possible to solve that interesting problem – the evolution of the Welsh house.[7]

But the shadow of a second European war was spreading, and having a direct effect on some of the buildings in which Peate, and Fox too, were by now interested. As part of its rearmament programme, the government had decided to build new airfields and training schools for the Royal Air Force. One of these developments was the creation of a bombing school on the Llŷn peninsula in Caernarfonshire. Even though protests against the construction of some airfields in England had partly succeeded, and

The search for the Welsh house

there was considerable local and national opposition in Wales, the small gentry house of Penyberth near Pwllheli was demolished in 1936 in order to build a new RAF station, and the site became the scene of the first direct action by the National Party of Wales and part of its founding mythology. Penyberth was an old house, with the family's ancestry recorded from the late sixteenth century.[8] Peate had reported in the Welsh-language press on the Council for the Preservation of Rural Wales's attempts to ensure that the area was not harmed by the development, but it was only after the house was demolished that he showed real interest. In September, months after its demolition, he wrote to draw Fox's attention to the matter: 'I note that the Air Ministry have demolished Pen-y-berth . . . to make room for their new bombing range . . . Would it be possible to ascertain whether the fittings, panelling etc. are available for our collections?' Fox visited the site that November, where he examined the piled-up timbers removed from the house. Fox thought the house was 'late Gothic' in style and date, of about 1500 – about a century earlier than it was in reality, it would seem. A local farmer donated to the National Museum a section of oak panelling and a window-head that he had saved.[9]

A similar issue now arose in Pembrokeshire. In 1937 the Navy bought a substantial proportion of the Trecŵn estate in Llanychaer near Fishguard. The smallholdings so acquired were almost all vacant, and their cottages mostly uninhabited or in ruins. The Navy gave permission for the National Museum to record any site it thought of interest before work began on Royal Naval Armaments Depot (RNAD) Trecŵn in 1938.[10] Fox and Lady Aileen recorded eighteen cottages in the company of a former resident. They measured the cottages in detail, tabulated the results and sought to place them into a chronological sequence based on their architectural and constructional details. Fox published his findings in an article well illustrated with photographs and plans in *Antiquity* in 1937. This was the first detailed study of traditional cottages in Britain, and the first to treat them as subjects worthy of scientific observation and analysis equivalent to 'proper' archaeological material. He concluded that 'It is urgently necessary, as a basis for the scientific study of the social anthropology of Britain, that the two-roomed cottage should be measured, planned and described in all its variations, and that the range of these variations should be plotted.'[11]

The Vale of Glamorgan was also being affected, and Peate saw an area he had come to know and love being changed into something different

and worse.[12] To his mind, the Vale in the 1930s remained that of the eighteenth-century mason-poet and antiquary Iolo Morganwg and the nineteenth-century radical preacher Edward Matthews, and remained an area where many of the older inhabitants still spoke Welsh. A new military airfield was built at St Athans in 1938, with satellite fields at Llandow and Rhoose (now Cardiff-Wales Airport). To an unwavering nationalist and militant pacifist, the government's war preparations fell like a dark shadow, and their effects were among the recurring themes of Peate's poetry of this time.[13] On the land bought by the Air Ministry for RAF Llandow or nearby were a number of burial mounds, and Fox and Aileen excavated these in advance of their destruction.[14] But the site had on it in addition an old farmhouse called Six Wells, and this too was demolished. Peate visited the house in December 1939, noting that the Museum would be interested in obtaining the freestone frames of the main door and two windows for the collection. However, Fox was at hand to study it before its demolition, and because he had persuaded Ministry of Works officials to create detailed plans the Museum was able to publish a twenty-eight-page study of the house.[15]

Peate's dealings with the creation of the Epynt firing ranges could be construed as similarly tardy, but he was acting under wartime constraints. In February 1940 the government confirmed that the army was to take over by compulsory purchase 60,000 acres on Epynt Mountain in Breconshire, including seventy-nine farms. Epynt was an almost entirely Welsh-speaking community and the issue quickly became an emotive one. In the last week of June, a week before the inhabitants were evicted, Peate went 'to visit all the houses that had been emptied – and to measure and photograph them (where needed). In this way there would be a record of one aspect of a lost culture'.[16] He wrote an emotive essay about his visit (which he republished three times), perhaps the single piece of prose which most completely encapsulated his feeling for the rural, Welsh-speaking Wales of his childhood, noting the heart-rending comments of an old lady who was about to be thrown out of her ancestors' home and who told him 'it is the end of the world here'. He certainly photographed some of the farms – according to the *Annual Report* he spent eight days surveying and photographing about sixty farmhouses[17] – but this essay is the only written record that ensued from his visit, and no records other than the photographs survive in either the Museum files or Peate's own papers.

It is interesting to speculate what might have been the consequence if it had been Fox rather than Peate who visited Epynt. Fox would have lacked Peate's cultural sensitivity to what was taking place,[18] but he would have studied and recorded what he saw in detail. In his review of the *Westmorland* volume of 1937 by the Royal Commission on the Historical Monuments for England, Fox had already noted that there was nothing to indicate that the importance of farm layouts as illustrating economic and cultural connections was or ever had been appreciated.[19] Looking at what Fox did with the cottager community in north Pembrokeshire, it is very likely that a Fox study-visit to Epynt would have led to a detailed and innovative study of farmhouses and farmsteads in the area, which would have been the first study of the buildings of a complete rural community in Britain. But that did not happen, and the National Museum's official record of this community is a collection of photographs and a literary essay, and a blacksmith-made door-fitting, which Peate had written to the authorities to ask for after his visit.

The different approaches adopted by Fox and Peate came to the fore openly in 1939. To set the context for that we must go back a few years. The journal *Antiquity* in 1927 had included a review that would become notorious in the annals of British archaeology. Its author, 'O.E.', is widely believed to be Mortimer Wheeler, then in his last year in Wales. His subject was the *Inventory* volume on Pembrokeshire published by the Royal Commission on Ancient Monuments in Wales. The review excoriated the Commission's antiquarian approach, its dependency on published sources and the total absence of fieldwork. It described the treatment of architecture as totally inadequate.[20] Fox, appointed a Commissioner in 1926, agreed and proposed a series of guidelines for drawing up future *Inventories*. They included the proposal that all structures of before 1714 should be included, with special attention directed to including any domestic structure, however simple, that could reasonably be held to have been erected prior to that date. By the time the Commission had moved its focus to Anglesey in 1930 it was reported that a typology of domestic and ecclesiastical architecture was being developed for the island, and in March 1931 Commissioners requested that special attention be given to 'humbler dwellings'. The Anglesey *Inventory* was published in 1937, and Fox praised it within the Commission as '[having] not only set [a] fresh standard for work in Wales, but dealt more completely with the archaeology and history of the district concerned than

did the publications of fellow Commissions for England and Scotland'.[21] Not everyone agreed. Iorwerth Peate was invited to review the volume for the county society's *Transactions*. In a characteristically hard-hitting four-page essay, Peate noted that whilst the English Commission was obliged to deal with structures up to 1714 and their Scottish counterparts up to 1707, no such date-limit was imposed by Charter on the Welsh Commission. According to its Chairman's preface to the volume, it had *chosen* to 'deal with the more important or typical buildings up to the end of the eighteenth century and by exception with a few outstanding examples of the early nineteenth century erected before the general decay of architectural and artistic tradition'. But Peate noted that actually *every* parish church had been recorded, whatever its date and merit, but not a single Nonconformist chapel. Peate acknowledged that the *Inventory* followed much of the good presentational practice already common to the English Commission, which did result for the first time in a summary of domestic architecture in the introduction. His comments on domestic architecture are worth quoting:

> The architecture recorded in this volume is that of church and mansion not of chapel and cottage. It is true that there are four photographs of cottages, a page of house-plans and bare references to the existence of cottages scattered throughout the volume. But most of the house-plans are of *plasau* [gentry houses] while those of the cottages are so small and inadequate as to be valueless. We are told that the character of Anglesey architecture 'is ultimately dependent upon English influences ... at no stage is there evidence of the growth of a native style'. Furthermore, we learn that much of the 'earlier local work is characterised by an obvious lack of understanding ... due in part to the isolation which Anglesey shared with the rest of N. Wales'. Later in the same chapter mention is made of 'buildings characterised ... by a native individuality'. I have pondered over these statements and have come to the conclusion that they must mean Wales has a distinctive architecture only to the degree in which it has absorbed English influences. But throughout Anglesey are to be found examples of a cottage type which, while it is found sporadically in England, is characteristic of the whole of the Welsh plateau and has greater affinities with Irish architecture than it

has with English. A Pembrokeshire variant of this type has been dealt with by Sir Cyril Fox in *Antiquity*, but in this Inventory such a treatment is notable by its absence.[22]

But the larger houses *were* allocated a plan, and an attempt was made to place them into a chronological sequence, identifying the staircase as the chief typological feature from the sixteenth century onwards. A page of comparative plans, to scale, was provided, and whilst those of the half-dozen ordinary farmhouses and cottages reproduced were indeed miniscule, they were no smaller than the plans provided for most parish churches. Peate will have known that Fox was a Commissioner, but perhaps not that he was the single person to have done most to drag the Welsh Commission to this point; but even if he did, it would probably have made little difference to him expressing his views without fear or favour.

'The Welsh House'

Peate completed *The Welsh House* in March 1940. The book is an extremely well-illustrated 200-page volume with all the prerequisites of a scholarly work, with every page comprehensively referenced. According to the author, it was based on 'a field survey and the facts so collected . . . supplemented by material from various written sources'. Tellingly – particularly so for a geographer – the second paragraph of his preface explained that he had chosen not to include any distribution maps, for they were not only useless, but misleading, since they would record only twentieth-century survivals, and what was the value of that? He would have preferred to have written the book in Welsh, but there was an increasing and welcome tendency amongst researchers in small nations to write scientific works in one or other of the great international languages; for the sake of accuracy 'and as a true record' Welsh-language quotations were included and translated into English. Peate began his Introduction by noting that folk culture as a subject for serious scientific study had only recently come into its own in Britain and that, to a high degree, only in Wales. The development of the 'Machine Age' and its consequences had transformed country life to a degree beyond comprehension; whilst many of those developments were to varying degrees beneficial, their cumulative effect for the student of Folk Culture was to destroy a mass of hugely important

evidence – and none more so than the evidence for illustrating past living conditions, particularly housing. Social reformers (estate owners and local authorities) had replaced traditional dwellings with new houses, but had done so at a time when good taste in architecture was at its nadir; and so extensive was this replacement of the old by the new that some people had maintained that Wales had no architecture.

But Wales had always been a land of peasant communities, rooted in its geography. Wet uplands were not places where architectural forms based on the rich cultures of the sunlit Mediterranean would have developed. A city-less peasant community had no need for splendid public buildings, whilst a nation without sovereignty could not foster the fine arts except through indirect and largely innocuous means. In such a country, incorporated since 1536 in a powerful neighbouring state, native architecture was non-professional in nature and expressed only in the homes of the peasantry. The architecture of native and incomer were fundamentally different and had their roots in different traditions. The former had remained essentially unchanged until the coming of industrialisation and its associated urbanisation, which saw a great rebuilding of the Welsh countryside. Nevertheless, he recognised that there were differences within peasant architecture, depending not only on climate and geography but also *'according to the social condition of its occupant or builder and his economic status'* (Peate's italics).[23] In many cases his wanderings in search of old houses over the previous twelve years had proved to be in vain, as historic structures were either left to decay or deliberately demolished.[24] Recently, too, the effects of the march of time were being aided by 'wanton and unintelligent destruction' by the Air Ministry and other agencies. Nevertheless,

> There is much to be said – if we wish to assess the extent of the survival in modern times of old types – for a careful survey of the distribution of every type of house in Wales, and the preparation of detailed distribution-maps of all such types [the same distribution maps that a few pages earlier he had castigated as valueless!], with measured plans and descriptions of each variation. [But] It became obvious to me that such a survey was beyond the ability of a museum official working on his own ... Such detailed surveying, parish by parish, is essential and will be carried out, if circumstances permit, over many years.[25]

It was also clear, he noted, that it was not possible to adapt some of the techniques used in archaeological research to the study of living cultures.

The first chapter proper of the book was on building materials. The traditional craftsman built as simply as possible in the materials available locally to him, but the nature of those materials varied from district to district, depending on factors such as geography, climate, height, soil, topography, geology and the tractability of the materials themselves: here, unquestionably, was Peate the geographer. Wales was an upland fortress on the edge of lowlands that stretched all the way to the Urals, and over this 'sea of lowland the tides of centuries have swept to break upon the fortress of the west'.[26] This upland, moorland, landscape had become a refuge of 'ancient racial types, of bygone customs and forgotten things', but geography had also conspired to create isolated communities. Now, however, the end of dependence on local materials had resulted in 'the widespread bad taste in modern building ... and in the absence of the craftsman's skill in building and the craftsman's restraint in design'.[27] In terms of building materials, the country could be divided into five main areas: Anglesey and Llŷn in the north-west were characterised by mud cottages as well as stone structures, as indeed was north-west Pembrokeshire. Hard rocks and slate, and the creation of crucks from oak, characterised the Harlech Dome and eastern Caernarfonshire, also in the north-west; mud and clay were in common use on the upland plateau of much of the interior, together with the primitive use of stone, accompanied by crucks; south Wales had its Old Red Sandstone, and the Vale of Clwyd in the north-east featured half-timber, brick and limestone, whilst the adjacent northern coalfield had sandstone as well as brick; and finally the south Wales coalfield had its Pennant sandstone, used for roofing as well as for walling.

The following chapter on circular houses provided a summary of current knowledge, using both archaeological reports and secondary sources. Most of the excavated evidence came from stone-built sites in western Wales; presumably houses in the eastern half of the country were built of timber. He suggested tentatively that the variety of hut-circles recorded in north-west Wales might represent social gradations or be chiefly residences. Lleufer Thomas had noted the previous existence of 'ink-bottle' houses (after their shape) in the squatter districts of mid Wales, but he himself had failed to find traces of any or anybody who could describe examples. One form that did survive was the corbelled circular pigsty of south Wales, for which he had by now evidence of the existence of

thirty-five examples, several of which he had photographed and published here; but again, he felt that a map of their distribution would be misleading.[28] Peate saw the Welsh pigsties as representing a survival of the beehive hut as found in Ireland and Scotland and elsewhere, although the recorded examples were all very late.

Most of the contents of his chapter on the long-house had already been published in 1936, and indeed most of the plans here (fourteen in all) and in the earlier paper were redrawn from the plans commissioned by Lleufer Thomas for his 1896 report.[29] Peate quoted documentary evidence (rather thin and ambiguous) to support his supposition that the type was once to be found all over Wales. He linked the long-house to the central-chimney house identified by Åke Campbell as one of two overarching plan-forms common in Ireland, a typology based on the location of the main fireplace, either at the gable or in the middle of the structure: 'The central-chimney type is to be found widespread in Wales in another form – in the houses where both men and cattle are found under the same roof, a type which we shall call the "long-house".'[30] The form was a response to environmental conditions, found throughout much of Europe as well as the 'Keltic' lands, but with two different forms, with the 'Saxon house' having the cattle stalled in the aisles of a wide building very different from types found in the British Isles.[31] Here, Peate demonstrated a tendency to read more than the reality into his evidence, quoting as examples of 'long-houses' descriptions which omitted the vital evidence of intercommunication between the two halves, whilst in Merioneth 'there was much evidence of the former existence of long-houses', but he found no examples surviving.[32] He identified the significant features as intercommunication, a transverse passage used as a feeding-walk and the house part with its floor higher than that of the cowhouse,[33] and although he knew of a few instances with a gable fireplace (such as Cilewent, which he later acquired for St Fagans), the usual location of the main fireplace was against the internal wall which separated the dwelling from the cowhouse.[34] Despite crediting Lleufer Thomas extensively, however, Peate chose to ignore Thomas's carefully constructed model of development for long-houses which was at odds with his own interpretation of the long-house as always having been a single-period construction, and which was to be the cause of much discord later (Chapter 10).[35]

He was equally interested in cottages, if only because the *tyddynwyr* (crofters) 'formed in a very real sense the essential nucleus of the Welsh

nation'.[36] He classified Welsh cottages largely on the basis of what he and Fox had seen, mostly the nineteenth-century examples found in the west, since he had seen only 'a handful' of central-chimney cottages.[37] Indeed, this chapter took much of its content and five of the ten text illustrations from Fox's 1937 paper,[38] though Peate also showed a keen awareness of work on Irish houses. 'The simplest type of rectangular cottage found in Wales is the single-roomed gable-chimneyed structure, where the occupants live and sleep in the same room',[39] while 'the next development... was the cottage partitioned into two "rooms"', either by furniture or partitioning.[40] A further development saw the setting aside of part of the sleeping-end for a dairy or a pantry.[41] The next typological stage was the creation of a loft above the sleeping-end. Early examples could have had the loft open, and with a removable ladder; later examples had their fronts boarded and a ladder fixed in position. Peate chose the term he was familiar with – *croglofft* (lit. 'hanging loft'),[42] cognate with the English 'cock-loft' – to describe this feature.[43] In his group of Pembrokeshire cottages Fox had observed that the dairy was usually placed next to the hearth, and thought this relationship ancient;[44] Peate chose to interpret Fox's reasoning to mean that the *croglofft* form was ancient, and disagreed, seeing it as 'a post-mediaeval development influenced (possibly but not necessarily) by the introduction into the Welsh rural economy of houses of more than one storey. In type and date, I believe the *croglofft* development to be comparatively recent.'[45] On the other hand, Fox had suggested that the distribution of the *croglofft* cottage was 'coastal, and west coastal at that', but Peate showed that it was wider, though he agreed that the type had survived in greater numbers in some coastal counties than in inland ones. However, 'no distribution significance should ... be attached to this fact since it happens that those areas in which it has so survived have been less affected by rural rebuilding than most other parts of the country',[46] a statement entirely at variance with what we now know about the 'Great Rebuilding' of the Welsh countryside. Peate felt that the two-storeyed cottage had developed earlier in those parts more open to English influence, such as Monmouthshire and the Vale of Glamorgan, whilst in parts of mid Wales, the single-storey cottage developed horizontally rather than vertically.[47] But in reality, the culture of Wales was different from that of the greater part of England, and closer parallels were to be found in Ireland, or indeed 'throughout the Keltic zone of the British Isles'.[48]

The curiously located next chapter was devoted to literary testimony in the early Welsh Laws and elsewhere, but he had nothing particularly new to say here (Timothy Lewis had already discussed the evidence but is not credited, although it is inconceivable that Peate was unaware of his work).[49] Nevertheless, this was a scholarly discussion incorporating the latest evidence and thinking on the interpretation of details in the Latin and Welsh-language versions of the Laws of Hywel Dda (died c.950: the earliest surviving written versions are of the early thirteenth century) relating to the value of buildings and their constituent parts, which in turn offer clues to building structure. He concluded that the *fforch* (L. *furca*) was in fact a pair of crucks (*nenffyrch*), and that the Welsh royal residence was a structure based around three pairs of crucks (six columns), which could also allow for aisles. Peate could not accept Lady Fox's explanation of the *fforch* as an upright post, forked at its tip to hold a ridge, as that would have resulted in a central-posted structure. The many references to hurdles, wattling, poles, rods and side-posts were well illustrated by a house recorded in the Strata Florida district of Cardiganshire in 1888, which had its roof supported by upright posts probably put in place after the ends of the cruck-trusses had been cut off due to rotting. Peate chose not to discuss the rectangular buildings which the Foxes had excavated on Margam mountain and at Gelligaer, which might or might not have been *hafotai* (temporary summer dwellings or shielings), since their 'problematical character' precluded any discussion.[50] An appendix listed houses mentioned in mediaeval literature, such as Iolo Goch's contemporaneous description of Owain Glyndŵr's house at Sycharth.

The following chapter, 'Some Stone and Half-Timbered Houses', is the least original in the book. The discussion of stone houses was based entirely on J. Romilly Allen's 1902 article on the round-chimneyed farmhouses of the St David's peninsula, with all sixteen illustrations and plans taken from Allen's paper; Peate acknowledged this and defended it by noting that much of what Allen had recorded had disappeared by the time he himself had attempted to study the area[51] (he discovered two more in 1942 and they are named, but no more, in the 1946 edition of *The Welsh House*). Peate concluded that these houses represented the convergence of two or more traditions:

> The central passage way and the opposite doors which occur regularly are a feature of folk buildings found throughout the whole of

> north-west Europe ... The nave-and-aisle lay-out ... is strongly reminiscent of the houses of the Welsh Laws ... it is reasonable to conclude that the north Pembrokeshire farmhouses are not an exotic type but represented the survival and modernisation of a well-established Welsh lay-out [in timber] adapted to a new stone technology introduced by the castle-builders of Norman and English times.[52]

The five pages devoted to timber-framed houses are weaker still, for hundreds of such structures were to be found in Peate's home county of Montgomeryshire and he should have made much more of an effort to identify how common and indeed ubiquitous in the area their plan-form was. But it was not his fault, for

> A detailed survey parish by parish is necessary to discover the present distribution of such houses and it is to be regretted that in the past the Royal Commission on Ancient Monuments in Wales neglected this aspect of their work. The Inventories relating to Denbighshire, Montgomeryshire and Radnorshire do not illustrate any such houses.[53]

Nevertheless, he felt that central-chimney houses represented a link between circular and rectangular houses. Welsh timber-framed houses belonged to a wider European tradition but also showed environmental influence and possibly a native tradition.

The last chapter, on building construction, is in many ways the best, though it would have made more sense to incorporate it within the chapter on building materials. Here he brought together to good effect the evidence of the early tourist observers with those of his correspondents and his own observations. This is where he came closest to reminding readers that his subject was the result of people creating to serve their own needs, and brought to the fore the work of the rural craftsmen so close to his heart, such as the thatcher, the moss-man, the carpenter and the plasterer. But the chapter also contained great lacunae, with the cruck truss essentially the only roof-form discussed in any detail. Although Hughes and North had argued that crucks were the products of a native Welsh tradition, Innocent believed them to be an English invention which spread into Wales; but, somewhat bizarrely, Peate thought that their

development in Wales was 'a long and complex story with which we are not concerned',[54] although he concluded that the cruck truss was a feature of building construction found throughout north-western Europe and well established throughout most of Wales.[55] His descriptions of thatching techniques and of doors, windows and chimneys showed his wide reading of early sources.

Apart from a few letters and photographs sent to him and kept amongst his personal papers, and a large collection of photographs in the Folk Museum photographic archives, no other materials pertaining to his research on houses survive (in marked contrast to Fox's detailed field diaries and text drafts), and it is accordingly difficult to know how much his fieldwork tours informed his final text. The impression from the book is that he made use of all he could find, particularly the examples of long-houses additional to those recorded for Lleufer Thomas, and cottages in Caernarfonshire. One clear benefit of his fieldwork, however, was that Peate saw three buildings that would later be re-erected at St Fagans, namely Llainfadyn cottage, Abernodwydd timber-framed farmhouse from mid Wales, and Cilewent long-house. Wheeler might well have noted that the book could have benefited from using a great deal more original recording and observation, and less already published material: certainly, the book would have been much poorer had he not included so much of Thomas's, Fox's, Allen's and Williams's work and their plans. As it happened, these served well to demonstrate the continuity with the deep past that he sought in following his declared aim of tracing the evolution of the Welsh house. All the evidence that he incorporated from these predecessor studies could in different ways be construed as deriving from the house of the Welsh Laws, but in truth there was nothing of substance that he did not use if it was relevant and available, such as the Victorian illustrations of timber-framed houses from Montgomeryshire. Fox's research on cottages was fortuitous, but the other buildings had been recorded because they were thought to be rare and threatened survivals which threw light on the early ancestry of the Welsh house; and in this sense Peate was very much following in an endeavour typical of the last decades of the previous century. An overview should properly draw upon all available evidence, but from today's perspective it serves to highlight the lack of original material – though as a groundbreaker, the study retains value.

How was Peate's volume received? The first edition was a small one, printed in wartime with only some 300 copies available for general

sale, but the book was reprinted in 1944 and again in 1946, selling in all 4,000 copies.[56] The Cambrian Archaeological Association awarded the author the G. T. Clark prize for the best book published during the preceding decade on the archaeology of Wales and the Marches in the post-mediaeval period, though there was little competition.[57] Reviews of the book were largely favourable or very favourable. A brief review in the *Times Literary Supplement* pointed out that 'mere Saxon readers' would have been grateful for a brief summary of the differences between such Welsh houses and their English counterparts, but was generally most positive and not put off by the 'sturdy nationalism felt between the lines of the writing'.[58] The architectural historian John Summerson (then still relatively unknown) noted that 'Mr Peate's book is important – one of the few really firm contributions to the study of folk-building in these islands ... A first class contribution to our knowledge not only of Welsh, but of English and European folk-building'. Summerson deplored the reluctance of scholars to tackle the English regional vernaculars in a similar spirit.[59] Irish comments were favourable.[60] Estyn Evans, now located in northern Ireland, was generally complimentary, but had to note that Peate's division of Wales into eleven geological regions was not reflected elsewhere in the book.[61] The Directors of the Irish Folk Commission and the Manx Museum were positive.[62] It was not until 1943 that his great hero W. J. Gruffydd was able to review the work, whilst regretting that he knew of no Welsh-speaker who could do justice in a review, but his was highly positive.[63]

The archaeological view was different. C. A. Ralegh Radford penned a three-page review for *Archaeologia Cambrensis* in which he expressed his disappointment that this was not the work that the subject deserved: 'The text shows little real appreciation of the problems involved. In describing the buildings it too often ignores or dismisses evidence which does not fit the author's theories or predilections.' Ralegh Radford took at face value Peate's words about peasant architecture being the only true architecture, and regretted that Peate had drawn too hard a line, for surely cottage shaded into farmhouse and the larger farmhouse into the house of the poorer squire.[64] Peate responded immediately. Anthropologists, historians and architects alike had all praised the book: it was only archaeologists who felt otherwise, and that was because they misunderstood the nature of folk culture and persisted in treating it as merely an adjunct to their own discipline and using their own methodologies. Worse, they thought that the subject dealt only with the social class known in English as

'peasants'.[65] This is another example of Peate's inconsistency: he was criticising Radford for pointing out that a holistic rather than a narrow view was needed, exactly the reverse of what Peate was castigating him for; but at least he had the sense not to send the more extreme response that he had also drafted.[66] It also seems not to have occurred to him that it was neither snobbery nor prejudice that fuelled the archaeological response, but rather what they viewed as a lack of academic rigour.

And what of that other archaeologist, Peate's immediate superior at the National Museum? Fox reviewed *The Welsh House* for *Antiquity*. First, he placed the work in context:

> This lavishly illustrated book has been awaited by an increasing body of persons interested in the peasant cultures of Britain and their expression in building construction. The record of our farm layouts and farmhouses, of our cottages and crofts . . . is woefully inadequate. In this respect we lag far behind continental countries . . . The lack of applied scholarship and University interest in these matters is deadening.[67]

There follow some minor disagreements, and Fox noted that he was now disposed to revise his ideas on the character of the roofs described in the Welsh Laws – crucks rather than central posts seem to have been the supports. Peate's appraisal of the cruck as a Highland Zone technique, widespread in Wales from an early date, felt convincing; and the other important achievement of the book was to draw attention to the significance of the long-house. However, Fox was not impressed by the fact that none of the fourteen plans of long-houses had a drawn scale; they did not differentiate between original and later work; and there were no drawings illustrating their construction (in marked contrast to Fox's own detailed study of Pant-y-betws, Llanfihangel Rhos-y-corn, Carmarthenshire, published in the same volume as the review).[68] The fundamental problem with the work, Fox felt, however, was that its layout was topsy-turvy: 'Mr Peate's cart is in front of his horse', since his chapter of building construction was the last in the book. Moreover, that subject was treated perfunctorily:

> There are many roof types, but the one dealt with is the cruck; and its devolution is, Mr Peate says, 'a story with which we are

not concerned'. But those who are interested in the 'Welsh House' cannot help being concerned with such details. They are overwhelmingly important in a peasant country where simplicity and absence of ornament make the dating of buildings difficult.

His criticisms were not meant to be carping, for Peate's task was urgent and important, and he was the pioneer in the study, on a fully national scale, of folk culture as expressed in Welsh houses. But construction, Fox felt, represented the grammar of the new language that Peate was teaching – 'the tongue in which the folk buildings tell their story', and those fundamental issues had first to be understood.

Fox's review had encapsulated the essential difference in approach between the two men. Peate regarded development and temporal change as relatively unimportant and unlikely to have influenced fundamentally the almost unchanging life of the folk of Wales, with physical geography a far more dominant influence. Fox, on the other hand, felt that a people's story could not be told without assessing how they changed and adapted to new and often initially foreign factors. How was it possible to write 'A Study in Folk Culture' – *The Welsh House*'s subtitle – by effectively ignoring changes in people's lives? Peate addressed many of Fox's criticisms in his preface to the second edition of 1944, though without naming him – 'To suggest that Folk Culture is concerned only with the bondsman's dwelling and the labourer's cottage is to misunderstand completely the meaning and scope of the subject'. He also offered an apologia for the lack of drawn scales, but with a characteristic sideswipe directed at 'the fastidious critic to whom a *drawn* scale is still a fetish'.[69] He had to observe that 'with the best teachers, grammar comes last if indeed it is ever taught as such'.[70] He also noted that travelling restrictions meant that there was little new material to include. But he had to stress that folk culture encompassed the rich as well as the poor, and the study should therefore accord a place to gentry houses (which he had not done): the difference between them and the homes of the poor was merely one of degree and not of kind. Finally, he noted that his work was only preliminary, until such time as those who had given so much attention to potsherds and earthworms would devote the same to this subject. In the meantime, 'I resolutely refuse to theorize on insufficient data' (*sic!*).

Peate's identification of native culture as essentially timeless and with homes reflecting principles dictated by custom, environment and place

suggests that although he classed himself as a radical in the great Welsh nineteenth-century tradition of his native Montgomeryshire, intellectually he owed as much to William Morris and the romantic socialists of the Arts and Crafts Movement;[71] and indeed he ended the work with a quotation from Morris. In this context, it is perhaps not surprising that he was in effect working to a predetermined script – indeed, one that he might not have been aware of – that too much analysis would have undermined. Perhaps it is only with hindsight, too, and ignoring the circumstances of the time, that we can identify that the fundamental problem with the book was one of timing – Peate recognised that he would not have the time to carry out the regional surveys that were necessary to underpin a Wales-wide overview, but in reality this introduction to the subject should really have been the concluding volume of a series rather than the first published; as a consequence, his synoptic overview suffered from an insufficient evidence base as well as trying to fit what evidence there was around preconceived theories. His lack of interest in architectural details seems to have stemmed from his ethnological approach and consequently more of an interest in continuity rather than change, and change in details, as Fox noted, would have assisted in developing a chronology of change. It was not until 1975 that a definitive Wales-wide overview was published; but had Peate not so resolutely refused to use the great tool available to him and widely deployed by the Scandinavian scholars he otherwise emulated – the distribution map – he would have seen for himself some of the truths about traditional building styles that were obvious even then, such as the distribution of timber-framed houses or even the fact that most long-houses were to be found in south Wales. To the end of his life he maintained that archaeologists were not qualified to study houses.[72]

As we have seen, Peate's comments about government indifference to the fate of historic houses was supported by a member of the Museum's Council, Lord Raglan (1885–1964), who saw potential in this new field of study, and at the local level which Peate saw as the necessary next step but which he had so far been unable to undertake. Raglan was author of many papers and several (contentious) volumes on anthropology, sufficiently well regarded to be made President of Section H (Anthropology) of the British Association and President of the Royal Anthropological Institute. Raglan was inspired to invite an expert in the field to join him in investigating thoroughly his home county, Monmouthshire[73] – though the

expert he chose was not Peate, but Fox. Raglan knew both well from his long association with the National Museum, in which he held a succession of key posts, including Chairman of its Archaeology and Art Committee, and later President (1957–62). His diffusionist beliefs were totally contradictory to Peate's 'bottom-up' views of architectural evolution, and may be one reason why Raglan chose not to involve him in his project.[74] The resulting three volumes of *Monmouthshire Houses* (1950–4) are regarded as seminal to the development of vernacular architecture as a field worthy of worldwide study in a way that Peate's work has never been. As well as providing a model for how an archaeologically exact regional study should be done, the work put forward some fundamental theses which implicitly recognised Peate's contributions, particularly in identifying the long-house as a distinct type. However, the authors put forward a concept they termed 'alternate development', whereby the upper and most prestigious end of a structure might be rebuilt first, only then followed by the lower end, often resulting in a house that could once have been a unitary byre-dwelling but with its cowhouse turned into a parlour.[75] This would prove to be a very significant proposition in the subsequent study of the long-house. Peate appears not to have reviewed *Monmouthshire Houses*, so we have no direct evidence of his views. Later in life, he was to claim that it was his work that inspired Fox and Raglan's,[76] and certainly the publication of *The Welsh House* did make Raglan think that a detailed county survey such as proposed by Peate could indeed be valuable.

Small wars

From 1948 on Peate was deeply engaged in setting up the Folk Museum, and it is hardly surprising that even a man of his prodigious capacity for hard work had to slow down his academic output. Apart from articles describing individual re-erected houses, which were also published as guidebooks, he wrote little of substance on traditional buildings from that point on. He reassessed the cruck truss in a paper in *Folkliv*, a response to a note by Lord Raglan on the topic claiming that the cruck was the poor man's response to the Gothic arch.[77] Peate disputed an early 'Keltic' date for the cruck, and hotly disagreed with Raglan's assertion of its derivation. They batted opinions back and forth until Raglan's contribution to a Festschrift for Cyril Fox in 1963, where Raglan reiterated his belief that the homes of the less well-off were the products of social diffusion; there

was no real evidence, *pace* Peate, that the Welsh Laws referred to cruck trusses, and that since the quality of known examples deteriorated over time, clearly they had started life as copies of the Gothic arch.[78] It was not a meeting of minds and the subject was incapable of amicable resolution, and Peate seems to have got fed up at this point.[79]

Throughout the 1960s and much of the 1970s Peate was intermittently engaged in a small but bloody war in defence of the longevity and indeed existence of the form that he had named the 'long-house', which he had defined as a single-build structure with cowhouse or byre and dwelling under one roof. He repeated this in his introductory remarks when chairing a session of the British Association for the Advancement of Science at its meeting at Cardiff in 1960, for he had heard rumblings of discontent and it seemed as if he was almost daring people to contradict him: but some did.[80] Peate repeated his position in his own contribution to the Fox Festschrift. The architectural historian J. T. Smith (an employee of the Royal Commission on the Ancient and Historical Monuments of England), also a contributor, chose to re-examine the evidence for long-houses in *Monmouthshire Houses* and concluded that whilst many of the traditional houses of the county had been long-houses or derived from that tradition, it was a truism that they were normally of two builds. Smith, with Stanley Jones, then spent a decade studying the houses of Brecknockshire, and concluded that all the farmhouses there before the seventeenth century belonged to the long-house family – music to Peate's ears.[81] What was not music was the more direct attack made by Peter Smith, of the Welsh Commission, who observed in the same volume that the byres of most long-houses examined by him were clearly later than the house-parts, which posed the question of whether the long-house was the product of a process of subdivision or of accretion. Significantly, he also observed that the type was not found in north Wales, contrary to Peate's earlier attempt to demonstrate that the current distribution of long-houses was only residual and that they were once the national house-type. Wilder claims by supporters of Smith that the long-house was a product of the Industrial Revolution when farmers moved into large-scale milk production were robustly (and correctly) refuted by Peate, and he remained immoveable from his position that long-houses were old, Wales-wide, and single-build structures.[82] The matter was not settled until 1975, when *Houses of the Welsh Countryside*, an encapsulation of Peter Smith's work over the past twenty years bringing together data from many thousands

of houses and plotted on dozens of detailed distribution maps, was published.[83] Even if Peate had responded on paper, it is difficult to see how he could have explained the astonishingly clear regional distributions of both construction techniques and plan-forms that this 'study in historical geography' now demonstrated and which showed conclusively that the long-house was a permutation of the regional house-type found largely in south Wales. He would no doubt have repeated his earlier constant assertions that what these maps represented were only pictures of survival. But one thing might have sweetened the pill – Peter Smith was later to concede that the long-house as a type did date back to the Middle Ages at least, as he himself had found the earliest known example, Tŷ Mawr, Castell Caereinion (in Montgomeryshire!), dated to 1460.

Given Peate's background and intellectual journey, it is no surprise that he sought to identify a peculiarly Welsh house-type. He failed to find it in the long-house, but may well have felt that the wider distribution of the type in Britain might have been a survival from Celtic times, and in that sense indeed Welsh; and he certainly felt that other building types showed a closer link to Ireland than to England. The long-house debate is not particularly important in itself, but it illustrates Peate's thought process and how he always regarded attack as the best form of defence, and how he never backed down or changed his view once he had formed it. Likewise, he chose evidence that would support his case but ignored or misconstrued deliberately what would not, often with blatant disregard for attempting to come to a balanced view. He welcomed warmly J. T. Smith's view that most farmhouses in south Wales were in one way or another descended from the long-house, but ignored Smith's emphasis on how important Fox's concept of alternate rebuilding was, and indeed the consequences it had for his own views. Although he prided himself on his rationality, here he could not see how illogical his position was on a matter – and, as a consequence, how lacking in the balance that is essential to true scholarship his work could be.

Notes
1. *Rhwng Dau Fyd*, p. 90; *Syniadau*, pp. 121–2. On Thomas, Eurwyn Wiliam, 'An unsung pioneer of folk life studies in Wales: Sir Daniel Lleufer Thomas, 1863–1940', *Folk Life*, 60 (2022), 66–81. For Lloyd, see Huw Pryce, *J. E. Lloyd and the Creation of Welsh History. Renewing a Nation's Past* (Cardiff, 2011).
2. J. Romilly Allen, 'Old Farm-Houses with round chimneys near St. David's', *Arch. Cambrensis* (1902), 1–24; S. W. Williams, 'An Ancient Welsh Farmhouse',

Arch. Cambrensis (1899), 320–5; Harold Hughes and Herbert L. North, *The Old Cottages of Snowdonia* (Bangor, 1908, repr. Snowdonia National Park Society, 1979).
3. He was not the first National Museum of Wales employee to use his leave in this way. Mortimer Wheeler had sacrificed his holidays to enable six-week excavation seasons at Segontium in the early 1920s: quoted in Jacquetta Hawkes, *Mortimer Wheeler. Adventurer in Archaeology* (London, 1982), p. 85. The staff of the Royal Commissions on Ancient and Historical Monuments were also starting to take an interest in traditional buildings, but only as a very small part of their remit.
4. T. M. Owen, 'Iorwerth Cyfeiliog Peate 1901–1982', *Folk Life*, 21 (1982–3), 8–9.
5. 'Survey of Welsh House-Types', *Bull. Board of Celtic Studies*, vii (1934), 341.
6. 'Survey of Welsh House-Types', *Bull. Board of Celtic Studies*, ix (1938), 299.
7. 'Some Welsh Houses', *Antiquity*, x (1936), 448–59; Åke Campbell, 'Irish Fields and Houses: a study of rural culture', *Béaloideas*, v (1935), 74. Peate's fieldwork was carried out contemporaneously with Campbell's, Campbell being invited to Ireland by Séamus Ó Duilearga in 1935.
8. Dafydd Jenkins, *Tân yn Llŷn. Hanes brwydr gorsaf awyr Penyberth* ['A Fire in Llŷn. The story of the fight over Penyberth airfield'] (Llandysul, 1937), pp. 185–8.
9. SFNHM Accession Correspondence 36.691.
10. The site had its own dedicated railway line and fifty-eight storage chambers, each 200 ft long, laid out in a herringbone pattern quarried into the hillsides on either side of the valley. The site remained in use until 1992: www.subbrit.org.uk/site/34/trecwn-royal-naval-armaments-depot (accessed 8 June 2015).
11. Cyril Fox, 'Peasant Crofts in North Pembrokeshire', *Antiquity*, xi (1937), 439.
12. Several of the sonnets he published in *Y Deyrnas Goll* of 1947 were written at this time and deal with the Vale of Glamorgan and the threat of war alike.
13. Catrin Stevens, *Iorwerth C. Peate* (Cardiff, 1986), pp. 37–8.
14. Sir Cyril Fox, *Life and Death in the Bronze Age. An archaeologist's fieldwork* (London, 1959).
15. Sir Cyril Fox, *A Country House of the Elizabethan Period in Wales, Six Wells, Llantwit Major, Glamorgan* (Cardiff, 1940).
16. 'Mynydd Epynt', *Y Llenor*, 20 (1941), 183–8, repr. in *Ym Mhob Pen . . . Ysgrifau* (1948), pp. 11–17; my translation.
17. *Annual Report 1939–40*, p. 22.
18. *Rhwng Dau Fyd*, pp. 101, 103.
19. Quoted by Fox in his review of *The Welsh House*, *Antiquity*, xiv (1940), 445–6.
20. 'O.E.', 'Review', *Antiquity*, i (1927), 245–7.
21. D. M. Browne, 'From Antiquarianism to archaeology: the genesis and achievement of The Royal Commission's Anglesey volume', *Arch. Cambrensis*, 156 (2007), 44.
22. 'Some observations on the Anglesey Inventory of Ancient Monuments', *Trans. Anglesey Soc.* (1939), 105–8.
23. *The Welsh House. A Study in Folk Culture* (3rd edn, 1946), p. 4.

24. The fate of some of the buildings noted in the book is discussed by Greg Stevenson in the foreword to the Llanerch Press reprint of *The Welsh House* (Cribyn, 2004).
25. *The Welsh House*, p. 7.
26. *The Welsh House*, p. 9.
27. *The Welsh House*, p. 12.
28. *The Welsh House*, p. 42.
29. 'Some Welsh Houses', *Antiquity*, x (1936), 448–59.
30. *The Welsh House*, p. 52.
31. *The Welsh House*, p. 54.
32. *The Welsh House*, p. 74. Peate's views on the prevalence of the type must derive partly from his extensive reading of the works of the English travellers, which mention frequently the presence of animals under the same roof as their owners. However, these were accounts of the dwellings of the very poorest at a time of great population increase and land pressure, when people were forced to live a hand-to-mouth existence, very unlike that of the prosperous farmers, who lived in carefully designed long-houses; and of course he wanted the long-house to be a national plan-form, derived from a deep and pan-European past.
33. *The Welsh House*, p. 79.
34. *The Welsh House*, p. 57.
35. D. Lleufer Thomas, in *Royal Commission on Land in Wales and Monmouthshire: Report*, (1896), p. 696. On Thomas's development model, see Wiliam, 'An unsung pioneer of folk life studies in Wales: Sir Daniel Lleufer Thomas, 1863–1940', 76–8.
36. *The Welsh House*, p. 85.
37. *The Welsh House*, p. 110.
38. Cyril Fox, 'Peasant Crofts in North Pembrokeshire', *Antiquity*, xi (1937), 439.
39. Peate, *The Welsh House*, p. 88.
40. *The Welsh House*, p. 91.
41. *The Welsh House*, p. 92.
42. *The Welsh House*, p. 93
43. Other terms existed, eg. *tŷ taflod* (probably borrowed into English as 'tallet') in Llŷn.
44. Cyril Fox, 'Peasant Crofts in North Pembrokeshire', *Antiquity*, xi (1937), 438–9.
45. It has long been accepted that there could be a typological link between the *croglofft* cottage and the classic open mediaeval hall which often had a two-storey upper end. Richard Suggett has now identified farmhouses of sixteenth- and seventeenth-century date in Snowdonia which originally had a *croglofft*, so it would seem that Fox has proved to be the more correct of the two: Richard Suggett and Margaret Dunn, *Darganfod Tai Hanesyddol Eryri / Discovering the Historic Houses of Snowdonia* (Aberystwyth, 2014), pp. 136–58.
46. *The Welsh House*, p. 98.

47. *The Welsh House*, p. 108.
48. *The Welsh House*, p. 111.
49. Timothy Lewis, 'The Evolution of the Welsh House', *Aberystwyth Studies*, 4 (1922), 97–103. The paper was cited in Robert Richards's chapter on dwellings in his *Cymru'r Oesau Canol* ['Mediaeval Wales'] (Wrecsam, 1933), pp. 125–45. For a later assessment of the evidence, see L. A. S. Butler, 'Domestic Building in Wales and the Evidence of the Welsh Laws', *Mediaeval Arch.*, 31 (1987), 47–58.
50. Lady Fox noted that 'I had a suspicion that Peate, an ardent Welsh Nationalist, disliked the idea of an English woman discovering a Welsh house': *Aileen – A Pioneering Archaeologist* (Leominster, 2000), p. 86.
51. J. Romilly Allen, 'Old Farm-Houses with round chimneys near St. David's', *Arch. Cambrensis*, 6th ser., ii (1902), 1–24.
52. *The Welsh House*, p. 146.
53. *The Welsh House*, p. 159.
54. *The Welsh House*, p. 165.
55. *The Welsh House*, p. 166.
56. Trefor M. Owen, 'Iorwerth Peate a Diwylliant Gwerin', *Trans. Hon. Soc. Cymmrodorion*, n.s., 5, 1998 (1999), 72.
57. That year's prizes – none had been awarded since 1940 – represented a near clean sweep for the Museum, with three of the four prizes, which were allotted per historic period, going its way – Grimes also winning for his Guide to the Prehistoric Collections and Fox for his paper on 'The Boundary Line of Cymru': *Arch. Cambrensis*, 100 (1948), 140.
58. NLW ICP Papers A 2/3, cutting from *TLS*, 17 August 1940.
59. [John Summerson], *The Architectural Review*, lxxxviii (1940), 122–4.
60. *J. Royal Soc. Antiquaries of Ireland*, 7th ser., 10, 211–12, and *Béaloideas*, 14 (1944), 292–4.
61. In *Geography*, 26 (1941), 93.
62. *The Welsh House*, dust jacket.
63. W. J. Gruffydd, 'Adolygiadau' ['Reviews'], *Y Llenor*, 22 (1943), 41–3.
64. C. A. Ralegh Radford, in *Arch. Cambrensis*, xcvi (1941), 100–3. Radford (1900-98) was Hemp's successor as Inspector of Ancient Monuments for Wales 1929-36, Welsh Commissioner 1935-48 and an interim Secretary of the Commission after Hemp's retirement.
65. Iorwerth C. Peate, 'Mr. Ralegh Radford and *The Welsh House*', *Arch. Cambrensis*, xcvi (1941), 219–22.
66. NLW ICP Papers A 2/3, three-page letter marked 'not sent' in author's handwriting.
67. Cyril Fox, review of *The Welsh House*, *Antiquity*, xiv (1940), 495–8.
68. Cyril Fox, 'A Croft in the Upper Nedd Valley', *Antiquity*, xiv (1940), 363–76.
69. Preface to the Second Edition, *The Welsh House. A Study in Folk Culture* (3rd edn, 1946), p. xi.
70. *The Welsh House*, p. xi.

71. 'Traddodiad Llanbryn-mair', *Syniadau* (1969), pp. 57–65; Trefor M. Owen, 'Iorwerth Cyfeiliog Peate', Welsh Biography Online: *http://yba.llgc.org.uk/en/s6-PEAT-CYF-1901.html* (accessed 5 September 2013).
72. For example, in a review of M. W. Barley, *The English Farmhouse and Cottage* (London, 1961), in *Antiquity*, xxxv (1961), 250.
73. Peate claimed credit for inspiring the work in *Rhwng Dau Fyd*, p. 90.
74. 'Another superstition, and by superstition I mean an irrational belief which has come down to us from the past, is that the folk design their houses to meet their own needs, and make them from materials which come most readily to hand': Lord Raglan, 'The Origins of Folk-Culture', *Folklore*, 58 (1947), 250.
75. *Monmouthshire Houses*, vol. 2 (Cardiff, 1952), pp. 72–4.
76. *Rhwng Dau Fyd*, p. 90.
77. 'The cruck truss: a reassessment', *Folkliv*, 21–2 (1957–8), 107–13; *Man*, 56 (1956), 101–3.
78. Lord Raglan, 'The origins of vernacular architecture', I. Ll. Foster and L. Alcock (eds), *Culture and Environment. Essays in Honour of Sir Cyril Fox* (London, 1963), pp. 373–88.
79. Today, it is accepted that the cruck truss probably originated in the eleventh century in the Welsh Marches, with no archaeological evidence for earlier examples, but did indeed become increasingly popular later as a timber version of the pointed Gothic arch: Nat Alcock, P. S. Barnwell and Martin Cherry (eds), *Cruck Buildings: a survey* (Donington, 2019).
80. NLW ICP Papers A 2/10, 'Anerchiadau, darlithoedd a sgyrsiau radio' ['Speeches, lectures and radio talks'], three-page typed MS, undated.
81. S. R. Jones and J. T. Smith, 'The houses of Breconshire', *Brycheiniog*, ix (1963), 1–77; x (1964), 69–183; xi (1965), 1–150; xii (1966–7), 1–91; and xiii (1968–9), 1–86.
82. Peate's refusal to accord any significance to straight joints in a wall (showing that it was of two builds, with one part later than the other) had been noted by Fox when he and Peate visited Pembrokeshire together: 'Crottufty measured by I.C.P. Did not notice straight-joint lean to', SFNHM /Box 59/ MS 1491/138/ Fox notebook, *Antiquity*, xvi (23 May 1942), 85.
83. To everybody else's satisfaction – he did not review the work, so we can only presume what his response is likely to have been; Geraint Jenkins asked me rather than Peate to review the book for *Folk Life*.

7
'A fair field full of folk':
Iorwerth Peate and folk life

The creation of a subject

Having looked at two areas of study for which Iorwerth Peate is particularly known – crafts and domestic architecture – we should now look at how he addressed the overarching subject of which he was the prime creator in the United Kingdom, folk life.

A huge amount has been written on the allied topics of folklore and folk life. We should perhaps give primacy to the former because the term has been in English usage since its invention by W. J. Thoms in 1846 as a replacement for the term commonly used until then, 'popular antiquities', whereas the latter – folk life – was first used in Britain by Peate. He based the term on the Swedish *folkliv*, which coincidentally appears to have been first used in 1847.[1] Peate progressed quite quickly from accepting, rather unhappily, 'bygones' as a term for the material culture of ordinary people, to replacing it with 'folk culture', which he introduced in print to Britain in 1930 in its Welsh form, *diwylliant gwerin*. It was even more of an intellectual leap to use the term 'culture' (a direct translation) rather than 'life' in English, for culture up to then was regarded as something created by and unique to a single, upper, social class, and it took a considerable leap of the imagination to conceive of the great unwashed as capable of producing and sustaining something that could be described as 'culture'. This was therefore a bold presentational move to make in Britain, although both 'folk culture' and 'folk life', along with the more academic-sounding 'ethnology', were popular terms in Scandinavia at the time.[2]

This change in terminology represented a fundamental change in anthropological study. Up to then ethnographers – observers from western countries – would investigate more 'backward' cultures, often supposing that the structures and way of life of those societies would offer clues about the historical progress of their own. The study of folk life differed significantly, in that the observer was usually *of* the culture and would almost always have been brought up to speak the language and understand its values. Peate exemplified this 'participant's classification' of the cultural values of the Welsh countryside, and he refused (consciously or not) to stray away from the known into what was to him the foreign land of industrial Wales.[3] In his introduction to a Welsh-language lecture he had delivered in 1929 on the traditional crafts of Cardiganshire he used this and three other terms, namely *diwylliant gwlad* (rural culture), which he used interchangeably with *diwylliant gwerin*, *llên gwerin*, or folklore,[4] and *traddodiad llafar*, oral tradition, but he did not define any of them; he clearly expected his audience to understand his meaning.[5] His paper entitled 'Welsh Folk Culture', at the British Association for the Advancement of Science at its York meeting of 1932, identified his subject as being essentially 'a peasant culture ... of high order'.[6] By 1932 the National Museum had its 'Folk Gallery', with Peate made head of a sub-department of Folk Culture and Industries, a term he was using more widely the following year.[7] In 1936 this became a full department and he was appointed Lecturer in Folk Culture at two colleges of the University of Wales. Peate put forward his proposition that any encompassing English term for the field should include the word 'folk' quite early. In 1933 he noted that

> It is highly desirable to differentiate between the study of backward peoples – what might be termed *ethnological studies* – and the study of peasant societies of a highly civilised nature – what might be termed folk study. It is hoped that the term 'folk' in contrast to 'ethnology' will be adopted generally by anthropologists to maintain this distinction.[8]

This statement explains Peate's hatred of the later term 'regional ethnology' when that gained currency instead of 'folk life' or 'folk studies'. He never questioned whether 'backward' societies might themselves have had high cultural values, values intangible to the western ethnologists

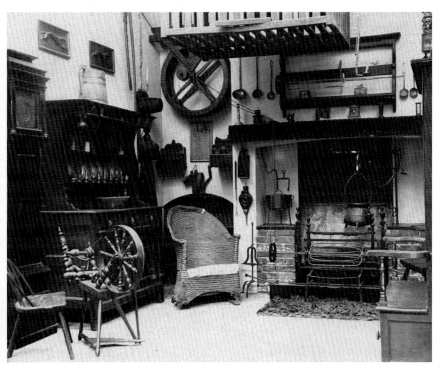

Figure 2: *The original Welsh Kitchen in the National Museum of Wales, as laid out by Cyril Fox.*

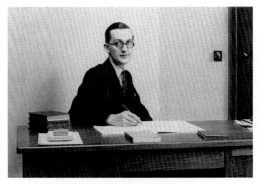

Figure 3: *The young Iorwerth Peate at his desk in the National Museum.*

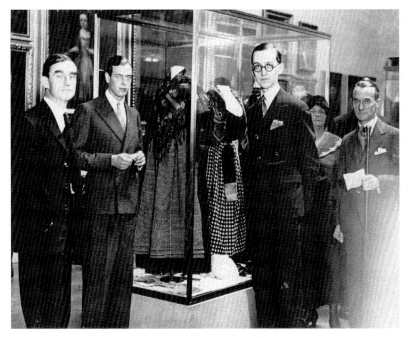

Figure 4: *The official opening of the East Wing Galleries in 1932: Fox and Peate with Prince George. Peate must have appreciated the fact that his nemesis, the Museum Secretary Archie Lee, is partly obscured in the photograph.*

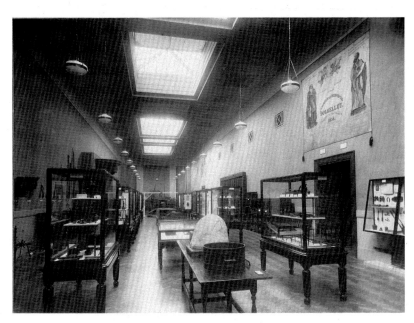

Figure 5: *The East Wing Folk Gallery, 1932.*

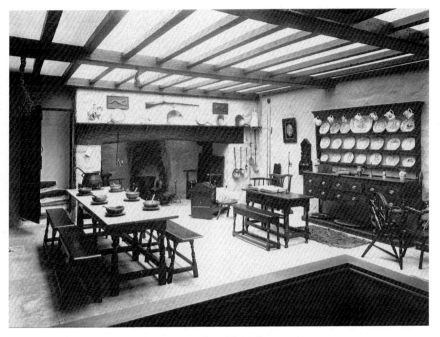

Figure 6: *Peate's Welsh Kitchen*, 1932.

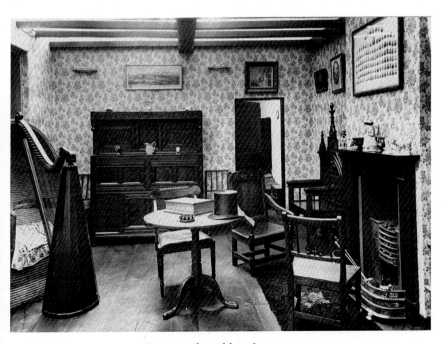

Figure 7: *The Welsh Parlour*, 1932.

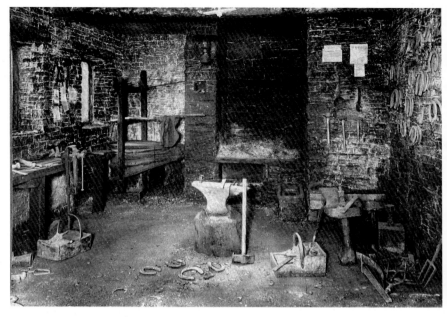

Figure 8: *The reconstructed Smithy in the East Wing Basement, 1934.*

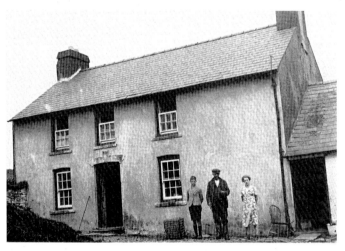

Figure 9: *Peate's most evocative Epynt photograph, with a family to be evicted from their home within a few days.*

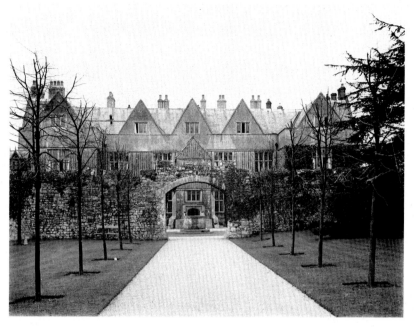

Figure 10: *St Fagans Castle, c.1910.*

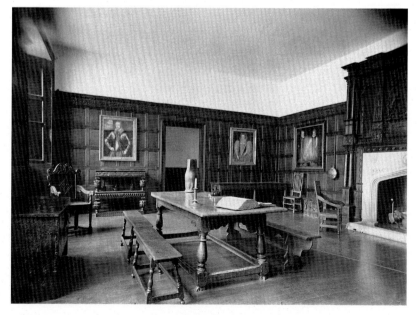

Figure 11: *The furnished Hall in St Fagans Castle, c.1950.*

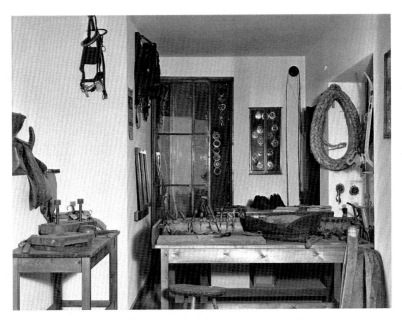

Figure 12: *The New Galleries at the Welsh Folk Museum, 1957: the Saddler's Shop case.*

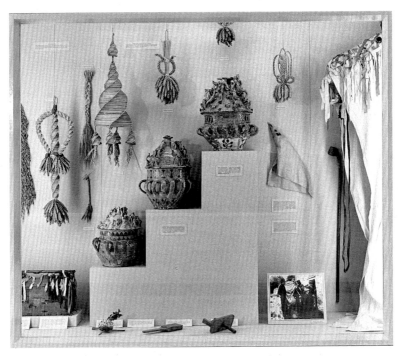

Figure 13: *The Folklore case.*

Figure 14: *The completed museum block, 1976.*

Figure 15: *Iorwerth Peate's bookplate, as designed by himself.*

who looked at such groups from the outside. This is a point of which he, as a Welsh speaker who constantly made much of how the core of his own culture was indissolubly linked to the language, the prime vehicle of its transmission, should have been aware. The man of logic was only applying it as far as he wished here.[9]

Peate refined the meaning of the concept as he saw it when he reviewed the first issue of the Swedish scholar Sigurd Erixon's journal *Folkliv* in 1938: 'the culture of the Welsh people – in its domestic, social and spiritual aspects', and 'the Welsh expression of a European material culture, super-national in its bases, and with the spiritual aspect of culture, national or regional in essence, exemplified by language and other expressions of the mind and spirit'. Tradition, he noted, was the factor which maintained the link between habits in present and past times.[10] To Peate, the study of folk culture encompassed 'man's mental, spiritual, and material struggle towards civilization', and his definition of its parameters is worth quoting:

> Folk culture . . . as a museum subject – and this needs repeated emphasis – is concerned not with the life of a particular class or stratum but with the life of the complete society, rural and urban, high and low degree, master and man. It is a study of the mental, spiritual and material struggle of the whole community: none is excluded. To equate 'folk' with a 'lower class' is a fundamental misconception.[11]

However, it was not so much the definition of what might be encompassed by 'culture' that was problematic: it was the word 'folk'. In both Swedish and Welsh, the appropriate words (*allmoge* and *gwerin*) had originally applied to all folk, the people in general, and had acquired a more restricted usage of 'country folk and manual workers' only later. English was 'more unfortunate' in that it had generally lost the original meaning and was nowadays restricted to meaning the lower orders of society, the 'always-receiving' peasantry to whom cultural traits were passed down and who themselves invented nothing. Erixon preferred to regard the lower stratum of society as a 'mother stratum' with a 'daughter stratum [the higher echelons of society] bearing the stamp of a more conscious intellectual life' – in other words, looking at social development as a bottom-up process rather than the usually assumed top-down one; 'and

the present writer agrees wholeheartedly with him.'[12] Throughout his life Peate insisted that the Welsh people did not recognise class distinctions, in the face of common sense and indeed historical proof to the contrary,[13] but implicit in the arguments of others that 'folk' should be reserved for the lower orders of society was at least an acceptance that they had a life and that that life could be worth studying.

The narrower definition of folk was perpetuated by Peate's contemporary, the influential American anthropologist Robert Redfield, who in his volume *The Little Community* saw 'the folk' as bearers of the 'little tradition' within the wider context of a broader civilisation, the 'great tradition'. Redfield's description of the 'folk society' had a very different meaning.[14] To Redfield, 'folk' meant a stage of primitive social development at the base of an evolutionary ladder which progressed thence via peasantry to an urbanised industrial society.[15] Don Yoder reiterated Redfield's definition in 1963. To him, whilst 'folklife' (as it is usually spelled in north America) involved the analysis of culture, that culture was 'the lower (traditional or "folk") levels of a literate Western (European or American) society, and [was] basically (although not entirely) rural and pre-industrial. Obviously, it is the opposite of the mass-produced, mechanised, popular culture of the twentieth century.'[16] Historians of the working class would have agreed with this latter clause, choosing to exclude country folk from their analyses of the urban proletariat. A further semantic jungle was the relationship between folk life and folklore. To Yoder, whilst folklore was largely limited to oral genres, such as legend, fairy lore, myths, proverbs and riddles, folk life was more closely related to cultural anthropology or the European ethnology. Peate made his position clear in reviewing the eminent American folklorist Richard Dorson's *Folklore and Folklife* for the journal *Folklore* in 1974. The title was surely unwarranted, in that the editor had made clear that 'folklore' was a subset of 'folklife', but he also took the opportunity to rail against those European and British scholars who had taken the 'gadarene path' of considering themselves merely 'ethnologists' rather than students of folklore or folk life (and regretted the fact that the journal *Folk Life* was now branding itself as a 'Journal of Ethnological Studies'). In equally combative mode, he pleaded with American colleagues 'to abandon such sentimental "romantic" expressions as "folkways" ... "foodways" and the like. They are truly "folksy"'; and it was equally sad that American students seemed to equate 'folk' with the lower classes of society.[17] For much of his life, however,

Peate would have agreed with one part of Yoder's analysis, namely that the subject dealt primarily with rural life and was not overly concerned with the contemporary, but he took grave umbrage at any suggestion that it dealt only with the life of the lower orders of society, although in practice he had moved away from this umbrella approach.

But to round off this brief excursus into terminology, we should likewise not forget that the term 'folk culture' was capable of entirely different interpretation even by Welsh speakers of Peate's own generation. To T. J. Morgan, who chose the subject for his inaugural lecture as Professor of Welsh at Swansea, it was clear that many of the 'disadvantaged classes' that he recalled from his youth in the industrial but still almost monolingual Welsh-speaking Swansea Valley strove hard to improve themselves and partake of pleasures that until recently had been the sole preserve of their social betters. His subsequent long article on the subject in a volume entitled *Diwylliant Gwerin* ('Folk Culture') chronicled the efforts of the urban working classes to improve themselves through education (often with the goal of becoming ministers of religion), poetry (thus contributing to the growth of the eisteddfod) and in particular through that medium of mass expression, choral music.[18] Roy Saer, the Folk Museum's folk-music expert, recalled the then Chairman of the Folk Museum Committee, Alun Oldfield-Davies, raised on the choral culture of the Welsh valleys, missing the point entirely and castigating the singing recorded on Saer's groundbreaking long-playing disc of traditional *plygain* performers as 'very crude'; Peate came to his office afterwards to sympathise.[19]

Peate, of course, had collected material pertaining to, and written about, folklore from his earliest days at the Museum. In 1929 he exhibited corn ornaments 'in the Folklore Case on the South Balcony', accompanied with a press release and an appeal for information about customs associated with cutting the last sheaf of corn, *y wrach* or *caseg fedi* (lit. 'the witch' or 'the harvest mare'). He used the replies as the basis of a well-researched article which included a detailed map showing areas where particular terms had been reported and where such a custom was not recalled – in other words, a proper distribution map, surprising in light of his later views on the matter.[20] During the 1930s and 1940s he published a number of notes and brief articles in *Man*, some on material aspects but others on folkloristic topics, such as his note on the wren, which was hunted and then paraded in a little decorated house, a custom recorded in the seventeenth century by the antiquary Edward Lhuyd.[21] An elaborate

wassail-bowl made in one of the Ewenny potteries of Glamorgan and dated 1834 had been acquired by the Museum in 1923, and he was able to link the use of such objects to the Mari Lwyd custom, in which a horse skull was paraded around Christmas and the New Year by a man hidden under a white sheet and accompanied by a group of singers who went from house to house demanding entry.[22] Similarly object-led (he readily confessed to having no musical knowledge) was a contribution on musical instruments, essentially a survey of the National Museum's holdings augmented with other known examples. He concluded that much work remained to be done before their true history was known, but he had at least set the ball rolling.[23]

In 1937 the Department sent out a questionnaire on Welsh Folk Culture. In the words of Fox's covering note, 'one of its objects [was] to secure useful and permanent contacts with at least one interested person in each parish in Wales'. The idea of having local 'correspondents' had been trialled successfully by the Irish Folklore Commission under its archivist Sean Ó Súilleabháin. That scheme (itself based on Swedish practice) was published as the *Handbook of Irish Folklore* (1942) and listed fourteen major subject areas, such as Settlement and Dwelling; Community; Folk Medicine; Principles and Rules of Popular Belief and Practice; and Mythological Tradition. This was fundamental to the success of the Irish collecting strategy, and emulating it was an eminently sensible step to pursue for a department with only two curatorial members, a heavy workload and a wide field to cover. It was not the first attempt to collect such material, however. In 1920 the Welsh Department of the Board of Education had launched a national scheme for the collection of rural lore via elementary schools and the University Colleges. This was done by distributing a pamphlet at the National Eisteddfod seeking a 'Collection of Welsh place and other names and of folk-lore of any district in Wales', but the results were variable and depended on the interest of individual schools inspectors.[24] The National Museum of Wales, in fact, had appointed 'correspondents' very early on, but they were the academic great and good or local worthies with an interest in a particular field of study, rather than grass-roots informants such as the Irish used.[25] Peate's questionnaire was much slighter than its Irish counterpart, and weighted towards material remains rather than folklore, divided into four sections covering respectively domestic, corporate, and cultural life, and crafts and industries.[26] The questionnaire was used as a basis for further, more

detailed questionnaires by Museum staff until the 1980s, and elicited in all some 800 responses. It was thus reasonably successful, but was limited in its main strategic aim of building up a network of correspondents. Although the questionnaire was taken as inspiration by St Fagans staff in how they should record reactions to the COVID-19 epidemic in 2020,[27] it was not really an attempt to record daily life as lived in 1937; while there was reference to contemporary practice, such as whether modern electrical lighting was used, the questions were overwhelmingly about recording historical usages in an attempt to record for posterity fragments of a disappearing and idealised rural past. Though he railed frequently about the insidious effects of the charabanc and other evils, Peate was not interested in recording how mechanisation was actually changing life in the countryside. It is only its methodology – copied from Scandinavia and Ireland – which links his questionnaire to current efforts of collecting the contemporary.[28]

In that same year Peate addressed the Cymmrodorion Society at the National Eisteddfod at Machynlleth, where he brought together many of the themes that he had identified during his first decade at the National Museum. His title, 'Diwylliant Gwerin' ('Folk Culture'), called for a couple of definitions. There were two aspects to culture, the spiritual and the material, and up to now Wales had mostly concerned itself with the former, though he would now address largely the latter. Spiritual culture was essentially national in its character, and in Wales was defined by the Welsh language: a national Welsh culture was indivisible from the language – which explained why so many, including him, were so intent on keeping the Eisteddfod entirely Welsh-speaking.[29] Material culture, on the other hand, was more universal, responding to man's interaction with the environment. The material culture of all western Europe was essentially the same, though he drew a parallel with geology, where older rocks might occasionally crop to the surface. The term *gwerin* needed less definition than did 'folk', for the original inclusive meaning of the latter, as in Langland's 'alle manner of men the mene [mean = poor] and the riche', had been subsumed by class distinctions.[30] The field thus encompassed the material remains of the whole life of man, his way of life, living conditions, his home, his tools and furniture, his social customs, his religion, his ideas, his thoughts, his institutions, his crafts and his industries. It had been the practice to study exotic and far-distant cultures whilst the treasury of knowledge at our own doorstep had been neglected; but it

delighted him that the National Museum of Wales was the only national institution in the whole of the British Empire to make the study of native folk culture one of its prime aims.[31] The rest of his lecture was a brief overview of the major heads of study, following the layout of the introductory essay to the *Guide* of 1929 and introducing the questions that needed to be addressed. Folk culture was a complex palimpsest with many aspects contributing to a total picture; he did not wish to return to the old ways, but heaven forbid that the golden cord that linked old and new – the Welsh language – be cut.[32]

Peate further expounded on his definition of 'folk culture' in English in 1941, by quoting Dr Ifor Williams's explanation of *diwylliant* as literally meaning 'de-wilding':

> The study of culture then is the study of man's mental, spiritual, and material struggle towards civilization. In museum practice, Folk Culture appears to me to be a more satisfactory term than either ethnography (the scientific description of races of men) or ethnology (the science of races and their relationship to one another, and their characteristics).

He conceded, however, that the term 'folk' could cause difficulties to English speakers, since it had lost its primary inclusive meaning and was now understood to mean 'the hewers of wood and the drawers of water', excluding the gentry and aristocracy; but that should not be the case.[33] The fact that several aspects (such as law, religion, language, political history and music) of the overarching whole were studied as subjects in their own right meant that in practice the principal concern of the student had to be material culture, which in itself touched on many aspects. He concluded in 1944 that

> Nothing is to be gained by attempting to 'preserve' Welsh culture. If its bases and ramifications are studied on the lines which I have indicated – museum + open-air museum + university – we shall be able to *develop* our cultural and material heritage and prove that another small nation has a unique contribution to make to world civilization. I venture to claim that in the developments outlined above there is nothing utopian and if they are implemented in our generation, Welsh culture will be enriched as never before.[34]

'Welsh Folk Culture'

In 1942 Peate published in book form the lectures he had delivered at Aberystwyth as *Diwylliant Gwerin Cymru* ('Welsh Folk Culture'). Reissued within the year, it won the University of Wales's Ellis Griffith Memorial Award as the best book published in Welsh on a Welsh subject in the previous three years. The publisher's blurb on the cover, which Peate must have agreed, noted that

> This volume is designed to be a textbook for students of culture. In it the author deals with the whole field of Welsh Folk Life . . . The nature of culture and the future of Welsh life is also discussed. This is one of those books which are indispensable to a Welshman.[35]

The 154-page book included twenty-nine illustrations, most of them photographs of items from the National Museum's collection, accompanied by his own drawings. A bibliography and a couple of appendices were included, including the 1937 questionnaire. Peate's introduction (for this was not a Museum publication, and therefore an introduction by the Director was not required) stressed that the subject was a new one in Britain: it was not studied regularly in any educational institution. Indeed, it was in Wales that most attention was devoted to the subject, and that in a museum rather than in a university. In English museums the subject was treated as a subset of archaeology, but the material remains of folk culture could not be properly understood through theories based on the work of the pick and spade. Yes, its study was closely allied to archaeology, but no more than to sociology or history, psychology or the world of the spirit. These were difficult days, and lack of knowledge of our heritage was a clear danger. Salvation lay in local culture, and an excellent response would be for the national institutions – the university, the library and the museum – to band together and in every rural district have one farm owned by the agriculture departments of the university where a local library and museum might be developed, as well as a home for cultural activities; and the very best way to start such a drive for regeneration was to study that culture and engender curiosity – the very aim of his book.[36] And while he knew more than anyone how lacking the book was, nevertheless it was timely to publish it rather than await definitive studies of the many subjects it encompassed (the same position as he had taken with *The Welsh House*).

The term 'folk' – *gwerin* – should refer to the way of life of Welsh people of all kinds and grades of society, he felt.[37] Of course there were degrees to culture, in time and space, and some elements could remain unchanged for long periods. The modern approach was for the student to look at a particular culture and compare it, or aspects of it, with another culture; and it followed that the only way for a Welshman was to study his own culture and compare it to others.[38] It had latterly become fashionable to talk of 'pure races' but there was no such thing, nor racial culture. The culture of every nation had been affected by constant change. Tradition was the link between the present and the past and it was one of the tasks of the student of culture to seek out the changes to traditional culture that arose from external imposition, from borrowings from neighbouring societies, and from individual invention.[39] Change affected all things, however, language as much as material remains, and no single language could be understood by all, for the scientist spoke a different language from the farmer; and since Welsh had not been taught as part of an educational system, it lacked the terminology required to cope with scholarship, business and industry. State support for Welsh was unlikely in the near future. But to summarise: the student of folk culture was an anthropologist in the widest meaning of the term, studying the whole of human life, but here he could not treat of that, merely follow the usual pattern for students of folk culture and address the material manifestations of the culture in question.[40]

The arrangement of the book followed that of the introductory essay in the *Guide to Welsh Bygones* and, in general terms, the questionnaire. His first topic chapter was on houses and was effectively a nine-page summary of *The Welsh House*. Here he crystallised one significant point that was not expressed so clearly in the larger work: 'Houses . . . have a way of descending the rungs of the social ladder. This is one of the natural laws of folk culture. That is, many former gentry houses have become farmhouses or the homes of labourers by today.'[41] The complexity of material culture was best exemplified by the contents of the house, for here the new and the old coexisted naturally. The Early Iron Age (500–50 BC) saw the genesis of the Welsh language and a rich culture based on farming.[42] The oldest cookery tradition was that of roasting or baking in an iron pot over which the fuel was placed, but the diet of the country folk in Wales remained foods mostly eaten with a spoon rather than a fork. Homes in the Middle Ages had very little furniture, and that so basic that there were

not even national distinctions within Europe.[43] An increasing interest amongst the Welsh gentry in following English fashions was accelerated in Elizabeth's reign; but the uplands remained conservative and preferred the tried and tested. The two-storey court cupboard, for example, went out of fashion in England in the seventeenth century, but remained in use in Wales until the nineteenth in the form of the two-part *cwpwrdd deuddarn*.[44] The later dresser, often taken to be the archetypal item of Welsh furniture, had developed from the buffet, or cup-board, and over time acquired a set of shelves; southern examples had their bottom halves open, whilst northern examples held cupboards. Much of the intellectual basis (only tangentially acknowledged) of his chapter on dress was based on Thalassa Cruso's *Catalogue* for the London Museum.[45] High-status individuals established trends which were widely followed, whilst foreign influences were wide-felt in Wales, as in England, with neither country having anything approximating to a national dress: in Wales the concept was largely invented by Lady Llanover in 1836, and that only for women.[46] But as with furniture, the consequences of being far from the centre of taste meant that the fashions of Cardiff were not unlike those of London, whilst there was little difference between the style of the Welsh countryman and his Cumbrian counterpart.[47] Certainly, there had been some regional differences, as the early tourists described, and the 'traditional' Welsh costume appeared to be most closely connected with Cardiganshire (from where most surviving examples appeared to derive), though the tall 'Welsh' hat appeared to be no earlier than the late eighteenth century.

Peate's chapter on social life was understandably long, at thirty pages, for it covered a great swathe of the field. Welsh society was a synthesis of old and new, but the absence of industrialisation and large towns had resulted in no entrepreneurial middle class, so that life in Wales remained essentially rural. In such a peasant society not affected by the fluctuation of the market, tradition remained strong and important.[48] The craftsman was the cornerstone of this society, and whilst industry did exist, its roots were rural and natural. A section on water transport gave Peate an opportunity to treat of Welsh shipbuilding, with ships often built on the beach in the small ports all along the coastline. Education got little more than a page. Games and pastimes fared better, probably because a considerable amount of documentary evidence survived and been published by his fellow-Montgomeryshireman, R. W. Jones.[49] Specific Welsh examples included *cnapan* (a mass-participation event akin to a riot) and *bando*

(rather like hockey), whilst the remains of several cockpits testified to that sport. The National Museum had an excellent collection of musical instruments, but here again there was the misconception that folk music was the preserve of the poor – in reality it was just that fashions had changed more quickly at the level of the gentry.[50] Similarly, folk music was national only to the extent that it was transmitted through the medium of language, but otherwise could be supra-national. The chapter concluded with a brief examination of cultural institutions, including the eisteddfod, of which much was known from the sixteenth century onwards; the Gorsedd, invented by Iolo Morganwg; and the antiquarian and allied societies, again established in the eighteenth century.

The next chapter, on folklore and customs, was much slimmer, for Professor T. Gwynn Jones's *Welsh Folklore and Folk-customs* (1930) was pretty comprehensive, and Peate needed only to draw attention to a few matters not discussed by Jones. Valentine cards and carved wooden lovespoons survived in great numbers, whilst 'bidding cards' invited guests to contribute gifts of money or in kind to help 'set up' the young couple. Peate had learnt much about magic and spells from a country doctor of his acquaintance, who had told him about the common custom of providing written spells to be placed in witch-bottles in the cowhouse, and many others. Many customs were seasonal and often pre-Christian in origin, but the coming of Christianity resulted in rebranding and a new lease of life for them rather than their extinction. The oldest human profession was farming. Giraldus Cambrensis depicted the Welsh of his day as predominantly a pastoral people, but Elizabethan writers noted that the lowland regions such as south Pembrokeshire and the Vales of Glamorgan and Clwyd were arable. By the eighteenth century the influence of improvers and gentry was being felt, and the coming of iron ploughs in the early nineteenth century provided an opportunity for Welsh makers, sadly all now gone. Harvesting was originally done with the sickle, which was then supplanted by the scythe; Peate did not choose to mention machines, even horse-drawn ones. All this related to arable farming, but pastoralism was important too. Since sheep were let out on common grazing, they had to be marked by cutting the ears in a specific way for each farm, and pattern books for regions were compiled and even published.

And what did the future hold? In his text, he noted, he had tried to analyse Welsh folk culture on the basis of evidence known to him about its material past. But he was writing at a time when civilisation itself was

under threat, and there were threats too nearer home. Industrialisation had brought with it immigration and resulted in the death of the Welsh language in those areas,[51] and the Depression in turn had meant emigration, whilst all the time centralisation favoured the urban areas. Educational emphasis on self-improvement had created a class which had turned its back on the old rural way of life: he himself was an example. Many social and economic changes, of course, were for the better, but society as a whole had suffered at the expense of the individual. The cancer was now in the heart of a community which had once been certain of itself, and the number of monoglot Welsh speakers was now few. Welsh speakers of past days had safeguarded the language because they had no other, but now it was a bilingual society, and people like him no longer lived in the traditional Wales.[52] It was scholars who were now fighting for the language, but the soul of the nation depended on whether ordinary people would accept that leadership. Much was being said that the future lay in international cooperation, with nations giving up part of their sovereignty for the benefit of all, and that surely was a good thing. But in such an arrangement, each nation would reserve unto itself the right to have control over its cultural matters. Wales did not have such control and it was vital for the future that it won that right: the principal duty of the Welshman of the future was to ensure the survival of the Welsh language and the spiritual culture based on it. If that were done, then it was likely that the value of locality, rural craft and agricultural life would be revived on modern lines, and it was to inform that process that this volume had been written.

Whilst trying, and succeeding to a very considerable degree, to give an overview of the entire subject, the book inevitably (and very honestly) adopted the approach of a museum curator. Its starting point was objects, and objects which survived to be represented in the National Museum's collections. Religion was one of the great gaps in his discussion as a consequence of this, and the monolithic Lutheranism of the Scandinavian countries meant that it was not a subject encompassed within the remit of the early folk museums, other than by re-erecting places of worship (which the Welsh Folk Museum later emulated), and so did not offer Peate a comparator. Despite Peate's comments about there being no such thing as racial purity, there does seem to be an implicit assumption in his thinking that there was an early 'pure' form to a nation's culture which was worth seeking. Likewise, he clearly saw no place for discussing the study

of language in the book, although he had himself already published collections of terminology and was acutely aware of its central role in cultural transmission. His habit of stuffing in irrelevant little bits displayed a lack of intellectual rigour; but that aside, this was the earliest overview of the new field in the British Isles.

Its wartime publication and the fact that it was in Welsh together ensured that there were almost no reviews of *Diwylliant Gwerin Cymru*. W. J. Gruffydd had intended to review the book together with *The Welsh House* but devoted too much space to the latter to have room, and his review never appeared; all he offered was a tantalising glimpse of what he would have said, namely 'a work which to my mind is truly remarkable'.[53] Alwyn D. Rees reviewed the book in the weekly *Baner ac Amserau Cymru*.[54] Rees was another Aberystwyth geography and anthropology graduate, and a tutor in the college's Extramural Studies department (he later became its Director), but their views were radically different, as Peate made clear when he was invited to respond. Mr Rees's '*naiveté* was astonishing'. Whether he had studied the subject or not, one thing was quite obvious: Mr Rees did not know what folk culture was. Rees had not understood the true definition of 'folk' and had criticised Peate's devoting most of a chapter to the gentry. He clearly believed there to be two cultures, the aristocratic one and a peasant one, so that to Rees 'folk culture' referred only to the lower class, which had been the viewpoint of upper-class people who had developed an interest in anthropology after a period as colonial governors. After quoting Erixon as his authority, he went on to denounce Rees for his 'impertinence' (using the English word – clearly the concept did not exist for him in Welsh), and that he would treat seriously comments from Rees only when he demonstrated that he knew something of the subject, but not before.[55] Rees, in fact, had come to reject Fleure's environmental determinism and evolutionism, ideas that were anyhow losing ground in the inter-war years and being supplanted by those espoused by the anthropologists Radcliffe-Brown and Malinowski. They held that the ideas of importance when studying communities were not those of those being studied but rather those of the researchers, but Rees rejected their ideas also. Fleure's successor, Darryll Forde, carried on Aberystwyth's interest in historical geography, and initiated a series of community studies across Wales. In 1939–40 Rees carried out fieldwork in the upland parish of Llanfihangel-yng-Ngwynfa in Montgomeryshire, published in 1950 as *Life in a Welsh Countryside*. This

Iorwerth Peate and folk life

was the first anthropological study of a rural community in Britain. Like Peate, Rees believed fundamentally that it was neither race nor geography but rather membership of a linguistic community that defined who was Welsh,[56] though Peate clung longer to environmental determinism as well as the role of language.

Rees's was the first of a series of ten studies of rural communities carried out in Wales up to the 1960s; seven of the researchers were Welsh speakers examining cultures with which they were familiar. All identified the family as the dominant group in the social structure, and none noted class as a feature of note (which would have pleased Peate).[57] Chapter-sized synopses or particular themes from four of these studies were collated by Rees and another of Fleure's students, Elwyn Davies, and published in 1960 as *Welsh Rural Communities*.[58] Although the four studies took very different approaches, what was concluded was characteristic of Welsh-speaking rural communities throughout the country, with the things which were emphasised being those to which the greatest value was attached within the societies themselves.[59] David Jenkins's study of the fishing village of Aber-porth in Cardiganshire incurred Peate's wrath. Jenkins identified a dichotomy in social pattern based on contrasting codes of behaviour and values. He traced the codes (which he labelled 'Buchedd A' and 'Buchedd B' – *buchedd* meaning 'lifestyle') to the consequences of the religious awakenings of the previous two centuries, with the first group conforming to the moral codes of nonconformist believers and the second more 'worldly' in its approach to life. Some of the other studies also hinted at similar divisions, but did not put matters so plainly. 'Theoretical ideas are published as facts' was Peate's view, with the 'Buchedd A/B' claims identifying 'a dichotomy in the Welsh rural population which is quite imaginary',[60] ignoring the fact that such a polarity of mores could of course be seen in any Christian or post-Christian society in Britain. Pots and black come to mind once again, with prejudice winning over a willingness to allow room for dissent from a received truth – but the truth would always be his.

And rather as Payne noted that Peate knew almost nothing about how the countryside worked, he demonstrated no interest in those fundamental aspects of the historical sociology of rural life that so interested Rees and his followers in community studies – the make-up of society, landownership and tenure, emigration, poverty and homelessness: his discernible interest was confined to religion (so long as it was nonconformist)

and crafts. His local hero, Samuel Roberts, whose *Cilhaul ac Ysgrifau Eraill* he had edited and in which the author was the first to draw attention to the relationships between landlord and tenant in Wales, had been forced to leave his tenanted farm and emigrate to the United States in 1857, so the omission is even more surprising. It might also perhaps have been expected that (perhaps in retirement), just as he had edited a collection of essays about his chapel, he would write a history of Llanbryn-Mair – but as Geraint Jenkins noted, despite his professed and oft-repeated affection for the place of his birth, he never visited.[61]

'Tradition and Folk Life'

It took thirty years for Peate to publish an English-language equivalent to *Diwylliant Gwerin Cymru*, though he had come close a decade earlier with an invitation from Thames and Hudson. 'The book which I am writing will be the first "textbook" to be published in English on the study of Folk Life as such ... there ought to be a considerable demand for it' was Peate's opinion, although publication dates had to be moved forward more than once because he did not have the time to write the book, preoccupied as he was with day-to-day administration, but also with 'preparation for building our new block'. However, by 1967 it had become clear to the publishers that the book that Peate was writing was not the one they thought they had commissioned: 'the book we were expecting to have was one about Folk Life in general rather than the Folk Life of Wales in particular'. Peate defended himself by saying that for a volume such as this to have any value it had to be based on case-examples, which in his case were all Welsh;[62] but ultimately both parties agreed that their positions were irreconcilable, and the contract was cancelled, with Peate returning some of his advance.[63]

The volume that Peate had in mind to write was published by Faber & Faber in 1972 as *Tradition and Folk Life. A Welsh View*. It is no surprise that he chose Faber, for it had since 1956 published the brilliant oral-history-based works of his great friend, George Ewart Evans (see Chapter 12), and Evans's son Matthew was a rising star within the company.[64] 'This book is not a textbook for students of Folk Life', starts the Preface.

> It has been written at the request of several persistent friends who have thought that, after a professional life of well over forty years,

I would have something of value to say about some aspects of a vast subject. I trust that they will not be disappointed.

It would appear that these friends (and the book is dedicated to Seamus Ó Duilearga and to the memory of Åke Campbell) were primarily his non-Welsh-speaking ones, for, as we shall see, much of the volume's content was not new. Peate's correspondence with Faber about *Tradition and Folk Life* is not preserved amongst his papers, so we do not know at whose suggestion the subtitle was added, but this sensible precaution may well have been Peate's, for he made clear in his Preface that the study was based essentially on Wales and that he could not claim to be the polymath who could take a worldwide view.[65] 'Once bitten, twice shy' is not an expression that one might readily couple with the name of Iorwerth Peate, but perhaps it is apposite in this case. Despite his protestations that this was not a textbook, the text on which the volume was very firmly based, *Diwylliant Gwerin Cymru* of 1942, had indeed been designed as such. *Tradition and Folk Life* was not so much an overview as a very personal view, he noted – 'It is the author's personal reaction, during a working life of well over forty years in the field to problems of folk-life study'[66] – and new facts and ideas that he found unacceptable were ignored. The bibliography itself was also very selective and not up to date, with many of the titles listed being up to sixty years old and long since superseded.

Some ninety per cent of the text is a translation of what he had said in the book's Welsh-language predecessor: but he had done a fairly heavy edit and shuffled the pack so that it is quite difficult at first glance to see what he dropped and what he added. The startling point that does emerge clearly, however, is how little his views had been influenced by material published in the meantime, with his views even on the various aspects of material culture remaining fossilised in the 1940s. Not unexpectedly, and not unreasonably in a self-confessed personal view, the author's 'political' views emerge here and there in the volume. His discussion of settlement and community, as a prelude to describing aspects of the social life of the inhabitants – or at least those of the non-industrial communities, as he made clear – noted that loyalty to *bro*, the small immediate locality, was not important to Wales alone.[67] Successive London governments had never addressed the country's transport problems, which meant that all major roads ran east–west but not north–south 'through the vast area of the Welsh-speaking communities': they did not realise that the unification

of Wales through the making of such roads, electrification, and the provision of piped water and other services 'would revive both her culture and her economy'.[68] Peate's penultimate chapter, on the countryside, enabled him to end the main text of the book with a panegyric on the decline of the rural craftsman. The editorial language of his opening sentence to the chapter, 'Though many of us stress quite correctly the truth that the student of folk life is concerned equally with town and country',[69] reflects a truth that he himself never espoused, with the second half of the sentence anchoring the roots of tradition in the countryside, for 'Man's life in the countryside is ... of fundamental significance in the study of folk life'. In Wales, 'as in some other countries' (a gracious concession) pastoral farming produced thinkers and poets. The bulk of the chapter is occupied by a discussion of how the different types of horse-drawn farm vehicles – the sled, the slide-car and the four-wheeled wagon – each evolved to suit a particular topography, with this local need foremost in the minds of the craftsmen who created them. But when mechanisation and modern transport overtook the rural communities the traditional pattern of local manufacture and social interdependence broke down almost completely: 'This metamorphosis has had its effect on the spiritual and cultural life of the countryside. Old values have weakened, the traditional church and chapel going has suffered, the Welsh language has deteriorated and with it the cultural activities based upon it. *Sic transit gloria mundi.*'[70]

The last chapter, on language, is subtitled 'a Note', and it may be that the publisher felt that some of this material was too detailed and too polemical to sit easily with the rest of the volume's content; but certainly, like the chapter on the countryside, one might have expected this to have been one of the introductory chapters to the book, particularly since Peate's argument that culture of all kinds was transmitted by language, and in the case of rural Wales by Welsh, and so was fundamental to understanding what he had to say. 'The study of Folk Life can never be complete if one's attention is confined only to material culture' was how he put it, 'for tradition is the chain which links the present with the past ... The principal element in conveying tradition from generation to generation is language, and the study of language is part of folk-life studies.'[71] Just as the various forms of traditional vehicle coexisted in time with the motor lorry, all ideal for use in their particular environment, so 'the simple speech of the country-man' coexisted with the developed vocabularies of philosophers and scientists,[72] both points ones he had made in 1942

but of course still valid. He traced the history of language development in Europe, noting that 'Keltic' probably developed in the upper reaches of the Danube before spreading east and west to a final resting place in western Britain, where Welsh now was a minority language threatened by a much stronger and official one. Such minority languages were subject to modification through contact, and the policy of bilingualism actively encouraged in Wales could lead only to a temporary situation ending in a complete English unilingualism (*sic*). Loss of contact with dialect and an attempt to teach a 'basic Welsh' as a second language would also emasculate the language as a medium of expression.[73]

But some things had not changed, and Peate remained resolute to the last in waving the banner that he had first raised some forty years earlier. So did the book manage to achieve what he had in mind for it? It certainly encapsulated his views, and remained the only overview of the subject until four years later, when Geraint Jenkins brought out his *Life and Tradition in Rural Wales* for Dent's eponymous series, which not surprisingly focused heavily on the author's own interests in crafts and manufacturing; and no doubt it served as a useful starting-point for Jenkins. *Tradition and Folk Life* offered Peate a platform for expressing in English views which were well known to Welsh-language readers, but had the potential of bringing important issues, such as the centrality of Welsh to those who spoke it and as a key to understanding life in rural Wales, and indeed the culture generally, to the notice of others not so blessed (which would have been Peate's view). The work was not reviewed in the journal one would have expected, *Folk Life* – presumably Jenkins, the editor, failed to find anyone brave enough to do so – but Peate will have been happy with the review given the work by Katharine Briggs, a recent President of the Folklore Society. She was pleased that Peate had not confined himself to the material aspects of his subject but set those within the wider sphere of folk traditions and life, music, poetry and seasonal customs. She, at least, was not put off by his views on the Welsh language, which she thought eloquent and apt; and the publishers will have been pleased that she drew attention to his many references to the folklore and traditions of countries other than Wales.[74]

After being out of print for many years, *Tradition and Folk Life*'s precursor, *Diwylliant Gwerin Cymru*, was reissued in 1975. The foreword to the new edition concentrated on the development of St Fagans ('the Welsh National Folk Museum') where the galleries would enable readers

to study further aspects of the subject, on which staff had written books and articles published either by the Museum itself, or in *Gwerin*, or in *Folk Life*. Text revisions were few. This was particularly clear in his chapter on houses, which was firmly based on his work of over forty years before but which found room to quote and praise the work of J. T. Smith (who supported his view on the importance of the long-house), though it ignored totally that of Peter Smith, whose important precursor article to his *Houses of the Welsh Countryside* of 1975 (a long chapter in *The Agrarian History of England and Wales* of 1967)[75] was not mentioned in the bibliography. At least publications by his appointees Minwel Tibbott, Ilid Anthony, Roy Saer, Elfyn Scourfield and Geraint Jenkins were included. The general impression given, however, is that Peate had not learnt anything of consequence over the past thirty-three years, and that what he had written then still remained the last word.

Peate did not elaborate on the links between folk life and its study and presentation in museums in either volume. However, he believed fervently that one of the tasks of a museum – a truly high-level objective, in today's terminology – and particularly that of a folk museum, was to contribute to the defence of civilisation. His most high-profile exposition of this belief was in his presidential address to Section H (Anthropology) of the British Association for the Advancement of Science in 1958. He was proud of his long-standing membership of the Association and regularly attended its annual meetings, held at venues throughout the United Kingdom. He chose a wide-ranging and ambitious title for his address, namely 'The study of Folk Life: and its Place in the Defence of Civilisation'. Like a former chairman, D. B. Harden, he deplored the change in the Section's name that was made in 1947 to 'Anthropology and Archaeology', believing that the original title was sufficiently broad to encompass archaeology, ethnology, folklore and folk life studies as well as physical and social anthropology. As a literate nation of long standing, the Welsh were very conscious of their cultural heritage, transmitted through the medium of Welsh. Modestly, he noted that 'We in Wales take particular pride in the contribution made by our country to [the study of folk life]', and ascribed the reason for that contribution as deriving from the primary roles that the language, and literacy in it, had on how culture was perceived. It was no surprise that people had begun collecting 'bygones' to represent that lost age; but he ignored the fact that similar collections were being developed elsewhere at the same time.[76] The study of folk life was a new occupation,

ignored by the universities, rather as archaeology had been fifty years previously, and had up to now depended on museum workers, with the result that studies were inevitably biased towards the material remains of the recent past. When W. J. Thoms devised the term 'folklore' in 1846, it was quite clear that to his mind it related to the hewers of wood and the drawers of water; but that should not be the case, for the study of folk life encompassed all degrees of society, despite the views of American anthropologists such as Robert Redfield, who differentiated between country and town dwellers: 'It may be that because I come from a people who lay no emphasis on class distinction, I find this connotation somewhat ludicrous', he noted, just as Langland had meant with his 'fair field full of folk'.[77]

Peate immediately went on to note that as he saw it, folk life was the study of non-industrialised societies, and even in countries of such low populations as Norway and Wales those who lived in heavily industrialised areas should be excluded; but crucially, *all* country-dwellers, of whatever social class, were included[78] (this was Peate at his hair-splitting best, and the discussion afterwards must have been interesting, to say the least). Equally, the study of folk life should not be confined to the last three hundred years or so: why was an eighteenth-century wassail-bowl a 'bygone' whilst a Bronze Age vessel was not?[79] This reverse takeover of archaeology as a disciple merited only a couple of sentences, however, whilst he glossed his earlier dogmatic assertion about industrialisation by noting that seeking traces of underlying folk traditions in industrial and urban societies was an entirely legitimate exercise.[80] A note on the importance of studying house-types, deploring how often Wales was neglected in 'British' studies, but praising the work of Fox and Raglan and the recording work of the School of Architecture at Manchester, provided an opportunity (once again) to dismiss the distribution-map as a tool of any use. Equally dangerous was the tendency to date fashion by its proximity to London, as happened so often with furniture and dress, and one had to be aware of the invention of tradition, as happened with the 'Welsh costume'.[81] It was vital that the dialects of all the languages of the British Isles be recorded and studied. But now he could address the second part of his title. To fail to record disappearing traditions and cultures was a crime, particularly at a time when society was unravelling in the western world. Passive barbarism, as Lewis Mumford had put it,[82] was rife in the United States, while the eastern bloc's approach was active. Small nations were being squeezed between these two behemothic schools of thought,

and if it was to be so, then the least that could be done was to record what was in danger of being lost.[83]

His last published thoughts on the matter were in a contribution to a Festschrift in honour of A. T. Lucas. He could see that folk life, just like archaeology years before, was now being recognised as a university subject; but (he being Peate) there was no case for over-rejoicing, for as 'ethnology' it suffered the risk of being lost in 'the groves of academe' and becoming a twin to (if not the slave of) that fake discipline, sociology. He deplored the tendency to dress simple concepts in terms taken from other disciplines so that the prejudices of individuals could be disguised under 'highfalutin' academic terminology, and where some students of the subject lost sight of the fact that they should be discussing the lives of ordinary people.[84] In this he remained unrepentant to the last, with the consequences of being unwilling to explore connections between material culture and its social context other than at a superficial level. Indeed, he had always regarded the study of folk life as being sufficient in itself and that it had a role to play in the defence of civilisation; and as such, there was no need to explore it at a deeper level. He recognised, almost in passing, that the creation of a more literate peasantry through the activities of the Sunday Schools followed by the almost fanatical quest for education in Victorian Wales resulted in the replacement of the oral tradition by the written word,[85] but in print questioned little of what might have been lost or taken new form under proletarian influences. Similarly, whilst he fought hard to create a Department of Oral Traditions and Dialects for the Folk Museum, and regarded its work as the Museum's greatest triumph (Chapter 11), his own exploration of folk life and folklore was very much from the perspective offered by material evidence. In this he was a traditional museum curator, albeit studying objects previously given little or no attention in their own right.

Notes
1. For a good discussion of the history of the terms, see Don Yoder, 'The Folklife Studies Movement', *Pennsylvania Folklife*, 13 (1963), 43–4, and Jonathan Roper, 'Thoms and the Unachieved "Folk-lore of England"', *Folklore*, 118 (2007), 203–16.
2. Trefor M. Owen, 'Iorwerth C. Peate: Portread', *Y Gwyddonydd* ['The Scientist'], 13, (Rhagfyr, 1975), 116.
3. The terms the 'observer's classification' and the 'participant's classification' are used by David Jenkins in his 'Land and community around the close of

the nineteenth century', in G. H. Jenkins and I. G. Jones (eds), *Cardiganshire County History, Vol 3: Cardiganshire in Modern Times* (Cardiff, 1998), pp. 94–5.
4. Llên gwerin (as *'llên y werin'*) is first recorded in 1858: *Geiriadur Prifysgol Cymru*, s.v.
5. 'Rhai o Grefftau Ceredigion', *Trans. Cardiganshire Ant. Soc.*, vii (1930), 50–1.
6. Reproduced as 'Welsh Folk Culture', *Welsh Outlook*, 19 (1932), 294.
7. 'Welsh Folk Industries', *Folk-lore*, 44 (1933), 176–88.
8. NLW ICP Papers A2/9 (ii), a (possibly unpublished) review of R. U. Sayce's *Primitive Arts and Crafts: An Introduction to the Study of Material Culture* (Cambridge, 1933).
9. The concept of 'intangible cultural heritage' was accepted and protected by UNESCO in 2006.
10. 'Folk Culture', *Antiquity*, 12 (1938), 319 and 321.
11. 'The place of folk culture in the Museum', *Museums Journal* (1941), 45 and 46.
12. 'The place of folk culture in the Museum', *Museums Journal* (1941), 320.
13. Bobi Jones, 'Y Traddodiad Gwerinol a'r Traddodiad Uchelwrol' ['The Folk Tradition and the Upper-class Tradition'], in Bobi Jones, *I'r Arch: dau o bob rhyw. Ysgrifau llên a hanes* ['Into the Ark: two of every kind. Essays on literature and history'] (Llandybïe, 1959), pp. 136–68.
14. Robert Redfield, *The Little Community* (Chicago and London, 1956).
15. Trefor M. Owen, 'Folk Life Studies To-day', *Amgueddfa*, 8 (1971), 19.
16. Yoder, 'The Folklife Studies Movement'.
17. Review of R. M. Dorson, *Folklore and Folklife: An Introduction* (1972), in *Folklore*, 85 (1974), 64–5. They didn't listen.
18. T. J. Morgan, *Diwylliant Gwerin ac Ysgrifau Eraill* ['Folk Culture and Other Essays'] (Llandysul, 1972), pp. 7–84. Huw Walters's *Cynnwrf Canrif: Agweddau ar Ddiwylliant Gwerin* ['Tempestous Century: Aspects of Folk Life'] (Llandysul, 2004), similarly examines aspects of industrial culture in south Wales.
19. *Welsh Folk Heritage / Traddodiad Gwerin Cymru 1. Carolau Plygain / Plygain Carols* (Penygroes, 1977); pers. comm. D. Roy Saer, 7 May 2020. The *plygain* was a church service associated with Christmas where groups would sing unaccompanied carols; it has latterly seen something of a revival.
20. NLW ICP Papers A4/4 Caseg fedi, press cuttings, 1929; 'Corn-Customs in Wales', *Man*, 30 (1930), 151–5. He retained an interest in this subject such that he addressed it again forty years later, but this time widening the scope of the paper to include European material: 'Corn Ornaments', *Folklore*, 82 (1971), 177–84.
21. 'The Wren in Welsh Folklore', *Man*, 36 (1936), 1–3.
22. 'A Welsh Wassail-Bowl: with a Note on the Mari Lwyd', *Man*, 35 (1935), 81–2; 'Mari Lwyd: A Suggested Explanation', *Man*, 43 (1943), 53–8; 'Mari Lwyd – Láir Bhán', *Folk Life*, 1 (1963), 95–6. See also Trefor M. Owen, 'The Ritual Entry into the House in Wales', in Venetia Newall (ed.), *Folklore Studies in the Twentieth Century* (Woodbridge, 1980), pp. 339–43.
23. 'Welsh Musical Instruments', *Man*, 47 (1947), 21–5.

24. V. H. Phillips, 'Tape Recording and Welsh Folk Life. Discussion Paper: Draft' (Cardiff, 1983), p. 34.
25. *Fourth Annual Report, 1910–11*, p. 7.
26. Reprinted as Appendix B to *Diwylliant Gwerin Cymru*, pp. 131–8.
27. '[He] asked volunteers, communities and schools to tell the museum about their everyday patterns and routines and about their cultural lives': Sioned Hughes, quoted by Amanda Powell, 'Collecting Covid stories from across the nation', *Western Mail Magazine*, 8 August 2020, 6; also Elen Phillips, 'The COVID-19 Questionnaire – revisiting collecting methods of the past', Amgueddfa Cymru – Museum Wales blog post, 15 May 2020.
28. I discuss this issue further later.
29. 'Diwylliant Gwerin', *Trans. Hon. Soc. Cymmrodorion, 1937* (1938), pp. 241–2.
30. I am paraphrasing Peate: 'Diwylliant Gwerin', p. 243.
31. 'Diwylliant Gwerin', p. 244.
32. 'Diwylliant Gwerin', p. 250.
33. 'The place of folk culture in the Museum', *Museums Journal* (1941), 46.
34. 'Folk Studies in Wales', *The Welsh Review*, iii (1944), 53.
35. *Diwylliant Gwerin Cymru*, cover; my translation.
36. *Diwylliant Gwerin Cymru*, p. xi.
37. *Diwylliant Gwerin Cymru*, pp. 1–2.
38. Again, I am paraphrasing Peate: *Diwylliant Gwerin Cymru*, p. 3.
39. *Diwylliant Gwerin Cymru*, p. 4.
40. *Diwylliant Gwerin Cymru*, p. 9.
41. *Diwylliant Gwerin Cymru*, p. 23.
42. *Diwylliant Gwerin Cymru*, p. 24.
43. *Diwylliant Gwerin Cymru*, p. 29.
44. *Diwylliant Gwerin Cymru*, p. 31.
45. R. E. M. Wheeler et al., *London Museum Catalogues 5. Costume* (London, 1935). Cruso was, briefly, the London Museum's first curator of costume and an archaeologist who later achieved fame as a gardening writer and television presenter in the USA.
46. *Diwylliant Gwerin Cymru*, p. 39.
47. *Diwylliant Gwerin Cymru*, p. 42.
48. *Diwylliant Gwerin Cymru*, p. 47.
49. R. W. Jones, *Bywyd Cymdeithasol Cymru yn y Ddeunawfed Ganrif* ['Welsh Social Life in the Eighteenth Century'] (Llundain, 1931).
50. *Diwylliant Gwerin Cymru*, p. 68.
51. Greatly overstating the case for much of Glamorgan still, at the time of writing.
52. *Diwylliant Gwerin Cymru*, p. 126.
53. W. J. Gruffydd, 'Adolygiadau' ['Reviews'], *Y Llenor*, 22 (1943), 43; my translation. No doubt he would have seen it as remarkable just because nothing similar had been published previously in Welsh, and of course there were almost no experts who could have reviewed it – but Ffransis Payne would have been one!

54. Alwyn D. Rees, 'Diwylliant gwerin Cymru. Ai aristocratig ynteu gwerinol? Damcaniaeth Dr. Iorwerth Peate' ['Welsh folk culture. Aristocratic or peasant? Dr Iorwerth Peate's theory'], *Y Faner*, 1 December 1943.
55. 'Alwyn D. Rees a Diwylliant Gwerin', *Y Faner*, 8 December 1943, and also Rees's further response, 'Y Ddadl ar Ddiwylliant Gwerin. Ateb i'r Doctor Iorwerth C. Peate' ['The Argument over Folk Culture. A Response to Doctor Iorwerth C. Peate'], *Baner ac Amserau Cymru*, 22 December 1943.
56. Dafydd Jenkins, 'Alwyn D. Rees – 1911–1974', *Y Gwyddonydd*, xiii (1975), 122–5.
57. For an overview, see Gareth J. Lewis, 'Welsh Rural Community Studies: Retrospect and Prospect', *Cambria*, 13 (1986), 27–40.
58. Elwyn Davies had accompanied Fleure to Manchester and later published important studies of transhumance in Wales, as well as becoming chairman of the Folk Museum's committee after Peate's days.
59. Elwyn Davies and Alwyn D. Rees (eds), *Welsh Rural Communities* (Cardiff, 1962), p. xi.
60. NLW ICP Papers A2/9 (ii), Adolygiadau; I have failed to find where this review was published (if indeed it was).
61. Geraint Jenkins, *Morwr Tir Sych. Hunangofiant* (Aberystwyth, 2007), p. 90; Jenkins's wife was from the parish and her brother ran the family farm, and a visit by Peate would have been noted immediately.
62. As he was to put it in *Tradition and Folk Life* (1972), p. 71, no doubt informed by this experience, 'One can write with real meaning only of a society well known to the author: to attempt a comparative study of various societies without intimate experience and knowledge of each would be meaningless and misleading'.
63. NLW ICP Papers A2/4.
64. He became Chairman of the company, was later ennobled as Lord Evans of Temple Guiting and appointed first Chairman of the Museums, Libraries and Archives Council.
65. *Tradition and Folk Life*, p. 22.
66. *Tradition and Folk Life*, p. 21.
67. *Tradition and Folk Life*, p. 71.
68. *Tradition and Folk Life*, p. 72.
69. *Tradition and Folk Life*, p. 126.
70. *Tradition and Folk Life*, p. 133.
71. *Tradition and Folk Life*, p. 134.
72. *Tradition and Folk Life*, p. 135.
73. *Tradition and Folk Life*, p. 137.
74. *Folklore*, 85 (1974), 139.
75. It is most unlikely that Peate was unaware of it – the copy in the Folk Museum library bears the date-stamp of that year.
76. 'The study of folk life; and its part in the defence of civilisation', *The Advancement of Science*, xv (Glasgow, 1958), 86–94, repr. in *Gwerin*, ii (1959), 97–109. A Welsh-language translation appeared as 'Astudio bywyd gwerin: a'i ran mewn amddiffyn gwareiddiad', in *Sylfeini*, pp. 9–23.

77. 'The study of folk life; and its part in the defence of civilisation', in *Gwerin*, p. 99.
78. *Gwerin*, p. 12.
79. *Gwerin*, p. 11.
80. *Gwerin*, p. 12; but implicitly anything discovered about such societies that could not be traced back to rural roots was not worthy of study.
81. *Gwerin*, p. 14.
82. Lewis Mumford, *The Condition of Man* (New York, 1944).
83. *Tradition and Folk Life*, p. 17.
84. 'Some thoughts on the study of folk life', in C. Ó Danachair (ed.), *Folk and Farm: Essays in Honour of A. T. Lucas* (Dublin, 1976), pp. 229–34.
85. 'Ordinary Folk', *Béaloideas*, 39/41 (1971–3), 281.

8
To dream the impossible dream... a folk museum for Wales?

Open-air museums and aspirations

Throughout much of his life and indeed thereafter, Iorwerth Peate has been known above all as the founder of the Welsh Folk Museum, and he assiduously fostered this belief. As always, the truth is more complicated, for the National Museum as an institution had decided that it should have an open-air branch almost from its foundation, nearly two decades before he joined it. Indeed, within a very few months of his appointment as the first Director in 1908, Evans Hoyle spent five weeks on a study tour of twenty-nine museums in north Germany and Scandinavia so that he would be better informed when writing the specification for the architectural competition for the new Museum building. Among the conclusions that he listed in his report of the tour were that the exhibits that most attracted the public were those that dealt with the history of culture, such as houses, furniture and clothing, and that having a large open-air courtyard where houses and other large antiquities could be displayed and where outdoor performances could take place would be of immense value.[1] He repeated his comments after a follow-up visit in 1910 when, after seeing Skansen (the great open-air museum in Stockholm, on which see below), he noted,

> While it would be undesirable to utilise any ground surrounding our building for any purpose on the lines of the latter, it was impossible not to feel how great would be the interest of a similar

open-air collection of historic buildings of Wales with the Welsh flora and fauna.[2]

Following the successful architectural competition, the Museum Council asked Dr F. A. Bather of the British Museum (Natural History), an internationally recognised authority on museums, to report on how the design might work from a professional perspective. Bather was fulsome in his praise, but amongst the detailed points he raised was that the planned provision for an open-air section in a central courtyard was far too modest: 'Wales is a country in which there must be many ancient buildings', he noted, and that to exhibit some of them would

> require a large stretch of ground [so that each might be] placed in its appropriate surroundings... I may perhaps be allowed the opportunity of urging the great value of such an open-air section, and to express the hope that it may be found possible to allow for some expression of it in the future.[3]

It is also interesting to note that there were at the same time informal discussions amongst the members of the Royal Commission on Ancient Monuments in Wales regarding the possible creation of a national collection of traditional Welsh buildings.[4]

The concept of the folk or open-air museum was created in the last decades of the nineteenth century in Scandinavia. It was a time of great emotional and nationalistic feelings in the region: Norway had become independent of Sweden, Finland was soon to become independent of Russia, Denmark had lost much of its territory to Germany following war, while the working classes were beginning to flex their muscles following the growth of industry and urbanisation. Folk museums are thus very much a feature of post-industrial nations, their founders (very often individuals) motivated by a desire to preserve the past before it was lost irretrievably. This was also the golden age of the great national and international exhibitions, and it was probably under the influence of these that Artur Hazelius (1833–1901), a language teacher, founded the Nordiska Museet ('Northern Museum') at Stockholm in 1873. It differed from other museums of its day mostly in its content – the costumes, tools, implements and furnishings of the everyday life of the local community – in other words, a folk museum. In the same year Hazelius exhibited a series of house interiors at the Paris

World Fair, and in 1891 opened an open-air section, Skansen, to exhibit examples of traditional buildings which he had moved and re-erected there. Hazelius saw the museum not only as a permanent exhibition by which people could be made more aware of their heritage, but also as a centre where traditional activities such as folk dancing, music and festivals could be transmitted to a new generation: and such has been the influence of Skansen that open-air museums in eastern Europe are still known generically as 'skansens'. The same motives influenced the setting up of another folk museum, Kulturen, at Lund in 1892, also with an open-air section. Two similar museums were founded in Norway around the same time, Maihaugen by Anders Sandvig at Lillehammer in 1887 and Bygdøy, Oslo by Hans All in 1894. Frilandsmuseet was relocated to Sorgenfri, Denmark, by Bernhard Olsen in 1897; and another was opened at Seurasaari in Helsinki, Finland by Axel Olai Heikel in 1909. Others were developed soon thereafter in the Netherlands, Germany, Poland and Czechoslovakia. The movement by now has developed to such a degree that there are hundreds of such museums across five continents, developing also into related concepts, such as the ecomuseum and the open-air and *in situ* museum of industrial technology, and, in north America in particular, into the living history museum (on which see Chapter 12).[5]

The larger of these folk museums generally comprised an indoors museum arranged on traditional grounds with galleries featuring permanent or temporary exhibitions showing sequences of objects, with an associated open-air section either within the same grounds or nearby. Several were also associated with research institutions such as universities, though the overwhelming number of open-air museums today are bereft of galleries or research sections and approximate to museums of buildings. Many open-air sections developed rapidly because the buildings they featured were of wood and were easy to dismantle and re-erect or even transport whole. Composite farmsteads were often assembled from buildings from different farms from the same region, so that a 'typical' regional unit was created. Most of the larger European open-air museums were laid out on a regional basis: as its director Peter Michelsen noted of Frilandsmuseet, 'The old country homes ... are arranged area by area according to their native district ...The basic idea of the plan is to make a walk round the rural park a journey throughout the whole country.'[6] In this way different agricultural practices and regional economies could be presented.

It was not until the years immediately preceding the First World War that interest in the concept was shown in Britain. In his Presidential Address to the Museums Association in 1903 Bather proposed that every great city should have an open-air museum on the Scandinavian model, for such museums should preserve the 'arts, industries and customs which from their truly national character afford the firmest foundations for the national life of the future'.[7] In 1912 a small group of prominent individuals came together and formed a committee under his chairmanship to engender interest in a project to use the Crystal Palace in London as a centre for a 'National Folk Museum'; they included Henry Balfour of the Pitt Rivers Museum, Sir Laurence Gomme (founder of the Folklore Society) and A. C. Haddon of Cambridge, and Count Plunkett, Director of the National Museum of Ireland and President of the Museums Association. The huge steel and glass structure had been relocated to Sydenham in south London after the end of the Great Exhibition of 1851, after being saved from destruction 'through the patriotic action of Lord Plymouth'. As the committee's Secretary, W. Ruskin Butterfield of Hastings Museum, said in an address that year,

> In no country is a National Folk Museum so necessary as in England, because in no other country is there such a dearth of distinctively national objects, and also because no other country has outgrown its past so rapidly and so completely in regard to indigenous customs, amusements, and modes of life generally,

and also because existing museums paid 'little or no concern to the ordinary man or woman'.[8] It is clear from the committee's scheme as reported in the *Times* and their letter to the *Museums Journal* that England in this context stood for Great Britain as a whole. The Crystal Palace itself would serve as the museum gallery, displaying recreated historical interiors and sequences of objects, while in the grounds buildings would be re-erected: 'We do not seek to violate local sentiment by the removal of buildings from their ancient sites, where there is no danger of their mutilation or demolition, but rather to rescue typical buildings of sufficient merit that would otherwise be destroyed', encapsulating the fundamental principles for acquiring buildings to which all future folk or buildings museums in Britain would subscribe. The committee also thought it probable that 'If an appeal were made, some of the English counties, and even private

individuals, would undertake to supply desirable buildings from their own area'.[9] Nothing came of the idea.[10] One of the members, however, was Evans Hoyle, and he, as we have seen, believed that Wales deserved such treatment.

The National Museum of Wales had acquired its first out-station, the Turner House Art Gallery in Penarth, in 1921, and at the same time started showing real interest in developing an open-air section where traditional buildings might be re-erected. This aspiration was recognised and acknowledged in the final report of the Royal Commission on National Museums and Galleries (1927–9), which also recommended, *inter alia*, the formation of a Standing Commission on Museums and Galleries, something which was implemented in 1931. The report recommended a national folk museum for each of the four home nations, with the most urgent need one for England, to be the start of a National Museum of England. It took nearly two decades before the Commission's recommendation 'that there should be [an open-air folk museum] . . . for Wales' was delivered.[11]

By 1930 Fox was aware that there was much to be learnt from Scandinavia, and Council agreed that he and Dr R. Paterson and T. W. Proger, senior members who knew well of Hoyle's earlier interest in this area, should visit Norway, Sweden and Denmark; Proger had been intimately associated with the growth of the Bygones Collection. They spent four days in each capital and visited eighteen museums. The open-air museums they saw made a great impression on them. Fox noted,

> Buildings (houses, bars, stables, churches, mills, workshops, etc.) illustrating the mode of life and immediate environment of the people from the earliest times for which such constructions are available (XII and XIII centuries) down to the XIX century. These buildings are fittingly and spaciously set out in parkland – Field Museums – and . . . in every case appropriately furnished with contemporary furnishings, often that which was made for that particular house. The intense interest aroused by an examination of these collections is heightened by the extraordinary effort made to create an air of reality. The storerooms of the farmhouses are in many cases *stacked* with dresses, furnishings, materials, etc., as they were when the buildings were inhabited. From the educational point of view the Field Museums are admirably arranged. The

visitor goes to the oldest house first and the sequence of buildings visited illustrates the growth of civilisation, of comfort, of the desire for privacy. Attention is drawn to the evolution of the fireplace, of the retiring room, of the upper storey.

Additionally, and importantly, the buildings were a focus for folk activities, rural crafts, dancing and music.[12]

Council accepted the report unanimously and resolved 'That the National Museum is incomplete without an adequate illustration of the life and work of people such as can only be offered by an open-air museum on the lines of that at Skansen, Stockholm.'[13] The *Annual Report* noted that

> Pending the creation of such an annexe to this Museum (which could not be regarded as a practical proposition at the moment) it was urged that the importance of the material illustrating the life and work of the people of Wales, now possessed by the Museum, should be emphasized by a descriptive name such as 'The Welsh Folk Collection'. The report has been approved by the Council, and this collection, in the Department of Archaeology, has been greatly added to during the present year.[14]

The Museums Association's annual conference was held in Cardiff a few weeks after the Scandinavia visit. Ernest Klein of the Nordiska Museet gave a paper that according to Peate opened Fox's eyes to 'the astonishing interest, vitality and possibility of museum work in the northern countries' and, as Peate recalled, 'we heard in detail of the methods adopted in the Scandinavian countries to record and collect materials illustrating folk life.'[15] After cautioning about directly copying another nation's approach, Klein noted that 'bygones' (his term) were living collections rather than accumulations of dead things: 'They try to inspire the people of to-day and give them a deeper and more conscious love of their home-country. They try to keep the old customs and traditions alive, so far as they have anything to say to our generation.' In seconding the vote of thanks, Fox noted that no lecture could give anything like an adequate idea of the fascination of the rural museums in Sweden. Their vivid, living quality was remarkable, their educational value extraordinary, and their scientific evidence such as to benefit students and general visitors alike.[16] Peter

Holm, the founder of Aarhus, also visited, and Peate was able to meet Bather, who was to be a great influence on his thinking.[17]

Peate believed that it was he who influenced Fox to drop the term 'bygones', and certainly 'the Bygones Collection' was soon after replaced by 'The National Folk Collection' as the official term.[18] In 1934 Séamus Ó Duilearga of the Irish Folklore Commission (on this, see Chapter 12) and two of his close friends, Carl Wilhelm von Sydow, Professor of Folklore at the University of Lund, and Dr Åke Campbell of the same institution, who was carrying out a survey for Ó Duilearga in Ireland at the time, visited Cardiff: 'They were astonished at the wealth of Welsh folk material and could not understand why there was not in Wales a flourishing national open-air museum of folk life' was how Peate recalled the visit in 1971,[19] or as he put it in 1976,

> The greatest favour that these three did was to preach to Cyril Fox the importance, indeed the necessity, of developing folk studies in the Museum. They succeeded, and it was their message during those days that made Fox an eager supporter of that development; from that came the Department of 1936 and the Folk Museum in 1947.[20]

Peate here was either forgetting or choosing to forget that Fox had been a demonstrable convert for some years (see above). And the message passed from Fox's office to the Museum's Court Room next door, where later in 1934, in formulating a long-term policy, the Council confirmed its earlier pronouncement 'that the provision of an Open Air Folk Museum as an Annexe to the National Museum is essential'.[21]

Fox was elected President of the Museums Association in 1934 and devoted his Presidential Address in Bristol to the 'importance of creating and developing collections illustrating the life and work of the people of Britain', or Folk Culture and Industry. Based on his experiences in Scandinavia, he claimed that such a museum 'would focus cultural achievements and cultural aspirations in a unique way [and act as] a living heart of a nation where people can foregather ... for instruction and inspiration'. Furthermore, he believed that 'the practice and elaboration of a common tradition enables the creative-like genius of a nation to reach the highest level of action of which it is capable'. Skansen had made the strongest of impressions on him: 'I say unhesitatingly that this

achievement of presentation, organization, and popularization is magnificent beyond the conception of those who have not personally studied it', he commented. He ended with a strong plea for funding from both government and philanthropists to follow the Scandinavian lead and create national and regional folk museums. In recognising that he had been 'unable to create any effective interest in the idea of a National Open Air Museum for Wales', he suggested that identifying and preserving redundant buildings was an important first step, as was doing the same with their contents.[22] Peate gave a brief update, somewhat more bullish than his boss, of where matters stood in Wales, feeling

> that... even now popular opinion in Welsh Wales is enthusiastic for the establishment of such a museum, and the Welsh peasant, with his enlightened interest in education, particularly in the history of his own nation, evinces a keen interest in and sympathy for the possibility of such a development.[23]

It was his efforts that had drawn the attention of the 'Welsh peasant' to such a possibility, in fact, but both men had many years of crusading ahead of them before such a thing came to pass, at least for Wales. Fox had an opportunity to revisit Uppsala and spend more time there in 1935.[24]

But the true feelings on the subject of some members of the National Museum Council and committees were revealed when it came to action. In 1936 the press reported that the owners of Greenmeadow in Tongwynlais (in the shadow of Castell Coch, north of Cardiff), a Victorian Gothic mansion in its own grounds, once owned by the Lewis family of Y Fan, Caerffili (who had owned St Fagans Castle from 1616 to 1736, when it passed by inheritance to the Windsor-Clives, later Earls of Plymouth) 'were prepared to present the freehold of the mansion to the Welsh nation' and that 'negotiations were pending' for its acquisition by the National Museum on behalf of the public. Major F. Treharne James, chairman of the Art and Archaeology Committee, wrote immediately to point out that this was all news to the Museum, and in a follow-up interview, stated his private views (which differed from official policy): 'Some people are anxious to have an outdoor museum on the lines of those in existence in Scandinavia, but, in my opinion, the establishment of any such museum is entirely outside the powers contained in the charter of the National Museum of Wales.' It was also the Museum's first duty to complete the

Cathays Park building by adding to the art galleries on the Museum Avenue side of the building, work estimated to cost £40,000.[25] Nothing came of the matter, and Greenmeadow was demolished in the 1940s.

Peate summarised his own aspirations in a six-page note that he wrote at the request of Geoffrey Crawshay in the latter's role as Assistant Commissioner for Distressed Areas (South Wales). The Distressed Areas were those officially recognised as in dire need by the Special Areas (Development and Improvement) Act of 1934, which appointed Commissioners with executive powers to help alleviate the problems that followed the Great Depression and the consequent decline of heavy industries.[26] Starting with the recommendation of the Royal Commission of 1929 that an open-air folk museum should be created for Wales, Peate noted how crucial such an institution was at a time when elements of traditional Welsh life still remained, but the barriers 'between the Welsh highland zone and modern Europe' were rapidly collapsing: 'if a record of it is to be made, it must be made at once and for this purpose an Open Air Museum is essential'. Some twenty to seventy acres (eight to twenty-eight ha.) of land would be required, with topography suitable for recreating highland as well as lowland landscapes of several periods. He referred to the Scandinavian exemplars which demonstrated how this could be done successfully, and rehearsed the value of such museums as reservoirs of talent that might lead to a renaissance of native culture and skills. An open-air museum should be created as an adjunct to the National Museum, 'financed and staffed separately ... but ... developed under the direction of the National Museum experts'. The site should be within easy reach of Cardiff and its heavily populated hinterland: 'For a Welsh Open-Air Museum to be successful and self-supporting, proximity to Cardiff is imperative: to place it on a remote site would be fatal.' Developing and operating the museum would help alleviate problems of unemployment, and it would be 'a centre for scores of social service activities' as well as a permanent centre for the inspiration of Welsh national schools of art and architecture, and Cardiff would be confirmed as a visitor destination of note.

And it would be wrong of him to put forward such a proposal without a possible site in mind: he had heard that Cwrt-yr-ala on the outskirts of the city, although in private hands, could meet all the Museum's requirements.[27] The document is a useful encapsulation of Peate's thinking in the immediate pre-war period. He again defined his Welsh tradition as that

of the uplands, that is rural Welsh-speaking Wales where remains of a culture unsullied by modernity remained; but he seemed to recognise that its destruction was inevitable, and talked of recording rather than preserving. He (and, implicitly, Fox) should play a central role in developing the new institution which should become a free-standing and cost-neutral establishment. He was also pragmatic enough to have accepted the lessons learnt in Scandinavia and recognised that location in the Cardiff area was crucial to success. The creation of a Welsh Reconstruction Advisory Council in 1943 gave the National Museum another opportunity to press its case for after the war. It submitted a comprehensive Memorandum, under the name of the President, Lord Howard de Walden, reviewing the state of museum provision in Wales and spelling out the functions that were necessary for a national institution to carry out and the breadth of subject areas that the National Museum had to cover. The Museum declared that it had two aims, namely 'to extend the usefulness to the public, and the range, of the national collections; and to develop the extra-mural work of the institution'. The latter could be met by forging closer links with educational institutions and making the collections more available to local museums, but the former required the establishment of an open-air institution. The latter recommendation was accepted by the Reconstruction Council but with no assurance of funding.[28] Catrin Stevens saw it as 'one of the cruellest ironies' that the greatest wish of the pacifist Peate should be furthered as a consequence of war.[29]

Peate expounded on the philosophical justification for such a museum in one of the essays that he chose to reprint in his volume *Sylfeini* ('Foundations') in 1938.[30] As one of the peasantry himself, he knew that *y werin* was not a dead entity but a living society; his worry was how to keep it alive in an age when values were diminished. Wales's folk culture was rural, but encompassed crafts and some industries, such as slate-quarrying. The complex industrial culture that had taken over parts of the country over the past century had never really become part of the whole, and once industry disappeared the nation would be left dependent on the essentials of the old native culture. Political parties united people *against* others, leading to hatred. What was required was something to unite and motivate the nation, and he appealed to his readership and those who loved Wales to join the National Museum in its task of ensuring that Wales could retain its native culture. Many believed that a museum was a repository for dead things, but it was actually a temple of

the living muse, and the National Museum of Wales could act as a catalyst for cultural regeneration.[31] The most significant development in the history of museums was the growth of open-air museums. He described their essential features, which, coupled with a nearby national (folk) museum, would display both the setting of native culture and its essential elements in galleries. The museum would become a natural centre for all national life and the study of the country's history. Lillehammer in Norway, for example, displayed forty different crafts and offered tuition in all. There was desperate need for such an establishment in Wales, for were not art and architecture languishing? The countryside was being spoilt by houses of which people should be ashamed. Would not the artist, the craftsman, the writer, the poet, the farmer and religious leaders all benefit from such an institution? His proposal was to make the National Museum of Wales into the fount of national inspiration by expanding it into the heart of the nation:

> I look forward to seeing on the soil of Glamorgan, in close connection with the beautiful institution in Cardiff – still there after the unsightliness of the coal industry is gone – a complete picture of the life of our nation preserved in an Open-Air Museum, and that home to all movements that have the nation's interests at heart. The Museum will be a home for new life and not a collection of dry bones.[32]

The acquisition of a site

In February 1946 the Museum's prayers for a suitable location were answered; but we must go back a couple of years to see why. In October 1943 the Museum's former President (1933–7) and Chairman of the Museum's wartime Emergency Committee (which had sacked Peate), Ivor Miles Windsor-Clive, 2nd Earl of Plymouth, died at the age of fifty-four, leaving an estate that included some 8,000 acres of land around Ludlow and the dower house of Oakly Park, the huge Jacobethan family seat at Hewell Grange in Worcestershire, and some 5,000 acres in Glamorgan. The main house of the Glamorgan estates was St Fagans Castle, which since Victorian times had been used as a summer home. The new Earl, Other Robert Ivor, a twenty-year-old soldier, was faced with substantial death duties. After a couple of years he and the family came up with an

uncomfortable but clear way forward: Hewell Grange[33] and St Fagans Castle had to be given up (in a parallel move, and responding to the same drivers, the Butes gave Cardiff Castle and its grounds to Cardiff City Council on the death of the 4th Marquess in 1947). The story of what transpired has been much told, not least by Peate, but he was clearly ignorant of all the facts, possibly up to his death. Less well known is what led to it and the fact that the Plymouths had no clear idea of what to do with the properties, until, in the case of St Fagans, they received a 'timely word' from Fox that it would be welcomed as the base for the Museum's long-wished for open-air museum.[34] The consequence of this was that on 4 February 1946 the as yet unmarried Earl and his mother, the Countess, called at the Museum and informed Fox that he wished to offer to the Museum St Fagans Castle, its gardens and the eighteen acres within its curtilage. Fox acknowledged the offer as 'the most generous, public-spirited, and far-reaching proposals which you had in mind for the future of St. Fagans', and agreed to keep the news confidential for the moment.[35] Following the meeting, the Earl wrote formally to Fox,

> I understand that for many years there has been a desire to secure a Field Museum as an adjunct to the National Museum of Wales.
>
> I am writing therefore to say that I am prepared to place St. Fagans Castle and gardens at the disposal of the National Museum if, and so long as, they should be required by the Council for Museum purposes.
>
> I know only too well the great interest which my father and grandfather took in the National Museum of Wales and I believe that it would have been their wish that since the family will no longer be living there the house and grounds should be given to the Museum for such a much desired extension of its services to the public.[36]

Fox called an informal meeting of the Officers and the Chairman and Vice-Chairman of the Art and Archaeology Committee to receive the letter, and together they visited St Fagans. The offer, when released by the Museum, came as a total and unwelcome surprise to the villagers: 'The village feels that a blow has struck it overnight', was how the *South Wales Echo* encapsulated local feeling.[37]

A folk museum for Wales?

With the benefit of hindsight, the site had both benefits and drawbacks; but given that it was the only site offered and it met most of the criteria set out by the Museum, its acceptance was unquestionably the right choice.[38] We can only speculate as to how long it would have taken for another offer to be made, and it is highly unlikely that what would have been offered could have been equal to St Fagans. Cennydd Treherne had leased Dyffryn House at nearby St Nicholas to Glamorgan County Council in 1939, a couple of years after purchasing it, but the house, previously the home of the Cory coal- and shipowning dynasty, had been rebuilt in Italianate style in 1893 and its ninety-acre gardens laid out formally in 1906, so would not have been suitable for all sorts of reasons. Tredegar House at Newport had the land but the house was huge, and it was not offered (it became a school). The Museum had no money to buy a site, and representations would have had to be made to the Treasury; almost certainly major political pressure would have had to be applied before any funding could be made available from that source, as well as a major appeal launched.

St Fagans Castle is a good example of an Elizabethan E-plan gentry house of 1580 within the remains of an earlier stone castle. The house, and particularly its outbuildings, was not in a good condition (a factor which no doubt played a part in the Earl's decision; the Museum later learnt that Queen Mary had put her foot through the floorboards when staying in 1935), and was coated in grey roughcast covered in wisteria. The formal gardens adjacent to the house, including a rose garden set out in 1899 and an Italian garden created in 1902, could be replanted to represent a contemporaneous design. They and the house are set on an escarpment and overlook a little valley into which ornamental fishponds were inserted sometime before 1730 (the earliest record), and above which, and adjoining the castle and formal gardens, ornamental terraces were created in the 1870s. At the far end of the valley and beyond the ponds was a swimming pool, above which rose further terraces of about 1900. The opposite side of the little valley also rose steeply, with some of it planted, but it flattened out at the end furthest from the house sufficiently for several buildings to be placed there if desired: this entire area was some twenty acres (eight ha.) in size. In it was a tunnel which connected to a fenced area of eighty acres (thirty-two ha.) beyond. The eighty acres was effectively divided into two parts: a six-acre area of flat land next to the tunnel entrance (where the car park and museum buildings now sit),

which had been designed as a kitchen garden and tennis courts, and the remainder of the site, which had been planted as an arboretum in 1908 with trees chosen by the Earl and overseen by his head gardener Hugh Pettigrew, and which was covered in dense and quite mature tree growth, the stands of trees divided by rides and circular clearings where the rides intersected. The parts of this area most accessible to the tunnel were flat.[39] It did not meet all the desiderata which Peate had noted in 1937–8 for the ideal site, within which 'a true representation ... of every type of Welsh countryside ... [where] the visitor may proceed ... from highland to lowland or *vice versa*', and certainly not the more explicit remark of 1944 that 'a tract of flat parkland would be unsuitable', but the time for being choosy was now past.[40] Little wonder that the Officers, Fox and Peate were all delighted: it was literally the answer to their dreams.

Peate penned his first official thoughts on the new site in a note for Fox's use titled, interestingly in view of his later feelings, 'St. Fagan's Folk Museum'.[41] This was his first expression of the problems and opportunities attached to the Earl's gift, the potential realisation of his and the Museum's strategic vision for many years. Now dreams had to be turned into reality. The note, dated 28 February 1946, is fundamentally about running costs, but to establish that required him to identify staffing and other needs. His preamble to addressing the issue of staff was to note, 'With the exception of any gardener(s) whose services have to be retained, it should be laid down that in *every appointment* to the Folk Museum staff a speaking knowledge of Welsh is essential'. There should be a head attendant and two others to staff the house; the head attendant should have previous museum experience and he suggested the names of three existing National Museum staff members (thanks to his earlier insistence, Welsh-speaking attendants were now available). A carpenter-handyman was required for outdoor work, supported by an assistant. The Keeper and/or the Assistant Keeper could perhaps live in the castle. More fundamentally, another senior appointment should be made to oversee upkeep of the buildings and the grounds, admissions and receipts, sales of produce, catering, staff supervision 'and later on transport of buildings for erection'. This person, who had to be a Welsh speaker with knowledge of crafts and organising ability, not a graduate but rather 'a good practical man of personality', 'should have the status and title of Assistant Keeper (Supervision)'. Craftsmen should be appointed to the staff 'to make the Folk Museum from the first a dynamic institution'. A wood-turner could

set up a pole-lathe and offer demonstrations while making the bulk of his products on a modern lathe, for which there was a ready market; 'Further appointments – a smith, weaver, potter, etc. – should follow as soon as possible'. Additional staff costs would come to £4,332 annually for the seven attendants, the new Assistant Keeper, head gardener and three other gardeners, the turner, carpenter and two cleaners. Receipts, from the sale of garden produce, turnery, the swimming pool (not explained, other than it required chlorination, so it was obviously being considered for use), sale of postcards, and admissions – 40,000 visits at one shilling each – came to £3,350, thus a deficit of £982; but since catering was not included in this equation, 'I am convinced that the final profits would eliminate the deficit completely'.[42] The Treasury agreed to offer fifty per cent for maintenance costs and in future 'the provision necessary to enable the net running costs of the out-door museum to be met', but offered no capital;[43] in other words, it refused to fund much more than the staffing costs (some of them, like Peate and Payne's salaries, already in the budget), and so St Fagans would become the first of any national museum site in Britain to charge for admission.

Fox described the offer and its potential in a five-page report to the Council meeting of 15 March.[44] The location was readily accessible to a large population and had a railway station and good road access. 'The Castle' provided 'as adequate a presentation of the history of civilisation in its material aspect in Wales as could be expected from a single dwelling-complex, and one of the functions of an open-air museum is to provide just such a focus'. The handsome late-Elizabethan dwelling sat within the curtain wall of a thirteenth-century castle; it would enable the visitor to 'appreciate the changed outlook of the landed gentry which the Renaissance brought to England' (*sic*: but no Peateian protest was scribbled on this copy of the document, at least). The house included a large hall and six other rooms on two floors suitable for exhibition purposes, most with contemporary carved oak friezes, mantelpieces and panelling; the layout of both floors offered easy circulation, whilst the original kitchen with its great fireplace might also be included as an exhibition space. In the attics were the rooms used by the family, and there was a separate flat on the first floor; more accommodation was available next to the boiler room behind the house. The stable-block could be adapted to display carts and wagons until re-erected farm buildings became available. Whilst the estate's large banqueting hall immediately outside the

curtilage – used as a military hospital during the First World War – was not included in the offer (a draft of the report has, crossed out, the query, 'Its possession is much to be desired; it would prevent serious delays in the development of the new museum; should discreet enquiries be made as to the possibility of getting it?'), there was a screened-off area of the gardens 'in which a building could be erected for illustrating the cultural history of Wales'. The gardens included greenhouses and required a staff of four for their maintenance, but such maintenance should be regarded as part of the amenity value and cultural significance of the complex. Additionally, there was sufficient ground to begin developing the open-air museum of reconstituted houses, with 'spacious setting' for six such buildings, including a watermill, which would heighten the interest of the grounds to visitors. However, there was one requirement that had to be met before the Earl's offer could be accepted. Fox reminded Council of his Memorandum of 1930, which made it clear that a minimum of fifty acres (twenty ha.), and preferably over one hundred, were required to provide an adequate home for an open-air museum and its collection of buildings 'reconstituted as and when they are marked down for destruction for public or private reasons': but as it happened, some eighty acres of the adjacent Park, with access from the Castle curtilage via a tunnel, was held in hand by the Estate. It was clearly necessary to add to the deed of gift a clause that secured for the Museum, by purchase or long lease, this additional acreage, which might not need to be taken up for five or more years. The clear final purpose had to be kept in view, namely period rooms in St Fagans Castle, re-erected buildings in the grounds, and a hall or gallery 'where the whole range of Welsh culture can be illustrated systematically in cases and on the walls'.

But matters would have to proceed slowly, because finance would initially be difficult, and many knotty problems of administration and organisation would have to be settled before a satisfactory cost estimate could be prepared. Estimates of attendance during the first year varied from 20,000 to 40,000 (Peate's figure?). About a dozen staff would be required (and here Fox enumerated Peate's list) and, 'Since St. Fagans will be concerned with Welsh folk-life, the aim should be that all new appointments to the staff should be Welsh-speaking'. An approach to the Treasury for additional grant would be made, but it was unlikely that any help would be forthcoming before April 1947; and approaches should be made to the county councils, cultural bodies and grant-making

trusts (a note headed 'Proposals' by Peate bears his pencilled annotation that the approach to the Treasury should be by Professor Gruffydd, Sir Leonard Twiston Davies and D. E. Roberts, and that £10,000 should be sought to operate the site for a full year).[45] Finally, Fox suggested stages of development. The ground-floor rooms of the Castle should be furnished and together with the grounds be opened to the public on 1 April 1947. The short-term policy thereafter should be a gradual increase in what was open to the public in the Castle; the building of an exhibition hall or gallery; developing and widening the range of crafts demonstrated; and obtaining half a dozen interesting buildings or groups to be re-erected within the eighteen acres. Longer term, Council should envisage taking over the eighty acres in zones of perhaps ten acres at a time. Seemingly as an afterthought, Fox added that it would ease staffing problems if the Plymouth Estate could make available to Museum staff any cottages that might become vacant in the village.[46] The Council meeting of 15 March 1946 thanked Lord Plymouth for his offer and resolved that a St Fagan's Castle Committee be formed. In addition to the Museum Officers (President, Vice-President and Treasurer) it would comprise the Chairman and Vice-Chairman of the Archaeology and Art Committee, H. J. Randall, LLB, FSA, Wing-Commander A. E. Renwick, MC, Professor W. J. Gruffydd, MA, MP, Dr William Rees, MA, FSA, Principal Sir Frederick Rees, Mr Ralph Edwards and Dr R. T. Jenkins, whilst Lord Plymouth and Wing-Commander E. J. L. S. Brooke, his agent, were also invited to serve on the committee.[47]

The partnership of the well-known Cardiff-based architect Sir Percy Thomas was engaged to develop a master-plan for the site, with Fox writing to commission Thomas on 18 May 1946 and holding a preliminary meeting with him a few days later. Thomas submitted his two-page report on 3 July. He had been asked firstly to study the site and make recommendations as to the best position for the erection of an exhibition gallery, refreshment rooms, car park, and so on. He saw the first stage as developing the Castle and its grounds by building a small ticket office immediately next to the entrance gateway; creating a men's lavatory near the Castle (presumably the facilities in the Castle would be made available to female visitors); and clearing some of the trees and shrubs near the banqueting hall in order to construct a public tea room to seat about one hundred, with a terrace in front overlooking the gardens and 'lily ponds'. If a permit to build a permanent structure were not granted, then

a 'Ministry of Works Sectional Hut or some other form of temporary building' would have to do. Sir Percy saw the second stage as the development of the eighty acres of woodland. When circumstances permitted, the road from the bottom of the hill near the railway station leading to Llwyn-yr-Eos farm should be widened to become the main entrance to the Folk Museum, leading to a large car park which should be created on the site of the existing kitchen gardens, with next to it 'a group of modern buildings comprising the main restaurant, administrative offices, and exhibition gallery, together with public lavatories'. Enabling those who wished to 'inspect the whole of the exhibits' to have refreshment between viewing the buildings in the woodland and then the Castle and its grounds was important. A subsidiary car park should be created at the top of the hill 'opposite the village school'. If this general thinking were to be approved, then Sir Percy was happy to develop sketch-plans of the tea room and ticket office.[48] These quick thoughts were to be crystallised into the master-plan for the spatial development of the Folk Museum; the only elements not carried through were the permanent restaurant in the Castle gardens (alternative small-scale provision was made in the Castle itself, as we shall see) and the secondary car park in the village, which never materialised.

More pressingly, plans for the use of the public areas of St Fagans Castle were also developed and summarised in a report prepared by Fox and Peate in January 1947. It was thought that these could be completed ready for opening sometime in 1947 (in fact, it was April 1948 before the Castle was opened: but in a form of soft opening, the gardens were opened to the public between 23 July and 28 September 1947 and attracted 8,914 visitors, including 995 on the August Bank Holiday), but they should be reviewed in light of a year's operational experience. On the ground floor, the hall should be furnished as a seventeenth-century room and the 'Drawing Room' as one of the eighteenth century. The dining room (an addition to the rear of the Castle) should be converted into an exhibition gallery to illustrate the life of the Welsh landed classes, social and corporate life, and material illustrating Welsh houses. The kitchen, while furnished with material from the seventeenth to nineteenth centuries, could be used as a tea room until such time as a more permanent arrangement could be devised. On the first floor, the rooms should be used to display material already in the collection, such as the library furniture from Coed Coch (by Gillows of Lancaster), a

four-poster bed and hangings from Plas Llanfair, Anglesey, embroideries and tapestries. Offices were proposed for the ground floor, while the Keeper and Assistant Keeper could be accommodated in two flats on the attic floor (see later). A separate but subsidiary report concerned the Folk Life galleries at Cathays Park. The main gallery was overcrowded, and transport and agriculture were unsuitable subjects for display there, and objects from those classes should be moved to outbuildings at St Fagans. The building of a Central Block at the Folk Museum would demand a new study of the relations between the Folk Life Galleries at Cathays Park and the Folk Museum; in the meantime, few alterations were proposed.[49]

A St Fagans Appeal Fund was established, for a minimum of £50,000 was needed to conserve and upgrade St Fagans Castle. In late 1946 the Museum published a bilingual appeal booklet by Peate: *St. Fagans Castle: A Folk Museum for the Welsh Nation*. It had eight pages of text per language, seven black-and-white plates of the Castle and its grounds, a plan of the Norwegian Folk Museum at Oslo, and a site plan identifying the twenty acres and the eighty acres. Peate rehearsed the history of the National Museum's aspirations for a folk museum out-station and what a folk museum actually was – 'It represents the life and work of a nation before the industrial revolution [a generic definition which was entirely true at the time]; it illustrates the arts and crafts, the building crafts in particular, of the people, the complete community, rich and poor alike.'[50] It would showcase the 'pride of the people in the best traditions of their past'. The picture he painted of what such a museum could be was not an imaginary one: it had been achieved at half a dozen locations in Scandinavia, where their influence on maintaining the pride of the people in the best traditions of their past had been remarkable. He then sketched the history of the Castle and its owners and the character of the house and its grounds, mentioning too the eighty acres so essential to the complete development. The intention now was to

> form in the Folk Museum as complete a picture of the Welsh past as is possible, to create a 'Wales in miniature' where the visitor can wander ... through time and space, from the 16th century to the 20th, from Anglesey to Monmouthshire, and see not only the old Welsh way of life but the variations in and the continuity of our culture.[51]

Buildings would be re-erected within their recreated home environment, while seasonal agricultural pursuits such as hedging and rick-thatching would be demonstrated, as well as traditional craftsmen producing wares for sale to the public. The Folk Museum would be an educational centre as much as a reconstruction of the past. The gardens and grounds of the Castle might house a watermill and a textile mill, while a small farmhouse unit would add to the attractiveness of their north end. Peate extolled the beauties of the gardens (the section heading is 'The Gardens as a Pleasure Resort'!), and the swimming pool and the tennis courts (the future location of the gallery complex in the eighty acres) would be made available for use. But although supported by government grant, the National Museum was an independent institution badly in need of funds to undertake all this work, for which at least £50,000 was needed immediately, and 'it is impossible to forecast what the ultimate expenditure upon the development of the scheme will amount to, but it may well reach twice the figure now being appealed for'.[52]

The appeal also appeared in the press and in magazines.[53] By February 1947 the Fund stood at £52,000, paid or promised. Glamorgan County Council had made a capital contribution of £10,000 but was also disposed to consider favourably contributing to the annual maintenance costs; Cardiff City Council had promised £1,000 a year from the rates to the same end.[54] A management subcommittee was appointed to oversee the maintenance and general running of the site, including staff matters. Peate had hoped that Gruffydd might chair it, but Fox wanted Wing-Commander Renwick, whom he believed to be close to the Plymouths, and Gruffydd would become Chairman of the Appeal Committee.[55] A man who would become one of Iorwerth Peate's bêtes noires was thus placed in a position of direct influence over his activities. There were also minor legal hiccups: the transfer of the Castle curtilage could not be done as a gift, so the Museum had to purchase it, for £5; and leasing the eighty acres for 999 years was also problematic, so the Plymouth Estates agreed to convey the land to the Museum for £2,000.[56]

Considerable work needed to be done to the house, including its complete rewiring, during which operation it was discovered that the spaces between the floor joists had been filled with seashells for insulation and soundproofing; and Tudor-style panelling was purchased from nearby Miskin Manor to line the long gallery. The furnishing of the Castle saw another clash between Peate and Ralph Edwards. Edwards complained

A folk museum for Wales?

about Peate's choice of items on display to the Chairman of the Folk Museum Committee, Renwick. Peate, understandably, was not amused and wrote back to Edwards, quoting the terms of appointment which made it clear that it was the departmental Keeper, and not members of a committee, who was responsible 'for the *selection and arrangement* of specimens for exhibition and of organized exhibits'. Edwards noted that it was up to Council to determine whether members of committees were barred from offering comments or criticisms. Peate escalated the conflict, writing to Fox and noting that while any member's criticism was welcome, 'the normal courteous way' of doing so would be to write to the Keeper concerned; he had no intention of trying to debar criticism, 'but I *do* object to the way this particular criticism has been presented'. The matter was discussed at Council, whose members batted the matter back to the Folk Museum Committee, who in turn recommended that the matter should lie on the table.[57] Renwick and Peate appear to have loathed each other, and the Castle was only one battleground; according to Peate, he opposed any proposal that Peate put forward almost on principle, and Peate came close to resigning many times. St Fagans Castle was to be the Earl's home, tidied up but no more, though the terraces would be improved by the addition of tables and parasols, and on no account was Peate to touch the eighty acres, which should be preserved as woodland. Matters came to a head when Peate was away at a meeting, and Renwick rearranged the furniture of one room in the Castle to look as he wished it. Fox remonstrated with Renwick on his behalf, whereupon (recalled Peate) Renwick came into his office cursing and swearing at him having the temerity to seek to undermine his authority as Chairman: Peate said he was neither his dog nor his slave and showed him the door. Renwick died shortly after serving his three-year term and was replaced by Wales's foremost historian, Professor William Rees, whom Peate regarded as helpfulness personified.[58]

It was not only committee members who tried to micro-manage. Fox took having the ultimate responsibility for the St Fagans project very seriously, to the extent that whilst grappling with policy and strategy issues he also involved himself in every detail: in May 1947, for example, he wrote to Peate instructing him on the importance of ensuring that the Castle windows were opened on fine days to keep the house 'sweet', and equally importantly to make sure that it was the duty of either the turner or the mason (the two resident craftsmen, both living in the stable yard) to

shut the windows every night – Peate was allowed the latitude of choosing which craftsman would undertake the duty![59] Ffransis Payne meanwhile was engaged in redesigning the formal part of the gardens that abutted the north gable of the Castle, introducing such features as a knot garden and topiary which were thought to be compatible with the Elizabethan house.[60] By now Peate and Payne had agreed that to manage properly the development of the fledgling Folk Museum required them to move their families from Rhiwbina Garden Village, north of Cardiff, to St Fagans. It may have been originally envisaged that they might be accommodated in vacant cottages in the village, but by 1947 the Castle option was becoming more viable. After inspecting the attic floor of St Fagans Castle with their wives – who Peate noted would have to put up with the loss of the 'most conveniently placed excellent shopping centre' that they were used to – a scheme of dividing the area into two flats was put forward, together with a list of necessary works, including radiators in the rooms, only the corridors being heated; separate staircases to each end of the floor already existed.[61] This proposal was put to Committee in January 1947, together with suggestions for the furnishing and display of the Castle (see above). But '[i]n our present houses, Mr. Payne and I have studies. I have a library of some two thousand or more books. We do not ask for study accommodation in the flats since such a request would increase the space problem.' Peate instead asked that the two be allowed to use their new offices in the Castle as their private studies out of hours.[62] Negotiations involved trying to secure a van that could pass under the stone arch of the gateway into the Castle courtyard so as to avoid having to manhandle furniture for a distance (Fox was not sympathetic – he thought the distance manageable), and an expectation (agreed) that the premises would be occupied rent-free, in exchange for recognition of the fact that both men would be shouldering a greatly increased workload for no financial recompense. A private garden was provided, which included felling trees and levelling ground, done by the gardeners in their own time, but the lack of suitable ground for clothes-lines was still unresolved and becoming urgent by July 1948.[63]

There were opportunities for promoting the new venture. David Morgan's, the family-owned department store established in Cardiff in 1879, had a history of supporting Welsh crafts: amongst other initiatives, it had supported the pre-war Brynmawr furniture-makers by giving the company free of charge a week's selling exhibition for several years. Peate

A folk museum for Wales?

suggested to Fox that if there were to be a Welsh Rural Crafts Exhibition at the store in February 1947 then it would be advantageous to have a Folk Museum stall; and if so, then an attractive model should be made to help encourage visitors to subscribe to the development fund, showing cottages on the eighty acres. This was agreed by the Appeal Committee, and Fox noted that 'a few buildings of the types which it is intended to procure, should be included. Mill. Chapel. Farmhouse. Croft Cottage. Farm complex'.[64] Paul Matt, former designer for the Brynmawr Company and now working for the South Wales and Monmouthshire Council of Social Service, was commissioned to make the model. The first new building to be erected at the Folk Museum was a cart-house built in traditional fashion – so convincingly that it was later listed as a building of historic interest by the Ministry of Works! It was erected against the wall facing the Banqueting Hall, using the existing garden wall as its rear wall. Staff carried out the work, with poles for the roof being sourced from the eighty acres and stone for the gables and piers from a ruined cottage in Peterston; the roof was thatched by the well-known local practitioner Tom David.[65]

Notes
1. W. E. Hoyle, 'Report on Visits to Museums and Galleries in North Germany and Scandinavia', *Second Annual Report, 1908–09* (Cardiff, 1909), p. 42.
2. W. E. Hoyle and A. Dunbar Smith, 'Joint Report by Director and Mr. A. Dunbar Smith (Architect), Upon their Tour of Inspection of Continental Museums', *Third Annual Report, 1909–10* (Cardiff, 1910), p. 33.
3. F. A. Bather, 'Report of Dr. F. A. Bather, F.R.S., upon the accepted design . . .', *Third Annual Report*, p. 20.
4. Douglas A. Bassett, *Folk-life studies in Wales: 1890s–1940s. A selective chronology of events . . . notes prepared to accompany a lecture on Iorwerth C. Peate and the Welsh Folk Museum* (Cardiff, 1966), p. 27.
5. This overview is largely summarised from the definitive history of the movement by Sten Rentzhog, *Open Air Museums. The history and future of a visionary idea* (Jamtli, 2007).
6. P. Michelsen in H. Rasmussen (ed.), *Dansk Folkemuseum & Frilandsmuseet* (Copenhagen, 1966), p. 234.
7. F. A. Bather, 'Presidential address', *Museums Journal*, iii (1903), 92.
8. W. Ruskin Butterfield, *A Plea for a National Folk Museum* (London, n.d. [1912]).
9. Henry Balfour et al., 'A National Folk Museum', *Museums Journal*, xi (1912), 221–5.
10. A further attempt was made in 1948, when the Royal Anthropological Institute established a committee chaired by H. J. Fleure and including Peate

as a member, but nothing came of this either: 'A Scheme for the Development of a Museum of English Life and Traditions', *Folklore*, 60 (1949), 296–300.
11. SFNMH/Building Specifications – Folk Museum – Statement for, quoting the *Final Report, Part I* (1929) of the Commission.
12. Charles Scott-Fox, *Cyril Fox. Archaeologist Extraordinary* (Oxford, 2002), pp. 107–8.
13. Council Minutes, 29 November 1930.
14. *Annual Report 1930–31*, p. 12.
15. NLW ICP Papers, A 2/9 (i), 'The Welsh Folk Museum', 18pp MS.
16. E. Klein, 'Rural Museums in Sweden', *Museums Journal*, 30 (1930–1), 257–63.
17. *Rhwng Dau Fyd*, p. 130.
18. *Rhwng Dau Fyd*, p. 131.
19. 'The Welsh Folk Museum', *Stewart Williams' Glamorgan Historian*, 7 (Cowbridge, 1971), p. 162.
20. *Rhwng Dau Fyd*, pp. 131–5; my translation.
21. *Annual Report 1934–5*, p. 17.
22. Cyril Fox, 'Open-Air Museums', Presidential Address, *Museums Journal*, 34 (1934), 109–21.
23. 'A Folk Museum for Wales', *Museums Journal*, 34, (1934), 229–31.
24. Scott-Fox, *Cyril Fox. Archaeologist Extraordinary*, p. 144.
25. SFNMH/Correspondence re above/Last Inn – Barmouth etc./Greenmeadow, Tongwynlais, cuttings from *Western Mail*, 1 April 1936, 4 April 1936.
26. The areas were south Wales, Tyneside, Cumberland and southern Scotland.
27. SFNMH/Building Specifications – Folk Museum – Statement for. Peate was able to visit Cwrt-yr-ala later: NLW ICP Papers A 2/9 (i), 'The Welsh Folk Museum', 18pp MS (1970). Cwrt-yr-ala at Michaelston-le-Pit was a house of 1820 by the architect Edward Haycock with contemporary grounds (the house was to be replaced in 1939 by one designed by Sir Percy Thomas).
28. Bassett, Douglas A., 'The making of a national museum', *Trans. Hon. Soc. Cymmrodorion*, Part III, *1984*, 40–4.
29. Catrin Stevens, *Iorwerth Cyfeiliog Peate* (Cardiff, 1986), p. 64.
30. 'Diogelu ein Gwreiddiau' ['Protecting our Roots'], *Sylfeini*, pp. 99–105.
31. 'Diogelu ein Gwreiddiau', pp. 100–2.
32. 'Diogelu ein Gwreiddiau', p. 105; my translation.
33. Hewell Grange became a Borstal in 1946.
34. Scott-Fox, *Cyril Fox. Archaeologist Extraordinary*, p. 175, quoting a letter from Lord Plymouth, 1986. Aileen Fox was later to recall that her husband had 'succeeded in the delicate negotiations with Lord Plymouth concerning the transfer of St Fagan's Castle and its surrounding parkland for a Welsh Folk Museum': *Aileen – A Pioneering Archaeologist* (Leominster, 2000), p. 106.
35. SFNMH/Files from Nat. Museum, Earl of Plymouth/7 February 1946, Fox to Plymouth.
36. SFNMH/Files from Nat. Museum/Earl of Plymouth/19 February 1946.
37. *South Wales Echo*, 22 February 1948.

38. Despite the reservations expressed by socialist historians such as the late Hywel Francis about the Museum's 'kow-towing' to the aristocracy: 'A nation of museum attendants', *Arcade* (16 January 1981), 8–9.
39. William Linnard, 'The Woods at St. Fagans', *Amgueddfa*, 24 (1976), 30–7; Deborah Evans, 'The Gardens of the Earls of Plymouth at St. Fagans Castle', *Gerddi. The Journal of the Welsh Historical Gardens Trust*, 3 (2001), 34–53.
40. SFNMH/Building Specifications Folk Museum – Statement for, 2; 'Folk Studies in Wales', *The Welsh Review*, 111 (1944), 51.
41. SFNMH/Files from Nat. Museum/Reports on Fishponds etc./St. Fagans Museum (Misc.).
42. SFNMH/Files from Nat. Museum/Reports on Fishponds etc./St. Fagans Museum (Misc.).
43. Douglas A. Bassett, *Folk-life studies in Wales: 1890s–1940s. A selective chronology of events: with particular reference to the National Museum of Wales* (Cardiff, 1996), p. 18.
44. SFNMH/Files from Nat. Museum/Memo on Policy and Reconstruction/A Folk Museum for the National Museum of Wales.
45. SFNMH/Files from Nat. Museum/Reports on Fishponds etc./St. Fagans Museum (Misc.).
46. Two cottages were made available, and rented by the Museum for gardeners until May 1947: Folk Life Committee, 2 May 1947.
47. SFNMH/Files from Nat. Museum Reports on Fishponds etc./Council Meetings & Resolutions.
48. SFNMH/Files from Nat Museum/Reports on Fishponds etc./Report from Sir Percy Thomas, OBE, LLD, PRIBA.
49. SFNMH/Files from Nat Museum/Utilization of Accomm. in St. Fagans.
50. *St. Fagans Castle*, appeal booklet, 4.
51. *St. Fagans Castle*, appeal booklet, 6.
52. *St. Fagans Castle*, appeal booklet, 8.
53. *Y Fflam* ['The Flame'], I/1 (Rhagfyr 1946), 51.
54. SFNMH/Building Specifications/St. Fagans Appeal Committee, 7 February 1947.
55. *Rhwng Dau Fyd*, p. 138; SFNMH/Building Specifications/Folk Life Committee, 7 February 1947. Renwick lived in a neo-Georgian house designed by Percy Thomas, St y Nyll, only a mile or so from St Fagans.
56. SFNMH/Building Specifications/WFM Committee Minutes/St. Fagans Castle Committee, 14 October 1946.
57. NLW ICP papers A3/5 (i), letters 4 October 1948, 5 October 1948, handwritten note 28 October 1948, and Council minutes of 19 November 1948.
58. *Rhwng Dau Fyd*, p. 143.
59. SFNMH/Reports on Fishponds etc./Council Meetings & Resolutions/CFF to ICP, 13 May 1947.
60. Ffransis G. Payne, 'Yr Hen Ardd Gymreig' [The Old Welsh Garden] repr. in *Cwysau. Casgliad o Erthyglau ac Ysgrifau* ['Furrows. A Collection of Articles and Essays'] (Llandysul, 1980), pp. 30–42.

61. SFNMH/Files from Nat. Museum/Officials' Flats/ICP memo to Director, 'Private accommodation at St. Fagans Castle', 20 January 1947.
62. SFNMH/Reports on Fishponds etc./ICP to CFF, 'Flats at St. Fagans Castle', 6 January 1947.
63. SFNMH/Officials' Private Garden, memo 23 January 1948, and ICP to Secretary, 23 July 1948.
64. SFNMH/Model of St. Fagans, notes 14 October 1946 and 4 November 1946.
65. SFNMH/Building Specifications/WFM Committee, 7 January 1949. Tom David and his two brothers had thatched *Y Bwthyn Bach* ('The Little Cottage'), the two-thirds-scale cottage given as a gift to the then Princess Elizabeth by the people of Wales in 1932; and coincidentally, one of the two pictures made to hang on its walls by amateur artist Saxon Jenkins was of St Fagans Castle: *bbc.co.uk/news/uk-wales-49839255* (accessed 31 July 2020). David had also demonstrated his work at several National Eisteddfodau.

9
Opening St Fagans and the early years

Opening and early development

A formal opening for the Welsh Folk Museum was contemplated almost as soon as the site was acquired. Whilst King George V had laid the foundation stone of the main building at Cathays Park in 1912 and opened it in 1927, the Museum's Council concluded that whilst St Fagans was of the highest potential importance educationally and culturally to the Welsh nation, it could not at the time of opening be sufficiently developed to invite King George VI to open it. Great efforts were made to get Princess Elizabeth to perform the ceremony, but a visit to South Africa by the King, Queen and the two princesses from February to April 1947 conspired against this and the matter had to be dropped.[1] In 1952 it was decided to hold back until 1953 since three buildings would be re-erected that year:[2] the long-delayed formal opening ceremony, including unveiling a plaque commemorating the gift of St Fagans Castle by the Earl of Plymouth, designed by the well-known Welsh sculptor R. L. Gapper, was eventually done by Princess Margaret during a visit in July 1954.[3]

The opening to the public that took place on Thursday 1 April 1948 was far less formal. Peate's press release stressed that the display of St Fagans Castle and its gardens was only the beginning, but made much of what there was to see in the form of loans and donations exhibited in the house: 'the magnificent Great Kitchen with all its appliances'; the State Bedroom with its four-poster; the complete collection of early nineteenth-century library furniture from Coed Coch, Abergele; and the restored Long Gallery displaying tapestries which had hung in the house. Sadly, it had not been possible to open a public tea room in time but it would be open later that

month. But all this represented merely the first step in the development of the Folk Museum, and it was greatly to be hoped that it would be possible in the near future 'to add regularly to the interest of the Folk Museum by the constant re-erection of cottages and houses from different parts of Wales'; but that of course depended on the cooperation and generosity of owners of suitable buildings. The Museum would be open from 11 a.m. until 7 p.m. until 30 September and until 5 p.m. from 1 October to 30 April, but be closed on Mondays. Admission was one shilling for adults, sixpence for children, and supervised school-parties would be free.[4] The first visitor was one of the local inhabitants, Miss Frithswith Matthews; her father, a Welsh-speaking native of the village, was over ninety years old and could recall the famous preacher Edward Matthews ('Matthews Ewenni', 1813–92) preaching in the village chapel.[5] Garfield Evans, the mason, recalled that she had pointed out to him the ruins just opposite the Bullhouse (often thought to be a dovecote by visitors and below where the Stryd Lydan barn would be sited) where her family had once lived.[6] Other early visitors included the 240 attendees to that year's Museums Association Conference, based at the National Museum, who travelled to the site by train.[7]

The 'magnificent Great Kitchen with all its appliances' was a bigger and better version of the successive recreated Welsh kitchens at Cathays Park (Peate's 'Welsh Kitchen' of 1932 remained on display until 1955, and visitors would still ask for it at St Fagans for very many years thereafter), but in a proper historical setting. The kitchen was a very large room, running almost the whole depth of the Castle, which later had one end partitioned off to serve as a scullery and with a mezzanine floor added above it. The only original features that survived apart from the doors and windows were the two very large fireplaces. The scullery was demolished, and items from Cathays Park, such as the dog-driven spit and hanging bread-crates, put in place (the scullery and mezzanine have since been reinstated). Storage was a major issue throughout this time, at Cathays Park as much as at St Fagans.[8] Peate had raised a warning flag in 1945 to the effect that every square inch of space at the disposal of his department was full, even the green room attached to the lecture theatre and basement corridors; he had suggested that part of the sub-basement could be used, but that required the installation of a lift and the scheme had been deferred due to cost, and then the acquisition of St Fagans Castle had appeared to lessen the pressure: but that was an illusion, for now more furniture had to be actively collected for the display of the house.

Opening St Fagans and the early years

In a memorandum he noted that every inch of vacant space behind the Castle was required for storage, including the servants' hall (which should become the principal furniture store), the rooms above it (for costumes and textiles), the laundry and brewhouse, and the lofts above the stables. Ten coaches, donated by the Marquess of Bute, and other items were stored in the Llandaf Fields Pavilion, but by 1950 this was required for civil defence use, and so the Museum erected a large shed at St Fagans.[9]

These curatorial needs were soon to clash with visitor expectations, or at least committee perceptions of how such should best be met. Visitors making the trip to St Fagans would expect to find refreshments. The long-term proposal, as we have seen, was to have a restaurant and cafe, to be built of local stone 'with practically the whole of the [bowed] front in glass and steel folding windows' and with an external terrace overlooking the ponds, to seat 200.[10] It was soon recognised that this would not be functional for at least five or six years.[11] In the meantime, finding a space to offer a temporary catering facility within the limited confines of the Castle was to cause much angst. There were tensions between the expected demands of the public, the viability of the operation, and Peate's desperate desire to retain as much as possible of the house for exhibition or office use – a tension still to be found in all museums today. The first proposal put forward was to use the Castle kitchen, with the public queuing under an existing glass portico. The essential aim, as Peate saw it, was to separate the catering business from the museum, and offer 'some convenience to the public who will come to St. Fagans not to take tea, but to see the Folk Museum'. It had been taken for granted that the Museum would not do its own catering, but experienced members of the management sub-committee, J. T. Morgan of the Cardiff department store David Morgan and Sons prominent amongst them, felt that no professional caterers would take on the provision of teas on the basis of such limited accommodation.[12] Morgan felt strongly about the matter:

> frankly I do not see how this can be done without coming inside the Castle . . . I am, naturally, fully aware of the objections by Dr. Peate to any suggestion that a portion of the Castle should be used, but frankly I am of the opinion that the time is coming when some of these objections must be over-ruled by the Committee. Possibly the Committee should have done so earlier, but, it appears that circumstances may well resolve the point for us.[13]

Peate believed that Morgan's proposal required taking over much of the ground floor of the building but even that would only offer 120 covers, when 'demand at the peak is likely to much exceed this', and his response was as might be expected:

> Thus the sacrifice of the Departmental Offices essential to the scientific and routine work of the Department: the relinquishment of effective control by officials of a great part of the building: and the turning of the Welsh Museum [sic] into a tea room to which a folk museum is attached, would not be effective even for its own limited purpose![14]

Peate here saw things very differently from a future director of the Victoria & Albert Museum, Sir Roy Strong, who in 1988 was to market his museum as 'An ace caff with quite a nice museum attached'. Peate recommended that catering be kept entirely separate from the Castle and sited where the permanent restaurant was to be located in time in the gardens, based around the acquisition of second-hand huts (presumably military), though he acknowledged they would be difficult to source because of strong demand. Fox noted prior to tendering a contract that it was desirable that the character of the food to be served should be distinctive and necessary that it should be as good and as plentiful as the circumstances of the time permitted; any caterer should also be asked to provide Welsh-speaking waitresses.[15]

The Museum invited tenders for the operation in April 1948. Responses from prospective operators were lukewarm, but when the tender was awarded to Hancocks they found to their considerable surprise that the tea room was quite inadequate to meet the demand, particularly if coach parties – even if pre-booked – arrived. A kiosk for the sale of mineral water and ice cream would be of great help; but Peate now had to point to the long priority list for huts.[16] Fox, however, found the proposal to use huts unacceptable: 'I do not feel that the proposed scheme of re-using Nissen huts is consonant with the standing of an institution such as we would wish the new Folk Museum to be'. Similarly, he was not happy with the architects' proposals for extending the servants' hall to become a catering venue, which would have meant the insertion of two large windows (presumably matching the pair already lighting the servants' hall) into the thirteenth-century curtain wall, which was 'on archaeological

grounds, wholly inadmissible' (it is highly unlikely that the walling in question was of this date but Fox was right to take his stance); an addition of a porch to the garden front of the house was equally unacceptable, while the proposal to lower the floor of the area to be included within the extended restaurant area by three feet, so that there would be one floor level, 'must be avoided' (he lost this battle, as can be seen today). This proposal was recorded in a note of a site meeting between the St Fagans Committee chairman Renwick, the Secretary and William Marsden, the architect (a partner with Sir Percy Thomas and Son since 1952; neither Fox nor Peate were present), concluding that it would be far cheaper not to build a free-standing tea room, but instead to double the size of the servants' hall through extension into the open area between it and the gardens, where there was already an access point.[17] The existing laundry could then serve as the kitchen. But there was a more fundamental principle at stake, one that Peate had raised and which Fox backed to the hilt (also unsuccessfully):

> The cogent arguments of the Keeper of Folk Life in favour of additional space and convenience for storage and work on furniture must be met. The taking-over for another purpose of the servery and the Servants Hall eliminates two of the best areas. Throughout the prolonged discussion of the catering problem the fear has been expressed by the Keeper of Folk Life over and over again that once a caterer gets into the Castle there will be no limit to the demands made on space. Indeed remarks made at meetings of the Folk Life Committee give good grounds for this fear.[18]

The lack of any funding in the next few years for the new restaurant and cafe building together with the relative ease and low cost of converting the servants' hall were to be the deciding factors, however, and by May 1948 new blue paving stones from the Forest of Dean had been sourced by Marsden for the flooring of the expanded servants' hall. The room was ready for when the Museum opened, providing some one hundred covers; the curtains were donated by the Holywell Textile Mills, whilst paintings by Sir Frank Brangwyn RA decorated the walls. A kiosk was also provided in the gardens. At the same time a new pebble-dashed and Snowcem surface was provided to the Castle, the old rendering having failed and let in water: photographs of the work reveal that the walls of the house

were of uncoursed rubble but with better quality quoins. All chimney-pots were also removed to stop water ingress.[19] The colour of paint chosen was based on a detailed report that Payne presented to the Folk Life committee in March, in which he discussed the evidence for limewashing houses of note in Wales from c.1400 to the late seventeenth century.[20] Not all were appreciative, however. The parish council deplored the fact that the Museum was open on Sunday afternoon, which was 'most detrimental to the quietude of the village and much deprecated by the local inhabitants', a point taken so seriously that the Chairman and Vice-Chairman of the Folk Museum committee, together with the Director and Keeper in Charge, met a deputation in February 1950,[21] though no action in favour of the villagers' opinion was taken. The problem of visitors parking cars in the village was being noted by 1953.[22]

It was hugely unrealistic to expect any caterer to find Welsh-speaking waitresses, but the net was cast wide for Welsh speakers for the directly employed staff: the advertisement for a carpenter and a stonemason was carried not only in the *Western Mail*, the *Echo* and the *South Wales Post*, but also in the *Cambrian News*, the *Welsh Gazette*, the *Liverpool Post*, the *Teifiside Advertiser*, the *Carmarthen Journal*, the *Montgomery County Times*, *Yr Herald*, *Y Cymro*, *Baner ac Amserau Cymru* and *Y Cloriannydd*.[23] Fox clearly had no issue with Peate's insistence that all staff at the Folk Museum should be Welsh speakers, if at all possible, and indeed supported him in this, as numerous memoranda and reports make clear; but they disagreed over gender. Fox felt that female attendants would be good in the Castle, but Peate thought otherwise:

> I disagree emphatically with the statement that 'women are more suitable than men' as indoor attendants. They would be less efficient in controlling crowds: they could not be called upon for moving furniture from room to room, for example. Moreover, they must be Welsh speaking and I submit that for the wage we pay women we cannot expect appointments from outside the Cardiff area ... Women cleaners, on the other hand, can be obtained in the village.[24]

Fox realised that the long opening hours would result in overtime working for the warding staff, and cause problems, not so much because of the cost (the total salary cost for the head attendant, five uniformed attendants

for indoor and outdoor duties, and one in the ticket office totalled £2,024 for a full year, including on-costs and bus fares), but rather because of strain on the men during the summer; in winter the converse might be the case. Accordingly, 'These men should then I think, not be uniformed attendants required to doff their uniforms and do hard work on occasions, but men who are to expect hard work, relieved by many hours of light work in uniform.'[25]

Another appointment was made to the pool of demonstrating craftsmen. One of the uniformed attendants, D. J. Davies, a countryman from Carmarthenshire, showed some baskets and walking sticks that he had made, and the Folk Museum Committee was happy to endorse that he be encouraged to make such items as part of his duties when he was not required for patrol duties; and in June 1949 he was appointed Craftsman in Basketry, though he was also expected to act as the Museum's tractor driver.[26] As well as the head gardener, the Museum took on two of the Plymouth Estate gardeners, and when the leases on their cottages in the village ended, acquired the lease of the cottages from the estate, letting them in turn to the gardeners. A well-known landscape gardener, Percy S. Crane, was invited to tender for advice on future planting (his name had been recommended by Lord Aberconway of Bodnant) but his price of £500 for a report to include plans and sketches of his proposals was considered excessive.[27] Major work was required, including cutting trees and cleaning out the fishponds.[28] Staff accommodation was seen as likely to become a growing problem. The Treasury was asked in 1951 for a loan to meet the cost of erecting six staff houses.[29] By 1952 the idea had been scaled down and costs were obtained for a pair of cottages, designed by Sir Percy Thomas and Son and which were built near what was later to be the main entrance to the Museum.[30] Peate and Payne were to have another, even more senior, colleague living on site, for in May 1948 Lord Plymouth agreed to sell the Gardens House to the Museum for £3,500 so that it could become the new Director's residence: Dr Dilwyn John was moving from London to take up his appointment and did not have a house in Cardiff, though he did not stay long and the property became offices as staff numbers grew.[31]

Peate pencilled in estimated costs against the suggested priority list he wrote in July 1947.[32] The first item, the gardens (including toilets and ticket office) might cost £7,000; the interior of the Castle, including the flats and alterations to the long gallery £5,000, and the exterior £2,000; a car park

for light cars 'on our road' would be £5,000, as would the temporary tea house; £5,000 needed to be allocated towards a mill and small houses suitable for re-erection within the Castle grounds; whilst the final item was 'The Pilgrim Trust Farm-house unit [Kennixton farmhouse] within the 80 acres', estimated at £10,000. Any buildings for re-erection which might be partially or wholly paid for by outside bodies could be inserted into the sequence at any time, whilst consideration of a permanent car park and the central block should be delayed until the Folk Museum had reached a more advanced stage of development. In November 1947 the Museum's officials met with representatives of the county councils to discuss funding. Renwick and Fox presented the principal facts and the sums that would be required, Peate then underlining the importance of the project for Welsh education. This would be the first national folk museum in Britain and here they were pioneers; the success of the task depended upon the Welsh people. The task itself was twofold; to create an adequate picture of the Welsh past, and to create a cultural centre to serve the Wales of the day and to enrich the Welsh cultural tradition of the future. The museum building, when erected, would become the recognised centre for research into every aspect and into all problems of Welsh life, the clearing-house for all studies relating to the cultural and social life of Wales. The Folk Museum would provide a living picture of the Welsh tradition and it was hoped that apprenticeship schemes would enable the Museum to send back into the countryside craftsmen trained in modern techniques.[33]

With the knowledge that the Folk Museum would open in 1948, it was perhaps inevitable that the University of Wales Press would invite Peate to write its annual bilingual volume for that year. The Press had been established in 1922 by the University of Wales to provide a way for scholars based in its constituent colleges to publish academic titles and quasi-academic works, like its *Cyfres y Brifysgol a'r Werin* series, and to which, as we have seen, Peate had contributed *Cymru a'i Phobl* in 1931 (the Press also reprinted that volume in 1948, seeing the opportunity for a further round of sales). The St David's day series was designed to offer short accessible introductions by scholars of note to well-known literary and historic figures, though occasionally an anniversary or similar event might prompt a title. Although now inevitably dated and out of print, the resulting *Amgueddfeydd Gwerin / Folk Museums* remains the best work published in Britain on the essentials of folk museums, crystallising the

history of the concept as well as outlining succinctly Peate's hopes and aspirations for the development at St Fagans. The first sentences of his foreword established the context briskly: 'When I was invited to prepare this booklet, it was noted that 1948 marked the tercentenary of the Battle of St. Fagans. To-day the battle is against economic difficulties to establish the Welsh Folk Museum: success will mean a new security for Welsh culture.'[34] The aim (as he had noted in the appeal booklet of 1946) was to form as complete a picture of the Welsh past as was possible by creating a 'Wales in miniature'; for 'This is an attempt to bring the museum to the core of all life, banishing completely the old idea that it is merely a repository for the dead bones of a dry culture.'[35] The little book is full of purple passages, but it was a fundamental opportunity for inspiring and convincing doubters, encapsulating all the aspirations of three decades. With the disclaimer that any thoughts in the text on possible developments were his own and not to be taken as expressions of institutional policy for the future, he firstly defined museums and their role:

> Too often we all think of museums as storehouses of dead things . . . [but] the principal purpose of a museum is to educate, and the chief aim of all men called to service in museums is (to quote the first Director of the National Museum of Wales) to awaken the best in the national spirit.[36]

Wales did not need to be ashamed of its record here – the National Museum had won fame as one of the most progressive museums which could teach people about their country and their heritage, and there were many of similar quality. But how should such institutions ensure they were not just curiosity shops? F. A. Bather had noted that it was

> not enough to show and preserve the things that have been; it is necessary to trace their organic continuity with the things that are and the things that shall be . . . It is time for us to get rid of the idea that a museum is a place for the preservation only of that which is dead . . . it is of more importance that a museum should preserve objects capable of yielding some lesson of use for our own time. And still more important is the preservation of arts, industries and customs, which from their truly national character, afford the firmest foundation for the national life of the future.[37]

The way to do that had been shown to be by means of a 'Folk Museum' which illustrated the complete national life through methods which could not be used by a normal museum. Peate traced the development of the movement in Sweden and elsewhere from the Nordiska Museet and Skansen, which together comprised a true folk museum. Hazelius's achievement was in taking a sudden leap in museum technique and transforming the museum from a curiosity shop into a home of national inspiration, not just by re-erecting buildings but by demonstrating crafts and holding events and festivals.[38] Having now seen Skansen and similar museums for himself (see Chapter 10), he noted that 'the effect is amazing... the experience was wholly ineffaceable. I felt that I had consciously conquered Time and had returned to a distant past to find revealed to me the spirit of far-off ages whose mystery I had never expected to penetrate'.[39] Local folk museums similarly served as centres for their own communities. He paid a double-edged compliment to John Ward, who had curated the folk-life collection in the Cardiff Museum and then at the National Museum before himself:

> Despite the excellence of Ward's work, and my homage to him is sincere, he was an Englishman who did not, and could not without learning Welsh, understand the mysteries of Welsh life. But to do him justice, he was an archaeologist and not a student of folk life; it was as an archaeologist that he looked at our culture.[40]

Whilst it was another archaeologist who next took an interest in the collection of 'Welsh bygones', that one had come under the influence of A. C. Haddon (the influential anthropologist and ethnologist) at Cambridge, who also believed in the need for folk museums. Sir Cyril Fox had taken a deep personal interest in the Welsh Folk Collection and his inspiration was behind the publication of the *Guide* of 1929.[41] Now there was a site, and it would be

> a Folk Museum in the full sense. That is, it will consist of the two parts which are so essential to the success of such an institution – a modern block of buildings for the scientific exhibition of the materials of our life and culture, and an open-air section where buildings are seen in their environmental setting.[42]

The block, however, would be costly, and its galleries, offices, library, lecture rooms, public restaurant, workshops and archive would have to wait; but as an example of what the archive would look like, he took the case of traditional buildings – 'In the course of time there will grow in this building a vast catalogue of facts, drawings, and photographs not only of houses in every Welsh parish but of details of the construction of roofs, doors, ceilings and windows.'[43] Buildings would be re-erected in appropriate settings of hedges and gardens, with a small number of Welsh black cattle and sheep. A stonemason, carpenter and turner had already been appointed, to be complemented in time by a weaver, blacksmith, potter, saddler and others. Apprenticeships would be 'an instrument for reinvigorating Welsh culture, sending out to the countryside craftsmen trained in modern techniques, making less laborious the crafts which are fundamental to the Welsh tradition.'[44]

'The time will soon come, we trust', Peate hoped, 'when the Welsh Folk Museum will integrate within itself all the elements of Welsh life. As a picture of the past and a mirror of the present, it will be an inspiration for our country's future: from it will radiate energy to vitalize Welsh life', and of course the Museum would act as a social centre for national movements and conferences of all kinds. But if the picture of Wales should be shown to the world, 'we should realize that only Welshmen can do so. None other can do this work ... only Welshmen working in Wales can be expected to be experts',[45] and it was the duty of all Welshmen to help create and maintain the Welsh Folk Museum so that Wales might 'serve civilization yet again as a small nation which is conscious of its part in a larger world.'[46]

Iorwerth Peate placed a slightly different emphasis in a lecture to the Royal Society of Arts in early 1949, when he noted that the Folk Museum was 'a museum of life and culture' that would 'not only provide a reconstruction of the Welsh past but will become a centre for architectural and craft education, both visual and instructional'. It would

> serve to reinvigorate many aspects of our social life, the texture of which has suffered so greatly in the dark periods of this century. The folk museum is not only a re-creation of a picture of the past: it is also an experiment in social regeneration. In it the museum takes a central place in the community – a place where nothing which strengthens and uplifts the soul of man will be unwelcome.

It is hoped that the near future will see the development of several such museums, national and regional, in all the countries of the British Isles.[47]

In response to a question about the representation of industry in a museum of Wales, he noted,

> I am very interested in that question. My own opinion is that coal-mining should not be represented in the National Welsh Folk Museum at St. Fagans, though coal-mining should be represented in a folk museum. There should be in Wales ... several regional folk museums for special subjects. There should be, I think, a quarrying folk museum in the Bangor area; a folk museum devoted to boat-building in the Cardigan Bay area; and a folk museum concerned completely with coal-mining and other such industries in the industrial area of Glamorgan. I think that could be arranged ... I fully agree that we cannot overlook the economic development of society down to the present day.[48]

A case for devolution?

Fox as Director had taken his duties as having the ultimate responsibility for the St Fagans project very seriously, to the extent that he not only led the strategic thinking for the new site, but also involved himself in every detail, to the extent that Peate chafed under his micro-management. And no wonder, too, that by spring 1948 Fox was feeling the strain, for he had been due to retire in December 1947; he had agreed to continue in post for a further year to oversee the first phase of the St Fagans project (Council had informally asked him to stay for five years, until his seventieth birthday, but he was concerned that his younger wife Aileen's career should not be jeopardised).[49] The year 1948 was to be momentous for both Fox and Peate, in fact, and even more so for the latter. Not only would there be a new Director that he would have to contend with, for good or bad, but St Fagans – his dream realised in terms of a viable site, at least – would open fully, and it appeared possible that at last he might gain some considerable freedom from external direction as well as having his administrative burden eased. Even though there were already out-stations at Penarth and Caerleon, the acquisition of a large new site was clearly

making it difficult to distinguish between the National Museum of Wales as a corporate entity and its headquarters at Cathays Park – a problem that has bedevilled the institution for much of its existence. 'So long as there is a Keepership of the Department of Folk Culture in the National Museum of Wales', Fox wrote to the Folk Life Committee in March 1948,

> the head office organisation of the Keeper must remain at the National Museum ... official records of all specimens purchased by or on loan to the National Museum of Wales, notwithstanding the fact that they may be exhibited at St. Fagans must continue to be kept in the National Museum.[50]

However, behind this official position the Director was coming to believe that the administration – and to a large extent the strategic direction – of the Folk Museum should be delegated. A clear precedent existed in the case of the British Museum, which by then had developed into two sister institutions – the British Museum itself in Bloomsbury, and the British Museum (Natural History) in South Kensington, each with its own building and director, though the latter institution did not become entirely separate, as the Natural History Museum, until 1963. Fox would now retire in 1948, and felt it incumbent to inform those who would appoint his successor of his views. Writing of himself in the third person, he noted to the Officers,

> It is ... not easy for him adequately to carry out Directorial duties at St. Fagans. The question therefore arises as to whether the time has not already arrived for the Director of the National Museum of Wales to be relieved of Directorial responsibility for the Welsh Folk Museum, and for the administration and organisation generally to be transferred to the resident St. Fagans staff ... As far as the Director is concerned the break should be complete – there would appear to be no satisfactory 'halfway' house.[51]

Fox then noted formally to Council and Court, 'The Welsh Folk Museum (National Museum of Wales) will have its own senior official: his official title should be "Director, Welsh Folk Museum (National Museum of Wales)".' The post-holder would be able to call meetings of the Folk Museum Committee, be solely responsible for all Folk Museum matters,

and report directly on them to Council and Court (Peate did not have direct access to these bodies, and all his proposals had first to go to Fox, who could put them forward over his name, amend them, or refuse to forward them). Fox suggested 1 October 1948 as the implementation date. Council did as every governing body would: it appointed a committee to progress the issue. This was chaired by Sir Leonard Twiston Davies the President, and included the Treasurer D. E. Roberts, Professor E. G. Bowen, Professor R. T. Jenkins, A. E. Renwick, H. J. Randall, the Director and the Secretary. Meeting on 2 April, the committee resolved that there should be one National Museum of Wales but that the Folk Museum should be led by a Director-in-charge, National Museum of Wales (Welsh Folk Museum). The proposed new title presaged the eventual outcome. Peate, naturally enough, held the same view as Fox. Although he felt obliged to apply for the post of Fox's successor as the Director of the National Museum, he wrote to Fox on 24 March 1948 laying out his stall as to what he really wanted. Each site should have a Director of equal status, though there might well be an initial difference in salary. The annual report for the Folk Museum should be bilingual and separate from that dealing with the rest of the National Museum. If his terms were met (hardly the most politic phrasing!) and he was to be invited to become Director of the Folk Museum, he was prepared to withdraw his candidature for the Directorship of the National Museum: 'This would satisfy the Welsh public which is taking so keen an interest in the Museum appointment and which is embarrassing me with a "fan mail" which takes my successful candidature for granted! I am most anxious not to see a public outcry about this.'[52]

Peate's 'Welsh public' was of course the Welsh-speaking public. He felt he had to apply for the overall Directorship, and although several influential people such as Thomas Jones and the Director of the Pitt Rivers Museum felt unable to act as referees, his candidature was supported by Sir Idris Bell (the President of the British Academy), H. J. Fleure and Sir John Myres. There was some criticism in the press that the post did not call for the ability to speak Welsh, and once the appointment of Dr Dilwyn John was announced, Peate received a number of letters of commiseration and the well-known Welsh-language author, Kate Roberts (his former neighbour at Rhiwbina Garden Village), wrote in *Baner ac Amserau Cymru* (which she and her husband owned) that while she disagreed fundamentally with Peate on many topics and how he expressed

his views on them, he was in her view the only candidate qualified for the post.[53] Peate was quizzed by the President Twiston Davies and Sir Wynne Cemlyn-Jones as to whether he really wanted the post of Director of the National Museum, and had answered honestly that he was really only interested in becoming Director of the Folk Museum and ensuring that the Council accepted Fox's recommendation. He was assured that this would happen at the next meeting of Council, where he would be offered the post he desired.

But things were not so straightforward. There was strong opposition within Council to Fox's proposal for two Directors, and the situation was not helped by the leading article in the *Western Mail* of 15 April (the day of appointing Fox's successor) which came out strongly against a separation and two Directors, particularly as the Folk Museum had not yet been developed fully. Accordingly, Peate was asked formally if he was still interested in applying for the Directorship, to which he responded that his reply would depend on Council's decision regarding the Directorship of St Fagans. According to Peate, at this point the Museum Treasurer, David E. Roberts (one of the two who had insisted that he be dismissed in 1941) cut in to say 'Never. There will never be a Director at St. Fagans', which Twiston Davies followed by saying, 'You have had your answer, sadly.'[54] The minutes of the meeting recorded that 'in view of the ruling that the Charter makes provision for the appointment of one Director only, the title of the head official ... shall be "Keeper-in-Charge"'.[55] In mid May Peate wrote to the Director again, rehearsing the history and growth of his department from 1945, when its staff comprised himself and Payne, a typist and a 'junior Attendant of 15'. He had supported Fox in developing the Folk Museum, which involved supervising additional staff, and he and Payne had readily acceded to Council's wish that they move to St Fagans, at considerable inconvenience and cost, whilst still paid the same as the other Keepers. 'It is completely evident that the dual nature of my post cannot continue. I cannot serve at Cardiff and at St. Fagans, nor should I be expected to.' He could think of no good reason why the first national folk museum in Britain should be handicapped by being treated as an appendage to another institution. The problems of the Folk Museum demanded a whole-time chief official *'on the site'*. 'If I am offered the position on such terms [that is, the halfway house option] I can only conclude that the Council has no trust in me personally and no real appreciation of my work.'

The matter was brought up at the meeting of the National Museum's Court in Bangor, with letters pleading Peate's case from Goronwy Roberts MP and Thomas Parry, but Twiston Davies as President felt it premature to vote on the matter before the Committee had come to a conclusion.[56] By July the membership of the Committee had changed somewhat: now it was chaired by the Vice-President, Lord Kenyon, rather than Twiston Davies, with as members Roberts, Jenkins, Renwick and Randall, as previously, but now also Alderman Frederick Jones, Rhys Hopkin Morris MP and Dr H. E. Quick. An 'Amended Scheme' was now recommended:

> the title of the chief executive officer at the National Museum of Wales (Welsh Folk Museum) shall be Keeper-in-charge. He shall be responsible to the Director for Welsh Folk Museum matters, and shall receive an additional £100 per annum for the extension of his duties ... He shall be responsible for suggesting policy, and for reporting upon developments and changes considered desirable,

and be responsible for practical matters like catering, receipts, fabric and gardens.[57] The Amended Scheme, which was adopted by the Museum, must have been the halfway house that represented the worst of all worlds to both Fox and Peate; it represented little release for the Director from his role over St Fagans and offered only a few additional powers for Peate, and certainly not the strategy and policy formulation role that he desired. The change of title, and the powers that went with it, might have been an attempt at cutting a Gordian knot, representing a line of least resistance that all the Museum's governance bodies (or at least the necessary majority of their members) could agree on, and hopefully making the issue go away; but that was not to happen, or at least not fully.

Fox wrote formally to Peate to inform him that Council on 16 July 1948 had appointed him Keeper-in-charge of the National Museum of Wales (Welsh Folk Museum) as from 1 July. Peate's response was that he would have to consider carefully whether he could accept this, but after a month's cogitation concluded that he could if he were offered his own Finance Officer.[58] That finance officer was some considerable time coming, but in a sense Peate had been hoist by his own petard, or at least by the belief that only one man could run and develop the Folk Museum, namely himself; in effect, the Council called his bluff, and he had for now to settle for less than he felt he or his museum deserved. The matter

came to public attention again in 1952. Peate knew that he had support on Court in a way that he did not on Council. In May 1952 he wrote to Court member Huw T. Edwards (the influential trade union leader and Chairman of the Council for Wales, the advisory body that preceded the office of Secretary of State for Wales)[59] enclosing copies of Fox's proposal of 1948 and what was passed, and detailed notes, asking 'Is there sufficient material here for you to prepare a memorandum?'[60] – and in case there was not, he suggested a form of words for a motion that Edwards could put to the Court, namely

> That the Welsh Folk Museum at St. Fagans remain an integral part of the National Museum of Wales, but that it be given complete administrative autonomy in accordance with the principles enunciated in March 1948 by the Director of the National Museum of Wales (Sir Cyril Fox)[61]

Edwards acted on this and notified the Director that he wanted to put forward the motion,

> That in view of the rapid development of the Welsh Folk Museum, and in recognition of its status as the only national Folk Museum in the British Isles, it shall form a separate unit for administrative and organisational purposes, within the framework of the National Museum of Wales, in accordance with the scheme prepared in March 1948 by the then Director – Sir Cyril Fox,

this being the second form of words suggested by Peate.

In a seven-page report to the Folk Museum Committee of September 1952, Peate noted that as far as he could ascertain, all national folk museums were administratively independent. The Standing Commission on Museums in discussing the possibility of a folk museum for England had noted that there was no single institution which would be the natural sponsor for such an institution. This of course was true, but hardly a valid comparison – the National Museum of Wales delivered for Wales the functions of all the English national museums and furthermore had encompassed folk life within its remit for many years, whereas the subject was not covered by any of the English national museums. Further, a national folk museum from its very nature was essentially different from

all other museums, and the answer was what Fox had advocated, two constituent and equal parts of one institution (nobody seems to have quoted the rather obvious parallel of the University of Wales and its constituent colleges throughout the debate). But despite his stature, Fox's scheme had not been adopted, and Peate now spoke after four years of experience of this halfway house, and 'I speak for the whole Folk Museum staff when I state that at no time has it worked smoothly ... more than once I have seriously contemplated resigning' (and then amended the draft to include, 'At various times, too, during this period, the entire staff has been discontented and I have had the greatest difficulty in retaining the services of certain of them'). He was never invited to meetings of the Finance Committee or to join deputations to the Treasury. Many aspects of his duties were nearer those of a Director than a Keeper, and whilst he reported in person to Council he did not attend Court, and had never known or been consulted as to what would be included in the report for the Folk Museum. Peate concluded by noting that St Fagans now attracted over 90,000 visitors and had a staff of thirty to forty, compared to a total (including the Museum Schools Service) of sixty to seventy at Cardiff.[62]

At the Court meeting at Llangollen in October Huw T. Edwards's call, according to the *Western Mail*, split the membership into two factions, for Goronwy Roberts MP had sought complete autonomy for the Folk Museum – clearly the forces of reform had not agreed a strategy amongst themselves. The paper's disingenuous editorial further introduced into the argument Lord Plymouth's gift of St Fagans to the National Museum, suggesting that a new, separate institution would go against the terms of the gift, and asking if Huw T. Edwards was committing 'the next Socialist Government' to dividing the National Museum into two.[63] Needless to say, the proposal went no further. In a private letter to Peate immediately afterwards, Edwards noted that he had had the opportunity of having a cup of tea with the President, Lord Kenyon, after the meeting, and that a very angry Kenyon had told him (the quote here is in English), 'If this goes through H.T. I shall resign & the Director will have to seriously consider his position', and then (in Welsh, like the rest of the letter), 'if this is their idea of democracy, well the sooner we see the back of both of them the better.'[64] Professor William Rees on behalf of the Committee then drew up a four-page note on the matter, concluding that 'The Committee is of the opinion that a settlement of the problem is urgent if the good relations existing between the National Museum and the Welsh Folk Museum and

their public is to be maintained', noting as evidence of tension between the two sites that 'The difference in the type of work was emphasised recently in the withdrawal of the entire wages staff at St Fagans from the Staff Association and their demand for a separate Staff Association'. The Committee recommended yet another halfway solution, in that responsibility for policy should be devolved to the Keeper-in-charge (whose post should be retitled Curator) but with financial responsibility resting with Cardiff, though there should be a Finance Officer located at St Fagans.[65]

Many subsequent commentators, both published (Lord, Mason) and unpublished (Waddington)[66] have failed to understand clearly the relationship between the central administration of the National Museum and its largest branch. Just as the 'arm's-length' principle that today supposedly separates government from the statutorily independent bodies that are funded by the taxpayer goes through cycles, where the 'long-arm' relationship (that is, indifference, but with reasonable funding) aspired to by the bodies concerned is inevitably succeeded by a period of 'short-arm' manipulation,[67] so too has the relationship between St Fagans and its corporate parent. Some of these commentators seem to have understood St Fagans to be an entirely separate institution – just as Peate wished it were – and not understood the shifting dynamic within which it has operated. The site has been sometimes treated as a problem child and sometimes (particularly in the 1980s) as a cash cow (for it was the only one of the National Museum's sites to charge for admission at the time) which needed to be worked harder, both to justify its existence to a then largely uninterested central administration and to subsidise the rest of the National Museum's activities. These external and internal drivers did not always work in tandem, either. Sometimes, as in the early days of the Folk Museum, the Treasury took a direct interest in the most mundane of matters, and both government and the National Museum were always more interested in the outputs they could maximise in income or other returns rather than the contributions they would have to make. The role of the Director has always been critical in this cycle, for governing bodies have always (except in very rare cases) taken their lead from the chief executive and so the relationship between successive Directors (and sometimes the alternative power bloc, the Secretary or later equivalents) and Peate as Keeper, Keeper in Charge and finally Curator was crucial. Fox was deeply interested in what went on and at times was ridiculously interventionist, but retired before the site began to accept buildings for re-erection and

on which he would no doubt have had views. As a scientist, his successor Dilwyn John had no knowledge of and did not wish to interfere in such matters, and Peate regarded him as always supportive. Fox had every right to regard the Folk Museum his baby as much as did Peate, and he behaved accordingly; John and his immediate successors, on the other hand, were content to take a much more hands-off approach.

An excellent, externally driven opportunity for both publicity and income came in 1951. The Committee organising the Festival of Britain for the centennial of the Great Exhibition were keen to spread events throughout Britain.[68] The National Museum saw a golden opportunity for St Fagans to participate, and the Festival committee offered financial assistance towards the costs of re-erecting those buildings which with this help could be opened in 1951. The Stryd Lydan barn and Esgair-moel woollen mill were accordingly funded as permanent memorials of the Festival, and shortly afterwards the Committee decided to also fund the re-erection of Kennixton farmhouse; the total cost of the three buildings came to £5,150, a most useful sum on top of the Pilgrim Trust's £10,000. New signs bearing the Festival logo were placed by the funded buildings, remaining in place until the 1970s. In addition to a pageant in Cardiff and other events in Wales, an exhibition and events programme at the Folk Museum was also agreed. Peate set about organising events at the site for the duration of the Festival, 16 July to 18 October 1951. Folk dancing exhibitions were provided by two parties from Monmouthshire and one from Yugoslavia. To the turner and basket-maker were added an exhibition of smithwork, leatherwork, cloth and a large selection of Welsh quilts, the latter accompanied by demonstrations and competitions. The Plymouth Estate lent its banqueting hall (which could seat 300 people) and there a series of lectures by academic luminaries on Welsh history and culture was given, as well as two performances of Saunders Lewis' drama *Blodeuwedd*, illustrated lectures on folk song, and three concerts.[69]

Notes
1. SFNMH/Building Specifications/Opening Ceremony, CFF to Lord Howard de Walden, 22 May 1946.
2. SFNMH/Building Specification/WFM Committee, 7 March 1952.
3. SFNMH/Building Specifications/WFM Committee Minutes, 7 May 1954. The Princess was presented with a blanket made by the Museum weaver: pers. comm. Prys Morgan, 8 December 2021.

Opening St Fagans and the early years

4. SFNMH/Reports on Fishponds etc./St. Fagans Folk Museum (Misc.), 'Welsh Folk Museum'.
5. *Rhwng Dau Fyd*, pp. 140–1.
6. Garfield Evans, pers. comm. Structures are shown here on the Tithe Map of 1839: https://places.library.wales/browse/51.489/-3.269/14?page=1&alt=st%20fagans&alt=st%20fagans&leaflet-base-layers_66=on (accessed 4 April 2023).
7. See museum.wales/blog/2018-07-12/Museums-Association-Conference-of-1948-at-National-Museum-Cardiff-/ (accessed 23 September 2020).
8. SFNMH/Files from Nat. Museum/Reports on Fishponds etc./Storage at St. Fagans Castle.
9. SFNMH/Files from Nat. Museum/Reports on Fishponds etc./memo of 25 September 1947; ICP to Town Clerk, 17 March 1950.
10. SFNMH/Reports on Fishponds etc./Architects/Sir Percy Thomas to CFF, 18 September 1946.
11. SFNMH/Miscellaneous/Refreshment Room/CFF note to Hancocks, 22 April 1948.
12. SFNMH/Files from Nat. Museum/Refreshment Room/'Provision of refreshment at St. Fagans', undated.
13. SFNMH/Files from Nat. Museum/Refreshment Room/'Provision of refreshment at St. Fagans', J. T. Morgan note, 29 April 1947. Morgan, like other members, was choosing to forget that the Committee was only advisory.
14. SFNMH/Files from Nat. Museum/Refreshment Room/'Provision of refreshment at St. Fagans', ICP note, undated.
15. SFNMH/Building Specifications/Opening – Director's Report/CFF to Folk Life Committee, 5 March 1948.
16. SFNMH/Refreshment room file, letters 22 April 1948 and 30 August 1948.
17. SFNMH/Report on Fishponds etc./Conveniences & Tea Rooms, 31 July 1947.
18. SFNMH/Reports on Fishponds etc./Report on Catering by the Director, undated.
19. SFNMH/Reports on Fishponds etc./Architects/Architect's Report on St. Fagans Castle, 4 May 1948.
20. SFNMH/Building Specifications/Opening – Director's report/Folk Life Committee, 7 March 1948.
21. SFNMH/Miscellaneous/St. Fagans Parish Council and PC memo, 28 November 1949.
22. Welsh Folk Museum Committee, 4 March 1953.
23. SFNMH/Misc/Pro Numbers etc./Misc, bilingual draft in type and ICP's hand, undated.
24. SFNMH/Reports on Fishponds etc./Reports on Welsh Folk Museum, St. Fagans/memo from ICP to CFF, 26 November 1947.
25. SFNMH/Box files/Building specifications/WFM Committee, 5 March 1948.
26. SFNMH/Box file/Building Specifications/WFM Committee, 7 January 1949, 3 June 1949 and 7 May 1954.
27. SFNMH/Files from National Museum/J. T. Morgan to CFF, 6 October 1947.

28. SFNMH/Building Specifications/WFM Management Sub-committee, 15 December 1947.
29. Welsh Folk Museum Committee, 6 July 1951.
30. SFNMH/Building Specifications/Bills of Quantities for Proposed Pair of Cottages, April 1952.
31. NLW ICP Papers 3/1 (i), Council Minutes, 16 July 1948.
32. SFNMH/Files from Nat. Museum/Reports on Fishponds etc./St. Fagans Museum (Misc.)/Suggested Priority Work, Outside Maintenance.
33. SFNMH/Files from Nat. Museum/Reports on Fishponds etc./St Fagans Museum (Misc.)/Deputation, 18 September 1947.
34. *Amgueddfeydd Gwerin / Folk Museums*, p. 5.
35. *Amgueddfeydd Gwerin / Folk Museums*, pp. 11 and 35.
36. *Amgueddfeydd Gwerin / Folk Museums*, p. 11.
37. *Amgueddfeydd Gwerin / Folk Museums*, pp. 11–13.
38. *Amgueddfeydd Gwerin / Folk Museums*, p. 21.
39. *Amgueddfeydd Gwerin / Folk Museums*, p. 27.
40. *Amgueddfeydd Gwerin / Folk Museums*, p. 41.
41. *Amgueddfeydd Gwerin / Folk Museums*, p. 43: Peate could now afford to be magnanimous, as Fox was retiring, and he had already taken one sideswipe at him in his remarks about Ward's inability to speak Welsh.
42. *Amgueddfeydd Gwerin / Folk Museums*, p. 47.
43. *Amgueddfeydd Gwerin / Folk Museums*, p. 49: the Royal Commission on Ancient Monuments only had its Anglesey material then; now it has fulfilled this part of Peate's dream at Aberystwyth, with the Folk Museum's collection of such material a poor second.
44. *Amgueddfeydd Gwerin / Folk Museums*, p. 55.
45. *Amgueddfeydd Gwerin / Folk Museums*, p. 57.
46. *Amgueddfeydd Gwerin / Folk Museums*, p. 63.
47. 'The Folk Museum', *Journal Royal Soc. Arts*, 97 (1949), 794–806. Peate was a member of the Royal Anthropological Institute's committee that in the same year published its Scheme for the 'Development of a Museum of English Life and Traditions'.
48. 'The Folk Museum', *Journal Royal Soc. Arts*, 97 (1949), 805–6; and in the fullness of time the National Museum was indeed to acquire a slate-quarrying museum in north Wales and a coal-mining museum in the south. With both *in situ* structures in the open air and museum galleries, they also fit Peate's criteria for being folk museums.
49. Charles Scott-Fox, *Cyril Fox. Archaeologist Extraordinary* (Oxford, 2002), p. 176.
50. SFNMH/Building Specifications/Opening – Director's report/Folk Life Committee, 5 March 1948.
51. NLW ICP papers A 3/5 (i), 'National Museum of Wales and Welsh Folk Museum. Argument and draft scheme, for separating the Welsh Folk Museum from the National Museum of Wales for administrative purposes only', 25 March 1948.

52. NLW ICP Papers 3/1 (i), Peate letter to Fox.
53. NLW ICP Papers 3/1 (i), file 'Swydd Cyfarwyddwr AGC 1948'. For the Rhiwbina milieu, see Llion Wigley, '"Mae yno dŷ rhwng gerddi yn ymyl tre Caerdydd": Gardd-bentref Rhiwbeina a'r dosbarth canol Cymraeg, 1912–1939' ['"There is a house between gardens near Cardiff": Rhiwbina Garden Village and the Welsh-speaking middle classes'], *Y Traethodydd* clxxvi (2023), 30–50.
54. *Rhwng Dau Fyd*, p. 142.
55. NLW ICP Papers A 3/5, Minutes of Council meeting, 15 April 1948.
56. NLW ICP Papers 3/1 (i), memo, 18 May 1948.
57. NLW ICP Papers A3/5 (i), meeting of committee, 2 July 1948. Peate's revised salary came to £1,400 p.a.
58. NLW ICP Papers 3/1 (i), Fox to Peate, 17 July 1948, Peate to Fox, 19 July 1948, and Peate to Fox, 16 August 1948.
59. On whom, see Gwyn Jenkins, *Prif Weinidog Answyddogol Cymru. Cofiant Huw T. Edwards* ['Wales's Unofficial Prime Minister. A Biography of Huw T. Edwards'] (Talybont, 2007).
60. NLW ICP Papers 3/1 (i), ICP letter of 20 May 1952 (to HTE); my translation.
61. NLW ICP Papers 3/1 (i), ICP letter of 20 May 1952 (to HTE); my translation. Fox penned a note to the Court saying that his own view was private, and that he could not support such a motion at this time: I do not know who sought his opinion.
62. NLW ICP Papers 3/1 (i), 'Administration Report to the Welsh Folk Museum Committee by the Keeper in Charge'.
63. NLW ICP Papers 3/1 (i), *Western Mail & South Wales News*, 18 October 1952.
64. NLW ICP Papers 3/1 (i), letter from HTE to ICP, undated; my translation.
65. NLW ICP papers A 3/5 (i), 'Memorandum on the Relationship of the Welsh Folk Museum and the National Museum', n.d.
66. Clare Waddington, 'A Museum of the Folkloric for the British Isles?' (unpublished MPhil thesis, University of Leicester, 2012), pp. 56 and 105–6: https://www.Academia.edu/40393803/A_Museum_of_the_Folkloric_for_the_British_Isles_MA_Museum_Studies_Dissertation (accessed 13 September 2010).
67. For an excellent discussion of the general situation in Wales in the early 2000s and treating of this topic, see Geraint Talfan Davies, *At Arm's Length. Recollections and reflections on the arts, media and a young democracy* (Cardiff, 2008).
68. For the Festival, see Moya Jones, 'The Festival of Britain (1951) beyond London': http://journals.openedition.org/mimmoc/3625 (accessed 1 October 2020).
69. *Personau*, pp. 31–3.

10
Developing the folk park

Developing policy

Iorwerth Peate believed that historic buildings were the most important subject with which any folk museum should be involved.[1] Such buildings, dismantled and re-erected, were of course the single most essential component of the Scandinavian open-air folk museums that Cyril Fox had visited in 1930. Even before the Council's resolution of that November that the National Museum's public presentation could not be complete without an open-air site, Fox was thinking actively of how to square the circle between the accelerating loss of historic buildings of great evidential value and the lack of funding to progress plans for an open-air museum. This prompted him to have a very lateral thought after becoming aware that the owner of Little Mill, Llanerchymedd on Anglesey was willing to sell the plant of the woollen factory to any interested buyer. He wrote to Major E. W. Cemlyn-Jones noting that

> It is my hope that the National Museum of Wales may be able to extend its activities to the creation of a folk museum somewhere in Wales before long – a folk museum in which typical old houses will be re-erected with all their contents, and in which typical industrial units will be re-created with their contents in such a folk museum. The Llanerchymedd mill would be most valuable indeed.[2]

But what could one do in the meantime? Fox's proposal (since government accounting practices could not contemplate the National Museum doing such a thing, even if it could afford to) was that a benefactor buy

'the whole thing, put somebody in the cottage with instructions to see that the "factory" suffered no damage, and so hold it for posterity? I should think £200 would buy the lot' – but the owner proved unwilling to sell the building, and nothing came of this radical approach. Fox grew pessimistic about the putative open-air museum and about acquiring buildings for it over the next few years, with no prospect for a site and no funding for acquiring and operating one. In his analysis of 1937 of what had led to the abandonment of the group of cottages that he recorded in north Pembrokeshire (Chapter 6) – amongst them, legislation requiring improvements that would destroy the essential features of such structures, and the fact that crofts could no longer yield a living – he reiterated the importance of detailed recording:

> Such a cottage as Llain-wen-isaf ought long ago to have taken its place in a series of the primitive dwellings of Wales in a National Open-Air Museum, but such a folk-museum seems as far from realization as ever; and the best that can be done today is to make a record sufficiently detailed to permit students, in a more enlightened age, to reconstitute a ruined or altered example. Only ruined or altered examples are likely then to remain.[3]

But as we have seen, a suitable site was acquired in early 1946 and Fox was able to report that the Treasury had agreed an allocation of £2,000 towards the maintenance of the new Folk Museum in 1947–8 'on the understanding that we get an equivalent sum from local sources'.[4] By the autumn the Pilgrim Trust had agreed to donate £10,000 over three years for 'the purchase, removal and re-erection of buildings'; in exchange, the Trust wanted to be consulted over which buildings its money would go towards, and be acknowledged with tablets near the buildings.[5]

It was exceptionally timely, therefore, that at long last Peate had the opportunity to see for himself how Scandinavian directors developed and ran their open-air museums. Long and eagerly anticipated, the trip did not disappoint; if anything, it exceeded his high expectations. In September 1946 and at the invitation of the Swedish Museums Association (or 'the Swedish government', as he chose to recall later),[6] he was able to join a month-long study tour as part of a British-American delegation. The members (seven Britons and two Americans) had already been chosen by their respective Museums Associations, but he surmised that his hosts wished

Developing the folk park

to have someone to represent folk studies, and so he too was invited. His British companions included his fellow Montgomeryshireman, R. U. Sayce, of the Manchester Museum, John Allen and Rupert Bruce-Mitford, of the British Museum, and the one whose humour Peate particularly appreciated, James Laver, of the Victoria & Albert Museum, whose maxim 'More Sayce less speed' was felt by the others to be very apposite for the participant who was always late. The intensive and tiring programme involved spending three weeks in Sweden, and he was then able to visit Oslo and Lillehammer in Norway separately. Peate kept a detailed diary of the visit, he wrote home frequently to Nansi and to his son Dafydd, and at Fox's request compiled a detailed report for the Museum, with recommendations arising from what he had seen. He found the visit of the highest value, particularly as

> I did not content myself with seeing merely the public galleries etc. In every case, I asked to see the administrative offices, the workrooms, storage accommodation, library and filing facilities and cataloguing arrangements. I also made enquiries wherever possible about schools service and the extra-mural connexions of each museum and staff. In many cases these 'visits behind the scenes' were of greater value than even the visits to galleries.

His thematic report paid attention to the ten folk museums he visited, the period-room museums, and museum techniques. The larger museums had open-air sections that were part of a greater entity, with galleries either on the site or in close proximity to the re-erected buildings. 'This is the big day', he noted of 11 September, when he visited the Nordiska Museet in the morning and Skansen in the afternoon. From there he wrote home:

> This is a wonderful place – I feel as if I have been living in a dream all afternoon. The effect is remarkable. I wandered from house to house as if I were in a past age. If Fox will leave me alone this *can* be done for Wales but as Bruce-Mitford says, the least done before he goes the better if he is to stir the pot. Bruce-Mitford has the measure of him![7]

Words had clearly been whispered into receptive ears! Skansen, with its seventy-five-acre (thirty ha.) site and huge visitor numbers (famously

145,000 on one day in 1939) had several restaurants; in one of the few times in his report that he made a direct reference to St Fagans, he noted that 'light beers and wines are obtainable in every museum for consumption with meals:– which will be all that will be necessary in the Welsh Folk Museum, in my opinion'.[8] Peate was particularly struck by the interpretation of the re-erected buildings, often invigilated by costumed women carrying out household tasks: 'The labelling of buildings completely destroys the atmosphere ... There is, therefore, *a complete ban on labels*, but in front of each building a small [numbered] iron stake is placed in the ground'. He remained behind after the rest of the party had left, soaking up the atmosphere and, along with Åke Campbell, being taken to dinner in one of the historic buildings, which pleased him immensely. By 1976 his one-day visit to these two sites was recalled as 'Of course, I spent many days at Skansen and the Nordic Museum', and in 1978, 'After weeks in the Scandinavian countries in 1946'. Like many of his stories, this grew with the telling, and his published version makes much use of the personal pronoun, such as when 'I' visited Uppsala and Lund to have discussions with particular individuals,[9] but his three weeks in Sweden actually followed the set itinerary of the group.[10]

More strategically, he questioned officials in detail about the costs of re-erecting and operating their historic buildings, finding it difficult to get answers, despite 'my quite desperate efforts', but concluded that the Pilgrim Trust's gift of £10,000 would not pay for many buildings, and that the sum required should be nearer £150,000. He was told that the proposed new building at St Fagans should be completely modern in character, and house library, archive, workshops and classrooms, as well as thematic galleries. Skansen's director, Andreas Lindblom, stressed that he get the full hundred acres he required for his museum in one tranche (unlike the ten-acre tranches that Fox had suggested to Council in March), and that his staff should not only be Welsh-speaking, but should also speak different dialects – 'a point I had not thought of'. Lindblom also told him that a true folk museum should never be static and that he should add at least one historic building every year (much more easily done in Sweden, with its log and timber-framed structures, than in Wales); and he was also greatly impressed by the response when he quizzed another director about his museum's governance, and was told that only one man made the decisions – the director.[11] Finally, he was equally impressed with the collecting of information: each of the principal folk museums

Developing the folk park

had about 200 voluntary agents, 'peasants, teachers, ministers etc.', who were issued with questionnaires: 'in this way nothing in any parish in the whole of Sweden is overlooked: nothing is destroyed before the museum knows of it'. Most of the party then moved on to Finland for a further week's visit, but Peate was not given permission to do this; however, since he had a few days in hand before he could travel back, he was able to visit Norway for a few days, seeing his friend Alf Sommerfelt and visiting the National Folk Museum and the 'remarkable' Fishing Museum in Oslo, as well as a day trip to Lillehammer.[12] Peate was delighted that his memorandum to the Council was accepted in its entirety, including his recommendation that knowledge of Welsh was essential for every member of staff, though to say as he later did that it was accepted as the foundation for the development of the Folk Museum was over-egging the pudding, as we shall see (below).[13]

In addition to tackling the minutiae of acquiring St Fagans Castle and its immediate operation, by the autumn of 1946 Cyril Fox was deep in the throes of developing an overarching policy for the site. This included thinking about not only the spatial aspects of the open-air section and what should be done there, but also the various roles and responsibilities of the new Folk Museum Committee that would oversee development activities on behalf of the Council. In early October Peate wrote to Fox on behalf of Payne and himself with comments on Fox's draft proposals. Some fundamental matters had to be addressed. The first was the issue of the time-range that the new museum would deal with. It had been agreed when the Sub-Department of Folk Life was created in 1932 that its collections would comprise material from the sixteenth century onwards, but no one had formally suggested when 'bygones' might somehow evolve into modern material not worth collecting, and the same issue applied to industrial material. Fox now suggested 1800 as a stop-date for material of interest to the Folk Museum, but Peate and Payne disagreed. They had collected a large number of house-furnishings of late Victorian date 'and have a general wealth of Victorian material of all kinds. No rule that might forbid its display should be made'. Additionally, some nineteenth-century buildings should be displayed in the grounds, as was done in Sweden, and the term 'Industrial Revolution' most certainly could not be associated with 'about 1800' in rural Wales (Peate's view was that its effects had barely been felt still in these areas).

The second issue that provoked a response was the role of the Folk Museum Committee, to which Peate and Payne had 'a fundamental and serious objection'. Fox had proposed that the Committee should have the power to refuse for geographical reasons the acquisition of specimens that the Department might wish to collect; but

> While it is necessary that a committee be kept informed by all means possible of the plans, work, difficulties and successes of the staff, it should neither be encouraged nor permitted to usurp the functions of that staff in deciding what is, or what is not, a suitable acquisition for the Folk Museum. From such a position, it is but a short step to uninformed meddling with the expert duties of the staff – to directing them as to what and how to exhibit, even to short-circuiting them in accepting from the public unwanted specimens.

This tension between the executive and its governing body was a fundamental point that was and has remained common in all sorts of contexts. Peate had had to deal with such an issue previously and it would arise again over the next couple of years with members of this very committee. Aiming for a 'regional balance' was anyhow unwise, for more material survived from some regions than others. The same argument applied to Fox's proposal that in time two buildings of each 'regional style' be displayed. 'What are the "regions"?' Peate and Payne asked.

> Is the whole moorland block to be considered a region? We shall land ourselves in all kinds of difficulties if we attempt to confine ourselves to 'two in each region'. And there will be several houses included possibly because of social and historical associations and not because they represent 'regional styles'.

Finally, Peate and Payne made a couple of points of detail. The 'Central Gallery' should not be a 'large, lofty, single-room gallery' because it should be realised from the start that evolutionary sequences of very diverse material and size would be displayed in it (three interconnecting galleries were actually built). And as for shops, a village grocer's shop should be secured complete and displayed, and even a small village 'street'. Fake 'period' shopfronts should be avoided at all costs: 'Our sales section

should be "the last word" in modernity and convenience and we should not introduce the fake note (Ye Olde Bookeshoppe) by displaying our wares behind an 18th-century bow window'.[14]

The resulting paper, dated 17 October 1946, was submitted as a memorandum to the Folk Life Committee and then progressed up the structure. Titled 'The Welsh Folk Museum: A Memorandum on Policy of Acquisition, Siting, and Reconstruction of Buildings', its authorship is noted as 'prepared by the Director in consultation with the Keeper of Folk Life'. The twenty-nine-point document began by noting that the Vice-President had said that rules were made to be broken, 'but unless the Department of Folk Life has rules to guide it, it is not to know when it is breaking them or to assess the desirability of so doing; it cannot, in short, accurately estimate the pros and cons of any individual proposal'. However, the novelty and complexity of the problems to be faced would require that any rules should be revisited in the light of experience. It set out the aim of the Folk Museum: it should be 'to present the culture of Wales as illustrated in the layouts, architecture, constructional materials and techniques, and furnishings of houses (including shops) and workshops, mills and farm buildings: they should be architecturally, historically or socially significant of Welsh culture' and the buildings so acquired should be re-erected in suitable re-created environments. The national character of the new institution was a fundamental element of policy, and a balanced picture would be presented; and if the experiment was successful, then similar regionally based museums were certain to be established. Siting of buildings was crucial and should be addressed by the Director and Keeper in consultation. The Castle grounds were the only area where buildings which needed to be powered by water could be sited, though other structures could also be located there.

What types of buildings should be acquired? The Castle, they felt, provided magnificently the Museum's needs for illustrating the life of the nobility and gentry, which reflected the culture of lowland Britain, and extension of its period – either back to the Middle Ages or forward to Georgian – should be catered for by the acquisition of single rooms or period detailing, accommodated chronologically in the central block. But in the short term, the Museum's resources should be spent on the acquisition of 'native' buildings, though their styles were not static and they had absorbed new ideas from the gentry. Examples of definite styles such as the timber houses of the Marches, the thatched houses of Glamorgan

and the round-chimney structures of Pembrokeshire would be sought, as would early and late examples. Some houses might be associated with famous persons. Houses of low quality (such as some upland long-houses) were as important as ones which exhibited good craftsmanship; farm complexes illustrating different methods of farming were also necessary. Multi-period houses could show the development of styles and construction. A rural-industry section should include a water-driven flour mill and a *pandy* (fulling mill), while the content of workshops was more important than their antiquity. The memorandum ended with a practical section. An architect was not necessary to the process of dismantling and reconstructing, for 'few such men are archaeologically minded'. Every scrap of significance should be preserved, but for stone houses the inner skin could be built of St Fagans rubble, or even concrete or brick. A competent mason and carpenter and a clerk of works who was a good draughtsman should be taken on to the permanent staff after a trial.

The paper thus laid down several guidelines for the future. It defined the Folk Museum as primarily an open-air museum with complementary galleries; it did not use a term that Peate had floated in 1941, namely that the site should deal with 'cultural ecology'.[15] The buildings should be representative, so its function was to be very much that of a classic folk museum and not that of a museum of buildings (a form later to appear): examples should be chosen not so much for any individual merit, but rather because they typified a form once or still common (for now) and thereby important, though the houses of historically significant individuals would be considered. Building construction would be interpreted further in the galleries, where shopfronts could also be shown. Significantly, the document makes no reference to strategic planning of the layout and interrelationship of the buildings to be re-erected. It had long been practice in European open-air museums to display their buildings on a regional basis, so that the visitor might, almost in miniature, gain an understanding of the architecture and life of one region before progressing to its neighbour. Implicitly, Fox and Peate were accepting at this early stage that this would not happen at St Fagans. A couple of reasons can be suggested. Firstly, the entire site was densely wooded, and growth would only happen slowly by accretion in a mediaeval-style fashion of encroaching along the fringes of the woods, and secondly, but no doubt of far less importance at the time (and despite Peate's researches), understanding of the building regions of Wales was still in its infancy.

Developing the folk park

The Folk Museum's re-erected buildings were accordingly placed one by one, largely by order of acquisition, in a pattern that gradually extended over much of the site and very much in the manner of earlier times when clearings were made in a virgin forest; and cutting down the trees and removing their stumps proved a major task for many years, particularly when fields were carved out to accompany the buildings. The resulting flat vista in no way resembled any particular Welsh landscape, and all views were framed by tall trees;[16] and specific attempts to address the problem, such as the planting of a bank of heather by the farmhouse of Cilewent, for example, could in no way replicate the exposed and bleak uplands of the Cambrian Mountains. This creation of a contrived landscape to reinforce the sense of a pastoral scene, an illusion of ruralia for the setting of the re-erected buildings has been criticised,[17] but as we have seen this was common and inevitable practice, given that the Folk Park was then about recreating rural life. Whether it was chance or whether lessons were learnt from St Fagans, the site chosen for the Ulster Folk Museum at Cultra near Belfast, with its open, undulating nature is vastly superior and capable of representing much better the countryside of northern Ireland. It was not until the 1960s and 1970s that detailed knowledge of regional styles (a concept Peate had queried) was available, so master-planning on that premise could not have been done meaningfully before then. Similarly, the rural-industry section mentioned was in practice to have its components scattered throughout the site, for clear topographical reasons in the case of the woollen mill, the tannery, the corn mill and later the gorse mill. Finally, although the document is specifically about buildings, it does not, even *en passant*, as much as hint that the Folk Museum might or could be about more than buildings and their contents and the activities associated with them, and that those aspects might be interlinked.

Offers of buildings

Some possible buildings were offered quickly. Lord Plymouth owned another great house in Glamorgan, the ruined Y Fan near Caerphilly, the seat of the Lewises, who had acquired St Fagans in the seventeenth century and whose lands passed to the Windsor-Clives after a dynastic marriage. Within its curtilage was a large corbelled dovecote of a type not uncommon in Glamorgan, also in poor condition. Plymouth offered it for re-erection at St Fagans, but it then collapsed. The decision was made

to refuse the offer on the grounds of both cost and practicality, though a section might be used for display purposes;[18] but this latter suggestion was not acted upon. But then in 1949, and like London buses, came two offers that were accepted.

At the April 1949 meeting of the Folk Museum Committee Peate was able to present details and photographs of the Esgair-moel woollen mill at Llanwrtyd Wells, Breconshire, which had recently fallen out of use and been offered by its owner, and 'which he strongly recommended for re-erection in the 80 acres'. At Fox's request (and against Peate's wishes – he did not think it necessary) the Committee met at Llanwrtyd Wells so that members might view the potential acquisition, which it was provisionally estimated would cost £2,000 to dismantle and re-erect. The Committee resolved 'To re-erect Esgair Moel mill at St. Fagans using such parts of the mill building as may be necessary (e.g., flag-stones, certain quoins, lintels, sills, floor-boards, roofing timbers, slates and chimneys' and 'To accept all the machinery, etc'; and crucially, 'That a complete photographic record be made of the outside and inside of the mill, and that measured drawings be prepared' – those measured drawings to be made by an architect, thereby ignoring the recommendation made in Fox's memorandum of three years earlier and agreed as policy. What Peate did was to despatch Albert Jones the Museum carpenter and Bob Carter for a fortnight to plan the building, and then send an architect. From the architect he received one plan only, with all angles squared and all unevennesses flattened out, whilst from Jones and Carter he received a folio of over thirty plans. When shown to the Folk Museum Committee the relative merits were clear and no more was said about the need to involve an architect; and of course when re-erected the acid test was met when all the water-driven machinery worked perfectly.[19] By the next meeting of the Committee the architects had reported that to power the mill, if it were to be re-erected in the eighty acres, would require a pond of about 150 ft by 80 ft and 5 ft deep.[20] This was clearly not realistic, and the Committee's chairman approached Lord Plymouth

> who agreed with the opinion that mills which required to be driven by water power should be placed near a natural supply rather than in the 80 acres. He was, therefore, prepared favourably to consider making available, upon terms to be arranged, an area of land to the north of the four fishponds for this purpose.[21]

Peate outlined in the *Museums Journal* the process that his staff had followed in dismantling and re-erecting the mill (and the Stryd Lydan barn, below). It took eight weeks for four men to record and dismantle the mill, involving much work over weekends.[22] Jones and Carter had measured carefully the building and the machinery; Peate then told the tale of the architect, of which he made much over the years (sadly, neither set of plans appear to survive). After recording, metal discs were used to number every timber and a number painted on every stone removed. An experienced haulage firm transported the dismantled materials. The same team then undertook the re-erection, and as Peate concluded,

> We are convinced that this is the only satisfactory method of ensuring detailed correctness in re-erecting a folk-museum exhibit: dismantling and re-erecting must be carried out by the same team, the success of both operations depending largely on the initiative and ability of the person in charge of the team, who keeps in constant touch with the chief executive official of the Folk Museum.[23]

As part of the process of re-erection, the mason, Garfield Evans, had decided that a stone bearing an Ordnance Survey benchmark (the significance of which he did not know) was important, and at his own expense had a trowel inscribed and a wooden mallet made by the wood-turner so that Peate could formally lay this 'foundation stone', an event which made a considerable impression on Peate and which showed to him how committed the small staff were to the new institution.[24] Equally, external factors dictated that as much timberwork as possible had to be saved, with specific conditions laid down by the Ministry of Works: 'Timber requirements to be reduced to an absolute minimum by the re-use of existing material wherever practicable; full details of linear dimension of timber required and its proposed use to be submitted for approval.'[25] Such controls did not apply to stonework, and it was in the Museum's financial interest at this time to remove only the marked stones and make up the difference with stone sourced as near to St Fagans as possible, and this is what was done; by the time that Cilewent farmhouse was dismantled, however, as much as possible of the original stonework was reused, a general policy followed ever since.

The second building to be offered was a barn from Penley in Flintshire. Stryd Lydan was a farm on the Gredington estate of the

Museum's Vice-President, Lord Kenyon. The barn when offered was a long, low building of timber-framed panels infilled with brick and with a slate roof: both bricks and slates were clearly later additions to what had been once a timber-framed and thatched structure. It had in fact a complex history, being a three-bay cruck barn to which had been added an open drift-house in which loaded wagons could shelter, and a smaller box-framed timber-framed structure beyond that. The building occasioned considerable interest amongst experts in the new science of vernacular architecture, since it was the first timber-framed building to be offered for re-erection at a folk museum in Britain; Lord Raglan, then engaged with Fox on their study of Monmouthshire houses, was particularly interested. Raglan gave his opinion of the building in an exchange of letters with Peate, from which it is clear that the decision to offer and accept the barn had effectively been taken by the senior governance of the National Museum before Peate was consulted and certainly before he had seen it.[26]

The barn was carefully recorded and then dismantled in the snow of February 1950 by Albert Jones, helped by Lord Kenyon's staff. It was decided to revert to the building's original appearance when it was re-erected, so the later brick infilling between the timber framing was replaced by open wattle panels. As little new timber as possible was used and no attempt was made to hide what had been replaced, and it was regarded as a central principle that the Museum should be totally 'honest' in its approach. Several of the cruck blades required strengthening and this was done using metal plates. However, one of the gable crucks had decayed and the gable rebuilt in brick, probably in the eighteenth century, but it proved impossible to obtain timber to make a replacement cruck, and inexplicably (to modern thinking) the brickwork was not retained or reproduced and a new gable of Glamorgan limestone built instead. A stone-flagged floor was laid throughout the building as a concession to the public and with future ease of maintenance in mind.[27] The barn's crucks were the subject of considerable debate between Peate and Raglan; Fox was retired by then.[28]

John Ward, Joint Curator of the Powysland Museum, drew Peate's attention to another possible building for re-erection in 1949. He had recently come across Upper Mill at Cefn Coch, Montgomeryshire, a timber-framed corn mill built in 1811 and last used in 1929. It seemed that the owner was anxious to dismantle the building and was prepared to give it to the Folk Museum; but then he appears to have changed his

Developing the folk park

mind and nothing further came of the matter.[29] Peate was also keen to acquire a windmill from Anglesey, regarding St Fagans as an appropriate site for its re-erection, since Glamorgan was a county of windmills, but the owner was entirely resistant to its dismantling.[30] Other buildings suggested or offered to the Folk Museum during its early days included the Norman church at Baglan, disused since 1882 and which the Folk Museum Committee agreed should not be recommended to Council, for reasons which were not specified; Y Fedw Deg farmhouse in Gwydyr Forest, which proved to be a total ruin; the thatched Twll-yn-y-wal, Port Talbot, which retained only a few original features; a cottage near Cwm-Ann, Carmarthenshire, which the owner was willing to sell but not donate; Morgan Griffith's House in Llantwit Faerdre, a charity house of 1664, which presumably was now of insufficient interest; and a long-house recorded by Fox and Raglan, Dan-y-Bwlch, Bwlch Trewyn. It was Leslie Monroe of the Ministry of Works – some of whose wonderful plans were published in *Monmouthshire Houses* – who drew the latter to Fox's attention, with the query, 'Do you think Peate would be interested for St. Fagans?' Peate visited the house but found the practical problems, including lorry access, to be insurmountable.[31] It was also suggested that the Folk Museum would be an appropriate resting place for Y Gangell, the childhood home of the minister-poet Elfed (H. E. Lewis, 1860–1953) from Blaen-y-coed, Carmarthenshire, but not enough survived to indicate what kind of building it had been originally.[32]

Only the last page survives of a draft note in pencil in which Peate listed possible building acquisitions sometime in the early 1950s. One was Penrhiw Chapel, a 'small unspoilt 18th-century structure' from Carmarthenshire about which preliminary enquiries had been made, but which Peate felt was possible as he had been told that it was in disrepair and not in regular use. Another structure was a corn-drying kiln at Llangrannog, Cardiganshire which he had been told was available and about which he had made tentative enquiries. The last building enumerated was a dovecote from Pembrokeshire: he provided no more detail. The monies from the Pilgrim Trust could be used to fund any or all of these projects, but he felt that the Exhibition Gallery was a better call on those funds, for this was required as soon as possible:[33] clearly here he was thinking that the interpretative value of a gallery outweighed that of a re-erected building and presumably thought that it would also be more of a game-changer for the site. In March 1952 the Folk Museum Committee

minutes record that a provision of £2,000 was made in the estimates for a 'Llangadfan tyddyn', which later came to be more commonly known by its name, Abernodwydd.[34] Abernodwydd was a seventeenth-century timber-framed and thatched house exhibiting considerable changes over time, having a corrugated-iron roof and weatherboarded walls when Peate first saw it (he had noted then that 'every effort should be made to preserve it'.[35] He elaborated on the principles followed in its re-erection:

> Was the house to be re-erected as it was originally built? This was obviously impossible, since we did not have enough evidence for the many details of the three-roomed central-hearth house. Furthermore it seemed wrong to reject the considerable timber-work of the seventeenth century and loft. But were we also to embody in the re-erected house later repairs and refinements? If this were done, the house would lose much of its significance as a museum specimen; we decided against it. We knew that the west stone wall replaced timber-framing – the mortises for which remained in the existing timber work. The timber-framed west wall has therefore been restored to the house. In the same way, the nineteenth-century chimney-stack disappears, the interior of the chimney being daubed with a mixture of cow-dung and clay, its capping appearing on the roof over the straw in the manner traditional to the district. The floor cobbling gives way to the earlier earth floor. Since one seventeenth-century window remained, the obvious course was to put aside the modern windows and insert wooden frames made on the seventeenth-century pattern.[36]

An offer of a farmhouse called Ciloerwynt (it was later recognised that its name should be 'Cilewent' – the abode of Ewent, a personal name, and not the made-up name which meant a shelter from the cold wind) in the Elan valley was received from Birmingham City Waterworks Committee during 1953; Peate had first seen it and identified it as a long-house during fieldwork in Radnorshire in 1934.[37] This and Abernodwydd were not the only buildings that he had seen during his fieldworking activity of the 1930s that eventually found their way to the Folk Museum – Llainfadyn cottage from Rhostryfan, Caernarfonshire, was another.[38] Cilewent was not a typical long-house, in that its cross passage had only one door and its fireplace was on the upper gable, rather than backing on to the cross

passage, but in those early days the offer was too good to refuse. The later timber-framed and weatherboarded barn attached to the upper end of the house was not removed, but the wooden sheep-yards were recreated. It was not until the Rhyd-y-car industrial workers' cottages were re-erected in the 1980s that the Museum started to grapple with the problems of presenting buildings as other than of a single period: all in Peate's time were 'restored' to a single period, normally the earliest that could be recreated with conviction.

Hendre'r-ywydd Uchaf from Llangynhafal in Denbighshire was dismantled in 1954.[39] The process was costly. The Treasury contributed only towards meeting the operational or running costs of the institution (the grant being £6,300 in 1949), and this remained the case until 1964. Re-erecting buildings had to be funded through grants and contributions – using even a proportion of admission money towards this was forbidden: that was counted as part of the block grant. The help of local authorities was therefore crucial. The Folk Museum Committee of 7 March 1952 was provided with a list of the financial commitments made by the various local authorities. Of the county councils, Merioneth had not given anything; Anglesey and Radnorshire had given £100 each; Caernarvonshire £150; Cardiganshire, Denbighshire, Flintshire and Pembrokeshire £250, the latter also giving £500 towards maintenance; Carmarthenshire £500; Montgomeryshire £2,050 and Brecknockshire £2,100, of which £1,500 was still due; Monmouthshire £3,500; and, trumping the lot but understandably so, Glamorganshire with its commitment of £20,000, of which the final £10,000 would be paid at the start of work on the administrative block. Newport County Borough had given £100, and Swansea £500; whilst Cardiff City Council had agreed to give £1,000 a year indefinitely towards maintenance.[40] Much of the help from local authorities was given in response to specific appeals, usually towards meeting the cost of re-erecting buildings from a local authority area – so Brecknockshire's contribution was towards the cost of re-erecting the woollen mill, Montgomeryshire's to help with re-erecting Abernodwydd, and so on. Contributions to the special Building Fund – treated by the Treasury as Private Funds and therefore outside their control – paid for all the substantial work needed to restore St Fagans Castle, as well as for re-erecting the chapel, the tannery, the farmhouses and cottages, the smithy and the corn mill. Peate recorded his thanks to the people of Wales for making all this work possible.[41]

All buildings selected for re-erection at St Fagans were removed in advance of dereliction or threat of demolition; none were picked solely because they represented a good example for the Museum. What were the criteria for acceptance? The key word was 'typical'. Peate put it like this:

> The fact that the timber work, for example, of a seventeenth century cottage may be exceptionally fine does not, in itself, justify its removal to the Folk Museum. The fact that it is exceptional and possibly unique can be a valid reason for rejecting it as untypical: on the other hand, if it is a superb example of a well-known and widely-distributed type in Wales, then it should be welcomed.[42]

He explained the issue succinctly to sixth-formers, 'We are seeking to create a balanced picture of Wales's traditional life at St. Fagans. The buildings that we relocate therefore have to be typical, so it is not a collection of *freaks* [English] or of architectural gems that we seek.'[43] It was also vital that owners were willing to donate these buildings, for the Museum could not afford to buy them, and equally vital that the chosen buildings were re-erected accurately, within the limits of concern for safety (so floors had to be sufficiently strong to bear the weight of numerous visitors, for example): 'The whole purpose of a folk museum is destroyed if one has a concrete floor instead of a lime mortar one, or softwood instead of oak. One has to be honest when recreating the building' was how Peate put it in *Rhwng Dau Fyd* in 1976.[44] These are admirable sentiments which the Folk Museum has always attempted to adhere to, even if Peate himself did not always do so. It is quite clear that it was Ffransis Payne who acted as the Museum's curatorial conscience. In an undated memorandum to Peate regarding the fitting out of the re-erected Kennixton farmhouse he noted, *inter alia*,

> Colour of paint on doors etc. RAJ [Albert Jones] tells me that you had decided on cream ... I ... am a bit concerned. I never saw cream paint in any farmhouse anywhere until 20 years ago ... [Peate listened] I gather ... that reproduction [of the elm fittings] in another wood rather than renovation was suggesting itself to [Albert Jones and Bob Carter]. The analogy colouring their views seemed to be the scrapping of the elm roof timber ... I pointed

out that in my opinion [unclear] was the maximum of new timber required to make it quite serviceable ... I do suggest most strongly that every foot of it that can be saved should be ... To scrap elm in favour of a better wood is indefensible ... This must not occur with fittings from Capel Penrhiw.[45]

The floors of Kennixton were of lime mortar containing crushed seashells to provide the lime required for the mix, and fortunately Professor Griffith John Williams knew of a recipe in Iolo Morganwg's hand for exactly this mortar.[46] The recipe was followed, with Garfield Evans making for himself the flat wooden overshoes specified for treading down the material. The detailed recording of buildings for re-erection, however, was very focused on practical matters: great pains were taken to replicate correctly the rare straw-rope underthatch matting at Kennixton, but whilst it is noted in print that the original house was added to substantially twice, no evidence for this (very likely) assertion survives, neither in drawn nor photographic form, and the structure was re-erected as a single unit, with no trace of the straight joints that must have existed between different builds. As re-erected, too, Kennixton was whitewashed, as was overwhelmingly the case for much of south Wales; and it was only later that it was decided that it should be coloured the iconic red beloved of visitors. Presumably there was evidence for this colour being present when the building was dismantled, but the evidence behind the decision has not survived. Accuracy in re-erection varied, sometimes in aspects of a single building, as demonstrated by Llainfadyn cottage. A by-then blind former resident who had emigrated to the slate mines of Vermont in 1901 could confirm on visiting the Folk Museum in 1975 that this was indeed his cottage from feeling the initials that he had carved into one of the slate windowsills; but on the other hand the feet of the rafters protruded beyond the wall-line (and still do, as the building was Listed after re-erection) in a fashion that was clearly the norm for Albert Jones, but was entirely alien to the vernacular tradition of north-west Wales. Similarly, the re-erected cottage was roofed with thin modern slates, very unlike the heavier and thicker ones that were usual in the eighteenth century, and which would have been laid on a wickerwork and turf base, as recorded in contemporary accounts (and which were reproduced in the Cae Adda cowshed re-erected next to Llainfadyn in 2003: the contrast between the two structures is highly instructive).[47]

Iorwerth Peate acted as his own curator of buildings, making his own decisions as to whether examples should be accepted for the collection or not, assisted in his decision-making by the views of Albert Jones on the practicalities of dismantling and re-erection.[48] One of the last buildings that Peate accepted for the Museum was a cruck barn from Hendre Wen, Llanrwst, seemingly of sixteenth-century date. In an advanced stage of decay, with its rough slate roof almost entirely hidden by ivy, it had megalithic stone walls with timber framing for the top third of the two long walls. The dismantling process (after Peate's retirement) suggested that the barn as it stood had been rebuilt in stone at a later date reusing earlier timbers, a conclusion that prompted Peate to complain to his successor that the Museum's first buildings curator, not appointed by him and an archaeologist to boot, 'your Mr Williams', could not possibly be right, and implying that appointing him was a mistake on Trefor Owen's part.[49] But whatever its date (and the timbers resolutely refused to divulge their secret when tested for tree-ring dating), the barn remains a fine example of the type found in the region.

Misunderstandings

The subtlety of St Fagans being a folk museum and interested only in acquiring examples of buildings that were once representative or commonplace, and not a museum that would attempt specifically to illustrate past building practices or offer a home to threatened architectural masterpieces, was not always understood or appreciated by historic buildings experts (the early idea that the homes of famous people could also be accommodated was soon dropped). In 1955 Peter Smith's attention was drawn to a ruinous cruck house, Tŷ Draw, Llanarmon Mynydd Mawr in south Denbighshire, which had fine detailing such as pointed doorways in its dais partition and an arch-braced central truss with cusped struts.[50] Smith showed the house to Lord Raglan and Professor Cordingley of Manchester University, and followed this up with a confidential letter to Raglan suggesting that the house would make a fine acquisition for the Folk Museum. Unfortunately – but perhaps not unexpectedly – Raglan showed the letter to Peate, who was probably consequently not disposed to view the house favourably when he went to see it; he certainly made no attempt to acquire it. Smith's later view of Peate's stance was that

Developing the folk park

I think that by then I knew the land of his fathers in many ways better than he did. Here, in the eastern borderland was work of an age and quality rarely found in the west. Had either of us [Peate and himself] grasped that this was a very early longhouse he might have looked more favourably on it as a Museum exhibit.[51]

But it was easy enough for Smith and others to suggest what they regarded as suitable buildings for the still-small national collection: Peate had to work within a rigid framework ruled by practicality and above all by finance. Tŷ Draw was thought to date to before the revolt of Owain Glyndŵr (it was actually built in 1480),[52] but the Folk Museum had dismantled in 1954 what Peate believed on stylistic grounds to be a late fifteenth-century single-storey timber-framed cruck farmhouse from Denbighshire, Hendre'r-ywydd Uchaf, re-erected between 1959 and 1962. The re-erection work was funded by the County Council and the Pilgrim Trust, so irrespective of Peate's view of the suitability or not of Tŷ Draw as a possible acquisition, the Folk Museum already had a house of roughly the same type and date from the same county, and he would have had no chance of getting funding to re-erect another one, superior as that was. Similarly, re-erecting timber-framed buildings from the Middle Ages posed a considerable challenge at this time. How representative were they of Welsh buildings of the period, given the state of knowledge? The survivors were then thought likely to be of reasonably high social status, and St Fagans already had a gentry house of the late sixteenth century displayed to the public, St Fagans Castle itself. Could the nascent collection justify another? They also offered technical challenges. Many surviving or recognised examples had been rebuilt or significantly added to in brick or stone, so that often little remained of the original mediaeval hall other than its main timber frames, and those often truncated or hidden by inserted floors. It was the usual policy for folk museums to re-erect buildings not so much as they were found, but rather as they were presumed to have been at a particular period of history, with later additions and alterations ignored. How could the scarce remains of a mediaeval timber-framed hall be rebuilt accurately, given these parameters and its likely condition?

On many occasions throughout its history, too, it has been widely believed that a building has been offered to the Museum and refused, when neither was true. An instance when both misconceptions came together, also involving Peter Smith, is worth quoting. In March 1964 the

Western Mail noted that Cardiganshire County Council was considering saving the remains of Brogynin, the supposed birthplace of the fourteenth-century poet Dafydd ap Gwilym. This gave Smith an opportunity to draw comparison with the likely fate of Plas Cadwgan, a fourteenth-century hall from near Wrexham whose fate exercised him and which Denbighshire County Council saw no value in preserving, as no poet or famous person was known to have lived there. In a lengthy article in a Welsh-language periodical Smith noted that such halls were rare survivals and it was a tragedy that the Welsh Folk Museum had refused to accept for re-erection another of this small group, Plas Uchaf, Llangar, Merioneth – 'an institution, one would have thought, that regarded it as its responsibility and duty to save for the nation this example of Welsh craftsmanship'.[53] The Folk Museum had recently re-erected a toll-house, a cockpit and a *croglofft* cottage: many examples of the latter existed still, and he could not find words to justify the acquisition of the first two, and certainly none could be compared for an instant with this wonderful and rare survival from the Middle Ages. The gauntlet thus openly thrown down had to be picked up, albeit that the whole exchange was tinged with sooty fingerprints from pots and kettles on both sides. Peate's response was mostly factual but he could not help also making the issue personal:

> I was greatly surprised by Mr. Smith's article ... Mr. Smith is a monolingual Englishman, a member of the Civil Service who works for the Royal Commission on Ancient Monuments of Wales. He clearly does not think knowledge of Welsh important for his post otherwise he would not occupy it. And yet he has gone to the trouble of publishing in translation his attack on Wales's County Councils, on the Historic Buildings Council, and on the Welsh Folk Museum *in Welsh*. Why?[54]

Smith was indeed an Englishman, but one who (presumably unknown to Peate, and who would not have welcomed the news had he known!) was interested in the Welsh language and its literature, and who had acquired sufficient proficiency to write letters in Welsh (exhibiting a charming Victorian grammar and spelling); and the staff of the Royal Commission were not civil servants. The gist of Peate's reply was that Smith did not understand the role of the Folk Museum and had so little knowledge of it that the toll-house he had noted as being re-erected was still awaiting

its turn to be so, and the cockpit was still *in situ* in Denbigh – and, moreover, that was a unique (not literally, albeit practically so) and scheduled example which the Ministry of Works had pleaded with the Folk Museum to accept. The Museum did not receive a penny from government to pay for its re-erection work, and the burden had to be shouldered by donors and, particularly, the county councils that Mr Smith was so keen to denigrate. The Museum would be delighted to acquire a mediaeval hall-house, but none of the eight listed by Smith, including Plas Uchaf, had ever been offered to the Museum. Peate and Albert Jones had inspected Plas Uchaf and found that only two original trusses survived, too little to justify its acquisition even had it been offered.

Plas Cadwgan was demolished in 1967. The Folk Museum refused the building on the same grounds as Plas Uchaf would have been, namely that very little of its original incarnation survived, but the Avoncroft Museum of Buildings, which opened to the public that year at Bromsgrove, Worcestershire with the aim of rescuing historic buildings which were under threat, was able to salvage the fine pair of cruck blades which formed the central frame of the hall, as well as the aisle truss and screen which divided the hall from the screens passage. These timbers were considered too fragmentary to justify attempting a recreation, and so a skeletal reconstruction was undertaken in 1976 using a steel frame to cradle the timber structure, an approach that a museum of buildings could take but not a folk museum, unless it did it in a gallery displaying construction techniques.[55] Plas Uchaf, on the other hand, was later saved from utter ruin and restored, as was the best preserved of all these mediaeval aisled-hall houses, Tŷ Mawr, Castell Caereinion. This had been discovered by Smith and after Peate's time it was tentatively offered to the Folk Museum, but the offer was not followed through, and this house too was restored in award-winning fashion in 2000. Tŷ Draw, which we mentioned earlier, after continuing dereliction was also finally saved and restored in 2005.[56]

By Peate's retirement in 1971, eleven buildings had been re-erected at the Museum – the Stryd Lydan barn and the Esgair-moel woollen factory within the grounds of the Castle, and Abernodwydd, Kennixton, Cilewent and Hende'r-ywydd uchaf farmhouses, Llainfadyn cottage, Pen-rhiw chapel, a toll-house from Penparcau, Aberystwyth, a tannery from Rhaeadr, and the cockpit from Denbigh, whilst another two craft buildings which would be re-erected to working order, the Melin

Bompren corn mill from Cardiganshire and a smithy from mid Wales, had also been dismantled. Peate felt that many more were still required. St Fagans had one long-house: regional types were needed. Likewise, there was one cottage – there should be a dozen. A small school, a pub, a church, and nineteenth-century farmhouses were essential – every effort should be made to bring Llwyn-yr-eos farmhouse by the entrance into the Museum's ownership.[57] But even when he wrote this list, in 1976, there was clearly to be no place at St Fagans for any building associated with the lives and work of the majority of the Welsh population since the middle of the nineteenth century – the Folk Museum was still designed to represent largely the Welsh-speaking, craftsman-dominated, rural and idealised Wales of his boyhood.

Industrial and urban Wales was not to be represented by buildings at St Fagans. It was not just what they represented that Peate deplored: he was equally uncompromising in his views on their architecture and aesthetic appearance. In 1943 he was pleased to review an article by Clough Williams-Ellis, if only to note his complete agreement with most of the author's opinions, though perhaps he had over-egged English influence on Welsh buildings at the expense of distinctive 'Keltic' elements. He then related a tale of how he had visited a south Wales industrial town with an unnamed but distinguished Welsh literary figure, and how the friend had approved greatly of what Peate considered to be a 'positively tawdry and ... vulgar' building, which only proved how amazingly insensitive his cultured countrymen were to architectural taste – or, indeed, other aspects, 'which may be the reason why the banalities of Dr. Joseph Parry and Dr. Caradog Roberts [the composers] have been so popular amongst us'.[58] For this reason, I think Peate would have been unhappy with the occasional later feeling that perhaps St Fagans should re-erect a more typical, Victorian, chapel, in addition to Capel Penrhiw's austere form harking back to the early days of nonconformity (which of course had attracted Peate to it, as had the fact that it was a Unitarian chapel and so not tainted by the inflexibility of Methodist doctrine). Similarly, he showed no interest in the concept of preservation *in situ*. But to be fair, *in situ* preservation was hardly known then – saving by re-erection was really the only future for buildings like Abernodwydd, since restoration on the original location was most often not an option for a whole suite of reasons. Nowhere after 1940 did he bemoan the loss of traditional buildings or that means (such as Listing, established by the Town and Country Planning Acts of 1944 and

Developing the folk park

1947, but very slow to be progressed in Wales) be found to preserve them in their original locations, and although he wanted St Fagans to influence architects to design new buildings in a manner respectful of Wales's history and tradition, he never specified that part of the role of the Folk Museum should be to serve as an inspiration for the conservation or restoration of existing examples. And, almost as an afterthought, it is worth noting that neither Fox nor Peate was the first to rescue historic buildings in Wales: that was Clough Williams-Ellis, who regarded Portmeirion, which he opened to the public in 1926, as 'a home for fallen buildings'. His first acquisition was the coved plaster ceiling and two large windows from the ballroom of Emral Hall in Flintshire in 1936, and around them he built the rest of his Town Hall; over the years he acquired more building elements, incorporating them into his wonderful contrived landscape – but that landscape was designed to remind visitors of Italy, not Wales.[59]

Notes

1. Iorwerth Peate to Trefor Owen, letter of 2 April 1954, repr. in R. Alun Evans, *Bro a Bywyd Iorwerth C. Peate* (Llandybïe, 2003), p. 106.
2. Cemlyn-Jones, later Sir Wynne, 1888–1966, was an influential Anglesey politician. SFNMH/Correspondence re above/Last Inn – Barmouth etc./Little Mill, Llanerchymedd, letter of 15 August 1930.
3. C. Fox, 'Peasant Crofts in North Pembrokeshire', *Antiquity*, 11 (1937), 439–40.
4. SFNMH/Building Specifications/Opening Ceremony, CFF to the President, Lord Howard de Walden, 25 May 1946.
5. SFNMH/Building Specifications/WFM Committee Minutes/St. Fagans Appeal Committee, 6 September 1946.
6. *Rhwng Dau Fyd*, p. 136.
7. NLW ICP papers A/3/5 (ii), 'Report of the Keeper of the Department of Folk Life on his tour of Scandinavian museums, September 1946' and file of brochures and papers, visit diary and letters home; my translation.
8. NLW ICP papers A/3/5 (ii), 'Report of the Keeper of the Department of Folk Life on his tour of Scandinavian museums, September 1946' and file of brochures and papers, visit diary and letters home; my translation.
9. *Rhwng Dau Fyd*, pp. 136–7; *Presentation of the Cymmrodorion Medal. Iorwerth Cyfeiliog Peate MA, DSc, DLitt, DLittCelt, FSA* (Cardiff, 1979), p. 18.
10. But he was later to visit the Scandinavian countries again on conferences in 1951, 1956, 1957 and 1967: Douglas A. Bassett, 'Iorwerth Cyfeiliog Peate. A selected personal chronology' (unpublished MS, 1994).
11. *Rhwng Dau Fyd*, p. 136.
12. NLW ICP papers A/3/5 (ii), 'Report of the Keeper of the Department of Folk Life on his tour of Scandinavian museums, September 1946' and file of brochures and papers, visit diary and letters home; *Personau*, pp. 77–8 and 57.

13. *Rhwng Dau Fyd*, p. 137. Peate spent what little leisure time he had shopping – or attempting to shop; his attempts to buy clothes for himself proved futile, for food and clothes were rationed in Sweden too. He found two pairs of stockings for Nansi, desperately hoping that his choice was right (posterity is silent on this point!).
14. SFNMH/Reports on Fishponds etc./Peate to Fox, 'Welsh Folk Museum', 11 October 1946.
15. 'The Place of Folk Culture in the Museum', *Museums Journal* (1941), 49.
16. And in years to come also the dull murmur of traffic along the link road connecting the M4 to Cardiff Bay.
17. D. Adamson, 'The Intellectual and the National Movement in Wales', in R. Fevre and A. Thompson (eds), *Nation, Identity and Social Theory: Perspectives from Wales* (Cardiff, 1999), pp. 62–3.
18. SFNMH/Reports on Fishponds etc./The Director and Keeper's Report on Llancaiach Fawr, 3 June 1947.
19. *Rhwng Dau Fyd*, pp. 147–8.
20. SFNMH/Building Specifications/WFM Committee Minutes, 3 June 1949, 1 July 1949, 2 September 1949.
21. SFNMH/Building Specifications/WFM Committee Minutes, 3 June 1949, 1 July 1949, 2 September 1949, WFM Committee Minutes, 4 November 1949.
22. 'Re-erected Buildings at the Welsh Folk Museum', *Museums Journal*, 52 (1952), 74–6.
23. 'Re-erected Buildings at the Welsh Folk Museum', *Museums Journal*, 52 (1952), 74–6.
24. *Rhwng Dau Fyd*, p. 148.
25. SFNMH Accession Correspondence, Esgair-moel.
26. SFNMH Accession Correspondence, Stryd Lydan.
27. Eurwyn Wiliam, *Welsh Cruck Barns. Stryd Lydan and Hendre-wen* (Cardiff, 1994), pp. 14–24.
28. Examination of the Stryd Lydan crucks by the Museum carpenters and myself in 1994 showed that Peate was correct: Wiliam, *Welsh Cruck Barns*, pp. 19–21.
29. SFNMH/Correspondence re. above/Last Inn, Barmouth etc./Upper Mill, Cefn Coch, letters of 31 October 1949 and 20 March 1950.
30. *Rhwng Dau Fyd*, p. 150. The mill in question was Melin Llynnon, Llanddeusant: *Liverpool Daily Post*, 12 August 1966.
31. SFNMH/Correspondence re. above/Last Inn, Barmouth etc., all 1949/50; Dan-y-bwlch correspondence of 8 June 1950 and 15 June 1950.
32. *Rhwng Dau Fyd*, pp. 150–1.
33. SFNMH/Miscellaneous/Pro Numbers etc./Misc.
34. SFNMH/Building Specifications/WFM Committee, 7 March 1952.
35. *BBCS*, ix (1937), 94: it was later established through dendrochronological dating that the house was built in 1678 and converted from an open hall into a storeyed house in 1708.
36. 'Abernodwydd . . .', *Montgomeryshire Collections*, liii (1953–4), 37.

37. WFM Committee, 3 July 1953; *BBCS*, viii (1936), 284.
38. *The Welsh House*, p. 101 and pl. 46.
39. WFM Committee, 5 November 1954.
40. SFNMH/Building specifications/WFM Committee, 7 March 1952.
41. *Rhwng Dau Fyd*, p. 139; 'Diogelu ein treftadaeth' ['Preserving our heritage'], *Barn* (Rhagfyr 1964), 58.
42. 'The Welsh Folk Museum', Stewart Williams' *Glamorgan Historian*, 7 (Cowbridge, 1971), p. 167.
43. 'Diogelu ein treftadaeth', 58; my translation.
44. *Rhwng Dau Fyd*, p. 121; my translation.
45. SFNMH Accession Correspondence 52.253, Kennixton.
46. Peate wrote of this in his article on Iolo, 'A Unitarian Romantic', *Trans. of the Unitarian Historical Society* (1965), 1–14. Peate's article was based on Williams's volume in which he published the transcript: *Iolo Morganwg. Y Gyfrol Gyntaf* (Cardiff, 1956), pp. 366–7.
47. Eurwyn Wiliam, *The Welsh Cottage. Building Traditions of the Rural Poor, 1750–1900* (Aberystwyth, 2010), p. 193. The story of the old inhabitant rediscovering his initials is told by Gwyn Erfyl, 'Y Gŵr o Lainfadyn – Owen Williams', *Barn* (Gorffennaf 1975), 693–5.
48. Albert Jones summarised his reminiscences in a six-page note in 1976: NLW ICP Papers A 3/3.
49. E. Wiliam, 'A Cruck Barn at Hendre Wen, Llanrwst, Denbighshire', *Trans. Ancient Monuments Soc.*, n.s., 21 (1976), 23–31. 'Your Mr Williams' was me; but I *was* right . . .
50. P. Smith and D. B. Hague, 'Tŷ Draw', *Arch. Cambrensis*, 107 (1958), 109–20.
51. Peter Smith in R. Suggett and G. Stevenson, *Introducing Houses of the Welsh Countryside* (Talybont, 2010), p. 194.
52. W. J. Britnell, R. J. Silvester, R. Suggett and E. Wiliam, 'Tŷ-draw, Llanarmon Mynydd Mawr, Powys – a late-mediaeval cruck-framed hallhouse-longhouse', *Arch. Cambrensis*, 157 (2008), 177 .
53. *Barn* (Medi 1964), 316–17; my translation.
54. *Barn* (Hydref 1964), 346; my translation.
55. *Avoncroft Museum of Buildings*, guidebook, n.d.
56. NLW ICP Papers A 3/3.
57. *Rhwng Dau Fyd*, p. 151; Llwyn-yr-eos was indeed acquired in his successor's time. Llanrhychwyn church, high above the Conwy valley, was offered in 1970, but declined, presumably because of its inaccessible location: SFNMH MS 1277/1–9.
58. NLW ICP Papers A 2/9 (i), untitled MS, 22 October 1943: I have failed to identify where this review was published. Like Peate, Williams-Ellis had long held Victorian architecture in disfavour: C. and A. Williams-Ellis, *The Pleasures of Architecture* (London, 1924), in which they described much of Victorian architecture as 'Satanic'.
59. Jonah Jones, *Clough Williams-Ellis. The Architect of Portmeirion* (Bridgend, 1996), pp. 130–2.

II

Frustration and fulfilment

Building curatorial capacity

The 1950s and 1960s were a period of great difficulties but also of real progress for the Welsh Folk Museum, when the staff, facilities and exhibits finally reached a level of which Iorwerth Peate had dreamt. Sourcing sufficient funding, however, remained a constant and real problem, as he later put it in an explanation for sixth-formers,

> From the start, the government refused to fund the development of the institution. If we wished to re-erect buildings, then (it was said) it was up to us to source funds in Wales to do so; if we wished to build a modern block to display our national collection and to be the centre of the whole development, then (it was said again) it was our duty to find the money to make that possible.[1]

He noted also that although Wales still had some very rich people as well as a few millionaires, the Folk Museum had never succeeded in attracting such sponsors. But whatever the reason behind the lack of adequate funding, the consequence was that the National Museum's Officers felt they had to keep a very tight rein on expenditure. Peate and even the Director had very little room to manoeuvre, and even the most insignificant items had to be taken to Committee and often thence to the Council, with almost no authority delegated. The minutes of the Folk Museum Committee meeting of 3 June 1949, for example, note that it was agreed that two tarpaulins (24 ft by 16 ft) be purchased from government surplus stock at fifteen guineas each, and that the purchase of

a second-hand typewriter for about £36 be authorised. It was resolved in the same meeting that immediate steps be taken to produce an illustrated handbook, to be sold at one shilling. Ten thousand copies were to be printed in English and 2,000 in Welsh, and 10,000 postcards of a watercolour drawing of St Fagans Castle by the Swansea artist W. Grant Murray (for which he was paid £20) also be obtained; up to that date, over 13,500 temporary guidebooks and 7,500 picture postcards had been sold.[2] The Treasury, too, kept a close eye on performance and in 1952, for example, asked that the sale price of publications and products, such as wood turnery, should be reviewed, with a view to increasing income from those sources.[3]

All the work of the new Folk Museum naturally depended on having the capacity to do it, and the curatorial work was still all done by Peate (in addition to his administrative duties) and Payne, until in 1953 the Treasury finally authorised a second Assistant Keeper. Twenty applications were received and three interviewed, and an Aberystwyth geography graduate, Trefor Meredith Owen, was appointed and took up his duties in June 1954.[4] He had spent the intervening year studying the Scandinavian approach to folk-life studies on a scholarship in Sweden on his own initiative, after completing a MA combining history and sociology on life in an upland part of Merioneth. Ffransis Payne's seniority was marked by his post being retitled Deputy Curator, Owen becoming Assistant Curator. In addition to having care of all the collections, Payne had developed to become the Museum's expert on costume and textiles and on gardening, obtaining much of his evidence from mediaeval Welsh poetry. His excellent MA thesis was published jointly by the Museum and the University of Wales Press as *Yr Aradr Gymreig* ('The Welsh Plough') in 1954. Peate respected Payne's decision to publish the work in Welsh but was saddened that not also issuing it in English deprived Payne of the international recognition that he deserved.[5] Although Payne was an immensely modest man, in retrospect he was able to recognise his own worth, noting

> Peate realized that I knew all kinds of things that he didn't know. The strange thing about Peate was this: although he had been brought up in Llanbryn-mair [sic], he was as ignorant of the farming scene as any man I've ever met. He really didn't know country life at all.[6]

Frustration and fulfilment

Owen noted later how much he benefited from the intellectual tension between the two men, with Peate's world-view that of a radical Independent to whom the *gwerin* meant everything, whilst Payne always spoke of 'peasants' and not 'folk' and regarded himself as primarily a historian.[7] In 1959 Owen published a catalogue and long introductory essay on *Welsh Folk Customs*; and although he played a full role in other aspects of the work, such as recording buildings being dismantled for the Museum, he became increasingly interested in the sociological aspects of folk life. It was no surprise when he was appointed to a lectureship in sociology at Bangor in 1966 – no surprise to anybody except Peate, who regarded the move as a personal betrayal.[8] To assist Payne and Owen with the material side of the collections, Peate in 1960 talent-spotted another Aberystwyth geography graduate, J. Geraint Jenkins, whom he had heard lecturing at a conference in Edinburgh. Jenkins had spent eight years at the Museum of English Rural Life in the University of Reading and in 1960 was successful at interview for two posts, one at the Science Museum and the other as an extramural tutor for Glasgow University, but as he later told it, was 'saved' by Peate's intervention and was delighted to return to Wales.[9] At Reading Jenkins had developed an interest in farm wagons, measuring nearly 700 examples and identifying twenty-seven types; the resulting study, *The English Farm Wagon* (1961), became recognised as a classic. At St Fagans he rapidly followed this with *Agricultural Transport in Wales* (1962), another of the National Museum's catalogues with introductory texts, and then spent several years studying in detail woollen manufacture, of which *The Welsh Woollen Industry* (1969) was the result; this study was of course justified curatorially because of the re-erection of Esgair-moel mill. Jenkins also published an overview of British crafts, *Traditional Country Craftsmen* (1965) during Peate's Curatorship. With time dedicated to proper study, Jenkins also showed what was possible on a more local scale, such as his detailed thirty-nine-page study of the crafts of Breconshire which dealt with not only the obvious ones, such as corn-milling, tanning and weaving, but also locally important ones, such as paper- and cider-making.[10] With Jenkins's arrival, Payne was promoted Keeper.

But ever since the 1930s Peate had also hoped that the dialects of the Welsh language could be recorded and studied at the Museum (see Chapter 3). He found a champion in Professor Griffith John Williams (1892–1963), head of the Department of Welsh at University College

Cardiff. Williams was chosen as a representative of the Privy Council on the Museum's Council in 1948, whereupon he was promptly appointed a member of the Museum's Finance Committee, even though his only interest was in the new Folk Museum. He was later transferred to the Folk Museum Committee and chaired it from 1959 to 1961. The study of dialects in Wales was not entirely virgin territory – T. J. Morgan of University College Cardiff had recorded elderly Welsh speakers in southeast Wales in the 1930s, for example – but demographic changes now showed that there was a desperate need to record dialect information before it was too late. Dialects preserved a wealth of information about custom and terminology, and in fact the Folk-lore Society had established a Committee on Welsh Calendar Customs in 1945, to seek such information as it had already published for England and was about to do for Scotland. This had no formal link to the Museum, but Peate was a member. The Representative Body of the Church in Wales distributed the section of the questionnaire relating to ecclesiastical matters to all its parishes, and responses were eventually deposited in the Folk Museum. However, the general part of the questionnaire, which dealt with calendar, seasonal and popular customs, was never distributed.[11] Against this background the Welsh Folk-life Survey Committee was created in 1955, to include representatives of the Museum, the four professors of Welsh in the University of Wales, and other eminent scholars, but with the clear intention that the objective was to further the work of the Museum, albeit using voluntary help.[12] At the same time Peate put forward a proposal to his Museum Committee that a permanent member of staff was needed to begin the collecting of oral information, to be funded (it was hoped) initially by the Rockefeller Foundation and afterwards the Treasury.[13] The note sent to possible funders and donors outlined the need for such activity, as 'revolutionary' changes that were happening to rural life in many countries had a particular effect in Wales, causing a formerly monoglot Welsh community to become bilingual. In the process, a vast technical vocabulary as well as a body of traditional practices and beliefs, song and folklore was disappearing. The replacement of horses by 'motor tractors', for example, meant the disappearance of a whole series of terms relating to traditional ploughs and horse-harness, which varied from dialect to dialect. The Museum proposed to cover the whole of Wales, area by area, 'by means of a tape recorder', and record domestic vocabularies (including terms for cooking, meals and social intercourse); agriculture (seasonal

operations such as ploughing, harrowing, sowing, reaping and livestock management); craft vocabularies; and cultural life (including religious activities, ceremonies, folk song and dance, folklore and folk tales).[14]

In the event, the Treasury agreed to fund the post whilst the Gulbenkian Foundation helped to pay for basic equipment, including a Land Rover. In Peate's recollection, Griffith John Williams delivered a radio lecture and appeal that provided the necessary spark by validating Peate's ambition, and it was one of his students, Vincent Phillips, who was appointed to carry out the task; but in fact Phillips had been appointed before Williams's talk.[15] Phillips was appointed to the Museum staff in 1957 as second Assistant Curator, and in 1958 an approach was made to the University of Wales's Board of Celtic Studies to make research grants to students 'to work on dialects in areas specified by the Assistant Curator'. The Treasury was asked to provide £1,500 a year to cover the fees and expenses of paid correspondents for 1959/60.[16] Phillips was expected to cover a huge field and felt it prudent to work on a broad front, salvaging as much as he could and concentrating on terminology, as some dialect work was being done by the university departments. Fieldwork was a difficult process; the machines used were bulky and heavy, and batteries and leads had to be carried in case an informant's house did not have electricity. Later a caravan was purchased, so extended periods of recording could be undertaken. In all, some 5,500 individuals were recorded, and silent colour films of activities such as farming, food preparation and crafts made. The Museum archive now contains some 250,000 photographs and prints and some 15,000 transparencies, as well as oral recordings. Peate later noted that he regarded the recording and research work done in the Department of Oral Traditions and Dialects under 'its brilliant head' Vincent Phillips as the crowning achievement in the development of the Welsh Folk Museum.[17] Peate himself retained an interest in craft terminology, and published vocabularies that he had collected from craftsmen, although his father had died before he compiled the list of carpentry terms that he had promised his son years before.[18]

By 1961 the Museum was in a position to appoint additional staff to help Phillips, with D. Gerwyn Lewis and Mary Middleton taken on as Research Assistants that year, to be joined by D. Roy Saer (1962), Robin Gwyndaf Jones (1964), and Lynn Davies and S. Minwel Tibbott in 1969. All these appointees held first or higher degrees in Welsh, as indeed did most appointees in Payne's Department of Material Culture. Lewis and

Middleton were dialectologists, like Phillips; Saer was set the task of recording folk song, and Jones (later to be known as Robin Gwyndaf) would specialise in folk tales, collecting over a decade some 400 examples of the genre from one tradition-bearer, Lewis Evans of Denbighshire, for example. Sadly, the two departments rarely collaborated, though Lynn Davies later collected fishing terminology in parallel with Geraint Jenkins studying the craft itself. There was only one case of a Museum-wide field research project, when the Soddy Trust (which sponsored geographical field research) funded a study of the Llŷn Peninsula, in which aspects of dialectology, folk song, crafts and traditional architecture were examined, but Trefor Owen, who would have edited the result, resigned and the work was never published.[19]

From the first Peate took a lead in interpreting the exhibited collections to the public and beyond. The division of work in the earliest days at St Fagans seems to be that whilst Payne looked after the collections, Peate performed the outward-facing functions, including interpretation for the public, and he never delegated this, writing all the *Handbooks* and promotional material himself almost to the last. The first *Handbook* was published in 1949 and updated in 1955 after the re-erection of the first buildings, and expanded on his earlier definition of a folk museum and the history of St Fagans Castle. He then gave a room-by-room description of the contents, since in true Scandinavian style no labels were provided that would intrude on the illusion that this was a genuine country house, rather than the series of rooms furnished to various periods that it actually was; but the *Handbook* did make this latter point very clearly, such as '*The Hall*, furnished in 17th-century style, was the room where the family and its servants met for meals' (a hugely doubtful assertion but typical of Peate's egalitarian view of past life in Wales).[20] The items are described in some detail and with interpretation, such as 'The virginal, dated 1654, comes from Plas Bodean near Pwllheli, Caernarvonshire, the painting on the lid depicting Apollo charming the beasts with the music of his lyre' (though visitors would have had to work out for themselves which was the item in question, standing behind rope barriers as they were, and barely able to see the decorated lid). He also made clear that some rooms, for now, were less complete than he would like. The gardens and grounds should be considered as part of the exhibit (rather than the 'pleasure resort' promised in the 1946 appeal booklet), and the wood-turner W. R. Evans (formerly of Aber-cuch) and the basket-maker D. J.

Davies were mentioned (though the latter was temporarily unavailable 'due to the need for his services in the re-erection of buildings'). Four buildings had already been re-erected, the Stryd Lydan barn, the Esgair Moel woollen factory, Abernodwydd farmhouse and Kennixton farmhouse: each is described briefly. Work on three other buildings was well advanced, namely a Unitarian chapel from west Wales, a seventeenth-century long-house, and a cruck-built timber-framed farmhouse. Finally, funds were urgently needed 'for the establishment of craft workshops, for the transport and reconstruction of houses, farm buildings, etc., and for the erection of the Museum building'. £94,000 had so far been subscribed or promised following the 1946 appeal but much more was required, for the Museum block alone would cost £250,000.[21]

Peate produced many revisions of the *Handbook*, with his last, of 1970, of fifty-two pages and illustrated with many photographs. The illustrations from earlier editions were reused where practicable, but in this edition a picture of the new offices and the exterior of the new gallery were included. The *Handbooks* were a mixture of something to carry in the hand to note what particular items were, and also a souvenir guide that acted as a good introduction to the subject covered by the exhibits, in effect a potted version of the Introduction to the *Welsh Bygones* of 1929, with some entries being synopses of that text and sometimes with parts included in full, if still appropriate. With relatively few curatorial staff still, and certainly no dedicated buildings expert, it was also Peate who researched and wrote articles on most of the early buildings re-erected at the site; these were subsequently republished as individual guidebooks by the Museum. In this way booklets on Abernodwydd, Hendre'r-ywydd Uchaf and the Denbigh Cockpit were made available. The Hendre'r-ywydd booklet, for example, in addition to outlining the documentary and architectural history of the house (Peate thought it dated to about 1470: later dendrochronological dating showed that it was built in 1509), noted that Denbighshire County Council had contributed £250 towards the cost and the Pilgrim Trust £3,500 from its original donation of £10,000. Whilst the four pairs of cruck trusses which held up the structure had survived well, much of the timber-framing forming the walls was in poor condition, but no problems arose with reconstructing the missing members, as sufficient survived to copy. The later fireplace and chimney was left out and the earth floor that the donor could recall reinstated, whilst a reproduction of a mediaeval central hearth, based on the testimony

of the Welsh Laws, was created. The booklet on the Denbigh Cockpit was titled in full *The Denbigh Cockpit and Cockfighting in Wales* (1970) and half of its text was devoted to what Peate knew of cockfighting; and in this case, £400 had been donated 'towards the cost of repairs' by the Ministry of Public Building and Works (the precursor of today's Cadw) to help fund a rather extreme version of 'repairs', but the Ministry was keen to find a way of saving this almost unique survival. The interior had been completely destroyed and whilst the arena ('the pit') and seating around it were reconstructed in stone, Peate acknowledged that they might well have originally been of timber. The handbook to the Esgair Moel Woollen Mill (working since 1952; a second technician was added to the complement in 1956) was written by Geraint Jenkins in 1965 and provided a comprehensive description of the processes carried out in the building, and was a precursor to his *The Welsh Woollen Industry*. Peate also published a collection of photographs of traditional buildings, *Farmhouses and Cottages in Wales*, thirteen of the twenty or so photographs ones he had taken during his fieldwork in the 1930s.

Planning and developing the galleries

Against this background, it is hardly surprising that creating the desperately desired new galleries was a lengthy and tortuous process. Based on what he had just learnt in Scandinavia, Peate had laid out the strategic brief in his 1948 volume. What was required was

> a modern block of buildings for the scientific exhibition of the materials of our life and culture . . . in more than one sense the heart of the new museum . . . In it will be galleries where material illustrating all aspects of Welsh folk life will be displayed . . . Here too will be the Museum offices. This building will contain not only workshops for the use of the technicians who arrange the Museum but rooms for housing data relating to all aspects of the traditional culture . . . This building will become a storehouse and a national centre for all information relating to Welsh life.[22]

As we have seen, Sir Percy Thomas was appointed as the Museum's architect immediately the St Fagans site was acquired, developing a master plan and overseeing works to St Fagans Castle and its curtilage. Percy Thomas

and his eponymous partnership were acknowledged as Wales's foremost architects from the 1920s onwards; Thomas himself was President of the Royal Institute of British Architects in 1935-7 and 1943-6, and was knighted for his services to architecture in 1946. His major Welsh structures up to then included the New Guildhall in Swansea, the Temple of Peace and Health in Cardiff and the innovative British Nylon Spinners factory in Monmouthshire. But he was also recognised as a major planner, leading the design of the new university campus at Aberystwyth and similarly prestigious projects all over Britain, and it was little wonder that it was his practice (by then known as Sir Percy Thomas and Son) that the Museum appointed. Thomas developed a large, flat-roofed scheme to answer the Museum's planned long-term aspirations for galleries, workshops, stores and offices in 1953, but of that only one part was built (in 1954-5), the red-brick building later to be known as the 'Red Block', in contrast to the grey brick chosen for later Museum constructions. This was (and is) a two-storey structure designed to provide storage on the ground floor, with the top-lit first floor provided with a woodblock floor so that it could be used as gallery space until such time as more extensive galleries could be built. Trefor Owen later recalled, since the Museum had only a couple of technicians at the time, that it was Ffransis Payne and himself, newly appointed, who erected the Meccano-type shelving and placed all the specimens removed from the Cathays Park basements and various storerooms in St Fagans Castle in place according to the catalogue.[23] One of the 'temporary' exhibitions shown in the upstairs gallery between 1954 and 1956 was on Welsh pottery, contemporary as well as historic. Peate was lent a Buckley three-tier money box which he desperately wanted for the collection – it 'makes me feel quite acquisitive' – but he did buy some modern Llangollen craft pottery for his own collection.[24] Peate wrote of his aspirations for the *Museums Journal* in 1957, by which time permanent cased displays, comprising period room and workshop recreations, and cases illustrating music, folklore, sport, farming, time-keeping, law and order, lighting, and the Eisteddfod were created.[25] Small-scale works to widen the new entrance to the Museum, including developing a car park for 350 vehicles and creating a new ticket office, were carried out in 1959, paid for from the Development Fund.

An ongoing dialogue between Fox and then Peate as de facto client and the architects had early on defined the broad parameters of what the main scheme should include; and Peate, armed with the experience of his

Scandinavian visits and constant contact with open-air museum directors, had a clear idea of what the basic principles behind a design should be. Like the architects, he wanted a thoroughly modern design, not only to contrast with the re-erected buildings but also to be a symbol for the future of what a new, forward-looking Wales should aspire to. By the 1960s Percy Thomas had given the lead role in handling the Museum commission to Dale Owen (1924–97), once his assistant and now himself a major figure in the Welsh architectural world. On behalf of the partnership Owen was responsible for the re-casting of the university campuses at Aberystwyth and Swansea and also designed Broadcasting House at Llandaf (1963–7, along with the Folk Museum the other key institutional building to be erected in Wales in the 1960s): he reinforced the increasingly modernist thrust of the practice. He was assisted as job architect on the St Fagans contract by John Hilling, who was similarly deeply influenced by modernist architecture and in his case its Scandinavian expression in particular; Hilling was later to become a prominent architectural historian.

For years, however, a total lack of money meant that planning led nowhere. The problem was partly political and partly organisational, not helped by the fact that the Welsh Office was not created until 1965, and so all financial discussions had to be held directly with the Treasury. One of Peate's fundamental complaints about the constitutional status of the Folk Museum was that he was excluded from direct discussions with Treasury officials and with whom he had met only once; and to Peate's irritation the Treasury naturally lumped all the National Museum's projects together, leaving it to the Museum itself to prioritise. Whilst the Standing Commission on Museums and Galleries was consistently supportive, this was merely another potential capital demand to successive governments and particularly the Treasury, which had to balance demands from both the National Library and the National Museum, and the total sum offered for all desired projects was simply far too little. Cledwyn Hughes MP proposed that £400,000 was needed for developing the Folk Museum but Henry Brooke, the Minister for Welsh Affairs, announced an additional grant of only £13,000 for the car park in 1961.[26] A revised schedule of works was prepared in 1962 in an effort to bring down costs. Excluding the lecture theatre planned earlier would enable a building of 42,000 sq. ft (3,900 sq. m) to be built for about £248,000 plus fees at nine per cent.[27] A breakthrough came finally in 1964 when discussions between the Treasury, the Standing Commission, the Library and

the Museum resulted in the government agreeing to fund a programme for the Welsh cultural institutions at a total cost of £700,000 over the next twelve years, of which the Folk Museum would get £185,000 in 1965-7 and a second tranche of £170,000 between 1970 and 1972. In 1965 Owen and Hilling went on a fact-finding mission to Scandinavian museums, seeing some locations together with Ffransis Payne, who was there studying modern methods of museum presentation.[28]

Percy Thomas's earlier master-planning had identified the obvious location for the museum block, namely the old tennis courts in the eighty acres. The new buildings were planned to take up the whole of this area, leaving room for an extensive car park to the south on the site of the former vegetable garden. One iteration of the plans had low-pitched slate roofs to the complex, but these were abandoned as a cost-cutting measure and the original flat-roofed structures reinstated on the plans.[29] The flat roofs worked well with the horizontal emphasis of the building, but possibly an opportunity was missed. At the Plas Menai National Outdoor Pursuits Centre on the Menai Straits in 1982, Bill Davies of the Bowen Dann Davies practice created a slate-roofed building which in its massing is similar to the Folk Museum block. It is generally recognised as the most successful large building of modern times at achieving a national Welsh ethos.[30] That cannot be said about the St Fagans building, but from the river, Plas Menai also sits against a backdrop, in its case the mountains beyond; and certainly successive generations of staff had cause to regret the flat roofs at the Folk Museum as they placed buckets to catch the rainwater coming into the galleries and stores as the roof cladding deteriorated. However, some of the principles underlying traditional building practices were followed, such as the unpretentious use of materials, with no attempt to disguise them; an honesty in exposing the structure (columns and beams) as in timber-framed buildings; and the adaption of the building to the ground form, with staggered levels following the rise of the land.[31]

The plans were implemented, after slippage to the timetable, in two main phases, in 1967-8 and 1971-2. The fact that the site sloped gently from north to south across the long axis of the plan was used to advantage, so that the view from the car park presented a long modernist grey brick two-storey elevation backed by the tops of trees behind – a striking resemblance in every way to Maihaugen at Lillehammer, acknowledged as inspirational but in fact a direct design reference never specifically noted

until now. Similarly, the visual effect on the folk park was mitigated by the buildings to the rear being single-storey. The basic design was essentially two courtyards surrounded by conjoined buildings, that to the east (the right side when viewed from the car park) being a service courtyard with offices to its front and workshops and reserve stores on the other sides. The new design was anchored to the store/temporary gallery of 1954 (the 'Red Block'), which now formed the eastern side of the service courtyard. The two administration floors were both divided lengthways by a central corridor, with the offices (including Peate's at the east end) on the south side of the first floor overlooking the car park and the library to the cooler north; on the ground floor, the north-facing rooms were below ground level and largely used for service functions. These structures formed the first phase, together with a large gallery space (designated as the Material Culture Gallery) to the west of this block and north of the planned second courtyard. Staff moved into the offices in October 1968 and work on the gallery began shortly after. It was opened officially by Iorwerth Peate on 10 July 1970 with a plaque bearing a (not very good) likeness of himself placed by the folk park entrance to the building to commemorate the occasion. Whilst the siting of the building was the only viable option, it did have some practical downsides, not least for the staff in the south-facing first-floor offices, which could be unbearably hot in summer; their colleagues downstairs were sheltered by the cantilevered first floor. However, the huge advantage was that whereas previously the material culture curators and Peate himself had their offices in St Fagans Castle and the oral traditions members were based in the Gardens House, all the curatorial and support staff were now together under one roof, with a proper library, archive and conservation area at their service.

The gallery complex forming the remaining three sides of the western courtyard was completed and handed over to the Museum in March 1973. Because of the sloping site, this courtyard was on two levels, and comprised a paved open space with a long pool on its upper level. Peate had wanted this to be a grassed area suitable for events but this was not possible and the modernist ethos of the building was retained. The front elevation facing the car park was cantilevered in keeping with the offices to its east, with its first floor supported on two rows of narrow pillars placed edge-on to the elevation. The gaps between the front row of pillars were glazed so that carts and wagons could be displayed between them. Above them was the top-lit Agriculture Gallery, its front presenting a

simple mass of plain grey brick to the visitor, with above it a clerestory window range; to the east, linking this build phase to the administration complex, was the Costume Gallery. The western wing was a split-level hall leading via wide steps to a landing, off which the gallery of Material Culture opened, whilst a ramp at the top doubled back above the steps and led to the Agriculture Gallery at the front of the building, directly above the carts and wagons. To the west again were the shop and toilets, with the restaurant above. The main entrance was detached from the block, slightly south and west of it, using the simple free-standing ticket office put up in 1956. This had the unfortunate effect that most visitors entering the Museum from this direction (and most did, once cars and coaches rather than service buses and trains became the usual mode of conveyance for visitors) would head immediately towards the open-air part of the Museum, which they could do without having to enter the building. The consequence of this was that very many visitors in fine weather never saw the galleries at all and one could tell what the weather was outside simply by the numbers of visitors indoors. The Agriculture Gallery was opened in April 1974 and the shop in July. The whole complex was completed in February 1976 with the addition of a wing projecting south from the east end of the office block, to house further offices including a relocated office for the Curator at the end of the first floor. For the architects, of course, the building itself was the statement; but for Peate and his colleagues the building was merely an envelope for what really mattered, the galleries and their contents. Neither they nor the public were really aware of its architecturally iconic standing, and whilst architectural historians regard it as having been designed to contribute to a nation-building agenda, its users merely looked upon it as a piece of functional architecture.[32] It was Dale Owen rather than the Museum who was concerned that the building should win prizes (the Museum then and for years afterwards regarded hunting for prizes as de trop), and it took until 1978 before it was awarded the T. Alwyn Lloyd Memorial Medal for Architecture by the National Eisteddfod; but then the Partnership did win for other schemes five times during that period, so there was probably an internal issue about prioritising their own submissions within the Percy Thomas Partnership. Likewise, Peate never regarded the building as handed over in 1973 as complete: the *Handbook* of 1970 noted that 'A further development will be a theatre and educational unit'; and in 1971 he noted, 'It is regrettable that the pioneer national folk museum of the

Commonwealth should have had to wait over twenty years for the erection of its main buildings and that they should have to be built according to such a piece-meal timetable.'[33]

Looking back in 1976, he felt that the theatre that was part of the original plans was no longer needed, with the great growth in theatres all over Wales, but there remained a great need for lecture rooms, research rooms, and conference rooms where all sorts of societies could meet. There was need too for a gallery to display furniture, since there were sufficient examples in the collection. He also noted, 'It had also been my intention to create a craft centre, where workshops relating to every traditional craft, living or no longer practiced, could be shown, and a permanent exhibition of their products.'[34] Regrettably, he had failed to persuade Dr Thomas Jones to facilitate the removal of the Gregynog Press to St Fagans, where it could continue working.[35]

The galleries were deliberately placed around a courtyard so that visitors might perambulate in sequence through them. No route was prescribed, but since the Material Culture Gallery was the first to be opened, it was laid out in a sequence starting from the then only entrance, that from the folk park, and reflecting closely the order of the 1929 catalogue, starting with house fittings and so on. The gallery consisted of tall cases along the walls and projecting into a central aisle beneath the exposed concrete beams supporting the roof, effectively dividing the long room into discrete units and maximising the display space available. The entrance end was left without cases so as to accommodate examples of carved wooden wall panelling, a fireplace overmantel and examples of 'traditional' furniture including a *cwpwrdd deuddarn* (two-piece cupboard), a *cwpwrdd tridarn* (three-piece cupboard) and several dressers, but also a side-table with pedestals and urns designed by Robert Adam for the richest landowner in Wales, Sir Watkin Williams-Wynn of Wynnstay. This and the overmantel were the only items representing higher-status life shown. Craft products were not displayed – perhaps it was felt that there was not sufficient space, and that the existing re-erected workshops and others hoped for might cater adequately for these aspects. Arranged typologically ('scientifically', as Peate had put it in his 1948 overview), the small individual labels, with full acquisition and location details but no description of how an object was used or by whom, could be interrogated – but only by those sufficiently interested and cognisant – to reveal a type's chronological development. The Agriculture Gallery, its

contents chosen by Elfyn Scourfield, had a logic to its layout too, for it reflected the seasonal sequence of activities associated with a predominantly arable farm (for the simple reason that far more objects were associated with arable rather than pastoral farming, from tractors to threshing machines). The visitor saw first an iconic grey Massey Ferguson tractor (manufactured 1946–56, and used on small farms much later) acting as anchor to the display of ploughing, then objects associated with crop-growing and ending with barn machinery near the door leading to the Costume Gallery. In its time this gallery, with its series of large floor-mounted objects and strong storyline, was very innovative and contrasted hugely with the old-fashioned layout of the Material Culture Gallery; but looked at from today's perspective, it benefited from the familiarity of many of its visitors with at least the concept of farming, for it did not have an introduction explaining that farming was the process whereby food was produced, or offer any historical context.[36] The gallery was also sometimes staffed by museum attendants who were themselves former farmhands and who were ready to share knowledge and anecdotes. The Costume Gallery linking the other two galleries at the east end in turn was laid out chronologically, starting from the Agriculture Gallery end, with costumes chosen by Ilid Anthony displayed as a series of tableaux incorporating period panelling and furniture. This layout had a knock-on effect on the order in which visitors entered the Material Culture Gallery. That had been designed to be accessed from its west (folk park) end, that being the only entrance when it was opened, but now visitors saw the contents starting with musical instruments, and exited after seeing wall panels and other items associated with the house, contrary to the logic of its layout. In reality, visitors would enter from any direction and probably never realised the significance of the order in which they saw things; but they did appreciate the sheer numbers of objects (hundreds), and there was something of interest to everyone, including children. Visitors lingered and talked amongst themselves, and although the labels were not very informative beyond the museological necessities of the time, the objects were identifiable by themselves or from the context of surrounding objects, and ultimately all dealt with everyday life. More by chance than design, then, and seemingly with little direction from Peate, three different concepts of gallery presentation were offered one leading to another – the three-dimensional catalogue of aspects of folk life and folk lore in the Material Culture Gallery, the process-driven narrative of the Agriculture

Gallery, and the chronological approach of the Costume Gallery; but the one thing they had in common was that they were all object-rich and object-led, and Iorwerth Peate will have been very pleased indeed. For many years, they offered the premier integrated displays of folk-life material in Britain: the only comparators, smaller and less comprehensive, were galleries at the Ulster Folk Museum, the National Museum of Scotland and (for agriculture and crafts) Reading University's Museum of English Rural Life.

Further aspirations

In 1967, with gallery provision either secured or in the building programme, Iorwerth Peate was asked by the Folk Museum Committee to prepare a note on possible developments for the next decade. With forty years' service under his belt – twenty in Cardiff and twenty at St Fagans, and with retirement in sight – he stressed in response that the opinions he was putting forward were ones that would offer him no personal gain. He began his memorandum with a historical retrospect in which he reiterated his position on the constitutional status of the Folk Museum. The current arrangement, whilst a move towards what Sir Cyril Fox had proposed in 1948, was still unsatisfactory in many respects. Accessions and library acquisitions were still processed at Cathays Park and staff appointments had to conform to Cardiff structures, so that the finance clerk (a qualified accountant) was under-graded. The Committee, too, was treated as simply a departmental committee, so that its chairmen were not *ex officio* members of Council. The time had now come to adopt Fox's scheme and for the Folk Museum to become a fully autonomous constituent part of the National Museum. The two curatorial departments should be strengthened – there should be two additional Assistant Keepers in Material Culture, one to specialise in furniture and the other in textiles (these came about, respectively, in 1967 and 1970), with the existing two Assistant Keepers to cover Agriculture and Crafts (one member) and Houses and Re-erected units (the other), though it was possible that a separate department would have to be created for this latter task (an Assistant Keeper to develop such a department was appointed in 1971).[37] The Department of Oral Traditions and Dialects was the only department in the National Museum of Wales without an Assistant Keeper, and the senior Research Assistant should be promoted to this grade. An additional

Research Assistant/junior archivist and two additional Research Assistant collectors and an extra technician were also needed, as was a Librarian. With the movement of staff to the new offices there would be temporary room in St Fagans Castle for a Schools Service; this would not be a loan service (the sheer size of many of the objects made it impractical), but rather the staff should teach the teachers how to use material available locally.[38]

With this invitation to Peate to put forward his views on the future, the Folk Museum Committee (with at least the knowledge, if not the wholehearted support, of the Officers) had in effect welcomed a reopening of the matter of the constitutional position of the Folk Museum, and yet another committee was created to look at the matter. Its brief was based on the premise that the Council wished to give to the Folk Museum as much autonomy as possible, consistent with the terms of the Charter and Statutes. The committee was chaired by the Vice-President, Alun Oldfield-Davies, and included Lord Plymouth (now President), Colonel Morrey-Salmon (Treasurer), Sir Hugo Boothby, Emyr Currie-Jones, Dr Elwyn Davies, Arthur Manley, Professor William Rees, Professor Stephen J. Williams, and the Director, Curator and Secretary. It was decided that the legal opinion of Roderic Bowen QC be sought regarding the Curator's authority, with the committee suggesting to him that the Curator should be responsible directly to Court, Council and committees for policy matters, and should accompany the Director and Secretary to the Welsh Office when financial estimates affecting the Folk Museum were being discussed. Draft Terms of Appointment for the Director and Curator to reflect these proposed changes were appended;[39] most of these recommendations were adopted, with the Director retaining overall strategic control, but those duties that related to the Folk Museum deputised for by the Curator. Peate, dryly, called this a perfect example of the difference between devolution and independence.[40]

Peate was given a public platform to reflect on his career when he addressed the members of the Cymmrodorion Society at the 1968 National Eisteddfod, on the twentieth anniversary of the opening of the Folk Museum. He recalled the early influence of T. Gwynn Jones, how his first published attempt (an earlier effort never got beyond the first chapter) to write on Welsh folk culture, *Diwylliant Gwerin Cymru*, was unsatisfactory (irritatingly, he did not specify what he regarded as its defects), and how he became convinced that Wales needed a folk museum

on the Scandinavian model. No doubt the assumption that museums were for dead relics lay behind governmental reluctance to provide funding, for it had taken twenty years before £200,000 could be found for the first part of a modern building to be erected, with the promise of a similar sum in the 1970s to provide further galleries.[41] The Folk Museum was primarily an educational institution with the role of enabling people to understand their past and so understand themselves. Re-erected historical buildings should inspire future architects, and the demonstration of traditional crafts in Scandinavian museums had seen a great resurgence there in crafts such as the glass-making industry. The next major task for the Folk Museum was to expand its provision for schools and teachers, through lectures and courses in all parts of the country. The new buildings planned for the future included a theatre as well as facilities for music, dance and performance of all kinds, appropriate for the nation's Folk Museum.[42]

With retirement now rapidly approaching, Peate demanded that he be presented with a volume of essays in his honour; as Geraint Jenkins later put it, 'Peate had urged me frequently to prepare a Festschrift in the Scandinavian manner as a tribute to him. As editor for the Society [of Folk Life Studies] it was impossible for me to refuse.'[43] The resulting sumptuous volume (*Studies in Folk Life. Essays in honour of Iorwerth C. Peate*, 1969) included essays from twenty contributors and an introduction from Fleure; amongst the contributors were Ó Duilearga, Ó Danachair, Lucas, Evans and Thompson from Ireland; two from Scandinavia, including Erixon; Sanderson and Fenton from Scotland; and several from Wales, including his colleagues Payne and Phillips, and former member of staff Trefor Owen. The Festschrift was presented to Peate at a dinner at the Angel Hotel in Cardiff on 21 March 1969, with the proceedings led by the senior Keeper, Vincent Phillips (Payne had just retired). One contributor could not attend as he was in Swaziland, another (Estyn Evans) as he was in the USA. A wide range of friends, colleagues and admirers were also invited. Raymond Wood-Jones of Manchester University's School of Architecture, whose study of the vernacular architecture of the Banbury region had been favourably reviewed by Peate, apologised for not being able to attend, whilst noting that

> I know that Iorwerth Peate had the most profound influence on Professor Cordingley [the founder of that School of Architecture's programme of studies in vernacular architecture, the only such

institution to be so influenced] in getting our studies under way in Manchester, and [we] are deeply indebted to him.[44]

A. T. Lucas, Director of the National Museum of Ireland, spoke warmly of Peate's work, and the volume was presented to him by the director of the Irish Folk Lore Commission, Seamus Ó Duilearga, who spoke in English and Welsh.

But even with retirement in sight, Peate still had the ability to look a gift horse in the mouth if he had not sought the gift himself, and even if, as in this case, he had himself previously identified such a need. In February 1970 he learnt from committee papers that the Director had proposed that a third education officer in history should be appointed and that the officer should be based at the Folk Museum. He had not been consulted (the Director, Dilwyn John, probably thought he knew what Peate's wishes in this matter were); and furthermore, the fundamental nature of how the Folk Museum could deliver its education provision had not been understood. Much of the work of the education officers at Cathays Park involved preparing and sending out study boxes and notes to schools, for the material they used was portable; but this was not the case for the folk collections:

> The materials of folk life lie at the threshold of every school in Wales and the Folk Museum's primary duty is to teach the teachers how to use the materials in their own locations ... For that purpose the Folk Museum's education officers should organise Saturday courses for teachers and senior pupils in each Welsh county in turn and summer schools for teachers at St. Fagans. They should spend a very considerable part of their time in the schools.

This was a radically different approach from what the National Museum's education staff did, envisaging direct contact with schools and facilitating teachers to use the resources available to them locally (only the most enlightened Directors of Education, such as Deiniol Williams in Breconshire, were advocating this approach). But how could Peate have implemented his ideas if he was refusing the offer of an officer? His practical objection – which may have been part of his argument as to why further new buildings were necessary – was that there simply was no room at St Fagans and that the third tranche of building work had to be

completed before the Museum could house such an officer (ignoring or forgetting the fact that he had declared in June 1967 that there would be room in St Fagans Castle after the curatorial staff moved to their new offices; see above); and 'In the meantime, its character [referring to his vision of what a Folk Museum education service should be and offer] should not be diminished by making it a departmental affair within the existing Museum School Service.'[45] Although a considerable number of education staff were in time to be based at St Fagans, servicing very large numbers of school visits, Peate was not successful in creating an independent service. The National Museum Schools Service of the time was in fact only part funded by the Museum, a consortium of local education authorities bearing half the cost, and this aspiration was not one that could have been realised.

Not surprisingly, Iorwerth Peate had strong views on the succession and who was best placed to carry forward his legacy. He fought hard to influence the appointments panel, and even though he supplied a reference for an interviewed candidate, got so far as to participate in a preliminary meeting of the panel on the day of the interviews and to join the members for lunch, though he was not allowed to attend the interviews themselves as he had wished. Five had applied for the post, and four were interviewed; Peter Smith's application did not make the cut. The interviewed candidates all supplied heavyweight references: Prys Morgan's application (which he had submitted believing that Trefor Owen was not a candidate) was supported by Sir Idris Foster and Professors Glanmor Williams and Alun Davies, Trefor Owen's by Professors E. G. Bowen, Hugh Morris-Jones, and J. Gwynn Williams. Of the two internal candidates, Geraint Jenkins's application was supported by references from Professor Melville Richards, Stuart Sanderson and G. B. Thompson, and Vincent Phillips's by Professor A. O. H. Jarman, Séamus Ó Duilearga and Peate. Phillips was Peate's candidate of choice: 'The quality in him which has impressed me most is his complete integrity', wrote Peate in his reference;

> he has always realized the unity of the Folk Museum and, in consequence, has involved himself more than any other senior member, past and present, of the Museum staff in the process of re-erecting old buildings which he visits regularly during the course of their re-erection. He has also read widely in the field of material culture . . .

Frustration and fulfilment

He is convinced that, for several years, with the small team of collectors allotted to his department, his duty is to collect; publication work must follow later.

Peate's reference to Phillips's involvement in re-erecting buildings was greatly over-egging the cake, and ignored the fact that both Jenkins and Owen had taken part in dismantling and recording some of the Museum's re-erected buildings. He was clearly opposed to Owen's candidacy, for if nothing else, Owen had committed the cardinal sin of leaving his post at the Folk Museum in favour of a lectureship in sociology at Bangor; and he copied on a scrap of paper in his own hand E. G. Bowen's only caveat about Owen's application, namely that he was 'basically interested in considerations affecting the theoretical aspects of sociology and folk culture rather than in the museum service as such', but not Bowen's conclusion that Owen was someone who, if appointed, would be able to carry forward the high traditions and universal regard in which the Folk Museum was held throughout Wales.[46] This, of course, represented a threat to how posterity might view Peate's legacy. Phillips, on the other hand, while an innovator in his collecting and archiving methodology, had published very little, and what little he had on his publications list (including in Peate's Festschrift) was written in language impenetrable to those who were not students of linguistics, and clearly offered no threat to Peate's legacy as a scholar and museologist; but it was Trefor Owen whom the panel chose as the Folk Museum's new Curator, as the weekly *Y Cymro* had predicted a couple of days before the interviews.[47] Two of Peate's appointees then left, to develop their careers, but he was happy to put another spin on the matter: 'Rats leaving the sinking ship', he noted with what we must presume to have been mordant satisfaction.[48]

Peate was given the opportunity for a public valedictory address in a televised retirement interview with David Parry Jones in 1971. 'The Welsh Folk Museum can now show a fairly complete picture of the Welsh tradition and the culture' was how Peate rated progress; but a couple of wishes remained unfulfilled.

> I would like St. Fagans to become, in a real sense, to become a centre for cultural work in Wales, a centre for all kinds, a centre for conferences on matters of national interest, a centre for plays, for music ... I hope when we have a theatre here and various lecture

rooms that the place will also become a centre for teaching. We have not so far taken part in the Museum Schools Service scheme, but I think a folk museum is a particular place in that world... We should be teaching the teachers to develop interest in the material lying at their very doorstep.[49]

Iorwerth Peate's first volume of autobiography, *Rhwng Dau Fyd* ('Between Two Worlds') appeared in 1976. The volume was well received by readers. Friends, acquaintances and people of a similar geographical background wrote to congratulate him. A former coal-miner from Flintshire thanked him for his contribution to the nation and for his stand as a Christian. The National Librarian, David Jenkins, felt it to be a substantial contribution to the history of Wales's national institutions and one that made it clear what a major achievement was the creation of the Welsh Folk Museum and ensuring primacy for the Welsh language within it, whilst hoping that Peate's private papers would one day reach the National Library.[50] Reviews, very largely limited as they were to Welsh-language publications, were also generally favourable. The *Western Mail*, true to its historic views, was more restrained: 'It is obvious that Dr Peate does not regret his actions that have sent the rest of Wales into paroxysms of joy or fury.'[51] A couple of reviewers marked it down somewhat as a work of literature, however. Alun Page drew attention to the fact that Dr Peate had quoted Edwin Muir's distinction between fable and story, and felt that the volume fell firmly into the 'story' category.[52] Hywel Teifi Edwards said much the same thing, and that it just did not have the creative spark that made the autobiographies of W. J. Gruffydd (*Hen Atgofion*, 1936) and D. J. Williams (*Hen Dŷ Ffarm*, 1953) great works of literature as well.[53]

Notes
1. 'Diogelu ein treftadaeth' ['Preserving our heritage'], *Barn* (Rhagfyr 1964), 58; my translation.
2. SFNMH/Box files/Building specifications/WFM Committee, 3 June 1949.
3. WFM Committee, 7 March 1952.
4. WFM Committee, 1 May 1953, 3 July 1953 and 2 July 1954.
5. *Rhwng Dau Fyd*, pp. 175–6.
6. Marged Haycock, 'The scholarship and creativity of Ffransis G. Payne', *Radnorshire Soc. Trans.* 2004 (2005), 32. Professor Haycock had interviewed Payne in 1987. Various aspects of rural life were in fact highly specialised and compartmentalised, and it is no great surprise that Peate knew little about farming.

7. Trefor M. Owen, *Ffransis G. Payne* (Cardiff, 1997).
8. Owen was to become Peate's successor (below). For his career, see Eurwyn Wiliam, 'Trefor Meredith Owen MA, FSA, 1926–2015', *Folk Life*, 54 (2016), 77–9. A longer study is in press.
9. J. Geraint Jenkins, *Morwr Tir Sych. Hunangofiant* (Llanrwst, 2007), p. 83.
10. J. Geraint Jenkins, 'Rural Industries in Brecknock', *Brycheiniog*, 14 (1970), 1–39. Geraint Jenkins was appointed the Museum's Keeper of Material Culture on Payne's retirement in 1969, then Curator of the Welsh Industrial and Maritime Museum and finally Curator of the Folk Museum in 1987: Jenkins, *Morwr Tir Sych*.
11. V. H. Phillips, 'Tape Recording and Welsh Folk Life. Discussion Paper: Draft' (Cardiff, 1983), pp. 35–6.
12. 'The Welsh Folk-life Survey', *Gwerin*, i (1956), 48.
13. WFM Committee, 4 March 1955.
14. Phillips, 'Tape Recording and Welsh Folk Life', pp. 35–6.
15. *Personau*, p. 44: 'it was he who delivered the radio talk that made the work possible'; my translation.
16. WFM Committee, 7 November 1958.
17. *Rhwng Dau Fyd*, p. 152.
18. 'Geirfau. 1. Termau'r Ffatrïoedd Gwlân. 2. Geirfa'r Saer' ['Vocabulary. 1. Woollen-mill Terms. 2. The Carpenter's Terminology'], *Bull. Board of Celtic Studies*, xvi (1956), 93–5.
19. [Trefor M. Owen], 'Aspects of Folk Life in the Llŷn Peninsula, 1967' (1971), report in Museum archive.
20. *Handbook* (1949), p. 13.
21. *Handbook* (1949), p. 28.
22. *Amgueddfeydd Gwerin / Folk Museums* (Cardiff, 1948), pp. 47–51.
23. Owen, *Ffransis G. Payne*, p. 15.
24. AWC/Box file/Exhibitions/Pottery Exhibition 1954–6.
25. Iorwerth C. Peate, 'The Exhibition Block at St. Fagans', *Museums Journal* (1957), 192–4.
26. *Western Mail*, 14 April 1961.
27. *Annual Report* (1961/2), p. 13.
28. SFNMH/Building Comm. Minutes, 9 April 1965.
29. E. Davey, 'A National Architect? The Percy Thomas Partnership and Welsh national identity' (unpublished PhD thesis, Cardiff University, 2013), p. 229.
30. Monica Cherry, *Building Wales / Adeiladu Cymru* (Cardiff, 2005), pp. 40–1; John B. Hilling, *The Architecture of Wales From the First to the Twenty-first Century* (Cardiff, 2018), pp. 247–8.
31. J. B. Hilling in email note, 22 July 2015.
32. *Western Mail*, 14 April 1961.
33. Iorwerth C. Peate, 'The Welsh Folk Museum', *Stewart Williams' Glamorgan Historian*, 7 (Cowbridge, 1971), p. 172.
34. *Rhwng Dau Fyd*, p. 153. It took until 2018 for this dream to be realised.
35. *Rhwng Dau Fyd*, p. 153; but the Press was revived at Gregynog itself.

36. A more detailed exposition was provided in the dedicated guidebook by Elfyn Scourfield, *The Agricultural Gallery at the Welsh Folk Museum* (Cardiff, 1976); also E. Scourfield, 'The Agriculture Gallery at the Welsh Folk Museum, St. Fagans, Cardiff', *Museums Association Annual Conference Bristol 1976* (London, 1976), pp. 34–5.
37. Me, responsible to the Curator rather than a Keeper, in anticipation that a full department would be created in time. One was, but like the existing departments was reorganised out of existence later.
38. SFNMH/ICP confidential memorandum, 'The Welsh Folk Museum. Possible Developments', June 1967.
39. NLW ICP papers A 3/5 (i), 'Constitution of the National Museum of Wales'.
40. *Rhwng Dau Fyd*, p. 146.
41. Iorwerth C. Peate, 'Yr Amgueddfa Werin a Bywyd Cymru' ['The Welsh Folk Museum and Life in Wales'], *Trans. Hon. Soc. Cymmrodorion, 1968* (1969), pp. 28–30.
42. Peate, 'Yr Amgueddfa Werin a Bywyd Cymru', pp. 33–4.
43. Jenkins, *Morwr Tir Sych*, p. 96. Jenkins also felt it easier to edit the proposed volume than to contribute a paper himself: pers. comm. My translation.
44. NLW ICP papers A1/28, *Studies in Folk Life*.
45. NLW ICP papers A/3/5, ICP note to the Chairman and members of the WFM Advisory Committee, 11 February 1970.
46. NLW ICP papers A 3/2 (i).
47. *Y Cymro*, 29 July 1970.
48. Eryl B. Roberts, pers. comm.
49. 'Iorwerth Peate interview in St. Fagans, 1971', https://youtube.com/watch?r=8CcYcOBOgl (accessed 13 March 2021).
50. NLW ICP papers A 2/6, *Rhwng Dau Fyd*. As we have seen, they did.
51. *Western Mail*, 16 December 1976.
52. *Western Mail*, 27 December 1976.
53. A statement with which I agree.

12

Retrospects

Contemporaries and contexts

Time, his old enemy ('Amser, yr hen elyn'), called for Iorwerth Peate after a brief illness at home in St Nicholas in the Vale of Glamorgan on 19 October 1982. How should we judge his legacy?

Iorwerth Peate was not alone in the British Isles in feeling as he did about his own culture and the importance of preserving it, and it is appropriate that we should now look briefly at some of his contemporaries and the institutions they created, headed or worked for. The head of the Irish Folklore Commission, Séamus Ó Duilearga (1899–1980), was a friend. They first met during what Peate came to regard as the entirely critical visit of Ó Duilearga, Campbell and von Sydow to Cardiff in 1934. The newly founded Irish state of the 1920s had shown an interest in Gaelicisation with attention focused on the oral traditions enshrined in the Irish language. Ó Duilearga (who had learnt Welsh) had been one of the scholar-collectors who visited the Irish-speaking areas (the Gaeltacht) to collect repertoires from tradition-bearers, and went on a six-month visit to acquaint himself with the long-established folklore archives and academic institutions of Scandinavia, the Baltic republics and Germany. In 1930 he was appointed Honorary Director of the Irish Folklore Institute and then of the government-established Irish Folklore Commission until it became the Department of Irish Folklore within University College Dublin in 1971. He invited the Swede Åke Campbell to carry out an ethnological survey in 1934 and the following year to record rural houses in parts of the country,[1] appointed Calum Maclean to work full-time in the Western Isles of Scotland, and threatened to do the same for Wales

if nothing similar was done.[2] In the 1960s, he accompanied Peate to see the dismantling of Cilewent farmhouse, lifting the last few stones on to the lorry so as to have had a hand in the work.[3] The collections of the Department of Irish Folklore were rebranded as the National Folklore Collection in 2005 and inscribed into the UNESCO Memory of the World Register.

The Republic of Ireland (Éire) has never had a state-funded open-air museum and there is only one other example of note, the Bunratty Folk Park, though there are several good archaeological parks with recreated structures. The leading figure in the material aspects of folk studies in Ireland was based in Northern Ireland. This was Emyr Estyn Evans (1905–89), another of Fleure's students, who was appointed a lecturer in geography at Queen's University, Belfast where he remained until his retirement in 1968. Like Peate, his first publications were on geography and archaeology,[4] but his *Irish Heritage. The Landscape, the People and their Work* (1942) paralleled closely what Peate and Bowen had done in Wales, similarly subscribing to the view that cultural landscapes were the result of interaction between people and the land. His other publications in this field included *Irish Folk Ways* (1951) and *The Personality of Ireland: Habitat, Heritage and History* (1973). His only general statement on Wales was in his BBC Wales Annual Lecture of 1973, *The Personality of Wales*, where he looked at the country as a non-Welsh-speaking geographer deeply influenced by the politics of Northern Ireland, concluding that those with a culture that differed from that of their neighbours survived as a discrete people, even if their language did not. His early works have been criticised by later scholars for his underlying assumption that the culture of the west of Ireland revealed survivals from early times.[5] In 1965 he established the multidisciplinary Institute of Irish Studies and was made its Director in 1970. Evans was also the founder of the government-supported Ulster Folk (later Folk and Transport) Museum which began to materialise at Cultra near Belfast in 1958. His former students George Thompson and Alan Gailey, distinguished students of folk life themselves, became successively its Directors. In his essay in *Studies in Folk Life*, Thompson noted that while what Peate had done at St Fagans was inspirational, inspiration was easily acquired and translating that into reality more difficult; so to him the Welsh influence on the Ulster Folk Museum was rather the thoughts of Fleure transmitted via the doings of Evans – possibly not the most tactful of statements in a Festschrift to honour Peate![6]

In the Isle of Man, William Cubbon (1865–1955), Director of the Manx Museum 1932–40, was at the heart of the island's cultural revival.[7] In 1933 a Norwegian philologist, Professor Carl Marstrander, recorded half a dozen Manx speakers, amongst them one Harry Kelly (below). Cubbon was succeeded by his assistant Basil Megaw (1913–2002), a Belfast-born archaeologist whose study visit to Scandinavia in 1936 at Marstrander's invitation helped shape his view of the directions the Manx Museum should be taking, including the setting up of the Manx Open Air Museum at Cregneash and the Manx Folk-life Survey. The Welsh Folk Museum is often termed the first open-air folk museum in the British Isles, but it was not: it was the first to re-erect buildings. Creagneash was the first, in 1938, although public interest in folk-life studies had gathered pace in the Isle of Man after Iorwerth Peate, in a lecture at Douglas, had emphasised the importance of preserving everything related to the island's heritage, and a reconstructed farmhouse kitchen was created at the Manx National Museum.[8] At Creagneash, a well-preserved village in the south of the island, Harry Kelly's cottage became vacant and was restored 'as a typical Cregneash home of past days', becoming the first exhibit in the *in situ* open-air museum.[9] Basil Megaw moved to Edinburgh in 1957 to become the first Director of a School of Scottish Studies established within the University. The School had an ambitious programme of folklore collection and became recognised as an internationally acclaimed research institution. The doyenne of collecting the material remains of Scotland's rural past, however, was Dr Isabel Grant (1887–1983). She became an authority on the social and economic history of Scotland, with her tour de force being the magisterial *Highland Folk Ways* (1961). Her most enduring legacy, however, was the Highland Folk Museum which she started by buying a disused chapel on Iona, and which she nicknamed *Am Fasgadh* ('the shelter'), for which she collected assiduously. After relocating to the mainland she settled at Kingussie, opening to the public in 1944. The three-acre site enabled her to create replica buildings and also use live demonstrations to interpret the exhibits. The Highland Folk Museum is thus able to claim to be the first open-air folk museum in mainland Britain, but the buildings on what is now an eighty-acre site are all replicas.[10] The most distinguished later student of Scottish folk life, and particularly its material aspects, was Alexander (Sandy) Fenton (1929–2012). A Cambridge archaeologist and son of a crofter-shoemaker, he became Director and then Research Director of

the National Museum of Scotland. His recording and collecting activities formed the basis of the Scottish Life Archive and also the basis of the National Museum of Rural Life at Kittochside. He was then appointed Director of the School of Scottish Studies where he set up the European Ethnological research centre, with one of its main products being the fifteen-volume *Compendium of Scottish Ethnology*. His own works included numerous significant contributions, such as *Scottish Country Life* (1976) and *The Food of the Scots* (2007).[11]

Institutionally, folk studies did not progress in England to the same extent as they did elsewhere in the British Isles. Perceptions of national culture did not recognise the same threats of loss as in the Celtic countries, and while bodies such as the Folklore Society and others interested in traditional music and dance existed, it was the Society for Folk Life Studies established in 1961 that almost alone carried the torch for folklife studies. Equally, it was only at Leeds that a university took formal interest. There, Sanderson's arrival from Edinburgh prompted the development of the first university teaching programme in Folk Life Studies in Britain, and in 1964 the Institute of Dialect and Folklife Studies was created there, with Sanderson as Director; it was wound up in 1983 on his retirement.[12]

George Ewart Evans (1909–88) was an independent scholar who made a very significant contribution to studying the folk culture of England. He was another friend of Peate (and one who remained such even though Peate was in the habit of correcting his written Welsh, by return!) Having moved to the remote Suffolk village of Blaxhall in 1947, he recognised that the older villagers had much to say about past life, and in 1956 published a book based on their oral recollections, *Ask the Fellows Who Cut the Hay*, which faithfully respected the local dialect. He followed this over the next three decades with ten similar volumes which recorded village life, rural culture and dialect, trades and poverty and remain unequalled for the light they throw on the traditional life of a particular area. A subsequent work of rural sociology about Suffolk, Ronald Blythe's *Akenfield* (1969), heavily edited the contributions of individuals and conflated their villages into one fictitious one, and translated local speech into standard English, much to Evans's displeasure, as he noted in a letter to Peate.[13] Somewhat later, younger museum-based scholars such as Peter Brears have also made an important contribution to recording aspects of local culture.

It was not until the 1960s that moves for regional open-air museums in England started, although indoor folk collections had started much earlier.[14] A gallery of folk-life material was opened at Strangers' Hall Museum, Norwich in 1924, for example, and another at Shibden Hall in Halifax in 1934. The York Castle Museum of 1938, with its recreated shop-settings and streetscape, was based on a private collection begun in the 1930s, as was the Ryedale Folk Museum established at Hutton-le-Hole, Yorkshire in 1964. However, by the 1960s more relaxed planning regimes and a desire to modernise threatened many traditional buildings, coinciding with a growth of interest in their study, helped by the formation of the Vernacular Architecture Group, whose members looked to Fox as their patron saint. Two museums of buildings were developed to try to save some of these threatened rural buildings. The Avoncroft Museum of Buildings at Bromsgrove in Worcestershire opened in 1967, and the Weald and Downland Open Air Museum at Singleton near Chichester was founded the same year, but only opened in 1970. Both concentrate on buildings from their area. Both today have a very serious educational purpose and would, like St Fagans, much prefer historic buildings to be preserved *in situ*. Several other smaller open-air museums have been developed in England since, often combining re-erecting original buildings with reconstructing prehistoric and other structures; Butser Ancient Farm, now at its third location, is particularly notable for its reconstructions and experimental archaeology work and has spawned imitators. Acton Scott Working Farm Museum near Church Stretton in Shropshire, established in 1975, interprets the farming of a later age, as do others, such as Cogges Manor Farm in Witney, Oxfordshire.

In Germany, open-air museums of industry began to develop in parallel with a renewed post-war growth in folk museums, like the open-air museum of technological history begun at Hagen, but like another example of the same date at Sibiu, Romania, the technical processes demonstrated are craft-based rather than being those of modern industry; and fundamentally they are about process rather than people and society. That was not the case at three British museums developed at the same time, namely Beamish, Ironbridge and the Black Country Museum, all reacting to the post-war desire to start afresh and demolish the old, particularly in those post-industrial areas most affected by lack of investment. The driving force behind Beamish, Frank Atkinson (1924–2014), influenced by a trip to Scandinavia, began to work towards creating an equivalent

for the north-east of England, but significantly encompassing the area's change from an agricultural region to one of the industrial powerhouses of the world. In 1966 he began a process that resulted in the creation of the North of England Open Air Museum at Beamish near Stanley, Co. Durham, with himself as Director. He initiated a policy of unselective collecting, thus establishing strong community links, and the initiative was funded by a consortium of four local authorities with the site, which exhibited re-erected buildings including townscapes and farmsteads, transport links and a coal-mine, winning both Museum of the Year and European Museum of the Year awards in the 1980s. The museologist Kenneth Hudson included Beamish as one of thirty-seven pioneers in museum development from thirteen countries which had broken new ground in such an original or striking way that others felt compelled to follow their example.[15] At Ironbridge, the location is paramount. The creation of the new town of Telford led to the development of a trust to care for the outstanding industrial monuments in the Ironbridge Gorge, in many ways the cradle of the British Industrial Revolution. The historic iron bridge was restored, the Coalport china works and the Jackfield tile works reopened as museums, and a large open-air museum created at Blists Hill, including a working ironworks, and interpreted as a living museum depicting life in the 1890s; and like Beamish it achieved the 'double' in winning the UK Museum of the Year and the European Museum of the Year awards in successive years. Another site, the Black Country Living Museum at Dudley, now with some forty dwellings, shops and workplaces set in twenty-six acres, describes itself as 'an immersive experience'. Most of these 'heritage' sites are based at former industrial sites and amongst communities with a recent memory of such activity, and the experience of local visitors, at least, is readily recollective without much need on the part of staff to provide fundamental interpretation; and equally they could seem to be more about reinforcing group memory rather than education and learning anew. Several of them present the past as having happened in 1900. The museologist Gaynor Kavanagh has noted that such was Peate's influence around the time of opening St Fagans amongst the museum professionals interested in telling the story of ordinary people that he could have had a profound effect on not only folk museums, but the later industrial museums, too, had he chosen to extend the field of study to which he gave his blessing to include the urban and industrial experience. She felt that the industrial museums would

have concentrated less on adopting an object-led approach and more on being people-led had he chosen to follow that route;[16] but the public presentation of St Fagans in Peate's time was never noticeably people-led.

It has been generally assumed in Wales that St Fagans scores highly amongst the great folk museums of Europe because of its pioneering status in Britain. But St Fagans was and is dwarfed in size by its European counterparts, for very many of the Scandinavian and north European open-air museums have hundreds of re-erected buildings, something that was always recognised as never possible in Wales, with its preponderance of stone buildings. This reality is reflected in the definitive history of the open-air museum movement, Sten Rentzhog's *Open Air Museums* (2007), a 530-page volume examining in detail the history and social impact of these sites; but it still comes as something of a surprise and disappointment to Welsh readers to note that Peate is mentioned only twice in the entire book, and St Fagans only five times (mostly for its development after Peate's time), the total text devoted to it being under two pages.[17] Nevertheless, apart from being Wales's most visited tourist attraction (683,000 visits in 2019–20), it is also the second most visited open-air museum in Europe.[18]

We have seen above that St Fagans had little direct influence on the creation and development of open-air museums in the other countries of the British Isles, given that they could look directly to Scandinavia or (in the case of industrial museums) to Germany for inspiration. Within Wales, both Fox and Peate believed that regional open-air museums were likely to be created if the founding model, St Fagans, was successful, but it was not until the 1980s that a few such developments occurred, fuelled by the growth of the wider preservation movement and interest in industrial history (below). The Greenfield Valley Museum was established to interpret life in an industrial location near Holywell, Flintshire whilst also looking back at its agricultural past, but ambitious plans to tell the whole story of the Rhondda Valleys sadly never moved beyond turning a former coal-mine into the Rhondda Heritage Park at Trehafod.[19] The restoration of a typical Anglesey cottage at Swtan, Church Bay, and its conversion into a local folk museum did not begin until 1998, but it is very likely that it was the existence of St Fagans which fuelled the impetus behind the project; the same is probably true of Penrhos cottage, Maenclochog, cared for by Pembrokeshire Museums Service. In truth, Wales was and is too small to require or sustain more than one large folk museum. Although somewhat

delayed in time, it is however clear that St Fagans had a very direct influence on the conservation and restoration of individual buildings in rural Wales.[20] The Welsh School of Architecture has for many years used the site for teaching its students, and it is again clear that it has had an influence (albeit unquantifiable) on the work of practising architects.[21]

Wales in miniature?

If the Welsh Folk Museum was the biography of Wales written in its material culture and through oral testimony, how successful was its author? How did the product that Peate left in 1971 compare with the National Museum's original aspirations for an open-air section and with his own for a folk museum that would tell the Welsh people about both the trades and crafts, the ways of living and working, the domestic and industrial environment, the clothes and customs of our forebears of all social grades? Huw D. Jones has seen it in rather stark terms: 'This holistic approach to the material culture of Wales was never implemented. Instead the museum instituted a narrower definition of folk culture which strongly emphasised the culture of rural, Welsh-speaking Wales – the culture of the gwerin – as the "authentic" expression of Welshness.'[22] This is overstating the case and conflates the site-based policies of the Folk Museum with the corporate policies of the National Museum as a whole, which since the creation of the Folk Museum has devoted considerable resources to interpreting in appropriate locations the country's industrial experience.[23] Pyrs Gruffydd too has felt that the Folk Museum gradually lost contact with its founding vision of reuniting folk with their heritage but also of contributing to building a new, modern nation on its foundations.[24] But there never was a formal brief for the Folk Museum other than that which Fox and Peate had envisaged for it, and of course its existence was not foreseen in the National Museum's founding Charter, apart from the 'complete illustration of... the... ethnography... and special industries of Wales and the collection, preservation and maintenance of objects and things of usefulness or interest connected therewith'. Various statements by the Museum Council over the years refined that, but the Council was led by its salaried officers, and not many members were particularly interested. Declared policy was always liable in practice to be overturned for pragmatic reasons, the most obvious and much discussed example being how receipt of the two tranches of major Impressionist works from the

Davies Bequest in 1951 and 1963 skewed dramatically the original policy of representing primarily the art of Wales;[25] in institutional terms, that decision led directly to the National Library feeling it had to take over the role of acting as the nation's national portrait gallery and home of works documenting the Welsh landscape. Likewise, the single largest building on the Folk Museum site was St Fagans Castle, and for early visitors (until buildings began to be re-erected on the eighty acres, and the new entrance opened in 1955) it was the interpretation of upper-class culture which predominated; and it is difficult to see how much more could have been done.

But just as he left out his personal life in his written biographies, and whether following National Museum policy or not, Peate equally deliberately left out huge parts of the story of Wales from St Fagans. His vision, and that followed by his successors, came under considerable criticism for presenting an entirely outmoded picture of Wales to the world from a new generation of historians and museologists interested in the industrial and proletarian traditions which developed amongst the majority of the population. Hywel Francis in 1981 was scathing:

> It's all about Welsh dance, music, costume, barns, coracles, carts and idyllic sterilised whitewashed cottages. But no word, as far as I can see, about land-ownership and social control except revealingly (?) in the first sentence of the guidebook where the Earl of Plymouth's 'generosity' is acknowledged in giving and selling land and property to the museum![26]

A decade later Dai Smith still saw a vision of 'wholeness, and harmony, and community, and distinctiveness, and togetherness, and uniqueness',[27] and no suggestion that Wales, as he later put it, was a singular noun but a plural experience.[28] However, Francis and Jones were not the first to note such issues. The critic and cultural historian Raymond Williams had done so in his 1978 novel, *The Volunteers*, set in a near future: 'What this place offered', he wrote,

> was a version of the life of a people: a version, characteristically, that attracted official visits ... The Welsh Folk Museum is a translation, culturally and physically, of a Scandinavian form ... It is an active material history of the people of Wales: up to a certain

point ... [for it] is an active history only of *rural* Wales: of farms and cottages, and of the early industries of tanning and weaving. All the later history, of the majority of Welsh people, is simply not seen ... The idea that the museum embodies is of an old Wales, still in part surviving, but with all the modern realities left outside in the car park ... That is why it is called a *folk* museum. Folk is the past: an alternative to People.[29]

Such sentiments did not really start to emerge until heavy industry in Wales was under threat, a situation still inconceivable when St Fagans was opened, when new coal-mines were still being sunk and steel plants modernised. Despite such comments from academics with a particular viewpoint, the Folk Museum's deliberate location in the area of greatest population density meant from the earliest days that the great majority of visitors were from the urban and industrialised areas, for many of those whose lives Peate commemorated lived too far away and could not afford the time or cost of travel. Visitor numbers had risen from 98,000 in 1961–2 to nearly 190,000 a decade later, despite the site being the only one of the National Museum group that charged for entry, and it seems clear that the presentation of a predominantly rural Welsh past was no impediment to their attendance. That may even have been an attraction in itself, for a considerable proportion of those living within an hour's travel of the site would have been separated from the land by only two or three generations; and perhaps ironically, a high proportion of Peate's warding staff – the ones the public met on site – were ex-miners. The opening of the Rhyd-y-car workers' houses from Merthyr Tydfil in 1987[30] was one of the main reasons for a dramatic increase in visitor numbers thereafter, despite a steep rise in admission fees, so we may legitimately think that even more visitors from the local catchment would have come had more been made earlier of their own background.

We can only interpret Iorwerth Peate's refusal to acknowledge the reality of the greatest shift in Welsh history since the Edwardian conquest – the Industrial Revolution – as a major and fundamental weakness in a man who prided himself on the rationality of his thinking. He seems to have blocked out the final chapter of his boyhood hero O. M. Edwards's *Wales*, of which there was a copy at home: this stressed the changes that followed the economic shift caused by the Industrial Revolution, when agriculture became less important in Wales than mining and

manufacturing.[31] One of the two men who had encouraged him in his study of Welsh houses, the doyen of Welsh history, Sir John Edward Lloyd, celebrated not only the religious revivals of the nineteenth century but also the transformation of the nation by industry, writing in 1930 that interaction between the industrialised regions and the purely rural parts of the country enriched the life of the nation and infused new vigour into its politics, its literature and its religion.[32] Peate readily acknowledged the negative effects (as he saw it) of that process, such as urbanisation and particularly anglicisation, and railed against them, but increasingly refused to accept that the life and beliefs of people so affected should or indeed could be part of the study of folk life. Daryl Perrins, not unsympathetically, has seen it as 'indicative of a fortress nationalism that has deep roots in Wales, a nation that has been perpetually under threat from extinction by invaders'.[33] Many of the topics which should have interested Peate were addressed by the historian A. H. Dodd in his seminal *The Industrial Revolution in North Wales*,[34] a work of considerably higher academic quality and breadth than anything Peate ever wrote. In this early work (1933, giving Peate many years to assimilate its lessons, had he so wished), Dodd addressed the transformation of an entirely rural and largely self-supporting population through quasi-industrial processes, such as quarrying, woollen manufacture and tanning, into a society inextricably part and parcel of a wider world. He discussed topics such as wages and prices, life and labour, pauperism and emigration, and revolt – all parts of the rural experience of Wales since at least the eighteenth century, and all fundamental aspects that Peate chose to ignore. Peate pursued some topics addressed by Dodd, such as early forms of transport, shipping and milling, but ceased to be interested when such processes passed a point when they could be categorised as industries rather than crafts. His voice would have been more credible if he had acknowledged in his academic and museological writings that his subject was part – and an increasingly small part – of the wider experience of the people of Wales; and his warnings and appeals might have been listened to more sympathetically.[35] He seemed not to appreciate that providing a proper context to what had happened in the countryside could have strengthened his case for the relevance and importance of what remained, instead of painting himself into a corner with the inevitable consequence of an eventual negative reaction from socialist historians. It may well be that he took this approach simply because he had no first-hand experience

of industrial urbanised culture (even though Nansi had worked until their marriage as a teacher in Rhymney in the eastern Valleys). His friend George Ewart Evans, who was born into such a milieu, was able to look out as well as in, and saw that industry overlay a then still remaining older culture:

> On the hills the Middle Ages were still alive ... In the valleys the newness, the vigour ... of the Industrial Revolution ... and in the hills and the moorlands barely half-hour's climb away the ancient pastoral culture that had hardly changed for centuries.[36]

As we have seen, it had never been envisaged that the Folk Museum site could be an appropriate environment for interpreting aspects of Wales's industrial past, even though small-scale objects representing life in Wales's industrial and urban communities were collected from early on, and aspects of intangible heritage such as mining terminology were recorded. Historians like Smith and Francis were writing at a time when the whole basis of social life in the industrial valleys of south Wales was under threat with the collapse of coal-mining and steel production, but were attacking something other than the cause of their society's misfortunes, an easy target in many ways. None of them seem to have understood that the wheel had come full circle, in that Peate too had been responding to an under-representation of his own culture when it was under threat. If Peate's version of history ignored what grew from it and supplanted it, the new 'industrial' history likewise frequently dismissed what had preceded it. Peate's was the more positive reaction in that he did not seek to attack industrial culture actively, even though he believed it to be the root of all the evils assailing his own cultural values. The labour historians felt they had to attack the portrayal of an older culture from which they felt excluded – a situation that Peate had predicted would happen as a consequence of language shift. In time, some Welsh speakers too became disenchanted with what Peate was trying to do and similarly accused him of presenting a 'fossilised' view, such that 'San Ffaganeiddio' ('to St Faganise') became used as a pejorative term.

On different grounds, Gaynor Kavanagh, too, has castigated St Fagans for failing to present a complete picture, and it is far more difficult to gainsay her standpoint:

The traditional Welsh kitchen was also home to traditional Welsh abuse, poverty, hunger and illiteracy. The traditional Welsh mine, blacksmith's shop or woollen mill were places where class division and social inequality were lived everyday . . . The term *traditional* is a euphemism for denial.[37]

A Director of Colonial Williamsburg apparently stated that the Welsh Folk Museum was 'the finest living museum in the world'.[38] That Director was being remarkably generous if he did make such a remark, for Peate had never really aspired for his creation to be a living museum, and certainly not one on the north American model. At Williamsburg, Plimoth Plantation and others, costumed first- or third-person interpreters go about their (acted) daily lives and work in public, a technique now commonly used by the 'industrial' open-air museums of Britain. Although both Fox and Peate had observed with interest the fact that front-of-house staff in Scandinavian museums were usually costumed and engaged in replicating traditional activities, the question of costumed interpreters does not seem to have been discussed for St Fagans. Visitors there were expected to observe and make what they wished of a building and its contents, helped by the quite detailed text available in the guidebook and the possibility of a conversation with a uniformed and peaked-capped warder who would have a varying knowledge and interest in a particular building (and later gallery). It may have been realised immediately that Scandinavian-style provision was simply not affordable. Subsequent discussions have always returned to the realisation that costumed interpretation is entirely feasible at sites interpreting a single period of history, but that at a multi-period site such as St Fagans it is not a viable option. Likewise, although he considered the presentation of traditional crafts vital, he never chose to recreate past agricultural techniques, as is commonly done at museums such as Greenfield Village in Michigan or Acton Scott in England. Despite such lacunae (if such they are), the positive experience of visiting the site has been well expressed by Lisa Lewis:

> the experience [generated] for the visitor is one of strolling through a familiar environment . . . providing a unity of place that supports the authenticity of the experience within each house . . . The combination of buildings and the disparate timeframes involved in their

interpretation ... actively encourages the visitor ... to perform a square mile into being ... At Sain Ffagan we re-live memories.[39]

She also places considerable emphasis on the fact that Peate in several of his writings expressed support for participatory activity at the site on the basis of what he had seen in Scandinavia, but in truth the site's presentation of its collections during his time was essentially a didactic one, and as she herself has noted it was only after his time that events and festivals became a more usual way of engaging visitors and enlivening their experience.[40] It is worth noting too that while Peate's early exhibition texts clearly put the objects displayed into context, labelling was minimal by the time the galleries at St Fagans were opened – possibly because the object-rich displays left little room, possibly because visitors were expected to buy a guidebook, or possibly because Peate the interpreter had of necessity become Peate the administrator.

Curator and collector

Moving on from the public face of St Fagans to museological practice, in current nomenclature Iorwerth Peate would be called a 'curatorial activist'. The term (originating in the United States) does not refer to a curator who collects actively in their sphere of interest as opposed to looking after and making use of what is already in a collection; rather, it became a term for organising art exhibitions with the principal aim of ensuring that certain classes of artists are no longer ghettoised or excluded from the main narrative of art history, and ensuring that the under- or unrepresented are no longer ignored by museums.[41] This can be translated in our context to ensuring that the story of all the people of Wales, of whatever original nationality, class, language, creed, colour, sex or orientation was and is told, and the development of the 'Welsh Bygones' collection represented a major step in identifying the need and taking forward such an agenda in Wales. However, the early Scandinavian collectors had ensured that pride of place in their open-air museums was given to representing the lives of the ordinary people of the countryside, and even in Wales folklore survivals were seen to be largely the preserve of the *gwerin* and collected from them, as we have seen.[42] This banner was picked up by John Ward and Cyril Fox, but Peate was to become the first museum curator in Britain to be paid to devote his entire time to developing such a collection so

that those who generated the items in the collection might be accorded an honoured place in the story told by the National Museum of Wales. In bringing into the museum arena the story of a previously excluded group – the British rural working class – Peate was very much acting as an activist curator.

But contemporary curators should not compare their views too closely with Peate's, or claim to draw too much of their inspiration from him. Activist curators set out to be *inclusive* in their activities, and contemporary collecting is about trying to represent the whole of life. Although Peate's vision of 'folk' claimed to include 'all manner of men', it ignored to a considerable degree the reality of life in Wales in his time. In his manifesto volume of 1948 he had noted that he wanted 'not to create a museum which preserved the dead past under glass but one which uses the past to link up with the present' and 'to show clearly the unity of all life and of all human activity, yesterday, today and tomorrow',[43] but he had specifically noted modern material as not worth collecting in his argument of 1946 with Fox about the temporal parameters that the Folk Museum should serve, and he did not really change his views. He did collect contemporary material, particularly in the 1930s, as Elen Phillips has noted,[44] but selectively and when the objects in question were craft items created by people working within or as a revival of the old tradition; they were to demonstrate continuity, not innovation, and were in no way representative of what was more widely produced or used, since these latter items were not under threat of being no longer produced or used. Similarly, his innovative championing of collecting oral testimony was never directed at recording contemporary activity – stress was laid entirely on traditional craft and lore, dialects and folk song. He was only interested in the contemporary as an expression of the past and as illustrating the perseverance of past virtues, where they still existed; we cannot really ascribe to him a leading role in developing contemporary collecting. In fairness to Peate, however, the concept of collecting the contemporary would have occurred to very few – if anyone – until after his day. It was not until Sweden's Samdok programme of the late 1970s that collecting objects representing a rapidly changing world was seen to be important.[45] Iorwerth Peate's definition of folk was exclusive, and his aim was to recreate the idealised Wales of his boyhood. Peate was of his time – or rather of his Edwardian youth – and while he was forward-thinking in seeing the merits and potential of his vision, its implementation depended on ignoring the present and going forward to the past.

Neither was he the only one of the National Museum's staff over the century or more of its existence who could be called a 'curatorial activist'. Another who deserves that epithet is David Morgan Rees (1913–78), the first Keeper of the Museum's Department of Industry in 1958. The growth of interest in industrial archaeology led to the creation of the new full department and Rees became the leading exponent of the subject in Wales. His department moved into the new West Wing of the National Museum in 1966, and in 1972 a branch museum, the North Wales Quarrying Museum (now the National Slate Museum), was opened in Llanberis. Unlike Peate, who almost denied the Industrial Revolution, Rees saw the industrialisation of Wales as a 400-year-old process; but like Peate, he saw his subject as concerned with human endeavour and achievement and ultimately based on geology and geography. Rees and his staff visited works and factories to keep abreast of modern developments, and whilst unable to collect the contemporary (because of the sheer size of the objects and machinery involved), he believed in recording new processes. The fruits of his extensive documentary research and fieldwork resulted in publications such as *Mines, Mills and Furnaces: An Introduction to Industrial Archaeology in Wales* (1969) and *The Industrial Archaeology of Wales* (1975), and in the new Industrial and Maritime Museum in Cardiff Docks to which the department decamped with its collections.[46] Morgan Rees thus deserves the appellation of 'activist curator' within Wales almost as much as does Iorwerth Peate, but whilst both built on the work of predecessors and Rees opened up a new field in Wales, Peate was the first in the British Isles to elevate his own area of interest to a nationwide academic discipline.

Whilst Iorwerth Peate would still recognise his creation, the physical appearance of the St Fagans site has been radically altered in the last few years, with new thinking behind that re-presentation. The physical elements of the redevelopment were completed in 2018 at a cost of some £30 million, winning the Art Fund Museum of the Year award for 2019. The site has now been now rebranded as the National Museum of History, where the whole history and prehistory of Wales is presented – the exact reverse of the situation that Peate found, in embryonic form, at Cathays Park in 1927. A new entrance has been made into the public complex, opening to a huge covered multipurpose foyer where before there was a rather useless split-level open courtyard. Above it the three original galleries have been replaced by two main spaces, one called the 'Life

is . . .' gallery, most approximating to a traditional display of social history material, and another called 'Wales is . . .', with a series of changeable modules on themes such as language, sport and religion, and a suite of education spaces such as Peate so desperately wished for. Some of what is exhibited and interpreted in the galleries and in activities is in response to the ongoing involvement of the public, with the intent of creating a participatory museum – objects reflecting how the Covid pandemic of 2020 onwards impacted on people's lives were being collected within months of its outbreak, for example. The far end of the site has been opened up by the addition of a new building exhibiting traditional crafts, called 'Gweithdy' ('Workshop'), which would have pleased Peate immensely, although of course it would have been against his nature to express such a view about somebody else's tampering with his creation. Visitors certainly approve of the redevelopment, coming in very considerable numbers to a much more welcoming site.[47]

The then Director General of the National Museum of Wales, David Anderson, in explaining the strategy driving this redevelopment, identified two, radical, principles on which he believed the site to have been founded, namely that 'The life of every person matters'; and secondly, 'People, not institutions, are the carriers of culture'.[48] These principles certainly underpinned the National Museum's early recognition that there was a place for 'bygones' and folk-life material, but require glossing. As a Christian, Iorwerth Peate certainly believed that all people mattered, whatever their class or creed; but in his vision for the Folk Museum it is clear that Welsh speakers from the countryside mattered most of all. And not all Welsh-speaking countrymen were created equal; divine gifts were bestowed unequally, with craftsmen of all kinds more liberally rewarded. His own radical freethinking brand of Christianity, too, meant that whilst he always gave primacy to the individual over the mass, he also believed further that culture was not merely transmitted by people but created by them. Nevertheless, over the years the third part of Peate's tripartite vision for the site – an open-air museum, traditional galleries displaying folk-life material, and a research institute – has withered. The research emphasis of former days has largely disappeared (and Peate's 'folk life' has been enhanced to include contemporary life and rebranded as 'Public History'), due partly to much of the subject fields being largely covered, but also and perhaps inevitably the result of ever-diminishing budgets. However, the National Museum now is intent on redefining itself as a

leader in the development of cultural democracy and the new pedagogy of community-led interpretation and co-production, and we should wish it well in this new endeavour. It would not have occurred to Peate or to any of his contemporaries to find out what the public wanted of and from a museum, and he might well have thought that doing what the public wanted would have been an abrogation of a museum's duty to speak truth to power.[49] Curatorial activism today has gone beyond collecting the contemporary – it is about giving voice to the people and about helping them to think their way to true democracy; this is the Museum playing a core part in social progress and growing a nation.[50] Although the Museum today does not need to (and should not) measure itself against any objectives that Iorwerth Peate might have set, its Vision of 'Inspiring People, Changing Lives', aligned to the national goals set out in the Well-being of Future Generations (Wales) Act 2015 and its overall ambition of acting as a catalyst to enable the nation to develop its cultural and social resources for public benefit would surely have struck a chord with him, for he believed above all that education about the past was crucial to developing the future.[51]

The final reckoning?

Who should be credited with the creation of the Welsh Folk Museum? The answer is not entirely straightforward, and both Fox and Peate could regard the result as *their* creation. Distance can hopefully add clarity, but contemporaries appear to have been clear in their views. When Fox was put forward for an Honorary Doctorate of Literature in the University of Wales, at the ceremony in July 1947 the eminent historian and former member of the National Museum's Council, Professor William Rees noted, inter alia, that

> Wales owes a debt to Sir Cyril Fox for his successful and sympathetic treatment of her past and for his part in making this available to her people ... The conception of a Folk Museum for Wales, about to be raised at St. Fagans under his guidance, is a pioneer effort in museum development in these islands.

A distinguished former member of the Museum's Court, Sir William Goscombe John, RA, put it similarly in a letter to Fox in 1949:

Those of us, who heard your first suggestion that such an addition to the National Museum of Wales was desirable, will remember how it was looked upon as quixotic and impossible to achieve. Well thanks to your faith and enthusiasm, and the great and unexpected generosity of Lord Plymouth, it is a going concern having had its first hundred thousand visitors. May I therefore offer you my most sincere congratulations upon the result, for to you alone is entirely due the credit of the great achievement.[52]

Goscombe John might not have known of Peate's role, but Rees did, very well, and his at least is a historian's balanced judgement. However, tributes, by definition, pay tribute, and often overstate. When Peate retired in 1970, the resolution passed jointly by the National Museum's Council and Court noted that

> as an Assistant Keeper in charge of the 'Collections of Welsh Byegones' [sic], in the early years of his service at the National Museum of Wales, he had the foresight and imagination to see the possibility of creating a National Folk Museum, and that Lord Plymouth's gift of St. Fagans Castle in 1946 had made it possible for his vision to become a reality. With great energy and steadfastness of purpose he had, as its first Curator, directed the developments of the Museum for 24 years. His achievements during this period had been remarkable and the Museum, which had largely been his own creation, had become one of the foremost Folk Museums in Europe.[53]

But if it was Fox who had planned and cajoled at the policy level, and who prompted Lord Plymouth to offer the site, equally it was Peate the propagandist who had built up recognition of the need and anticipation for its fulfilment amongst the inhabitants of rural Wales. His public not unreasonably saw the success of the development as a vindication of Peate's aspirations. By dint of getting his side of the story in print (for Fox, as we have seen, never wrote of these matters) and portraying himself as the white knight battling against every stratagem of Fox's to derail *his* dream, Peate reinforced if not created the perception that he was the one true founder of the Welsh Folk Museum; the instances where he credits Fox with 'supporting' him still manage to give Fox a subservient role.

There is no doubt in my mind that the almost unique tripartite structure of the Folk Museum is due more to Peate than to Fox, who showed no obvious interest in what should happen behind the public presentation or indeed in the field. Additionally, whilst Peate lost the battle for a greater stature for St Fagans as a free-standing national institution the resulting publicity reinforced the view that here was an underdog valiantly defending the rights of the people for equal representation, and in that he may well have won the war and ensured that it was he who gained most of the credit – credit at least equally and conceivably more largely deserved by Fox. Irrespective of whose idea the concept of a national open-air folk museum for Wales was, there can be absolutely no doubt that Iorwerth Peate was the right man to develop the idea and turn it into reality on the ground. He brought with him or quickly developed all the necessary skills and attributes to the project. He created an early vision for the idea that was more ambitious than the National Museum's original concept, took total ownership of it and did not deviate from seeking to deliver it. He fought ceaselessly both inside and outside the National Museum to protect a vision that was little understood and almost never accepted completely by members of the Museum's Council, and never took no for an answer. A total workaholic, he used his external profile as poet and commentator to enhance his own profile with a symbiotic relationship to the Folk Museum project, with the result that his name will forever be linked indissolubly with it. But Peate was also extremely aware that he was the only man in Wales who had this vision, and out of that feeling he created his own mythology.

In his earlier years of service Peate was an extraordinarily faithful member of the National Museum's staff, and in many ways he remained so. Circumstances – Fox's behaviour, his treatment during the war, and his belief that only he could create an institution that would serve Wales as he wished it and if it were essentially separate from the Cathays Park site, changed his views somewhat. From very differing starting points, Peate and Fox came to agree that the Folk Museum should be accorded a measure of independence within the corporate structure of the National Museum. Peate naturally welcomed Fox's proposal with open arms, for he had no direct access to Council and Court and was not included in funding discussions; but in addition to these pragmatic reasons, Peate had a deeper one. Fox and the National Museum believed Peate was charged with creating an entity within the Museum with a particular role and

purpose, namely an open-air museum to interpret and display the life and work of the inhabitants of rural Wales in the past; but in reality Peate was working to an older agenda, that of the founders of the Scandinavian folk museums who saw their institutions as drivers of national regeneration, a mission that the National Museum's hierarchy then had not understood or seen a need for. Peate's Folk Museum was created to preserve and disseminate the language and values of his boyhood to a wider world and create a beacon of hope that would help overcome the evils of industrialisation, urbanisation and anglicisation: 'Wales in miniature' at St Fagans was very much 'Peate's Wales', and he was a leading contributor in creating a picture of a Welsh past that remained for decades. Furthermore, he saw himself as crucial to enabling this national transformation, and he could only create the instrument that he saw as essential to the task – the Folk Museum – if he were Director of what would be essentially a freestanding national institution.[54]

How does he compare as a scholar? He was not as profound a man of letters or as great an academic as either his mentors, T. Gwynn Jones, W. J. Gruffydd and H. J. Fleure and their contemporary Sir Ifor Williams, or his own contemporaries, such as Sir Thomas Parry, Griffith John Williams and Saunders Lewis (for example), for most of their work has stood the test of time. The comparison in quality between *Y Crefftwr yng Nghymru* and Gwynn Jones's contemporaneous *Welsh Folklore and Folk Custom* is little short of astonishing. The same is true of the work of the historians T. Jones Pierce and David Williams, and (slightly later) Glanmor Williams, Gwyn A. Williams and John Davies. Although Peate's *Cymru a'i Phobl* of 1931 and *Y Crefftwr yng Nghymru* of 1933 were praiseworthy early examples of writing on aspects of history in Welsh, he had been pipped to the post by R. T. Jenkins's seminal *Hanes Cymru yn y Ddeunawfed Ganrif* ('The History of Wales in the Eighteenth Century') of 1929 and its less successful successor *Hanes Cymru yn y Bedwaredd Ganrif ar Bymtheg* ('The History of Wales in the Nineteenth Century') of 1933.[55] His inflexible certainty was often based on astonishing naivety. Although handicapped by having to familiarise himself with all sorts of disciplines such as archaeology, anthropology, ethnology, folklore, philology and dialectology, it is clear that Peate as an intellectual simply did not compare to the likes of Eric Hobsbawm, who came up with the concept of the 'invention of tradition' and how that served incipient nationalism, Raymond Williams with his definitions of culture, or E. P. Thompson,

who advanced the revolutionary thesis that the eighteenth century was not a period when traditional culture (however defined) was on the wane, but rather a period when plebeian culture developed new customs as a form of resistance towards the emerging market economy.[56] Peate's ethnological writings were based firmly on those of his Scandinavian predecessors, such as Campbell and particularly Erixon, but with none of their original thinking, and he remained entirely resistant to the newer thinking of the American folklore scholars and sociologically influenced geographers, such as Alwyn Rees and David Jenkins. His surveys of Welsh culture were eclipsed in their detail and coverage by those of Estyn Evans for Ireland. In the field of material culture and specifically the study of traditional crafts, Ffransis Payne's *Yr Aradr Gymreig* was a far more scholarly work than any of Peate's volumes. The earlier works of Geraint Jenkins are of a similar or higher academic standard, though Jenkins was not ploughing a new furrow, and his prolific later works of synthesis and museology bear the marks of hasty writing and slipshod research. Trefor Owen's works are notable for their scholarship but relatively few in number. Peter Smith's *Houses of the Welsh Countryside* and his supporting works have revolutionised our understanding of Welsh vernacular architecture, but he built on foundations laid by Peate and (particularly) Fox. Richard Bebb's work has developed hugely our understanding of traditional Welsh furniture but has not opened up an entirely new field. The only scholar in an allied field who has made an individual mark comparable to Peate in Wales is Peter Lord, whose writings from the 1990s onwards have revolutionised our understanding and appreciation of art and artists; but while Lord's scholarship has exceeded Peate's, his field has been less wide. Lord himself has judged the Folk Museum for being devoid of politics and presenting a static, closed version of history ending in the mid-nineteenth century. However, he also saw that Peate made a major contribution to the arts in Wales through his studies of traditional craft and bringing the work of contemporary craftsmen to the public eye by means of exhibitions at the National Eisteddfod, and that his contribution to the intellectual discussion about the aesthetics of material culture in his time was incomparable.[57]

It is perhaps easier to judge Peate's academic legacy if we try to visualise where scholarship in this and related fields would have been without his influence. The work he carried out at Cathays Park and then continued, to an understandably decreasing output, would not have been

done, and nor would all the work of colleagues and successors such as Ffransis Payne, Trefor Owen and Geraint Jenkins: Owen would probably have been a university-based sociologist, and Jenkins would have carried out his work exclusively outside Wales, and he too might have left the museum field. Traditional culture in Wales would have been recorded and examined largely through the lens of the more sociological studies which followed those of Alwyn Rees, Owen, Geraint Jenkins and David Jenkins. The important work of collecting oral material that was transmitted through the medium of the Welsh language would probably have been restricted to dialectological and sociolinguistic studies in the universities, and studying folk song and folk tales remained largely the preserve of amateurs. The study of vernacular architecture in Wales (and indeed Britain as a whole, to an extent) would have progressed far more slowly, for it is unlikely that *Monmouthshire Houses* would have been written, since *The Welsh House* would not have existed for Raglan to see what might be possible. Without St Fagans as a national reference point, it is equally unlikely that the move to preserve examples of traditional buildings in the Welsh countryside would have progressed to the extent that it has, fairly limited as that may have been.

Albeit under Fox's instruction and supervision, it was Peate who first introduced the study of the material remains of the recent past as a valid professional discipline to Britain. Whilst Fox saw the display and interpretation of 'bygones' as a means of enabling people to understand better their deep past, to Peate the presentation and (crucially) study of these objects validated the continuing lifestyles of his people. In being the first to treat everyday objects as worthy of detailed examination and typological analysis (as archaeological relics had been since the 1870s), he developed an entirely new academic field: 'It will ... be apparent that I look upon folk culture as a complete philosophy of life, as a subject which touches life at all points' was how he put it in 1941.[58] He believed the subject to be of fundamental importance not only to the history of the nation but to its self-identity and future. Fox, like his predecessor Wheeler, had no conception of Welshness and certainly not of how it might be interpreted as a separate emerging component in the wider British picture presented in the National Museum's Archaeology galleries, but Peate was able to start doing this almost subversively. He planned a means of carrying out that study and how it might be presented and transmitted to future generations, and because of this and the breadth of his interests and activities he

unquestionably deserves a place in the pantheon alongside his scholarly contemporaries in Wales and indeed beyond.[59] It is true that T. Gwynn Jones was the first to spot the need for such investigation but he identified Peate as the man to do it, and even though the quality of the resulting output could be uneven (just as his poetry was old-fashioned when he wrote and his other literary writings were equally romantic in their approach), Peate addressed the task with resolution and diligence. In the early years he was literally peerless, for it was he who had introduced the discipline to Britain and no one else worked in the field for many years. Because the subjects he studied were new to him, he was frequently out of his comfort zone – or at least most people would have been. Rather, his natural certainty made him put forward as fact untested propositions which when long disproved to everybody else's satisfaction remained fact for him. Equally, circumstances, in the form of delivering an over-riding objective, consciously or unconsciously tampered down the intellectual rigour of his early years and Peate the scholar turned into Peate the proselytiser, and finally to Peate the administrator.

A strange dissonance is apparent in his work as early as the 1930s. His studies of crafts or activities are detailed and rational, but he chose entirely to ignore the most salient facts of the history of Wales. He tended to formulate theories on insufficient evidence and ignored facts or interpretations which did not conform to his theses. He castigated others who did not subscribe to his definition of 'folk' as encompassing all classes of society but made no reference to the houses of the gentry in *The Welsh House*. His was a practical interest and his conclusions, albeit coloured by romanticism, were empirical, so it is no great surprise that his life's work did not lead to a theory of folk life which we might have expected after such a prodigious output. While he was a pioneer who undertook and published some truly innovative work, his scholarship and grasp of an evolving field then stood still, so that the grand old man became the grand old fossil of the subject he had himself largely created. Whilst this book has concerned itself principally with his curatorial and academic work, we cannot forget that he was also highly active as a poet and man of letters and critic for all this time, and for twenty years had a weekly newspaper column as well, until pressure of work finally forced him to give up.[60] Several of his larger works are prefaced by the remark that they had to be written in what little spare time he had. Inevitably, with such a prolific output, much of what he wrote is repetitious; but after a brief

initial period he saw himself primarily as a propagandist rather than a scholar, and it was therefore his duty to spread the gospel as widely and in as many forums as possible.

Lisa Lewis has suggested that Peate's work in attempting to create a participatory museum 'where Welshness [was] constructed' makes him more of a revolutionary than a reactionary, as he is more commonly perceived.[61] However, it would be more accurate to use the term 'perpetuated' rather than actively 'constructed', and whilst the medium chosen to interpret the message (an open-air folk museum) was reasonably modern, the message itself was in fact an existing one that emphasised and reinforced the primacy and indeed, to a large extent, the myth of the rural *gwerin*. Peate was constructing a national narrative on foundations that had been laid by the nineteenth-century collectors who had seen value in preserving representations of a rapidly vanishing culture, and through his writings and his work at St Fagans he became the prime later exponent of this movement. There was little or no state support for the Welsh language and everything associated with it in the inter-war period, and few who helped Peate carry the torch. His friend E. D. Jones in a review in 1938 noted that:

> In spite of Mr. Peate's vision, I fear that his folk museum, even though it might contain all the visual signs of our culture laid out in the most extensive park in Glamorgan, will merely be a collection of curiosities if the language and literature of Wales cannot be saved. A Folk Museum cannot do that. It can enlighten and strengthen an existing culture, as it certainly does in Scandinavia and Germany. But in those countries the state supports national culture . . . a Folk Museum cannot take the role of the state.[62]

Much has changed. By now the state does support national culture. The Welsh language has legal standing, and Welsh-medium education at all levels continues to grow apace. Much of this is down to one man, but that was not Iorwerth Peate; rather, it was his old adversary Saunders Lewis – however, both were united in their unflinching stand on the importance of preserving the Welsh language, not only for its own sake but as the crucial signifier of national identity.[63] Peate, too, had a dream, and his vision of Wales as a small nation contributing on the international stage was a proper aspiration. To achieve that status he dreamt of a

countryside full, not of happy peasants, but of people employed meaningfully in a mix of agriculture and locally based light industry, using locally sourced raw materials and energy sources if at all possible – placing him very firmly ahead of most thinkers of his time. However, to think that he could stem the tide of the consequences of the Industrial Revolution was magnificently delusional and incapable of a happy resolution. He did indeed dream the impossible dream, and fashioned a tool that he thought would do the job; but in his case, the dream came half a century too late. However, this begs a further question, namely how much did the founding and continued presence of the Folk Museum influence common and government perceptions alike of the importance of Welsh language and rural culture? As Raymond Williams had noted (above), the very existence of the institution meant that it was used by government and its agencies as an exemplar, and at least implicitly its messages were accepted as official aspirations; but it may be that its existence also contributed to a 'reservation' mentality, whereby a box was seen to have been ticked and that which needed to be preserved had been so treated without need for further intervention.

For several decades, along with the University of Wales, the National Library and the BBC, the Folk Museum played the role of a true national institution, and arguably it has always done that. However, it never quite became the national cultural centre that Peate had hoped for, the natural home for cultural and allied societies and movements that he had prophesied for it in 1948. This was partly because of the slowness of developing facilities at the site, and by 1970 he was acknowledging that a theatre was no longer needed, since others had been developed elsewhere. Dispersed and multipurpose cultural centres now carry out many of the functions that he envisaged. Movements or groupings that he might have believed would find a natural home or be developed from meetings at the Folk Museum emerged and found centres elsewhere, such as Merched y Wawr (lit. 'Women of the Dawn'), a Welsh-speaking women's movement which broke away from the Women's Institute in 1967, or Mudiad Ysgolion Meithrin (the Welsh-language playschool movement) founded in 1971. Other groups and societies were already in existence (such as the Welsh Folk-song Society) and, although their officers were often drawn from Folk Museum staff, did not require an office, and the same applied to societies such as Cymdeithas Llafar Gwlad (effectively the Welsh Folklore Society), the Welsh Mills Society and Capel, the Chapels Heritage Society.

An institution for the study of the history, language and literature of Wales, the Centre for Advanced Welsh and Celtic Studies, became part of the University of Wales in 1985.[64] As a purely research institute working in established academic fields, it rapidly surpassed the Folk Museum in what it was able to do and quickly gained international standing for the quality of its research projects, but of course it has never covered those subject areas in which St Fagans has specialised. The 1970s saw a resurgence in self-sufficiency and in rural crafts, but much of the impetus behind both features was driven by incomers such as John Seymour, whose books on self-sufficiency were hugely influential.[65] Incomers also filled the gaps in the countryside left by the continuing exodus from the land by native inhabitants, and deepened the linguistic crisis in the Welsh-speaking heartlands to an extent that would appal Peate, were he still alive now.

Iorwerth Peate was always conscious of the relentless march of time, not just in personal terms but also professionally – establishing a fully functioning folk museum, doing what he wanted it to do, was a desperate race against the forces not only ravaging his Wales but also conspiring to destroy the evidence for its past that was so necessary to help its future.[66] He paid considerable lip-service at various times – particularly in the earliest days – to the fact that things had changed over time (and indeed went so far as to say in print in 1971 that 'Ideas, attitudes, conditions – life itself – change from century to century'[67]), but most often, his past was timeless and eternal, preserving the values and virtues of its upland core. He had trouble acknowledging that the part of it that he recognised, the rural Welsh-speaking past of craftsman, poet and divine, was dying or indeed largely dead, and that the self-taught, cultured country-dwellers of his days as an extramural lecturer were largely no more. However, despite his dismissal of all that transformed south-east Wales (like much of northern England and the lowland belt of Scotland), his great service was to recognise the importance of what just about still survived in the Welsh uplands, an area largely untouched directly by the effects of the Industrial Revolution. In this it was comparable to Ireland, the Scottish Highlands and Islands, and indeed much of Scandinavia, in offering ethnologists a last chance to record the vestiges of peasant cultures and perhaps even revive them.

He did implicitly accept that change happened, to material culture, at least – for how otherwise did one explain the typological changes that he exhibited in his Material Culture Gallery? – but he was extremely

reluctant to accept that *values* could change: they, surely, were eternal. It was just that he never seemed to want to extrapolate from the specific to the general, for if he had done so then his whole edifice of an immutable tradition would have been undermined. The 'Llanbryn-Mair tradition', on which his entire world-view was founded, would have been revealed for what it was, a mid-Victorian creation; but his mind was incapable of contemplating such a thought. The Welsh Folk Museum was his attempt to create a last bastion from which he might send forth new and reinvigorated disciples to rekindle the flames of craftsmanship and culture; and in that sense it is quite true that St Fagans was indeed Llanbryn-Mair-juxta-Ely,[68] idealised and carefully curated to tell the story he wanted told and the foothold from which he would lead his counter-attack on the forces of evil. Like many great and driven men, he had his weak spots. Very many revered idols of the recent past have proved to be mortal – John F. Kennedy and Martin Luther King spring to mind – and Peate too had his feet of clay, but his foibles were far more forgivable. Nevertheless, once his mind was made up – and on many matters it was crystallised very early – he was entirely incapable of changing it. Inflexibility is not a sin, but it is a weakness, and whilst he would not have acknowledged suffering from it for a second, the trait permeated his life's work. His character – usually self-confident and unprepared to compromise – was reflected in his work. He clearly felt the hand of history upon his shoulder, and this certainty gave him the confidence to follow the vision that he had been granted and the certainty that he was right to follow his preordained journey, for he had been condemned to play his part in transmitting *etifeddiaeth yr hil*, the birthright and burden of his people.

In reviewing Peate's autobiography of 1976, his old friend Sir Thomas Parry felt that only two great visions had emerged from Wales in the twentieth century, the first being Sir Ifan ab Owen Edwards's (in creating Urdd Gobaith Cymru – the Welsh League of Youth) and then Dr Peate's (in creating the Welsh Folk Museum).[69] Trefor Owen concluded that Peate was an indifferent scholar, but that his great contribution was the creation and development of the Welsh Folk Museum.[70] Peate was indeed an indifferent scholar, but of all his circle of Welsh-speaking literary acquaintants he was one of the few to project his country beyond its borders. Iorwerth Peate retired with his legacy largely secure, but it was under Owen that the Folk Museum reached its peak in terms of staff numbers and academic achievement, truly achieving international research excellence in its areas

of study, albeit on foundations laid by Peate. From a later and somewhat wider perspective I have to come to a different conclusion: rather than for his contribution to the development of St Fagans, Iorwerth Peate is most worthy of a place in history because he was the first curator in Britain to develop from a collection of material gathered largely for its ethnographic and comparative value a whole science, that of folk-life studies, in which for the first time the doings of ordinary people – *y werin* – were accorded a full and rightful representation in museums across the land, and to a lesser extent in academic curricula. Born amongst such people, he saw a new way of using museum collections to tell history without recourse to written accounts and interpretations, for of course the written word had very largely neglected the stratum of society to which folk-life material related. He had been appointed to carry out the National Museum's declared policy of expanding its core activities to include representing the daily life of the people of Wales, something that no other national museum in Britain had ever included within its remit. The implementation of that vision introduced to Britain a new way of presenting history – no longer only via books or oral transmission but in a way which could be entered and explored and even interpreted from their lived experience by an older generation to a younger one.[71]

The Museum concluded very early in its existence that an open-air branch was necessary to do justice to this aspiration; and whilst that policy was not always supported wholeheartedly by all members of the Museum's governing bodies, on the whole it was pursued actively by more than one director, and particularly by Sir Cyril Fox. Apart from its literary dimension, no unified conception of a traditional culture worth commemorating existed before Peate. His work on material culture was entirely innovative, and using his own nomenclature we can rightly call him the father of folk-life studies in Great Britain, whilst in the Welsh context he can truthfully be said to have not so much researched or interpreted a tradition, as to a considerable extent created it. I noted in the Introduction Trefor Owen's comment that Peate was 'a cluster of paradoxes',[72] and another of them is that whilst he was old-fashioned as a poet and uncertain as a commentator, he was ahead of his time in his (albeit initially uncertain) choice of career. The 'Great Man' theory of history first expounded by Thomas Carlyle in the early nineteenth century has long been discredited, but Iorwerth Peate could well qualify for consideration within that canon, since the theory is based on the two premises

that every great leader is born already possessing the traits that will enable them to rise and lead instinctively when the time comes, and that there has to be the need for that greatness to emerge.[73] However, his superiors or successors either did not really appreciate his deeper vision of the Folk Museum as a driver for national regeneration, or found it to be impractical. The seed was not embedded sufficiently deeply for it to germinate after his time, but the recent reimagining and repurposing of the site is moving it much closer to playing such a central role.

Iorwerth Peate was not the man who invented the idea of the folk museum – that revolutionary concept, along with the study of the everyday life of the people, was introduced in Scandinavia by Hazelius and his contemporaries sixty years before the site at St Fagans was acquired. He was not the man who first thought that the National Museum of Wales should have an open-air branch – that was its first Director, W. Evans Hoyle, when Peate was about ten years old. He was not the man who drove the concept within the National Museum either: that was Sir Cyril Fox, who was responsible for ensuring that the Museum Council came to support the concept, called for it to be rolled out across the British Isles, ensured that the St Fagans site was offered to the Museum, and laid down the strategic direction for the new institution. However, Peate was the man who persuaded the Welsh people – and in particular Welsh speakers – that the country needed a folk museum, who fashioned its original tripartite form of open-air section, thematic galleries and a research institute, to the extent that he became accepted widely as its sole creator as well as its first head. Peate would have wanted us to think that he dreamt the impossible dream and – triumphantly – fought the impossible fight, but he was not alone in ensuring that the dream became reality. In fact, it took Peate and Fox together to achieve the National Museum's strategic aim, and neither of them could have done it on his own: it required the creative tension between these two remarkable men with their complementary skills, and however rocky the road for both of them, their dysfunctional relationship achieved great things. But it is to Peate alone that we must give credit for turning the somewhat dilettantish collecting of 'bygones' into the professional collecting, studying, presenting and interpreting the material and oral evidence for past life in Britain, and for ensuring that the study of folk life or ethnology today still plays a prominent role in contributing to our understanding of society. His inspiration, obsession, drive, and even arrogance all contributed to making him a

true nation-builder, and we must acknowledge that he carried out as no other could his preordained task of ensuring that the values he ascribed to Llanbryn-Mair were transmitted to continuing generations. The last words that I ascribe to him will serve as his challenge of 1971 to his successors: 'I have the faith to *know* that this young national institution will become with the years one of the finest bastions of that unique culture that Wales contributes to the civilization of the world'.[74]

Notes

1. The photographs, drawings and plans of houses and implements made by him can be accessed at *www.duchas.ie/en/ppl/cbeg/238222947* (accessed 4 August 2019).
2. V. H. Phillips, 'Tape Recording and Welsh Folk Life. Discussion Paper: Draft' (Cardiff, 1983), p. 39.
3. *Rhwng Dau Fyd*, p. 192.
4. His first book was *France: A Geographical Introduction* (London, 1937).
5. *www.ricorso.net/rx/az-data/authors/e/EvansEE/life.htm* (accessed 4 October 2019).
6. G. B. Thompson, 'The Welsh Contribution to the Development of the Ulster Folk Museum', in Geraint Jenkins (ed.), *Studies in Folk Life. Essays in Honour of Iorwerth C. Peate* (London, 1969), pp. 29–33.
7. *manxliterature.com/browse-by-author/William-cubbon/* (accessed 8 August 2020).
8. 'I am happy to think that I had a small part in launching the project in 1938', Iorwerth C. Peate, 'The Folk Museum', *J. Royal Society of Arts*, 97 (1949), 797; B. R. S. Megaw, 'The Manx folk collections in the National Museum', *Proc. Isle of Man Nat. Hist. and Ant. Soc.*, 4 (1941), 383.
9. Catriona Mackie, 'Open-Air Museums, Authenticity and the Shaping of Cultural Identity: An Example from the Isle of Man', in C. Dalglish (ed.), *Archaeology, the Public and the Recent Past* (Woodbridge, 2013), pp. 13–33.
10. Isabel Frances Grant, *The Making of* Am Fasgadh. *An Account of the Origins of the Highland Folk Museum by its Founder* (Edinburgh, 2007).
11. Heather Holmes, 'Alexander Fenton (1929–2012), CBE, M.A., B.A., D.Litt., Hon. D.Litt (ABD), FRSE, FRSGS, FSA, FSA Scot, Professor of Scottish Ethnology', *Folklore*, 123 (2012), 362–4.
12. 'Stewart Forson Sanderson, pioneer in studies and recording of folk culture and dialect', *The Scotsman*, 11 November 2016.
13. Gareth Williams, *Writers of Wales. George Ewart Evans* (Cardiff, 1991), p. 56; George Ewart Evans, *The Strength of the Hills: An Autobiography* (London, 1983). For more on the two men's interaction, Gareth Williams, 'Hanes, myth a'r traddodiad llafar yng ngwaith George Ewart Evans'['History, myth and the oral tradition in the work of George Ewart Evans'], *Y Traethodydd*, clii (1997), 135–47.

14. For a good review of these, see Gaynor Kavanagh, *History Curatorship* (Leicester and London, 1990), pp. 22–31.
15. Kenneth Hudson, *Museums of Influence* (London, 1988).
16. Kavanagh, *History Curatorship*, p. 42.
17. Sten Rentzhog, *Open Air Museums. The history and future of a visionary idea* (Jamtli, 2007).
18. Beth Thomas and Nia Williams, 'Moving Towards Cultural Democracy: Redeveloping St. Fagans', *Trans. Hon. Soc. Cymmrodorion*, 21 (2015), 140. Free entry has helped very considerably the visitor numbers, and it should be remembered that the numbers quoted are visits rather than visitors, which the Museum does not count. The number quoted is the last not affected by the consequences of Covid when this work was written.
19. For the creation of the Rhondda Heritage Park, see Bella Dicks, *Heritage, Place and Community* (Cardiff, 2000).
20. Greg Stevenson, who carried out several exemplary restorations in west Wales, was also inspired to revisit some of the buildings recorded by Peate and to publish a reprint of *The Welsh House* (Cribyn, 2004).
21. Professors Bill Davies and Simon Unwin, pers. comm.
22. Huw D. Jones, 'Exhibiting Welshness. Art, Politics and National Identity in Wales 1940-1994' (unpublished PhD thesis, Swansea University, 2007), p. 41: https://www.academia.edu/2309465/Exhibiting_Welshness_Art_Politics_and_National_Identity_in_Wales_1940_1994 (accessed 9 April 2021).
23. In this way, existing National Museum sites at Llanberis and Dre-fach Felindre were re-presented, Big Pit at Blaenafon became part of the organisation and was redeveloped, and the new Waterfront Museum at Swansea was created in partnership to succeed the Industrial and Maritime Museum in Cardiff Bay.
24. Pyrs Gruffydd, 'Heritage as national identity: histories and prospects of the national pasts', in David T. Herbert (ed.), *Heritage, Tourism and Society* (London, 1995), p. 61.
25. The charge principally laid by Peter Lord: see in particular his *The Aesthetics of Relevance* (Llandysul, 1993).
26. Hywel Francis, 'A nation of museum attendants', *Arcade* (16 January 1981), 8–9. Francis had clearly based these observations on Raymond Williams's, see n.29, below.
27. D. Smith, 'Labour history and heritage', *Social History Curators Group Journal*, 18 (1990–1), 5.
28. Dai Smith, *Wales: A Question for History* (Bridgend, 1999), p. 36.
29. Raymond Williams, *The Volunteers* (1978, repr. Cardigan, 2011), pp. 30–1.
30. An initiative ascribed to Geraint Jenkins by Bella Dicks, *Heritage, Place and Community*, p. 94, and Lisa Lewis, *Performing Wales. People, Memory and Place* (Cardiff, 2018), pp. 57–8, but he had nothing to do with it. The first industrial and urban buildings to be re-erected at St Fagans, the Rhyd-y-car terraced houses, were opened to the public three months after Jenkins took over as Curator; similarly, the initiative to dismantle and later re-erect the Gwalia

Stores was driven by the failure of Jenkins's ambitious but impractical plan for an eco-museum in Ogmore Vale. He had nothing to do with the decision to re-erect the building at St Fagans.

31. O. M. Edwards, *Wales* (London, 1901), p. 399. Sir Owen M. Edwards (1858–1920) was a towering figure whose work in raising historical and literary awareness laid the foundations for the nationalistic revivals of later years. Peate noted his delight in meeting him once when Edwards visited Machynlleth School: *Y Llwybrau Gynt* (1971), pp. 11 and 18. Edwards's *Wales* was not surpassed as a general introduction until David Williams's *A History of Modern Wales* (Cardiff, 1950). For Edwards, see Hazel Walford Davies, *O. M. Cofiant Syr Owen Morgan Edwards* (Llandysul, 2019).
32. J. E. Lloyd, *A History of Wales* (London, 1930), p. 60.
33. Daryl Perrins, 'Arcadia in Absentia: Cinema, the Great Depression and the Problem of Industrial Wales', in Ieuan Franklin, Hugh Chignell and Kristin Skoog (eds), *Regional Aesthetics* (London, 2015), p. 35.
34. A. H. Dodd, *The Industrial Revolution in North Wales* (Cardiff, 1933; 3rd edn 1971, repr. Wrexham, 1990).
35. Peate was not alone amongst Welsh speakers in holding such a view. D. J. Williams, who had worked for a while as a miner, was of the same opinion: Emyr Hywel, *Y Cawr o Rydcymerau. Cofiant D. J. Williams* (Talybont, 2009), p. 55.
36. George Ewart Evans, 'The South Wales miners and their inheritance', *Eighth Report of the South Wales Miners' Library* (1982–3), 14.
37. Gaynor Kavanagh, 'Museums in a Broken World', in John Osmond (ed.), *Myths, Memories and Futures. The National Library and National Museum in the Story of Wales* (Cardiff, 2007), p. 48.
38. Catrin Stevens, *Iorwerth C. Peate* (Cardiff, 1986), p. 1. Vice-Presidents of the institution had also visited in 1961–2 and in 1971–2.
39. Lewis, *Performing Wales*, pp. 58–9.
40. Lewis, *Performing Wales*, e.g. pp. 67 and 82, though Geraint Jenkins would not have had the authority to employ craftsmen, as she seems to suggest (he reported to a Keeper, and he to Peate; and even Peate, as we have seen, did not have authority to engage staff), and Peate had seen for himself how crucial demonstrating craftsmen were and appointed several before Jenkins's appointment; and the first of the calendar of events (Lewis, *Performing Wales*, p. 70), the May Fair, was started before Jenkins became Curator.
41. Maura Reilly, *Curatorial Activism: Towards an Ethics of Curating* (London, 2018).
42. Such as by Peter Roberts in his *Cambrian Popular Antiquities* (1815). On early folklorists in Wales, see Juliette Wood, 'Datblygiad Astudiaethau Gwerin yng Nghymru, 1700–1900' ['The Development of Folk Studies in Wales, 1700–1900'], in E. Wyn James a Tecwyn Vaughan Jones (goln), *Gwerin Gwlad. Ysgrifau ar Ddiwylliant Gwerin Cymru. Cyfrol I* (Llanrwst, 2008), pp. 11–38.
43. *Amgueddfeydd Gwerin / Folk Museums*, p. 13.

44. Elen Phillips, 'A picture of the past and a mirror of the present: Iorwerth Peate and the origins of the Welsh Folk Museum', in Owain Rhys and Zelda Baveystock (eds), *Collecting the Contemporary. A Handbook for Social History Museums* (Edinburgh and Boston, 2014), pp. 40–62.
45. Harriet Purkis, 'Collecting the home in different ways: Samdok's ethnographic methods compared to other approaches', in Rhys and Baveystock (eds), *Collecting the Contemporary*, pp. 170–209, and references therein.
46. D. A. Bassett, *David Morgan Rees, OBE, MA, FSA*. Address given at his memorial service, 1978.
47. The redevelopment process is outlined by Beth Thomas and Nia Williams, 'Moving Towards Cultural Democracy: Redeveloping St. Fagans', *Trans. Hon. Soc. Cymmrodorion*, 21 (2015), 140–5. The strategic decision behind the development was agreed under Anderson's predecessor, Michael Houlihan.
48. For example, in 'David Anderson (National Museum Wales): Interview', *Buzz*, 14 November 2018: *https://www.buzzmag.co.uk/author/admin/* (accessed 21 December 2020).
49. Neither he nor Fox seem to have responded to the discussion within the Museums Association in the 1930s to proposals for 'rural museums', which would have been 'a centre for activity, not a mere show-room. [They] should be formed and run by the inhabitants': editorial, *Museums Journal*, 30 (1930–1), 162, and 'Rural Museums for Britain', editorial, *Museums Journal*, 30 (1930–1), 161–80.
50. Sioned Hughes and Elen Phillips, 'The journey towards activism at St. Fagans National Museum of History', in Robert R. Jones and Richard Sandall (eds), *Museum Activism* (London and New York, 2019), pp. 245–55.
51. Amgueddfa Cymru – National Museum Wales Operational Plan 2019/20: *https://museum.wales/media/47978/Operational-Plan-2019-2020.pdf* (accessed 3 January 2021).
52. Charles Scott-Fox, *Cyril Fox. Archaeologist Extraordinary* (Oxford, 2002), pp. 177 and 179.
53. NLW ICP Papers A 3/2 (ii), Cynigion a basiwyd gan Lys a Chyngor AGC parthed ymddeoliad Iorwerth Peate a teyrnged iddo ar ei ymddeoliad [Proposals moved by the Court and Council of NMW regarding Iorwerth Peate's retirement and testimonials offered to him].
54. In retrospect, it is clear that realpolitik would have ensured that such a situation, even if agreed, could not have prospered for long, just as the Ulster Folk and Transport Museum was amalgamated with the Ulster Museum in the 1990s to form National Museums Northern Ireland, with the review that made that recommendation led by a former Director of the National Museum of Wales: Alistair Wilson, *A Time for Change . . . A review of major museums in Northern Ireland* (Bangor, 1995).
55. R. T. Jenkins (1881–1969) became Professor of Welsh History at Bangor. He emphasised that history needed to be approached impartially, but, like Peate, paid scant attention to economic history: Alun Llywelyn-Williams, *R. T. Jenkins* (Cardiff, 1977).

56. Eric Hobsbawm (ed.), *The Invention of Tradition* (Cambridge, 1983); Raymond Williams, *Culture and Society 1780–1950* (London, 1958); and E. P. Thompson, *The Making of the English Working Class* (London, 1963), and (particularly for this sentence) *Customs in Common* (London, 1991).
57. Peter Lord, *The Aesthetics of Relevance* (Llandysul, 1992): Peter Lord, *Y Chwaer-Dduwies. Celf, Crefft a'r Eisteddfod* (Llandysul, 1992); Peter Lord, *The Visual Culture of Wales: Industrial Wales* (Cardiff, 1998); Peter Lord, *The Visual Culture of Wales: Imaging the Nation* (Cardiff, 2000); Peter Lord, *The Tradition. A New History of Welsh Art 1400–1990* (Cardigan, 2016). Lord's analysis of Peate from an art historian's perspective was followed by that of Fflur Gwynn (now Morse, a curator at St Fagans) in her MA dissertation at the Royal College of Art. In this she explored the relationship between craft, national identity and display, examining the attempt to establish a craft revival in post-war Wales, to which she ascribed a vital role for Peate through his promotion of the subject and exhibitions at the National Eisteddfod and the Folk Museum, but concluding that the attempt was unsuccessful because the time was wrong and the art establishment in Wales was being led in other directions: *https://www.rca.ac.uk/students/branwen-fflur-gwynn/* (accessed 30 April 2021).
58. 'The Place of Folk Culture in the Museum', *Museums Journal* (1941), 48.
59. Although A. H. Dodd did not think Peate's work was worthy of mention in his survey of work undertaken on Welsh economic and social history (A. H. Dodd, 'Welsh History and Historians', in Elwyn Davies (ed.), *Celtic Studies in Wales. A Survey* (Cardiff, 1963), pp. 62–3); but the *Bibliography of the History of Wales* (Cardiff, 1962) accorded his works full representation.
60. As both poet and scholar, he held the strongest of views on those who sought to distinguish between the two crafts. Literary purists, he noted in 1932, might hold that major poets did the nation a disservice by withholding their talent for the sake of seeking scholastic and administrative opportunities, but the poetic works of A. E. Housman and T. H. Parry-Williams were none the worse for being composed respectively by professors of Latin and Welsh; in fact both were *better* poets for having developed their critical faculties such that they could judge for themselves what was good or not in their poetic work. And were not recent major works of Welsh scholarship such as W. J. Gruffydd's *Llên Cymru* ('The Literature of Wales'), G. J. Williams's *Iolo Morganwg*, or Henry Lewis's *Datblygiad yr Iaith Gymraeg* ('The Development of the Welsh Language') also major works of literature as well as scholarship, just like Gibbon's *Decline and Fall of the Roman Empire*? The final answer to any who dared make such an invidious statement was to think again of Housman and G. J. Williams and to remember that a poet's reputation was not based on the *scale* of his output: 'Celfyddyd ac Ysgolheictod' ['Art and Scholarship'], *Y Llenor* (1932), 99–102, repr. *Sylfeini* (1938), pp. 39–44.
61. Lewis, *Performing Wales*, p. 36.
62. E. D. Jones, *Y Llenor*, 17 (January 1938), 64; my translation. Jones was Keeper of Manuscripts in the National Library of Wales.

63. Lewis's seminal text, 'Tynged yr Iaith' ('The Fate of the Language'), was delivered as a BBC Wales annual lecture in 1962: it resulted directly in the formation of Cymdeithas yr Iaith Gymraeg, the Welsh Language Society, whose badge Peate sports proudly in his retirement portrait. Whilst published by the BBC, I have heard it said that the Corporation had erased or recorded over their only audio copy of the lecture, and that the only professional-quality copy remaining was that recorded by the Folk Museum – and whilst this may be a myth, it is one that Peate would have been proud of. Many others, such as D. J Williams, felt that the survival of the Welsh language was key to nationhood: Emyr Hywel, *Y Cawr o Rydcymerau. Cofiant D. J. Williams* (Aberystwyth, 2009), pp. 78–9.
64. The Centre, based in Aberystwyth, was the dream of Elwyn Davies who chaired the Folk Museum Committee in the early 1980s; Griffith John Williams had also been a great supporter.
65. For example, *Self-sufficiency* (London, 1973) and *The Complete Book of Self-Sufficiency* (London, 1976).
66. For example, his comment that 'much valuable evidence has disappeared': 'Some Aspects of Agricultural Transport in Wales', *Arch. Cambrensis*, xc (1935), 219, and many references to the problem in *The Welsh House*.
67. 'Ordinary Folk', *Béaloideas*, 39/41 (1971–3), 286. He was also happy to accept that religious thought had progressed through change, e.g., 'Dogma a Gonestrwydd Meddwl' ['Dogma and the Honest Mind'], *Sylfeini* (1938), pp. 139–50.
68. St Fagans sits by the banks of the river Ely which flows to the sea at Cardiff.
69. NLW Peate Papers A2/6 Rhwng Dau Fyd. Thomas Parry (1904–85) was a leading Welsh scholar, a fellow pacifist who had been Librarian of the National Library of Wales and Principal of the University College of Wales, Aberystwyth. He was knighted in 1978.
70. Trefor M. Owen, 'Iorwerth Peate a Diwylliant Gwerin', *Trans. Hon. Soc. Cymmrodorion*, n.s. 5, 1998 (1999), 78.
71. On writing the history of Wales, see Huw Pryce, *Writing Welsh History: From the Early Middle Ages to the Twenty-First Century* (Oxford, 2022).
72. Owen, 'Iorwerth Peate a Diwylliant Gwerin', 62.
73. Thomas Carlyle, *On Heroes, Hero-Worship, and The Heroic in History* (London, 1840); Bert Alan Spector, 'Carlyle, Freud, and the Great Man Theory more fully considered', *Leadership*, 12 (2015), 250–60: https://doi.org?10.1177/174215015571392 (accessed 17 July 2021).
74. 'The Welsh Folk Museum', *Stewart Williams' Glamorgan Historian*, 7 (Cowbridge, 1971), p. 172.

Select Bibliography

1. Works by Iorwerth C. Peate

(with others) *Gyda'r Wawr* ['With the Dawn'] (Wrecsam: Hughes a'i Fab, 1923).
'The Dyfi Basin: A Study in Physical Anthropology and Dialect Distribution', *Journal of the Royal Anthropological Institute of Great Britain and Ireland*, 55 (1925), 58–72.
'A North Cardiganshire Woollen Yarn Factory. Its History, Machinery, Trade and Rural Associations, with a note on a Family of Montgomeryshire Millwrights', *Y Cymmrodor*, 39 (1928), 68–87.
Guide to the Collection of Welsh Bygones (Cardiff: National Museum of Wales, 1929).
(ed.), *Studies in Regional Consciousness and Environment. Essays presented to H. J. Fleure, D.Sc., F.S.A.* (Oxford: Oxford University Press, 1930).
'Some Welsh Wood-Turners and their Trade', in Peate (ed.), *Studies in Regional Consciousness and Environment*, pp. 175–88.
'Rhai o Grefftau Ceredigion' ['Some Cardiganshire Crafts'], *Transactions of the Cardiganshire Antiquarian Society*, vii (1930), 50–5.
Cymru a'i Phobl ['Wales and its People'] (Caerdydd: Gwasg Prifysgol Cymru, 1931).
'A Caernarvonshire Inventor: A Note on the Work of John Williams (*Ioan Madog*)', *Y Cymmrodor*, xlii (1931), 148–54.
'Welsh Folk Culture', *Welsh Outlook*, 19 (1932), 294–7.
'The Kelts in Britain', *Antiquity*, 6 (1932), 156–60.
Y Crefftwr yng Nghymru ['The Craftsman in Wales'] (Llandysul: Gwasg Aberystwyth, 1933).
'Y Naw Helwriaeth' ['The Nine Huntings'], *Bulletin of the Board of Celtic Studies*, vi (1933), 301–12.
'Welsh Folk Industries', *Folk-lore*, xliv (1933), 176–88.
'The Nine Huntings', *Antiquity*, 8 (1934), 73–80.
'A Folk Museum for Wales', *Museums Journal*, 34 (1934), 229–31.
'Archaeology and Folk Culture', *The Archaeological Journal*, 91 (1934), 211–20.
'Some Aspects of Agricultural Transport in Wales', *Archaeologia Cambrensis*, xc (1935), 219–38.
'Traddodiad Ewrop' ['The European Tradition'], *Y Llenor*, xv, (1936), 8–15.

'Some Welsh Houses', *Antiquity*, x (1936), 448–59.
'Diwylliant Gwerin' ['Folk Culture'], *Trans. Hon. Soc. Cymmrodorion*, 1937, 241–50.
Sylfeini ['Foundations'] (Wrecsam: Hughes a'i Fab, 1938).
'Folk Culture', *Antiquity*, xii (1938), 318–22.
The Welsh House. A Study in Folk Culture, as *Y Cymmrodor*, xlvii (1940; repr. Liverpool: Hugh Evans / The Brython Press, 1944, 1946).
'The Place of Folk Culture in the Museum', *Museums Journal*, 41 (1941), 45–50.
'Mynydd Epynt', *Y Llenor*, xx (1941), 183–8, repr. in *Ym Mhob Pen . . . Ysgrifau* (1948), pp. 11–17.
'Anthropoleg a Phroblemau Cyfoes' ['Anthropology and Contemporary Problems'], *Y Llenor*, xx (1941), 17–24, repr. in *Ym Mhob Pen . . . Ysgrifau* (1948), pp. 18–25.
Diwylliant Gwerin Cymru ['Welsh Folk Culture'] (Lerpwl: Hugh Evans / Gwasg y Brython, 1942, repr. 1943, 1975).
'Yr Ardaloedd Gwledig a'u Dyfodol' ['The Rural Areas and their Future'], *Y Llenor*, xxii, 1943, repr. in *Ym Mhob Pen . . . Ysgrifau* (1948), pp. 120–8.
'Two Montgomeryshire Craftsmen', *Montgomeryshire Collections*, xlviii (1943), 3–10.
'Museums and the Community', *Montgomeryshire Collections*, xlviii (1944), 124–30.
'John Tibbot, Clock and Watch Maker', *Montgomeryshire Collections*, xlviii (1944), 175–85.
'Folk Studies in Wales', *The Welsh Review*, iii (1944), 49–53.
Clock and Watch Makers in Wales (Cardiff: National Museum of Wales, 1945, and subsequent edns).
'Gwerth Amgueddfa' ['The Value of a Museum'], *Lleufer: Cylchgrawn Cymdeithas Addysg y Gweithwyr*, 2 (1946), 14–16.
Amgueddfeydd Gwerin / Folk Museums (Cardiff: University of Wales Press, 1948).
Ym Mhob Pen . . . Ysgrifau ['In Every Head . . . Essays'] (Aberystwyth: Gwasg Aberystwyth, 1948).
'The Welsh Folk Museum and its Development', *Laos* (1951), 169–79.
'Welsh Life since 1536', in Heather Kay (ed.), *The Welsh Gift Book* (Cardiff: University of Wales Press, 1950), pp. 12–17, reissued as *The Land of the Red Dragon* (Cardiff: University of Wales Press, 1953), pp. 9–17 (and subsequent edns).
'Traddodiad Llanbryn-Mair' ['The Llanbryn-Mair Tradition'], *Trans. Hon. Soc. Cymmrodorion*, 1954, 10–17.
'Some Welsh Historic Buildings', *Trans. Ancient Monuments Society*, 3 (1955), 79–87.

Select Bibliography

'The Cruck Truss: A Reassessment', *Papers of the International Congress of European and Western Ethnology, Stockholm 1951* (Stockholm, 1956), pp. 107–13.
'The Study of Folk Life: and its Part in the Defence of Civilisation', *The Advancement of Science*, 15 (1958), 86–94, reprinted in *Gwerin*, 2 (1959), 97–109.
Farmhouses and Cottages in Wales. A Picture Book (Cardiff: National Museum of Wales / Welsh Folk Museum, 1962).
'The Welsh Long-house: A Brief Reappraisal', in I. Ll. Foster and L. Alcock (eds), *Culture and Environment. Essays in Honour of Sir Cyril Fox* (London: Routledge & Kegan Paul, 1963), pp. 439–44.
'Sefydliadau Ymchwil Enwog: V. Amgueddfa Werin Cymru, Sain Ffagan: Astudio Bywyd Gwerin' ['Famous Research Institutions: V. The Welsh Folk Museum, St Fagans: Studying Folk Life'], *Y Gwyddonydd*, ii (1964), 8–17.
'Bywyd Gwerin Cymru' ['Welsh Folk Life'], in Dyfnallt Morgan (ed.), *Gwŷr Llên y Ddeunawfed Ganrif* (Llandybïe: Llyfrau'r Dryw, 1966), pp. 19–25.
'Ein Trysor Gwerthfawrocaf' ['Our Most Valuable Treasure'], *Amgueddfa*, 3 (1969), 2–9.
Syniadau ['Ideas'] (Llandysul: Gwasg Gomer, 1969).
'Iorwerth C. Peate', in Alun Oldfield-Davies (ed.), *Y Llwybrau Gynt I* (Llandysul: Gwasg Gomer, 1971), pp. 7–30.
'The Welsh Folk Museum', *Stewart Williams' Glamorgan Historian*, 7 (Cowbridge: D. Brown and Sons, 1971), pp. 161–72.
Tradition and Folk Life. A Welsh View (London: Faber & Faber, 1972).
'Society in Wales', in R. Brinley Jones (ed.), *Anatomy of Wales* (Cowbridge: Gwerin Publications, 1972), pp. 43–53.
'Ordinary Folk', *Béaloideas*, 39/41 (1971–3), 280–6.
Rhwng Dau Fyd. Darn o Hunangofiant ['Between Two Worlds. A Part Autobiography'] (Dinbych: Gwasg Gee, 1976).
'Some thoughts on the study of folk life', in C. O. Danachair, *Folk and Farm: Essays in Honour of A. T. Lucas* (Dublin: Royal Society of Antiquaries of Ireland, 1976), pp. 229–34.
Personau ['Persons'] (Dinbych: Gwasg Gee, 1982).

2. General Works
Bassett, Douglas A., 'The making of a national museum', *Trans. Hon. Soc. Cymmrodorion*, 1982, 3–35; Part II, 1983, 3–36; Part III, 1984, 1–100; Part IV, 1992, 193–260.
Bowen, E. G., *Wales. A Study in Geography and History* (Cardiff: University of Wales Press, 1941).
Carter, Ellen Jane, '"Iorwerth Cyfeiliog Peate: Dyn v. Myth. Pa lais sydd gryfaf?", traethawd tuag at radd MA, Prifysgol Caerdydd' ['"Iorwerth

Cyfeiliog Peate: Man v. Myth. Which voice is loudest?", extended essay in part requirement for MA degree, Cardiff University'] (2017).

Chapman, T. Robin, *Llên y Llenor. Iorwerth Peate* ['A Writer's Writings. Iorwerth Peate'] (Caernarfon: Gwasg Pantycelyn, 1987).

Davies, Elwyn and Alwyn D. Rees (eds), *Welsh Rural Communities* (Cardiff: University of Wales Press, 1962).

Dicks, Bella, *Heritage, Place and Community* (Cardiff: University of Wales Press, 2000).

Evans, R. Alun, *Bro a Bywyd Iorwerth C. Peate* ['Iorwerth C. Peate: Background and Life'] (Llandybïe: Cyhoeddiadau Barddas, 2003).

Fox, Cyril, 'Peasant Crofts in North Pembrokeshire', *Antiquity*, xi (1937), 427–40.

Francis, Hywel, 'A nation of museum attendants', *Arcade* (16 January 1981), 8–9.

Grant, Isabel Frances, *The Making of Am Fasgadh. An Account of the Origins of the Highland Folk Museum by its Founder* (Edinburgh: National Museums of Scotland, 2007).

Gruffudd, Pyrs, 'Tradition, Modernity and the Countryside: The Imaginary Geography of Rural Wales', *Contemporary Wales. An annual review of economic & social research*, 6 (1993), 33–47.

Gruffudd, Pyrs, 'Back to the land: historiography, rurality and the nation in interwar Wales', *Trans. Royal Inst. British Geographers*, 19/1 (1994), 61–77.

Gruffydd, Pyrs, 'Heritage as national identity: histories and prospects of the national pasts', in David T. Herbert (ed.), *Heritage, Tourism and Society* (London: Mansell, 1995), ch. 4.

Jenkins, Geraint (ed.), *Studies in Folk Life. Essays in honour of Iorwerth C. Peate* (London: Routledge & Kegan Paul, 1969).

Jenkins, J. Geraint, *Morwr Tir Sych. Hunangofiant* ['A Dry-land Sailor. An Autobiography'] (Aberystwyth: Cymdeithas Llyfrau Ceredigion, 2007).

Jones, Huw D., 'Exhibiting Welshness. Art, Politics and National Identity in Wales 1940–1994' (unpublished PhD thesis, Swansea University, 2007): https://www.academia.edu/2309465/Exhibiting_Welshness_Art_Politica_and_National_Identity_in_Wales_1940_1994

Kavanagh, Gaynor, *History Curatorship* (Leicester and London: Leicester University Press, 1990).

Kavanagh, Gaynor, 'Museums in a Broken World', in John Osmond (ed.), *Myths, Memories and Futures. The National Library and National Museum in the Story of Wales* (Cardiff, Institute of Welsh Affairs, 2007), pp. 47–57.

Lewis, Lisa, *Performing Wales. People, Memory and Place* (Cardiff: University of Wales Press, 2019).

Lord, Peter, *Y Chwaer-Dduwies. Celf, Crefft a'r Eisteddfod* ['The Sister-Goddess. Art, Craft and the Eisteddfod'] (Llandysul: Gomer, 1992).

Select Bibliography

Mackie, Catriona, 'Open-Air Museums, Authenticity and the Shaping of Cultural Identity: An Example from the Isle of Man', in C. Dalglish (ed.), *Archaeology, the Public and the Recent Past* (Woodbridge: Boydell and Brewer, 2013), pp. 13–33.

Mason, Rhiannon, 'Representing the Nation', in John Osmond (ed.), *Myths, Memories and Futures. The National Library and the National Museum in the Story of Wales* (Cardiff: Institute of Welsh Affairs, 2007), pp. 23–37.

Mason, Rhiannon, *Museums, Nations, Identities: Wales and its National Museums* (Cardiff: University of Wales Press, 2007).

Morgan, Prys, 'The Gwerin of Wales: Myth and Reality', in I. Hume and W. Pryce (eds), *The Welsh and Their Country* (Llandysul: Gomer, 1986), pp. 134–52.

Morgan, Prys, 'The creation of the National Library and the National Museum of Wales', in John Osmond (ed.), *Myths, Memories and Futures. The National Library and the National Museum in the Story of Wales* (Cardiff: Institute of Welsh Affairs, 2007), pp. 13–22.

Owen, Trefor M., 'Iorwerth C. Peate: Portread', *Y Gwyddonydd*, 13 (Rhagfyr 1975).

[Owen, Trefor M. and Iorwerth C. Peate], *IORWERTH CYFEILIOG PEATE. Cyflwyniad Bathodyn y Cymmrodorion / Presentation of the Cymmrodorion Medal* (Caerdydd: Amgueddfa Genedlaethol Cymru (Amgueddfa Werin Cymru), 1979).

[Trefor M. Owen], *Iorwerth Cyfeiliog Peate M.A., D.Sc., D.Litt., D.Litt.Celt., F.S.A. Cyn-Guradur Amgueddfa Werin Cymru / Former Curator of the Welsh Folk Museum* (Caerdydd: Amgueddfa Genedlaethol Cymru: Amgueddfa Werin Cymru), 1982 (funeral address).

Owen, Trefor M., 'Iorwerth Peate a Diwylliant Gwerin' ['Iorwerth Peate and Folk Culture'], *Trans. Hon. Soc. Cymmrodorion*, n.s., 5, 1998 (1999), 62–79.

Owen, Trefor M., 'Iorwerth Cyfeiliog Peate', Welsh Biography Online: http://yba.llgc.org.uk/en/s6-PEAT-CYF-1901.html

Owen, Trefor M., *Ffransis G. Payne* (Cardiff: University of Wales Guild of Graduates Ethnology and Folk Life Section, 1997).

Peach, Linden, *Pacifism, Peace and Modern Welsh Writing* (Cardiff: University of Wales Press, 2019).

Phillips, Elen, 'A picture of the past and a mirror of the present: Iorwerth Peate and the origins of the Welsh Folk Museum', in Owain Rhys and Zelda Baveystock (eds), *Collecting the Contemporary. A Handbook for Social History Museums* (Edinburgh and Boston: MuseumsEtc, 2014), pp. 40–61.

Rees, Alwyn D., *Life in a Welsh Countryside. A Social Study of Llanfihangel yng Ngwynfa* (Cardiff: University of Wales Press, 1950, and subsequent edns).

Reilly, Maura, *Curatorial Activism: Towards an Ethics of Curating* (London: Thames and Hudson, 2018).

Rentzhog, Sten, *Open Air Museums. The history and future of a visionary idea* (Jamtli: Carlssons, 2007).

Roberts, Manon Wyn, *Barddoniaeth Iorwerth C. Peate* ['The Poetry of Iorwerth C. Peate'] (Llandybïe: Cyhoeddiadau Barddas, 1986).

Scott-Fox, Charles, *Cyril Fox. Archaeologist Extraordinary* (Oxford: Oxbow Books, 2002).

Smith, D., 'Labour history and heritage', *Social History Curators Group Journal*, 18 (1990–1), 3–6.

Stevens, Catrin, *Writers of Wales. Iorwerth C. Peate* (Cardiff: University of Wales Press, 1986).

Stoklund, Bjarne, *Folk Life Research: Between History and Anthropology*, a National Museum of Wales seventy-fifth anniversary lecture delivered at the Welsh Folk Museum (Cardiff: National Museum of Wales, 1983).

Thomas, Beth and Nia Williams, 'Moving Towards Cultural Democracy: Redeveloping St Fagans', *Trans. Hon. Soc. Cymmrodorion*, 21 (2015), 140–5.

Thompson, G. B., 'The Welsh Contribution to the Development of the Ulster Folk Museum', in Jenkins, Geraint (ed.), *Studies in Folk Life. Essays in honour of Iorwerth C. Peate* (London: Routledge & Kegan Paul, 1969), pp. 29–33.

Tomos, Robyn, 'Cyrraedd y Cain a'r Prydferth' ['Reaching the Fine and Perfect'], *Barn* (Gorffennaf/Awst 2003), 56–8.

Ward, Alexandra, 'Archaeology, Heritage and Identity: the creation and development of a National Museum in Wales', PhD Cardiff, 2008: orca.cardiff.ac.uk/id/eprint/54744/1/U585133.pdf.

Wiliam, Eurwyn, 'Three giants: Iorwerth Peate, Cyril Fox and Peter Smith, and the study of vernacular architecture in Wales', *Trans. Ancient Monuments Soc.*, 61 (2017), 8–33.

Wiliam, Eurwyn, '"I have a dream"? Iorwerth Cyfeiliog Peate and the creation of the Welsh Folk Museum', lecture to the Honourable Society of Cymmrodorion, February 2021: https://www.cymmrodorion.org/talk/i-have-a-dream-iorwerth-cyfeiliog-peate-and-the-creation-of-the-welsh-folk-museum/

Williams, Gareth, *Writers of Wales. George Ewart Evans* (Cardiff: University of Wales Press, 1991).

Wood, Juliette, 'Datblygiad Astudiaethau Gwerin yng Nghymru, 1700–1900' ['The Development of Folk Studies in Wales, 1700–1900'], in James, E. Wyn a Tecwyn Vaughan Jones (goln), *Gwerin Gwlad. Ysgrifau ar Ddiwylliant Gwerin Cymru. Cyfrol I* ['Country Folk. Essays on Welsh Folk Culture. Volume I'] (Llanrwst: Gwasg Carreg Gwalch, 2008), pp. 11–38.

Index

A
Aberconway, Lord 199
Aber-cuch 248
Abergele 193
Abernodwydd 66, 128, 230–1, 237–8, 249
Aberporth 155
Aberystwyth xiii, 9, 20–2, 25, 29, 33, 44–7, 50, 64, 89, 98, 115, 149, 154, 237, 244–5, 251–2, 302
Aberystwyth, University College of Wales 20–2, 43, 81, 98, 302
Aberystwyth tollhouse 236–7
Act of Union 63
Acton Scott farm museum 271, 279
Adam, Robert 256
All, Hans 169
Allen, John 219
Allen, J. Romilly 126
Amgueddfa Cymru – National Museum Wales 43
Amgueddfeydd Gwerin / Folk Museums 200
Anderson, Dr David xvi, 283
Angel Hotel, Cardiff 260
Anglesey 105, 116, 119, 123, 183, 185, 217, 229, 231, 273
Anglesey Inventory 119–20
Anthony, Dr Ilid E. 160, 257
Anthropology 1, 21, 23, 29, 51, 66, 117, 132, 144, 154, 160, 287
Antiquity 74, 116–17, 119, 121, 130
Appleton, Robert 91
Archaeology 2, 22–3, 26–7, 33, 43, 45–8, 51, 53, 59–60, 64, 66, 74–5,79, 82, 86, 90, 119, 129, 149, 160–2, 172, 178, 183, 268, 271, 282, 287, 289
Aarhus 61, 178
Arts and Crafts Movement 112, 132
Atkinson, Frank 271
Australia 11
Avoncroft Museum of Buildings 237, 271

B
Baglan 229
Banbury 260
Bangor, University College of North Wales 23, 44, 56, 64, 89, 263, 300
Barry Island 49
Bassett, Dr Douglas A. xv, 43
Bather, Dr F. A. 168, 170, 173, 201
Baxandall, David 82
Beamish 271–2
Beakers 25
Bebb, Richard 106, 233, 288
Bell, David 110–11
Bell, Sir Idris 206
Berlin 60
Bethel 8, 40
Bevan, Aneurin, MP 89
Bible, the 31, 58, 61, 109
Birmingham 230
Blache, Vidal de la 35, 47
Black Country Museum 271
Blaen-y-coed 229
Blists Hill 272
Blue Books, Betrayal of the 19
Blundell, G. E. 77
Blythe, Ronald 270
Board of Education 146
Bodnant 199
Borderland 34, 235
Boothby, Sir Hugo 259
Bowen Dann Davies Partnership 253
Bowen, Professor E. G. 25, 30, 33–4, 58, 206, 262–3, 268
Bowen, Roderic, QC 259
Brangwyn, Sir Frank 197

Brecon Beacons, the 8
Breconshire 31, 74, 118, 226, 245, 261
Brewer, C. C. 45
Briggs, Katharine 159
Bristol 173
British Academy 74, 206
British Archaeological Association 26
British Association for the Advancement of Science 1, 92, 132, 134, 142, 160
British Broadcasting Corporation 58, 90–1, 268, 292, 302
British Empire 44, 148
British Museum 168, 205, 219
British Nylon Spinners 251
Bro xiv, 8, 31
Broadcasting House, Llandaf 252
Brogynin 236
Bromsgrove 236, 271
Bronze Age 6, 25, 28, 47, 51, 65, 161
Brooke, Henry 252
Bruce-Mitford, Rupert 219
Brynmawr 31, 88
Brynmawr & Clydach Valley Industries 96, 109, 112, 188–9
Brythons 26
Buchedd A/B 155
Buckley 251
building materials 32, 123, 127
Bute, Marquess of 45, 61, 195
Butterfield, W. Ruskin 170
Butser Ancient Farm 271
Bwlch Trewyn 229
Bygdoy 50, 169

C

Cae Adda 233
Caerleon 51, 204
Caernarfon 44
Caernarfonshire 116, 123, 128, 230
Caerphilly 110–11, 225
Cambrian Archaeological Association 25, 129
Cambrian Mountains
Cambridge 38, 53, 75, 98, 170, 202, 269
Campbell, Professor Åke 91, 124, 157, 173, 220, 267, 288
Canada 11
Capel Garmon 28
Cardiff University Settlement 96
Cardiff Municipal Museum 44

Cardiff Naturalists Society 64
Cardiff, University College of South Wales and Monmouthshire 45, 99, 246
Cardigan Bay 204
Cardiganshire 24, 31, 64, 80, 96–8, 101, 116, 126, 142, 151, 155, 229, 231, 236, 238
Carlyle, Thomas 295
Carmarthenshire 23, 31, 38, 65, 115–16, 130, 199, 229
Carter, F. R. (Bob) 57–8, 86, 226, 232
Castell Caereinion, Tŷ Mawr 135, 237
Castell Coch 174
Catholicism 9, 17, 31
Cefn Coch 228
Cefn Mabli 57
Celts (also Kelts) 25–7, 135, 270
Cemlyn-Jones, Sir Wynne 207, 217
Central Landowners' Association 78
Chair 46, 48, 57, 64, 77, 83, 106, 109
Chamberlain, Neville 95
Chapman, Robin xiv, 7
Charabanc 98
Charters, Royal 44
Christianity 13, 152, 283
Church in Wales, the 246
Cilewent 124, 128, 225, 227, 230, 237, 268
Civilisation 7, 29, 36–7, 97, 144, 152, 160, 162, 172, 181
Clark, Professor Grahame 53
Clarke, William 45
Clocks 106–8
Clwyd, Vale of 123, 152
Coed Coch 184, 193
Cogges Manor Farm 271
Colonial Williamsburg 279
Commons, House of 44
contemporary collecting 281
Conway, Kellyanne xi
Cooke, Mavis 86
Coombe Tennant, Winifred 96
Copenhagen 92
Cordingley, Professor R. A. 234, 260
corn mills 112, 225, 228, 231, 138
cottages 40, 55, 65, 116–17, 120–1, 123–5, 128–31, 137, 183, 188–9, 192, 194, 199, 218, 233, 250, 273, 275–6
Council for the Preservation of Rural Wales 36, 117
Council for Social Service in Wales 61, 96, 189

Index

COVID-19 147, 283
craft 6, 13, 29, 37, 53–4, 62–3, 95–111, 146–7, 177, 180, 185, 188, 245, 247–8, 256, 260, 281, 288, 290, 293
Crane, Percy S. 199
Crawshay, Geoffrey 175
Croglofft 125, 137, 236
Crucks 123, 126–7, 130, 228
Cruso, Thalassa 151
Crystal Palace 170
Cubbon, William 269
Cultra 225, 268
cultural ecology 224
Cumbria 151
curatorial activism 284
Currie-Jones, Emyr 259
Cwrt-yr-Ala 175, 190
Cwm-ann 229
Cwm Ystwyth 31
Cych 28
Cyfeiliog 19, 23
Cymmrodorion, Honourable Society of 44, 108, 147, 259
Cymru a'i Phobl 29, 33, 83, 200
Cymru Fydd 10
Czechoslovakia 169

D
Dafydd ap Gwilym 236
Danube 159
Darowen 25
David Morgan and Sons 195
Davies, Professor Alun 262
Davies, Alun Oldfield 145, 259
Davies, Aneirin Talfan 14
Davies, Bill 253
Davies, D. J. 199
Davies, Dr Elwyn 47, 155, 165, 259, 302
Davies Bequest 275
Davies, Lord, of Llandinam 85
Davies, Lynn 247
Davies sisters 96
Davies, John 97
Davies, Dr John 287
Davies, Robert and John 101
Davies, Walter 88
Dee 102
Denbigh cockpit 152, 236–7, 249–50
Denbighshire 116, 127, 231, 234–6, 248–9
Denmark 61, 168–9, 171

Depression, The 49, 58, 95, 153, 175
Din Lligwy 30
Distressed Areas 175
Diwylliant Gwerin Cymru 7, 12, 149–54, 156–7, 159, 259
Dodd, Professor A. H. 277
domestic architecture 120, 141
Dorson, Richard 144
Drane, Robert 46
Dresser 46, 48, 55, 57–8, 151, 256
Dyffryn House 179
Dyfi 8, 20, 23, 25, 60, 84
Dylan, Bob 4

E
Ebbw Vale 63
Ecomuseums 169
Edern 37
Edwards, Averil 61
Edwards, Sir Ifan ab Owen 294
Edwards, Sir Owen M. 276
Edwards, Huw T. 209–10
Edwards, Professor Hywel T. 15
Edwards, Ralph 76, 90, 183, 186
Eilian, John 7
Elan Valley 37
Elfed 229
Ellis, T. E., MP 10
Emral 239
Enclosure Acts 55
England
Epynt 118–19
Erixon, Sigurd 143
Esgair-moel woollen mill 212, 226, 237, 245, 249
Ethnology xii, 141–2, 144, 148, 160, 162, 270, 287, 296
etifeddiaeth yr hil 3, 294
Exchequer, Chancellor of 44, 96
Europe xiii, 2, 21, 23, 27, 29, 31, 34–5, 52, 97–8, 102–3, 107, 116, 124, 127–9, 137, 143–4, 147, 151, 159, 169, 175, 224, 270, 272–3, 285
Evans, Professor E. Estyn 24, 98, 129, 260, 268, 288
Evans, Garfield 194, 227, 233
Evans, George Ewart xvii, 156, 270, 278
Evans, Hugh 40, 54
Evans, Lewis 298
Evans, Dr R. Alun xiv

F

Evans, W. R. 248
Ewenny 15, 102, 146

F

Faber & Faber 156-7
Farmhouses and Cottages in Wales
Fenton, Professor Alexander 260, 269
Fermor, Patrick Leigh 4
Festival of Britain 212
Ffestiniog Railway 106
field museums 171
Finland 168-9, 221
fire-dogs 28
Fishguard 117
Fleure, Professor H. J. 9, 21-6, 29, 33-6, 46-9, 51, 73, 87, 98, 154, 206, 260, 268, 287
Flintshire 102, 227, 231, 239, 264, 273
Forde, Professor Darryll 154
Forest of Dean 197
folk culture 27, 50, 62, 64, 97, 129, 131, 141-3, 145, 147-50, 154, 176, 270, 275
folk life 142-66
Folkliv 69, 133, 141, 143
Folk Life Studies, Society for 1, 92, 270
Folklore 22, 141-5, 152, 159, 161, 267-8
Folk-lore Society 246, 270
Fox, Lady Aileen 76, 90, 117-18, 190
Fox, Sir Cyril Fred
 seeks separate Director for St Fagans 204-9
 writes *Monmouthshire Houses* 132-4
 appointed to National Museum of Wales 46-8
 creates policy for historic buildings 221-4
 acquires St Fagans Castle 177-85, 285
 visits Sweden 171-3, 218
France 24, 31, 47, 88, 111
Francis, Professor Hywel 275, 278
Frilandsmuseet 169

G

Gailey, Dr Alan 268
Gapper, R. L. 193
Gelligaer 126
George, D. Lloyd 78, 85
George V, King 50, 193
George VI, King 193

George, Prince 58
Germany 167-9, 267, 271, 273, 291
Giraldus Cambrensis 102, 152
Glamorgan, Vale of 6, 102, 106, 117, 267
Gomme, Sir Laurence 170
Goidels 26
Gorsedd 13, 44, 56, 152
Gothic 102, 117, 133-4, 139, 174
Grant, Dr Isabel 269
Great Exhibition 170, 212
Great Rebuilding, the 122, 125
Great War, the 49, 102
Greenfield Village 279
Greenmeadow 174-5
Gredington 227
Grimes, W. F. 48, 75-6, 138
Griffiths, James, MP 86
Gruffydd, Pyrs 38, 274
Gruffydd, Professor W. J. 6, 8, 20, 40, 51, 64, 73, 84-9, 129, 154, 183, 264, 301
Gulbenkian Foundation 247
gwerin, y werin 5, 97, 141-3, 147, 149-50, 245, 274, 280, 291
Gwerin (journal) 92, 160
Gwydyr Forest 229
Gwyndaf, Dr Robin xvi, 247-8
Gyda'r Wawr 22, 30, 33
G. T. Clark Prize 129

H

Haddon, A. C. 170, 202
Hafotai 126
Hancocks caterers 196
Handbook to the Welsh Folk Museum 244, 248-9, 255
Harden, D. B. 160
Hardy, Thomas 4
Harlech Dome 123
Hartley, Dorothy 105
Hastings 170
Hazelius, Artur 168-9, 202, 296
Heikel, A. O. 169
Helsinki 169
Hemp, W. J. 75
Hendre Wen 234
Hendre'r-ywydd Uchaf 231, 235, 238, 249
Hewell Grange 177-8
Highland Zone 130, 175
Hillforts 30
Hilling, John B. 252-3

Index

Hiraethog, Gruffudd 99
Historic Buildings Council 236
Hitler, Adolf 9, 27, 84
Holywell Textile Mills 197
Holm, Peter 173
Howard de Walden, Lord 176
Hoyle, Dr W. Evans 44, 46, 65, 167, 171, 296
Hughes, Cledwyn, MP 252
Hughes, T. Rowland 58
Hyde, H. A. 74, 82, 86
Hywel Dda 106, 126

I
Iolo Goch 126
Iolo Morganwg 13, 118, 152, 233
Industrial Revolution 27, 31, 40, 100, 103, 106, 134, 185, 221, 272, 276–8, 282, 292
Iron Age xiii, 28, 47, 150
Ironbridge 271–2
Islwyn 111
Italy 24, 31, 35, 239
Ireland 124, 129, 135, 147, 170, 173, 225, 260–1, 268, 288, 293, 300

J
James, Major F. Treharne 174
Jarman, Professor A. O. H. 262
Jenkins, David 155, 162, 288
Jenkins, David (2) 264
Jenkins, Eveline 89
Jenkins, Dr J. Geraint xiii, xvi, 9, 11, 92, 97, 105, 156, 159–60, 245, 248, 250, 260, 262, 288–9, 298–9
Jenkins, Professor R. T. 183, 206, 287, 300
John, Dr Dilwyn 16, 199, 206, 212, 261
Jones, David Parry 263
Jones, E. D. 291
Jones, Edgar 48, 81, 85
Jones, Gwenallt 9
Jones, Huw D. 274
Jones, R. Albert 226, 228, 232–4, 237
Jones, Professor R. M. (Bobi) xiv, 3, 7
Jones, R. W. 151
Jones, Stanley 134
Jones, Professor T. Gwynn 6, 21–2, 29, 50, 53, 61, 73, 103, 152, 259
Jones, Professor Thomas 61

Jones, Thomas 110, 259
Jones, Dr Thomas, CH 89, 206

K
Kahneman, Daniel 4
Kavanagh, Professor Gaynor 57, 272, 278
Kennedy, John F. 294
Kennixton 200, 212, 232–3, 237, 249
Kenyon, Lord 208, 210, 228
Klein, Ernest 172
King, Martin Luther 294
Kulturen 169

L
Langland, William 147, 161
Laver, James 219
Lee, Archibald H. 45, 50, 86
Lee, Laurie 4
Lewis, D. Gerwyn 247
Lewis, Professor Henry 64, 301
Lewis, Professor Lisa 279, 291, 298
Lewis, J. Saunders 8, 11, 13, 17, 34, 36, 88, 212, 287
Lewis, Timothy 126
Lewis family 26, 145
Lhuyd, Edward 26, 145
Liberal Party 10, 19, 35, 85, 96
Lillehammer 169, 177, 219, 221, 253
Lindblom, Andreas 220
Linnard, William 99, 108
living history museums 169
Llainfadyn 128, 230, 233, 237
Llain-wen-isaf 218
Llanarmon Mynydd Mawr, Tŷ Draw 234
Llanberis 282, 298
Llanbryn-Mair xiv, 6, 8, 19–20, 25, 38, 58, 85, 107, 156, 244, 294, 297
Llandaf Fields 195
Llandow 118
Llandudno 48
Llanerchymedd 217
Llanfair Caereinion 106
Llanfihangel Rhos-y-corn 130
Llanfihangel-yng-Ngwynfa 154
Llangadfan 230
Llangar 236
Llangrannog 229
Llangynhafal 231
Llanover, Lady 151
Llanrhystyd 46, 56, 96, 97

Llanrwst 234
Llantwit Faerdre 229
Llanwrtyd Wells 226
Llanychaer 80, 117
Llewelyn, F. C. 91
Lloyd, Sir John Edward 23, 115, 277
Lloyd, T. Alwyn 36, 255
Lloyd-Johnes, Herbert 61
Llwyn yr Eos 184, 238
Llŷn 3, 37, 80, 116, 123, 248
Llynfawr 28
Londonderry, Marquess of 78
Long-houses 124, 128, 130, 132, 134, 137
Lord, Peter 5, 111, 288
love-spoons 56
Lowland Zone 47
Lucas, A. T. 162, 260–1
Ludlow 177
Lund 220

M

Maclean, Calum 267
Machynlleth 20–1, 40, 78, 82, 108–9, 147, 299
Mackinder, Sir Harford 47
Man, Isle of 269
Manchester 21, 44, 47, 161, 219, 234, 260–1
Manley, Arthur 259
Maihaugen 169, 253
Margaret, Princess 193
Marsden, William 197
Mary, Queen 179
material culture 7, 26, 34–5, 50, 66, 83, 141, 147–8, 157–8, 247, 256–8, 262, 274, 288, 293, 295
Margam Mountain 75, 126
Mari Lwyd 56, 84, 146
Matheson, Colin 99
Matthews, Edward 118, 194
Matthews, Friswith 194
Megaw, Basil 269
Melin Bompren 237–8
Memory xiii, 4, 157, 268, 272
Menai Bridge 109
Methodism 9, 31
Merioneth 24, 105, 109, 124, 231, 236, 244
Merthyr Tydfil xiii, 96, 276
Meyler, H. H. 20
Michelsen, Peter 169
Middle Ages 107, 135, 150, 223, 235–6, 278

Middleton, Mary 247
Ministry of Labour and National Service 81–3
Ministry of Public Building and Works 250
Monmouthshire 61, 80, 125, 132, 185, 189, 212, 231, 251
Monmouthshire Houses 133–4, 228–9, 289
Montgomeryshire 6, 19, 23–4, 106, 116, 127–8, 132, 135, 151, 154, 198, 219, 228, 231
Monroe, Leslie 229
Moorland 24, 30, 35, 64, 99, 123, 222, 278
Morgan, Professor T. J. 246
Morgan, Professor Prys xvi, 5
Morgan, Lt. Col. W. E. Ll. 48
Morrey-Salmon, Col. H. 259
Morris, William 5, 14, 99, 103–4, 132
Morris, Rhys Hopkin, MP 208
Morris-Jones, Professor Hugh 262
Mountain Ash 109
Muir, Edwin 3, 264
Mumford, Lewis 161
Murry, J. Middleton 2, 13–14, 99, 103–4
Murray, W. Grant 244
Museum of English Rural Life 245, 258
Museums Association 44, 82, 170, 172–3, 194, 218
Museums Journal 170, 227, 251
Myres, Sir John 23, 206

N

Nantgarw 102, 110
Nash-Williams, V. E. 62, 74–6, 82
National Council for Civil Liberties 86
National Council for Social Service 96
National Eisteddfod of Wales xiii, 44, 78, 108–10, 146–7, 192, 255
National Library of Wales xvi, 44, 61, 85, 106–7, 111, 252, 264, 275
National Museum of Scotland 270
National Museum of Wales
 Art and Archaeology Committee 79, 90, 174, 178
 Emergency Committee 81–5
 Folk Gallery 59–60, 142
 Folk Industries Gallery 107
 Museum Affiliation Scheme 65
 National Slate Museum 282
 Reardon Smith Lecture Theatre 58, 61, 89

Index

Royal Charter of 43–4
Turner House Art Gallery 171
National Trust 36
Netherlands, the 169
Newall, R. S. 75
Newport 179, 231
Nordic 33
Nordiska Museet 168, 172, 202, 219
North, F. J. 90
Norway 87, 161, 168–9, 171, 177, 219, 221

O

Ó Súilleabháin, Sean 146
Oak 102, 117, 123, 232
Oakly Park 177
Offa's Dyke 47
Oldfield-Davies, Alun 145, 259
Olsen, Bernhard 169
oral tradition 10, 12, 57, 142, 162, 247, 254, 258, 267
Orkney 3
Orwell, George 8
Oslo 23
Owain Glyndŵr 10, 126, 235
Owen, Bob 109
Owen, Emrys Bennett xvi
Owen, Sir Isambard 44
Owen, I. Dale 252, 255
Owen, Trefor M. xii–xiv, 1, 11, 73, 91, 234, 248, 251, 260, 262, 288–9, 294–5
Oxford 23, 98, 271
Oxford Dictionary of National Biography 2

P

Page, Alun 264
Pandy 19, 97, 224
Paris 168
Park Place 91
Parry, Dr Joseph 238
Parry, Sir Thomas 6, 9, 84, 88–9, 208, 287
Parry-Williams, Sir Thomas 9, 301
Pastoralism 30, 152
Patagonia 11
Paterson, Dr R. 171
Paviland 28
Payne, Ffransis G. xiii, xvii, 8, 12, 50, 63–4, 87, 90, 110, 113, 155, 181, 188, 198–9, 207, 221–2, 232, 244–5, 247–8, 251, 253, 260, 288–9
Peace Pledge Union 86
Peach, Linden 9
Peate, Dr Iorwerth C.
 attends university at Aberystwyth 20–4
 as archaeologist 25–8
 compiles catalogue 52–9
 character 9–13
 on crafts 95–114
 early life 19–20
 on ethnology 141–66
 as geographer 29–35
 as museum leader 283–96
 appointed to National Museum 48–52
 sacked by National Museum 82–90
 tensions with National Museum Director 73–81
 as nationalist 10–11
 creates new period rooms 57–9
 as poet and man of letters 5–7
 on rural matters 35–8
 opening St Fagans 194–215
 as scholar 287–9
 visits Sweden 218–21
 on vernacular architecture 115–39
 on Wales's industrial past 275–8
Peate, Dafydd 95
Peate, Dafydd (2) 2
Peate, George 95
Peate, Nansi 2, 6, 10–11, 22, 96, 219, 278
Pembrokeshire 35, 54, 76, 98, 116–17, 119, 121, 123, 125, 127, 139, 152, 218, 224, 229, 231, 273
Penarth 171, 204
Penley 227
Penmaenmawr 28
Pen-rhiw chapel, 237
Pentan 28
Penyberth 3, 11, 17, 80, 88, 117
Penydarren locomotive 46
Personau 2
Pettigrew, Hugh 180
Personality of Britain, The 34, 47
Phillips, Elen 281
Phillips, Sir Thomas 82
Phillips, Vincent H. 247, 260, 262–3
Pierce, Professor T. Jones 287
pigsties, circular 123–4
Pilgrim Trust 200, 212, 218, 220, 229, 235, 249
Pitt Rivers Museum 170, 206

Plas Bodean 248
Plas Cadwgan 236-7
Plas Uchaf 236-7
Pluncket, Count 170
Plymouth, 2nd Earl of 81, 88-9, 177
Plymouth, 3rd Earl of 85, 183, 186, 193, 210, 225-6, 259, 275, 285
Poland 169
Pontcysyllte 109
Pontypool 102
Pontypridd, Lord 43-4
Porthmadog 106
Portmeirion 239
Port Talbot 229
Porthcawl 77
Powysland Club 66-7
Powysland Museum 65-6, 107, 228
Prehistory 26, 34, 39, 53, 75, 282
Prehistoric and Protohistoric Societies, International Congress of 26
Price, Eileen (Mrs Fellowes) 59, 87
Privy Council 44, 81, 246
Proger, T. W. 171
Pughe, William Owen 52
Pumlumon 23
Pwllheli 117, 248

Q
Quakers 67, 96
Quick, Dr H. E. 208

R
Radnorshire 31, 75, 100, 116, 127, 230-1
Raglan, Lord 80, 132-3, 161, 228-9, 294, 289
Ralegh Radford, C. A. 129-30
Randall, H. J. 183, 206, 208
Rapallo House Museum 48
Reading 245
Reardon Smith, Sir William 49, 58
Redfield, Robert 144
Rees, Abraham 107
Rees, Alwyn D. 154-5
Rees, D. Morgan 282
Rees, William 91, 98, 112
Rees, Professor William 183, 187, 210, 259, 284
regional ethnology 142
religion 2, 9, 31, 110, 145, 147-8, 153, 155, 277, 283

Renaissance 22, 102, 175, 181
Rentzhog, Sten 273
Renwick, Allan E. 79, 183, 186-7, 197, 200, 206, 208
Rhaeadr 237
Rhondda 95-6, 273
Rhiwbina 8, 36, 188, 206, 215
Rhoose 118
Rhostryfan 230
Rhwng Dau Fyd 2-3, 232, 264
Rhŷs, Sir John 26
Rhymney 61, 278
Richards, Professor Melville 262
Richards, Robert, MP 83
Roberts, Dr Caradog 283
Roberts, David E. 81, 183, 206-7
Roberts, Dr Kate 4, 206
Roberts, Manon Wyn xiv
Roberts, Dr R. Alun 56
Roberts, Samuel ('SR') 19, 156
Roberts, Samuel 106-7
Romans 22, 31-2, 67
Rose, Walter 97
Rowntree, Joseph 96
Royal Commission on the Ancient and Historical Monuments of Wales 76, 127, 168, 230, 236
Royal Commission on the Historical Monuments of England 119, 134
Royal Commission on Land in Wales 115
Royal Commission on National Museums and Galleries 171, 175
Royal Anthropological Institution 23, 132
Royal Institution of South Wales 48
Royal Air Force 116
Royal Society 107
Royal Society of Arts 203
Royal Welsh Agricultural Show 46, 108
round-chimneyed houses 115-16, 126, 224
Ruabon 43
Rural Industries Bureau 96
Russia 168
Ryedale Folk Museum 271

S
Saer, D. Roy 145
Sanderson, Stewart 260, 262, 270
Sandvig, Anders 169
Savory, H. A. 75

Index

Sayce, R. U. 98, 219
Scandinavia 50, 132, 142, 147, 153, 167–8, 170–6, 185, 217–18, 220, 244, 248, 250, 252–3, 260, 267, 269, 271, 273, 275, 279–80, 287–8, 241, 293, 296
Science Museum 245
Scott Report 36–7
Scott-Fox, Charles 76
Scourfield, Dr Elfyn 160, 257, 266
Seurasaari 169
ship models 58, 60, 63
Six Wells 118
Skansen 91–2, 167, 169, 172–3, 202, 219–20
Slad 4
Smiles, Samuel 104
Smith, Professor Dai 275
Smith, A. Dunbar 45, 57
Smith, J. T. xvii, 134, 160
Smith, Dr Peter xiii, 134–5, 160, 234–5, 262
Smithy 54, 60, 97, 106, 231, 238
Snowdonia 8, 32, 115, 137
Soddy Trust 248
Sommerfelt, Dr Alf 23, 50–1, 87, 221
South Africa 193
South Wales Echo 84
South Wales Miners' Federation 86
Spain 24, 28, 31, 88
Standing Commission on Museums and Galleries 61, 171, 209, 252
Stapleton, R. George 36, 38
Stephens, Meic 2
Stevens, Catrin xiv, 7, 176
Stockholm 167–9
Stonehenge 75–6
Strata Florida 126
Strong, Sir Roy 196
Studies in Folk Life 260, 268
Stryd Lydan barn 194, 212, 227, 237, 249
Sturt, George 97
Summerson, John 129
Swansea 43–4, 48, 63–4, 88, 102, 145, 231, 244, 251–2
Sweden xiv, 11, 19, 168, 171–2, 202, 219–21, 240, 244, 281
Sycharth 126
Sydenham 170
St Athans 118
St Clears 31
St Davids 116–17, 127

St Fagans xv, 2, 177–89, 193–201, 204, 211–12, 224–5, 237–8, 250–9, 275–6, 279–80
St Fagans: National Museum of History xvi, 1, 282
St Nicholas 179, 267
St Paul's Cathedral xiv
Sylfeini 176

T

Talerddig 20
Tannery 225, 231, 237
Teifi 98, 101–2
Thomas, Sir Alfred 44
Thomas, Sir D. Lleufer 48, 65, 115, 123–4, 128
Thomas, Gwenllian 45
Thomas, T. H. (*Arlunydd Pengarn*) 45
Thompson, E. P. 287
Thompson, George 260, 262, 268
Thoms, W. J. 141, 161
Tibbot, John 107
Tibbott, S. Minwel 160, 247
Toll-house, Penparcau 236–7
Tongwynlais 174
Tradition 7, 20, 35, 47, 95, 108–9, 122, 127, 142, 144, 150–1, 158–9, 161, 175, 200, 248, 250, 263, 279, 281, 283, 288, 295
Tradition and Folk Life 156–7, 159, 165
Treasury, the 63, 179, 181–3, 199, 210–11, 218, 231, 244, 246–7, 252
Trecŵn 117
Tredegar House 179
Treherne, Cennydd 179
Tre'r Ceiri 30
Trevithick, Richard 46, 105
Tudors 31
Twiston Davies, Sir Leonard 61–2, 82, 84, 183, 206–8
Tywi 101–2

U

Ulster Folk and Transport Museum 24, 225, 258, 268
Unitarianism 31, 238, 249
United Kingdom 141
University of Wales 29, 40, 43, 83, 88, 91, 142, 149, 200, 210, 244, 246, 292–3
University of Wales Board of Celtic Studies 247

University of Wales Guild of Graduates 51
Uplands 5, 16, 31–3, 55, 122, 151, 176, 225, 293
Uppsala 91, 174, 220
Urdd Gobaith Cymru 294
Usk 102

V
Vermont 233
vernacular architecture xiii, 47, 115, 133, 260, 288–9
Vernacular Architecture Group 271
Victoria & Albert Museum 50, 90, 196, 219
Victorian 5, 10, 35, 57, 128, 162, 174, 177, 221, 236, 238, 241, 294
villages 30–1, 35–6, 54, 270
Von Sydow, Professor Carl Wilhelm 173, 267

W
Wagon 6, 63, 79, 102, 106, 158, 181, 228, 245, 254–5
Ward, John 45, 202, 280
Ward, John (2) 228
wassail bowl 84, 102, 146, 161
Weald and Downland Open-air Museum 271
Welsh Bygones, Guide to 36, 52–3, 64, 83, 150, 202, 249, 280
Welsh Calendar Customs, Committee on 246
Welsh Folk Museum
 Department of Material Culture 247
 Department of Oral Traditions and Dialects 12, 162, 247, 258
 Gwalia Stores xiii, 298
 Italian Garden 179
 Rhyd-y-car Terrace xiii
 St Fagans Castle xiii, 174, 177–9, 182, 185, 187–8, 193–4, 221, 231, 235, 244, 248, 250–1, 254, 259, 262, 275
Welsh House, The xi, xiii, 13, 33, 80, 83, 88, 115–39, 149–50, 289
Welsh Industrial and Maritime Museum 282
'Welsh Kitchen' 48, 57, 194, 279
Welsh language xii, 5–6, 9–10, 12, 17, 20–1, 23, 27, 30–1, 34, 50, 61, 78, 147–8, 150, 158, 236, 245, 264, 289, 291–2, 302

Welsh National Party 10, 38, 91, 95, 103, 117
Welsh Reconstruction Advisory Council 67, 176
Western Mail 61, 198, 207, 210, 236, 264
Westminster 10
Whalley, G. H. 43
Wheeler, Sir R. E. Mortimer 16, 25, 30, 45–6, 48, 65, 119, 128, 136, 289
Willans, J. B. 24
Williams, D. J. 3–4, 264
Williams, Professor David 287
Williams, Deiniol 261
Williams, Sir Glanmor 262, 287
Williams, Professor Griffith John 99, 233, 245, 247, 287
Williams, Professor Gwyn A. 287
Williams, Sir Ifor 83, 88, 106, 148, 287
Williams, Isaac 48, 108
Williams, Professor J. Gwynn 262
Williams, James 109
Williams, John 106
Williams, Raymond 275, 287, 292
Williams, Professor Stephen J. 259
Williams, Waldo 9
Williams-Ellis, Clough 238–9
Williams-Wynn, Sir Watkin 256
Windmills 229
Windsor-Clive family 174, 177, 225
Wood-Jones, Dr Raymond 260
woollen mills 250, 279
Woolworth 98
Worcestershire 177
Wren, Sir Christopher xiv
Wrexham 65, 101, 109, 236
Wye 64, 102
Wynnstay 256

Y
Y Crefftwr yng Nghymru 7, 83, 101, 105, 287
Y Cymro 198, 263
Y Fan 174, 225
Yoder, Don 144–5, 162
York 142
York Castle Museum 53, 271

Z
Zola, Émile 88